beyond geometry

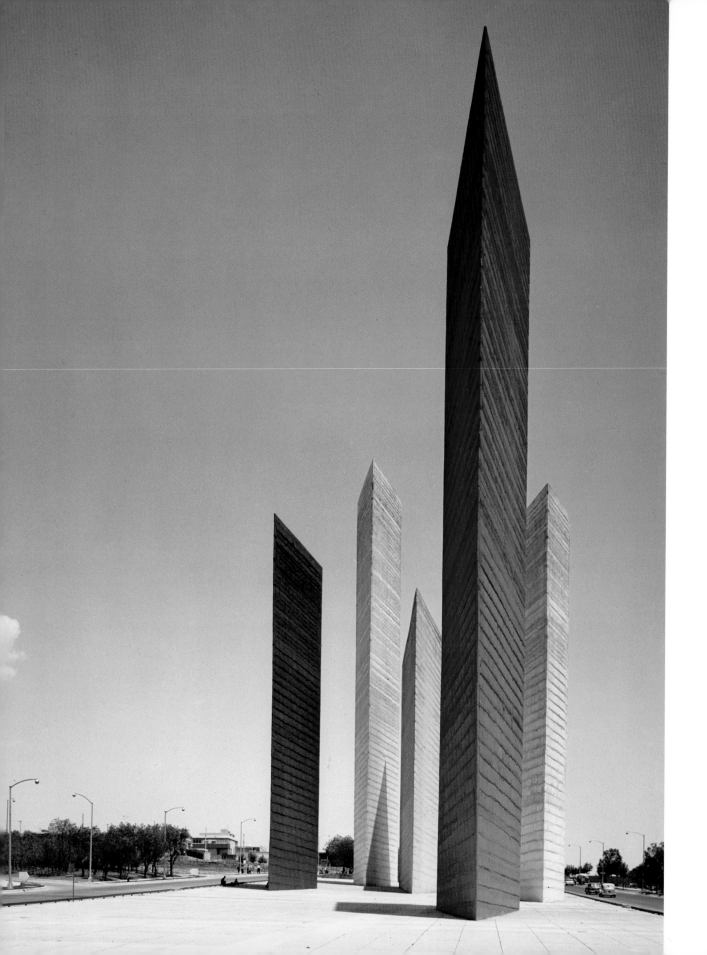

beyond geometry

Experiments in Form, 1940s–70s

geometry

Lynn Zelevansky

with contributions by
Valerie L. Hillings
Miklós Peternák
Brandon LaBelle
Peter Frank
Inés Katzenstein
Aleca Le Blanc

Los Angeles County Museum of Art

The MIT Press
Cambridge, Massachusetts and London, England

Copublished by Los Angeles County Museum of Art, 5905 Wilshire Boulevard, Los Angeles, California 90036 and The MIT Press, Cambridge, Massachusetts 02142

Library of Congress Cataloging-in-Publication Data

Beyond geometry: experiments in form, 1940s–70s / Lynn Zelevansky . . . [et al.].
 p. cm.
Published in conjunction with the exhibition of the same name organized by the Los Angeles County Museum of Art.
Includes bibliographical references and index.
 ISBN 0-262-24047-5 (alk. paper)
 1. Art, Modern—20th century—Exhibitions.
2. Avant-garde (Aesthetics)—Exhibitions.
3. Arts—Experimental methods— History—20th century—Exhibitions. 4. Morellet, François—Exhibitions. 5. Oiticica, Hélio, 1937–1980—Exhibitions. 6. Bochner, Mel, 1940—Exhibitions. I. Zelevansky, Lynn. II. Los Angeles County Museum of Art.

N6487.L67L673 2004
709'.014'007479494—dc22
 2003066823

Exhibition itinerary:
Los Angeles County Museum of Art:
6/13–10/3/04
Miami Art Museum, Florida:
11/18/04–5/1/05

Beyond Geometry: Experiments in Form, 1940s–70s was published in conjunction with an exhibition of the same name organized by the Los Angeles County Museum of Art. It was supported in part by grants from the National Endowment for the Arts and the National Endowment for the Humanities, dedicated to expanding American understanding of history and culture. Additional support was provided by Gallery C.

Transportation assistance was provided by Lufthansa German Airlines.

Special thanks to the Cultural Services of the French Embassy/French Consulate Los Angeles, the Trust for Mutual Understanding, Vitae, Institut für Auslandsbeziehungen, the Embassy of Brazil, Istituto Italiano di Cultura, the Consulate General of the Netherlands, and the Polish Cultural Institute.

Any views, findings, conclusions, or recommendations expressed in this publication do not necessarily represent those of the National Endowment for the Humanities.

Director of publications: Stephanie Emerson
Editor: Thomas Frick
Designer: Katharine Go
Production coordinator: Karen Knapp
Supervising photographers: Peter Brenner and Steve Oliver
Rights and reproductions coordinator: Cheryle T. Robertson

Printed and bound in Germany by Cantz, Ostfildern

Beyond Geometry was composed in Priori, a family of typefaces designed by Jonathan Barnbrook that includes both serif and sans serif versions. Priori was directly inspired by the work of modernist British typographer Eric Gill (in particular his Perpetua and Gill Sans faces), as well as by Uruguayan-born Edward Johnston's celebrated 1916 typeface for the London Underground. Another influence was Barnbrook's affection for vernacular lettering on the cathedrals and public buildings of his London neighborhood. Priori's combination of hard-edged square and circular geometry and archaic decorative flourishes gives it versatility as both display and text type.

Frontispiece: Mathias Goeritz, *The Towers of Satellite City*, 1957–58

(continued on p. 237)

Stanisław Dróżdż, Między (Between), 1977

Foreword

Beyond Geometry: Experiments in Form, 1940s–70s looks at the history of post–World War II abstract art, examining the role of radically simplified form and systematic strategies in vanguard work from Central and Western Europe and North and South America. It is the first major museum exhibition to treat these issues art historically in an extensive international context. It is also the first to examine South American geometric art beyond a regional situation.

An essay rather than a survey, *Beyond Geometry* tracks parallels, intersections, and divergences in the evolution of what, by the late 1960s, had become an expansive intercontinental discourse. At the same time, it questions the precedence often given to U.S. minimalism in previous accounts of the period.

An exhibition of this scope requires the support of numerous individuals and organizations. In particular, we at LACMA would like to thank the National Endowment for the Arts, the National Endowment for the Humanities, Gallery C, the Trust for Mutual Understanding, Vitae, and the governments of France, Germany, Brazil, Italy, the Netherlands, and Poland for their generous sponsorship. We are also extremely grateful to the many lenders, institutional and private (listed on page 237), whose willingness to part temporarily with wonderful works of art has made this exhibition possible.

Beyond Geometry, positioned on the brink between the immediate past and history, seeks to broaden our understanding of a period many of us lived through and can recall. It is one in a long line of ambitious thematic exhibitions that have distinguished LACMA over the decades. We are most grateful to Lynn Zelevansky, curator and department head of modern and contemporary art, for conceiving and realizing this fascinating and highly original project.

Andrea L. Rich
President and Wallis Annenberg Director
Los Angeles County Museum of Art

Hélio Oiticica, *Nucleus 6*, 1960–63

bey□nd qe□metry

Objects, Systems, Concepts

Lynn Zelevansky

Beyond Geometry: Experiments in Form, 1940s–70s examines the use of radically simplified form and systematic strategies in the development of vanguard art throughout the West in the decades after World War II. This was a period of intense experimentation, a time of transition after high modernism and before the advent of the first fully postmodern generation.[1] It includes what were arguably the most influential years in Western art since the decade before World War I—from around 1960 to the early 1970s. The exhibition chronicles an increasing global awareness. In the 1940s most art movements were regional; by the beginning of the 1970s, improved modes of communication, the availability of inexpensive printing techniques, and cheap air travel had permitted a broad-based intercontinental art discourse.

There were theoretical and formal underpinnings to this unprecedented confluence, some of which had roots in high modernism. However, the postwar and early Cold War years spawned intellectual and formal concerns that were far more crucial to what became a widespread rethinking of the modernist agenda. There was intense interest in existentialism and phenomenology, in the art and attitude of Marcel Duchamp, and in systems for making art, which (in theory at least) suppressed metaphor as well as the emotive expression and authority of the creator. The international artists represented in exhibitions and publications around 1970[2] may have already been aware of one another's work to varying degrees, but it is more significant that they shared sources and ideas to which they had been exposed locally. As a result the conceptual basis of their art, often independently conceived, was nonetheless related.

Given that the period saw the onset of globalization and the coalescence of an intercontinental art world in the mode we know them today, why concentrate on only three artists as I do in this essay? Considering the multifarious forms and categories of art encompassed by the exhibition, and the further distinctiveness of individual artists' practice, to draw generalizations seemed not just unenlightening, but futile. Rather, I felt that a careful look at three figures, each from a different continent, might provide fodder for a substantive argument and allow for some larger understandings. One sees in the work of François Morellet, Hélio Oiticica, and Mel Bochner the sources and stimuli that were available to them regionally—what was possible within the contexts out of which they came. In radically different ways, those influences helped each of them to develop an artistic voice that was strong enough to have an intercontinental impact.

In the postwar period, certain prominent U.S. artists and their supporters believed they were creating something completely new and unattached to European tradition.[3] In 1965, minimalist object-maker and theoretician Donald Judd proclaimed, "I'm totally uninterested in European art and I think it's over with."[4] He and painter Frank Stella dismissed their European counterparts as tied to an old form of modernism characterized by an attachment to traditional "relational painting" and "rationalistic philosophy."[5]

Minimalism was arguably the most original North American artistic development of the postwar period. There were European precursors, and artists in Europe and South America were working on many of the same ideas as the minimalists, but nothing created elsewhere looked quite like minimalism.[6] For one thing, in the hands of its most central figures, it was emphatically three-dimensional. Many artists working with radically simplified form in other regions remained attached to painting, which up to the 1960s was the dominant modernist art form. The minimalists played a large role in changing that, at the same time shifting the paradigm for sculpture itself. Their works were more horizontal than vertical in orientation, and were usually a single shape rather than a configuration of parts.

The minimalists also espoused the notion of the "literal" in art, the idea that all meaning resides in the physical object itself, rather than its metaphoric content or relationship to the world outside itself. When minimalism emerged in New York, there seems to have been little awareness that this literalism was European and prewar in origin,[7] an essential tenet of *art concret* as formulated by the Dutch modernist Theo van Doesburg in Paris in 1930.[8] For van Doesburg and his cohort, the term "concrete" signified this literalness.

With its emphasis on three-dimensionality, minimalism gave this concept of the concrete in art new force. A sculpture is by definition more "literal" than a painting because its space is actual, not dependent on illusion. Seeking intellectual rigor as opposed to personal expression, and an active involvement on the part of the beholder as opposed to an Olympian remove, minimalists intensified this quality, creating objects without pedestals that shared the quotidian space of the viewer. In this way they questioned the established boundary between the invented world of a traditional sculpture (defined by the pedestal) and the everyday environment that surrounded it. By placing large, simply shaped, three-dimensional forms directly on the floor, thereby insisting that the viewer interact with the work as a body in space, the artist Robert Morris, for example, attempted to define the intellectual as one with the physical; he engaged the beholder's awareness of herself as a perceiving organism, not just a pair of eyes and a mind.

The U.S. bias against European abstraction can be overstated—the minimalists and the postminimalists who followed them generally held the Russian avant-garde of the 1910s and 1920s in high regard, for example[9]—but there is no question that the term "geometric abstraction," associated with Europe, was objectionable to many in the North American vanguard. It brought to mind the looming presence of Piet Mondrian in New York in the first half of the 1940s, which generated numerous acolytes of the Dutch master, especially among the American Abstract Artists group.[10] In the 1960s those seeking to create a new North American art rejected this influence as most abstract expressionists had done before them.[11] For minimalists geometry was synonymous with composition, the balancing of separate elements that defined an older, now passé art. Also, in phenomenologist Maurice Merleau-Ponty's terms, geometry

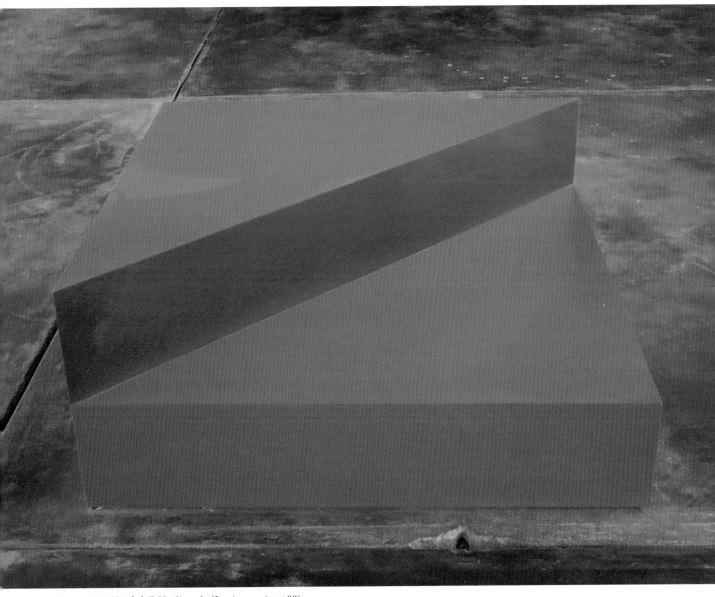

Donald Judd, *Untitled (DSS 38)*, 1963 (fourth example, 1988)

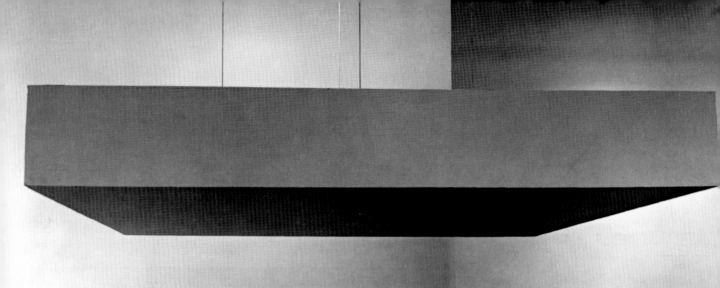

Robert Morris, *Hanging Slab (Cloud)*, 1962

represented an "ideal" rather than a "presence,"[12] and was completely disconnected from the physical immediacy and temporality that these artists sought. They might use geometric forms, but their simple "wholes"[13] generated a "gestalt" (an immediate sense of the work in its entirety, according to Morris)[14] that was unavailable to traditional geometric abstraction. Finally, a long-standing separation existed between constructivist and expressionist (or surrealist) modernism, promulgated by prominent theoreticians as diverse as Alfred Barr[15] and Georges Bataille. In reality these tendencies frequently influenced each other,[16] but the dichotomous view reinforced the notion that geometric abstraction was bloodless and based in positivist logic.

In fact Mondrian and Kazimir Malevich, exemplars of geometric modernism, created their work intuitively. Van Doesburg, who with Mondrian practiced and promoted neoplasticism and De Stijl—forms that were elegant and controlled in their severe geometry—simultaneously practiced and promoted dadaism, which embraced chaos and rebellion. For a while dada also intrigued Mondrian. (During this period both artists signed their letters with "dada" appended to their surnames.) Under the aliases I. K. Bonset and Aldo Camini, van Doesburg sponsored dada events, created dada poems, and published the dadaist pamphlet, *Mechano*.[17] He saw dada and De Stijl as opposed tendencies, but believed that dada's revolutionary character was essential to the realization of De Stijl's utopianism.[18]

Around 1930 van Doesburg began to use arithmetic as the basis of his work. This "scientific" method—indicative of his growing interest in an objective ideal—was at odds with Mondrian's intuitive approach and caused a rift between them. Nonetheless, "systematic" concrete art, based in mathematics, non-individualistic, and with the goal of achieving order and harmony, provided a foundation for the continuation of constructivism after World War II. Following van Doesburg's death in 1931, the Swiss artist Max Bill took up the mantle, successfully disseminating the precepts and ethos of concrete art in Central and Western Europe and South America after World War II. Bill had no interest in dada. Rather, he advocated "a new form of art . . . which . . . could be founded to quite a substantial degree on a mathematical

line of approach to its content."[19] For him this was an art based in "reason" in which geometry was "the means of determining the mutual relationship of its component parts."[20]

The reception of Bill's work and ideology must be understood in the context of postwar Europe and the Cold War. In a 1966 exhibition catalogue, philosopher and writer Max Bense wrote: "There is no intellectual activity which today could do without the rational aura. I think that the painting of Max Bill has visibly demonstrated this fact on aesthetic grounds. Therefore I find it impossible to speak about his work in other than rational terms."[21] At the time, the memory of conflict was still fresh for many and the threat of nuclear holocaust relatively new. Bense interpreted Bill's work as a series of aesthetic messages communicated semiotically, topologically, statistically, and as information.[22] The implication was that the rigor of scientific thinking ensured the moral and intellectual authority of art in the face of social and political instability. However, the contradiction inherent in Bense's phrase "rational aura" underscores the difficulty of demystifying abstraction, which does not easily support a single, quantifiable definition. Bill advocated a narrow and controlled art, perhaps in part because he found the meaning of nonreferential (or abstract) visual language uncomfortably ambiguous.

Underlying Bill's theories, which posit universal notions of beauty and emphasize rationality, harmony, and "the human spirit," is the assumption that seeing is detached and rational, a straightforward biological mechanism that functions the same way in all people. As James Elkins makes clear, true seeing is actually "irrational, inconsistent, and undependable . . . No matter how hard we look, we see very little of what we look at."[23] Apart from the environmental and biographical factors that affect perception, in everyday life we block out much of the world and focus obsessively on the details that concern us simply in order to function.[24] Looking thoroughly, seeing with care and refinement as one must with art, takes experience and a degree of knowledge. In addition, without background in the arts generally and understanding of a particular artist's intent, it is difficult to distinguish one kind of abstraction from another, or to interpret a "nonobjective" work with any certainty. The more abstract the art, the more it depends on the discourse that surrounds it.[25]

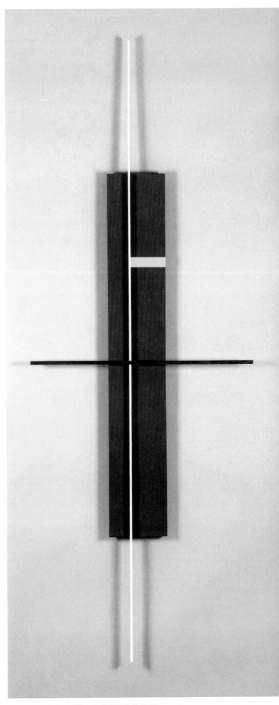

Burgoyne Diller, *Untitled (Wall Relief)*, c. 1950

Although he was a literalist, Bill's approach was disdained by the minimalists. Not only was it based in a priori logic—Bill's "reason"—it involved the "relationship of component parts," which artists like Stella, Judd, and Morris opposed.[26] Bill's success in proselytizing concrete art made him extremely visible internationally in the decades after World War II, no doubt contributing to the U.S. reaction against "geometric abstraction." Frank Stella, for one, referred to "European geometric painting—sort of post-Max Bill school . . . very dreary."[27]

Nonetheless, Bill profoundly influenced artists in Europe and South America, providing a surprisingly flexible methodology that allowed them to move in directions that he could not have anticipated and of which he would not have approved. French artist François Morellet encountered Bill's work for the first time in 1951 on a visit to Brazil.[28] It opened Morellet to the possibilities inherent in radically simplified form, and led him to devise systems for art making:[29] In response to Bill, Morellet began organizing his paintings according to preestablished "rules" that he set for himself, and producing them more or less mechanically. By 1956 he was using titles such as *Right Concentric Angles* and *Lines, 45°, 135°*, which conveyed the terms by which the canvas was made. He has said that a painting itself interests him less than the system that created it.[30]

Morellet was not alone. Art produced systematically had great currency on all three continents in the postwar era. Artists such as Jesús Rafael Soto, in Caracas and Paris, and Bridget Riley, in England, executed their predetermined plans by themselves or had assistants do it. Others, like Donald Judd and Carl Andre in the United States, sent their plans to fabricators. The industrial connotations these procedures engendered undermined the artists' image and authority as creators, simultaneously reflecting and encouraging the antiestablishment social and political mores of the times. A goal was to counteract established values, and the use of systems elevated process over product, further undercutting the standards on which the art market depended.

For Morellet, a systematic approach had major advantages. It allowed him to dispense with traditional composition. Despite what Judd and Stella believed, postwar artists all over the West saw the balancing of one element against another in painting and sculpture as an unacceptable compromise, and Morellet was no exception.[31] The presence of parts did not require him to perform this compositional balancing act, because the elements could be organized in a nonhierarchical grid or series of lines, in the manner later utilized by artists such as Sol LeWitt.

In 1956, in *From Yellow to Purple* (p. 16), Morellet avoided balance by creating two sets of concentric squares. Both sets move from yellow on the inside to purple on the outside in seven steps, with white intervals between them and a white square at the center. Each square and each interval is of equal width. The left squares move from yellow to purple through blue and green; the right squares move from yellow to purple through red and orange. Color is never mixed. Rather, red lines on top of a blue background make purple; red lines on top of a yellow background make orange; blue lines on top of a yellow background make green. The weight of the lines and the spaces between them determine the hue. Only the squares in primary colors have no lines on them. In this painting many simple "rules" result in a fairly complex system.

For Morellet, anything that separated artistic activities from those of "ordinary" people was retrograde. Around the same time that he learned of Bill's work he encountered Buddhism, as well as the writings of the Armenian spiritual teacher G. I. Gurdjieff and his disciple P. D. Ouspensky. Gurdjieff advocated a mathematical approach to art making, which would affect viewers emotionally as well as intellectually.[32] He believed that most people's conception of the "I" is false, because there is no authentic sense of self, only ego. To begin to overcome this one must strive for greater consciousness of the self.[33] For Morellet the practice of a systematically produced art promoted this ideal.[34] While the teachings of Gurdjieff and Buddhism have not remained central to his life, he has continued to value the detachment from egoistic concerns he associates with them.[35]

Carl Andre, *144 Pieces of Aluminum*, 1967

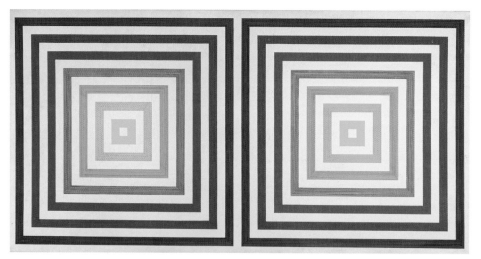

François Morellet, *From Yellow to Purple*, 1956

By imposing as little of himself as possible on his systematic art, Morellet also sought to make the spectator responsible for its meaning, so that she could take credit for the richness of its interpretation.[36] The viewer thus becomes a partner in the creative act. Similar ideas had profound reverberations all over the West by the 1960s. As Michael Fried famously complained about minimalist sculpture, "the experience of literalist art is of an object in a *situation*—one that, virtually by definition, *includes the beholder*."[37]

In 1951 Morellet (who never formally studied art) discovered the works of Mondrian and Marcel Duchamp.[38] Mondrian had an immediate impact; Duchamp worked on him more slowly but no less profoundly. Arguably the most influential artist for the second half of the twentieth century, Duchamp introduced a radical self-consciousness to art making, undercutting traditionally mystifying notions of the artist and creative act. In 1916 he signed someone else's mural at the Café des Artistes in New York,[39] questioning notions of originality and their relationship to market mechanisms. He saw the museum as a social frame for art rather than as a neutral space. With his "ready-mades"—found objects that were sometimes "assisted" (altered) but always recognizable, and placed as art in an art context—he questioned the traditional distinction between the realms of art and everyday life, as well as the value of artistic labor, the uniqueness of the art object, and evidence of the artist's hand. Believing that the future of art lay in "intellectual" as opposed to "animal expression," he was the progenitor of much conceptualism.[40] (In 1969 conceptualist Joseph Kosuth proclaimed, "All art [after Duchamp] is conceptual in nature."[41]) Throughout Europe and North and South America artists found that his legacy combined surprisingly well with geometrically based work.[42] Morellet came to see in the ready-made a strong stand against the artist as "arbitrary artisan-creator."[43] He admired the distance that Duchamp established between himself and viewers, which allowed them to interpret the works freely.[44]

Dada met concrete art in Morellet as it did in van Doesburg. It entered the work not just via Duchamp, but also Jean Arp and Sophie Taeuber-Arp, whom Morellet met in 1958 through Ellsworth Kelly. Kelly had been interested in the role of chance in art since the early 1950s,[45] and Morellet followed suit, influenced by the collages that the Arps created around 1916. He made works based on numbers found in the telephone directory. First he created a grid and wrote many telephone numbers on it, one digit to a square. Assigning one color to odd and another to even integers, he then painted each square the assigned color. Morellet was interested in the way that colors, arranged arbitrarily, interacted with each other. Chance "did not destroy the composition, it parodied it, made it ridiculous and gave premier place to the rule of the game—to the system."[46]

It is a truism in the study of postwar art that works that look alike may well be conceptually unrelated. In abstract languages false cognates abound. Nevertheless, since form and content are inextricably linked, visual resemblance may have significance, even if it does not indicate sameness, and in some instances a careful analysis of related morphologies can yield insights into the practices of very different artists. European writers have noted similarities between Morellet's paintings from the 1950s and works by U.S. artists done some years later, usually arguing for Morellet's earlier use of a given pattern. In most instances the resemblances between these very simple designs are superficial and inconsequential.[47] However, one such case has significance, but not the significance that Morellet's supporters posited.

In 1973 a controversy erupted in the magazine *Flash Art*, when a German gallery took out an advertisement accusing North American artist Sol LeWitt of copying the work of the Europeans Jan Schoonhoven,

Sol LeWitt, "Circles and Grid, Arcs from Four Corners and Four Sides," 1972

François Morellet, *22 Weaves*, 1960
Oil on wood; 31½ x 31½ in. (80 x 80 cm)
Collection of the artist

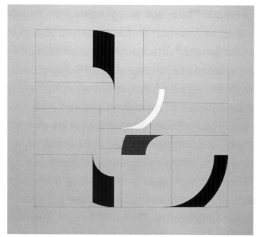

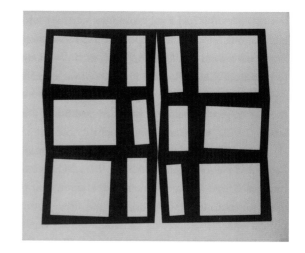

left: Hélio Oiticica, *Metaesquema No. 171 (seco I)*, 1957–58

right: Hélio Oiticica, *Metaesquema No. 296*, 1957–58

would be to launch it into space, so that it could become complete, not as surface or appearance, but as essence.[63] He did this in 1960 with his *Bilaterals* and *Spatial Reliefs*, mostly monochrome, shaped two-sided paintings on wood that were suspended from the ceiling on wires. They were the embodiment of a theory he was developing in which color, structure, space, and time were fused. Confronted with these works the spectator/participant would not experience time through contemplation, as with traditional works of art. Rather "he finds his living time as he becomes involved, in a univocal relationship, with the time of the work."[64] Thus, in a wholly different manner than Morellet, Oiticica put the viewer at the center of his practice.

The viewer's centrality was expressed philosophically in Merleau-Ponty's ideas about perception. The French phenomenologist was widely read on all three continents during this period. Believing that previous theories described thinking about seeing rather than seeing itself, Merleau-Ponty developed a concept that was experiential and immediate. He envisioned phenomenology as akin to the visual arts, which he held were capable of directly presenting to the world the "pre-objective" response that he described.[65] (Through the late 1960s this lent him particular significance throughout the diverse communities of the international art world.[66]) He saw the "perceived thing" not as "an ideal unity" but rather as a "totality open to . . . an indefinite number of perspectival views . . . [It] is itself paradoxical; it exists only in so far as someone can perceive it."[67] Oiticica, in describing his art as "not yet completed" and "situations to be lived,"[68] called for the participation of the "subject," in Merleau-Ponty's terms.

Oiticica's concern with the spectator is evident by 1959[69] with the creation of the *Bilaterals* and *Spatial Reliefs*, which viewers had to circle to take in. His *Nuclei* of the early 1960s took matters a step further (*Nucleus 6*, p. 8). Here geometric paintings not only leave the wall; they cluster together to

Dada met concrete art in Morellet as it did in van Doesburg. It entered the work not just via Duchamp, but also Jean Arp and Sophie Taeuber-Arp, whom Morellet met in 1958 through Ellsworth Kelly. Kelly had been interested in the role of chance in art since the early 1950s,[45] and Morellet followed suit, influenced by the collages that the Arps created around 1916. He made works based on numbers found in the telephone directory. First he created a grid and wrote many telephone numbers on it, one digit to a square. Assigning one color to odd and another to even integers, he then painted each square the assigned color. Morellet was interested in the way that colors, arranged arbitrarily, interacted with each other. Chance "did not destroy the composition, it parodied it, made it ridiculous and gave premier place to the rule of the game—to the system."[46]

It is a truism in the study of postwar art that works that look alike may well be conceptually unrelated. In abstract languages false cognates abound. Nevertheless, since form and content are inextricably linked, visual resemblance may have significance, even if it does not indicate sameness, and in some instances a careful analysis of related morphologies can yield insights into the practices of very different artists. European writers have noted similarities between Morellet's paintings from the 1950s and works by U.S. artists done some years later, usually arguing for Morellet's earlier use of a given pattern. In most instances the resemblances between these very simple designs are superficial and inconsequential.[47] However, one such case has significance, but not the significance that Morellet's supporters posited.

In 1973 a controversy erupted in the magazine *Flash Art*, when a German gallery took out an advertisement accusing North American artist Sol LeWitt of copying the work of the Europeans Jan Schoonhoven,

Sol LeWitt, "Circles and Grid, Arcs from Four Corners and Four Sides," 1972

François Morellet, *22 Weaves*, 1960
Oil on wood; 31½ x 31½ in. (80 x 80 cm)
Collection of the artist

Morellet, and Oskar Holweck; the ad included images of purportedly related works.[48] The resemblance between Morellet's and LeWitt's complex grids is striking, and Morellet says that when he first saw LeWitt's drawing in the magazine, he thought it was his own. LeWitt defended himself in a later issue of the journal, stating that he had been unaware of Morellet's work. He pointed out that his 1972 drawing (juxtaposed to a Morellet painting of 1958) was the culmination of a series of 195 drawings and could not be understood alone. LeWitt also wrote, "My art is not one of formal invention, the forms I use are only the carrier of the content."

This formulation had been central to LeWitt's project, and so his comments on the controversy in the catalogue for his 1978 retrospective are surprising: "The French artist François Morrellet [sic] had previously done drawings using grids with a similar spacing. Although at the time I was unfamiliar with his work, it is possible that I had seen one reproduced or on view at The Museum of Modern Art's *The Responsive Eye* exhibition. When I became aware of the similarities of our work, I abandoned mine."[49]

It is unclear why he chose to do so.[50] Working systematically, using a related abstract language, LeWitt did not need to "copy" Morellet to come up with a similar image. In addition, Morellet's painting and LeWitt's drawing appeared more similar in reproduction than they would have in reality. The drawing from *Arcs, Circles, and Grids* illustrated in *Flash Art* was 37.1 x 37.1 centimeters, and existed with the other 194 in the series as an artist's book, with the narrative structure that implies. The book is related to one of LeWitt's mural-sized graphite wall drawings, *Circles, Grids, Arcs from Corners and Sides* (1973). The 1958 Morellet painting was on a stretched canvas of 80 x 80 centimeters, a form with a place in art history and a relationship to illusion and temporality decidedly different from LeWitt's works.

The works' resemblance is significant not because their impact and meaning is the same, but because it results from shared ideas and methodologies. In *Flash Art* LeWitt wrote, "My own work of the last ten years is about only one thing; logical statements made using formal elements as grammar." Morellet would fully agree with that procedure, which is a product of making systems paramount. In defining "conceptual art" (a term he coined), LeWitt made other statements that also could apply to Morellet, including "Irrational thoughts should be followed absolutely and logically" and "The artist's will is secondary to the process he initiates from idea to completion. His willfulness may be only ego."[51]

By LeWitt's definition, Morellet has many of the attributes of a conceptual artist. He devises systems and follows them absolutely, allowing the idea to become "a machine that makes the art."[52] As with LeWitt, the system used is referred to in the title. Morellet strives to avoid subjectivity and yet he is anti-rationalist. These qualities came together slowly for Morellet; they were first coalescing in 1958, when he made the work that closely resembles LeWitt's of more than a decade later.

Morellet deserves credit for his early exploration of many of the methodologies that would become the foundation for conceptual art. He and artists with related concerns in Europe set the stage there for the preoccupations with process and systemic thought that would characterize the international vanguard of the late 1960s and 1970s.

In 1950 Max Bill had a solo exhibition at the Museu de Arte de São Paulo, and in 1951 he won the international grand prize at the first São Paulo Bienal. His impact in Brazil was profound; several young Brazilians moved to Europe to study with him at the famed Ulm School.[53] The Bienal also inspired the formation of Grupo Ruptura in 1952. (It included Mauricio Nogueira Lima, among others.) Ruptura's rigid theories of painting emphasized the two-dimensionality of the support (often industrial metal), the use of glossy enamel rather than traditional oils (to reduce evidence of the brushstroke and the artist's hand), modularity, and rationality over emotional expression. In Rio de Janeiro, Grupo Frente (Front) was Ruptura's counterpart. (Grupo Frente included Ivan Serpa, Aluísio Carvao, Lygia Clark, Lygia Pape, and Hélio Oiticica, among others.) Ultimately the two groups clashed, Ruptura artists accusing those in Grupo Frente of valuing experience over theory.[54] They were right, and the neoconcrete movement was born in Rio as a result of this rift. The artists attached to it rejected "serial form and purely optical effects," embracing experimentation, expressiveness, and subjectivity. According to poet and critic Ferreira Gullar, neoconcretists "reaffirm[ed] the creative possibilities of the artist, independent of science and ideologies."[55]

Hélio Oiticica, among the most dynamic of the neoconcretists, presents a remarkable integration of contrasts. Critic Guy Brett maintained that "two sides co-existed in Hélio—delirious abandon and meticulous order, intellect and trance."[56] Coming from a family of scientists, Oiticica remained methodical to the end of his life, even in his most innovative works never abandoning the Mondrian-derived geometry that inspired him in his youth. He compulsively categorized and ordered every facet of his creativity, clearly numbering his works according to the class and subclass of objects to which they belonged[57] or the project of which they were a part. He also wrote continually and in detail about his work in essays, notebooks, and letters, all of which he also ordered and preserved. These activities were conceptually inseparable from his installations and performances.[58] His development from the neoconcrete *Metaesquemas*, paintings in gouache on paper or board of permutations of rectangles and squares, to more radical forms was far more linear than one would expect, especially from viewing the later work.[59] At the same time, Oiticica celebrated the body. He lived for a while in Rio's *favela* (slum) Mangueira, where he became a *passista*, a lead samba dancer. Eventually he would refuse all categories that were not his own, writing, "Today it is clearer to me than ever that it is not the external appearance which generates the characteristic of the work of art but, rather, its meaning, which arises from a dialogue between the artist and the material with which he expresses himself. Hence the mistake and vulgarity of the distinction between 'informal' and 'formal.' In the work of art, everything is informal and formal."[60]

Dramatically and with grace Oiticica integrated the legacies of constructivism and dada in a manner that would have surprised even van Doesburg.[61] (According to concrete poet Haroldo de Campos, Oiticica particularly admired Duchamp and his legatee, composer John Cage.[62]) For Oiticica color was paramount and often dictated structure, evidence that fundamentally he remained a painter. However, by 1961 he was certain that painting per se had run its course. It was no longer possible to "accept development 'inside the picture,'" which he believed was "already saturated" with content. Painting's salvation

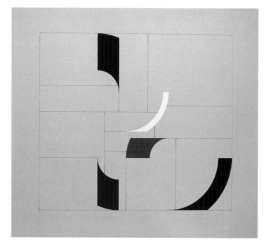
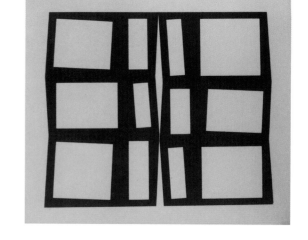

left: Hélio Oiticica, *Metaesquema No. 171 (seco 1)*, 1957–58

right: Hélio Oiticica, *Metaesquema No. 296*, 1957–58

would be to launch it into space, so that it could become complete, not as surface or appearance, but as essence.[63] He did this in 1960 with his *Bilaterals* and *Spatial Reliefs*, mostly monochrome, shaped two-sided paintings on wood that were suspended from the ceiling on wires. They were the embodiment of a theory he was developing in which color, structure, space, and time were fused. Confronted with these works the spectator/participant would not experience time through contemplation, as with traditional works of art. Rather "he finds his living time as he becomes involved, in a univocal relationship, with the time of the work."[64] Thus, in a wholly different manner than Morellet, Oiticica put the viewer at the center of his practice.

The viewer's centrality was expressed philosophically in Merleau-Ponty's ideas about perception. The French phenomenologist was widely read on all three continents during this period. Believing that previous theories described thinking about seeing rather than seeing itself, Merleau-Ponty developed a concept that was experiential and immediate. He envisioned phenomenology as akin to the visual arts, which he held were capable of directly presenting to the world the "pre-objective" response that he described.[65] (Through the late 1960s this lent him particular significance throughout the diverse communities of the international art world.[66]) He saw the "perceived thing" not as "an ideal unity" but rather as a "totality open to . . . an indefinite number of perspectival views . . . [It] is itself paradoxical; it exists only in so far as someone can perceive it."[67] Oiticica, in describing his art as "not yet completed" and "situations to be lived,"[68] called for the participation of the "subject," in Merleau-Ponty's terms.

Oiticica's concern with the spectator is evident by 1959[69] with the creation of the *Bilaterals* and *Spatial Reliefs*, which viewers had to circle to take in. His *Nuclei* of the early 1960s took matters a step further (*Nucleus 6*, p. 8). Here geometric paintings not only leave the wall; they cluster together to

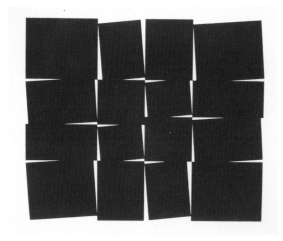

left: Hélio Oiticica, *Metaesquema No. 537*, 1957–58

right: Hélio Oiticica, *Metaesquema No. 535*, 1957–58

create enclosures that surround the "participator" (Oiticica's word), emphatically engaging her physically. The *Nuclei* are the forerunners of the *Penetrables*, begun in the same year. Inspired by the makeshift houses in Brazil's *favelas*, these architecturally scaled structures are to be traversed bodily and experienced with all the senses. Eventually they would exist within their own landscapes. In 1963 Oiticica created his *Bolides*. These works, first constructed of wood and then made with found containers, frequently glass, are like three-dimensional interactive paintings in which color is experienced by touch and smell as much as by sight. In them, as in so much of his work, natural and geometric form converges. Born of Oiticica's desire to give color "body,"[70] many of the wooden *Box Bolides* (p. 22), realized in vibrant hues, have drawers that contain pure pigment or colored sand. Viewers were meant to handle these substances. Oiticica designates the *Glass Bolides* "Trans-Objects," because they utilize ready-made elements (a reference to Duchamp).

The *Parangolé*, a garment resembling a cape that he first created in 1964, is arguably Oiticica's most radical innovation. He derived the name from indigenous slang, but for him it had the same character as "Merz" had for dadaist Kurt Schwitters: It signified the experimental nature of his ideological position and thus of his entire oeuvre.[71] The *Parangolés* were inspired by banners and other mundane geometric objects and sometimes had brief messages written on them.[72] As a manifestation of color interacting with the human body, they were also intimately connected to the samba and in the original documentation are worn by Mangueira dancers. They require bodily participation; only on the moving figure can their colored layers be seen. By 1965, when he was writing about these works, the word "magic" appears often in Oiticica's copious notes. The *Parangolés* engage in a form of transubstantiation. With them, the "participator" becomes the "structural nucleus of the work, the existential unfolding of this incorporeal space."[73]

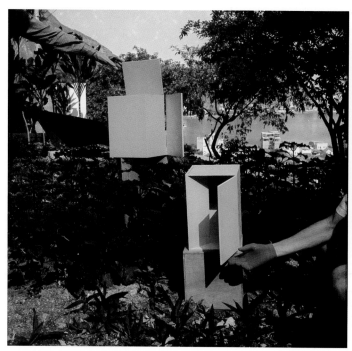 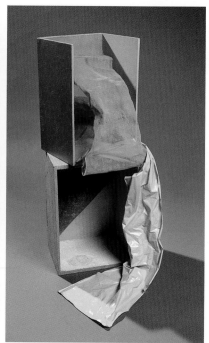

left: Hélio Oiticica, *Box Bolide 1*, 1965–66

right: Hélio Oiticica, *Box Bolide 8*, 1964

With the *Penetrables* and *Parangolés*, Oiticica's physical works had fused with the theories that generated them and that they generated in turn. Thus, *Tropicália* of 1967 was a major installation of *Penetrables* set in a constructed tropical environment within an art space that included sand, pebbles, parrots, and regional plants. It was also the embodiment of Oiticica's "General Outline of the New Objectivity," meant to express the state of Brazilian avant-garde art at that moment. Its tenets were "1—General constructive will; 2—a move toward the object as easel painting is neglected and superceded; 3—the participation of the spectator (bodily, tactile, visual, semantic, etc.); 4—. . . a position on political, social and ethical problems; 5—tendency toward collective propositions and consequently the abolition, in art today, of 'isms.'"[74]

Tropicália was Oiticica's attempt to realize a specifically Brazilian context for vanguard art and to combat cultural colonialism, as manifested in Brazilian artists' absorption of U.S. and European pop and op art. His thinking in this regard started, he says, with the *Parangolés*; living and working in the *favelas*, he must have understood the power of a culture that was uniquely Brazilian. He was too sophisticated to idealize cultural isolation (he admired many European artists and wrote, "For me, the painting of Pollock takes place virtually in space,"[75] which for him was the highest praise), but he was adamantly opposed to

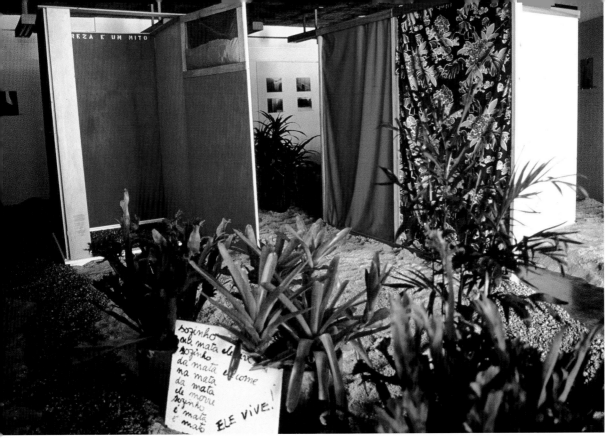

Hélio Oiticica, *Tropicália*, 1967
Copyright © by Projeto Hélio Oiticica

a universalizing international culture, which he believed curtailed freedom. Within a few years, the notion of *Tropicália* was adopted and reinterpreted by others. By 1970, in his entry in the catalogue that accompanied the first major museum exhibition of conceptual art, *Information*, Oiticica had repudiated the notion of *Tropicália*, which he felt had been turned into something conservative, another ism. "The achievements of *Tropicália*," he wrote, "have been individual ones."[76]

Despite his rejection of *Tropicália*, Oiticica's greatest contribution remains his remarkably successful attempt to define an authentically Brazilian vanguard art practice. He was not alone in this. He had colleagues like Lygia Clark and Lygia Pape, with whom he was close. Clearly, the cultural environment in Brazil, as "colonial" as he may have believed it to be, provided the possibility for the creation of profound and cosmopolitan work that could exist in easy dialogue with its counterparts in the commercial centers of Europe and the United States. Oiticica shared with many artists in those locations a concern for "duration" in art as an interactive experience, an embrace of flux, change, and unpredictability, and a desire to eradicate artistic categories of all kinds. As intensely and originally as any of them he questioned the boundary between quotidian and artistic space. Underlying all of his work was the role of the viewer, whose entire body was a perceiving organism.

In 1966, at 26, Mel Bochner emerged as an artist with a fully realized form of what later became known as conceptual art.[77] His first New York works, made in the two previous years, attest to an insistent search for original expressive means, regardless of the consequences. The breakthrough came with strategies of counting and the patterns it engendered. Numbers were useful not only because no one could lay claim to them, but also because they were inherent in ideas of generation, sequence, and system; they were a means of putting the process of art making in the forefront. For Bochner, minimalism provided the model for this in its focus on what he terms "what's upstream from the work" (i.e., the thought that precedes it).[78]

His first strong statement of this position came in 1966, when he was asked to organize a Christmas exhibition for the School of Visual Arts in New York, where he taught art history. He presented *Working Drawings and Other Visible Things on Paper Not Necessarily Meant to Be Viewed as Art*. The show comprised four identical loose-leaf notebooks containing photocopied preparatory drawings by artists he admired (Judd, Andre, Flavin, LeWitt, Eva Hesse, Jo Baer, Robert Smithson, and others). New photocopying technology made the sampling of multiple sources simple and inexpensive. In filling the books Bochner intermixed the photocopied drawings with texts that interested him: anonymous materials from scientific journals, the work of mathematicians, biologists, engineers, architects, musicians, and choreographers. The binders were presented on pedestals the height of tabletops, so that viewers had to stand uncomfortably hunched over to peruse them.[79] The discomfort, unexpected in the gallery context, was a continual reminder that this activity was apart from the art-viewing norm.[80] It also was a way of insisting on the beholder's responsibility to participate in the artistic process.

In his work Bochner emphasized analytical thought but denied that words were more objective than other visual forms. A piece of 1970 announces, "Language is not transparent." The eponymous work is dramatic: Preceded by the number 1, its message in large white chalk letters appears on an unfinished black rectangle whose paint drips to the floor, suggesting that meaning is as transient, ephemeral, and unstable as the words' dissolving support. *Language Is Not Transparent* invokes both the formal pedagogy of a blackboard and graffiti's iconoclastic scrawl.

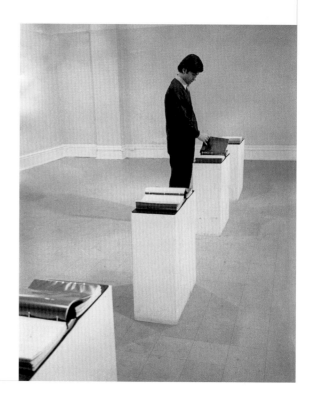

Rather than beginning with linguistic constructs as many conceptualists did, Bochner began with the idea of serial order. He saw seriality itself as a method distinct from the traditional notion of works forming a series (Monet's Haystacks for example). What Bochner calls the "terms" of a work (Morellet's "rule of the game") are derived from a systematically predetermined process in which "order takes precedence over. . . execution" and the completed work is "fundamentally parsimonious and systematically self-exhausting." In other words, it is lean—its form predicated on necessity—and finite.[81]

Many of Bochner's most resonant works have developed from an engagement with limits. The gallery's lack of insurance and funds for framing mandated the photocopies and notebooks in *Working Drawings*. In *36 Photographs and 12 Diagrams* (1966) photographic documentation solved the problem of exhibiting a serial piece that existed only as a single, small construction that the artist reconfigured daily.[82] The Measurement Pieces evolved when, creatively stymied and facing two blank sheets of paper on the wall, Bochner noticed the space between them: "I saw that it was as much the subject as the paper. I measured that distance on the wall . . . When I took down the sheets of paper I had the measurement alone. It puzzled me. It still puzzles me. What does it mean to have twenty-five inches drawn on the wall?"[83] Confronted with these works, the viewer must consider whether a measurement can exist by itself or has to measure something.[84] Bochner was interested in the way that the predictability of an established order

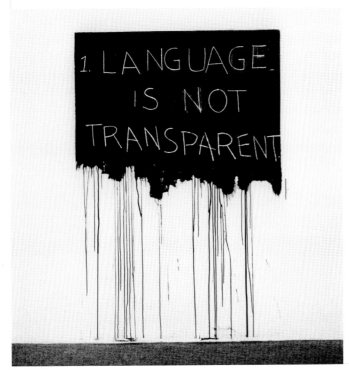

opposite: Mel Bochner, *Working Drawings and Other Visible Things on Paper Not Necessarily Meant to Be Viewed as Art*, 1966
Four identical loose-leaf notebooks, each with 100 Xerox copies of studio notes, working drawings, and diagrams, displayed on four sculpture stands
175 x 34 x 12 in. (444.5 x 86.4 x 30.5 cm)
Collection of the artist

Mel Bochner, *Language Is Not Transparent*, 1970
Chalk on paint and wall
72 x 48 in. (182.9 x 121.9 cm)
Collection of the artist

could turn into something unpredictable. Such paradoxes, which suggest powerful codependent opposi-tions — absence and presence, nothing and something — undercut a system metaphorically, collapsing its conventions and dissolving its boundaries.

No Bochner work does this more emphatically than *Continuous/Dis/Continuous* (1972). In this ephemeral installation, the artist attaches a single line of masking tape around the walls of a space at his own eye level, and then covers it with another layer of tape; he rubs blue carpenter's chalk over the layers, creating what he terms a "halation" that records the original continuity of the line. He removes the top layer of tape and writes sequential black numbers clockwise over the entire length of the bottom layer. Next he removes random lengths of tape, revealing the wall beneath. (The blue chalk halo remains, defining the original taped area.) He then adds red numbers in sequence, moving along the line counterclockwise. The red numbers jump across the black numbers, filling all the gaps where tape was removed. Some ques-tions may arise as the viewer circles the room: "Which series is continuous and which is discontinuous?. . . Is the work the sum of its parts or are the parts so disjunctive as to be unable to form a whole?" "If they do not form a coherent whole, what are you looking at? If they do, on what plane do they cohere? Conceptual? Perceptual?" "Can two discontinuities be held in the mind at once?"[85]

Once again Bochner discomforts the viewer, emphasizing her responsibilities in this nontraditional artistic environment. Not only will she probably have to stretch to read the work (Bochner is tall and the numbers are at his eye level), *Continuous/Dis/Continuous* complicates her role. She must make more choices and mental leaps, as she engages the artist's desire to know "the status of the *subject* [herself] in relation to an object which is only the sum of its self-cancellations."[86] She might ask herself whether this is the denial of meaning or the recognition that ideals of sense and closure are constructions. What is being measured here, and what is the measured result? Given the conundrums at the heart of this work, it is not surprising that Bochner's written description of it begins with a quotation from Jorge Luis Borges: "There is a labyrinth that is a straight line."[87]

Continuous/Dis/Continuous embodies another seeming paradox in Bochner's practice: Despite his leading role in the inauguration of conceptualism, he says that his work has always been an attempt to rethink the issues of painting. For him it was never a question of whether painting was relevant as art, it was "about its relevance as a sign."[88] In other words, during the 1960s what painting represented as a form — its negative associations with tradition — limited its meaning. At that time Bochner did not make paintings, but a concern for the concepts associated with the medium underlay much of his production. So, among its other references, *Continuous/Dis/Continuous* is a kind of homage to Barnett Newman. For Bochner, Newman's merging of ethics and aesthetics was exemplary.[89] It showed him that art was not just making "*chotchkies* for rich people." *Continuous/Dis/Continuous* was the first piece that Bochner made after moving into Newman's studio on White Street in New York, shortly after the older artist's death.[90] The use of masking tape and the halation around the line recall Newman's "zips" (the lines that divided his canvases), and Bochner says that the fact that the work is impermanent — it disappears at the end of an exhibition — reinterprets Newman's idea of the "here," which, enigmatic and multivalent,

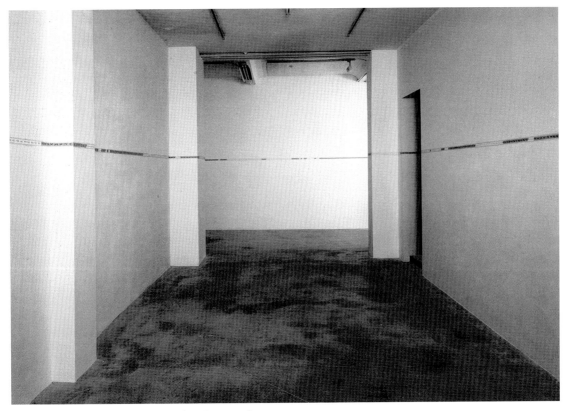

Mel Bochner, *Continuous/Dis/Continuous* (installation view), 1971–72

Mel Bochner, Test piece for *Continuous/Dis/Continuous*

suggests immediacy and presence.[91] Bochner is emphatic, however, that while it may refer to painting, this work is something quite different. Painting on canvas, instantly apprehended as a convention, can never wholly escape representation. Like Oiticica's installations, *Continuous/Dis/Continuous* involves a temporal journey; the viewer walks through it. It exemplifies what Bochner calls "the primarily present." It does not represent anything other than itself.

Many of Bochner's influences have been French. As a young man with an avid interest in philosophy, he read Jean-Paul Sartre, Merleau-Ponty, and Roland Barthes, as well as Alain Robbe-Grillet and other exemplars of the *nouvelle roman*.[92] (Robbe-Grillet reduced metaphor and anthropomorphism in the quest for a neutral stylelessness, an ideological position also embraced by the minimalists and echoed in Bochner's insistence that the seriality on which his work was based was a method and an attitude, not a style.[93] For Barthes, far from benign, language is "a reflex response involving no choice" and a blind force. For him as for Bochner, "language is not transparent."[94]) Bochner's concern with experiential perception aligns him with these thinkers, as does his embrace of irresolution. His work embodies the notion that meaning, based in the experience of a particular individual at a particular moment in time, is constantly shifting and fundamentally evanescent.

Morellet, Oiticica, and Bochner are extremely different artists, yet they share a variety of concerns: When painting was considered by many influential artists and critics to be passé, the province of an older time and generation,[95] they were all involved with issues related to that medium, even if they believed it was spent or temporarily unusable. Morellet, who began his career as a painter, has since the 1960s consistently ventured into alternative forms, but still makes paintings. Oiticica began as a painter and, strongly motivated by color, applied the conceptual issues of that medium to objects and installations. Bochner began with installations and photographic conceptualism that had an intellectual relationship to painting, and is now a painter.

In 1967 critic Willoughby Sharp proclaimed, "The old art was an object. The new art is a system."[96] Clearly this was hyperbole, yet these artists confirmed it. Systems put the emphasis on process—on the thought that preceded the creation of the object. Artistic precedents for a systematic approach lay in the constructivist movements of the first half of the twentieth century and in aspects of dada, in particular the work of Duchamp. (*Three Standard Stoppages* [1913–14], for example, derived from a preestablished, arbitrary methodology that Duchamp followed rigorously.) While Morellet and Bochner made systems explicit in their individual works, by the 1960s this aspect of Oiticica's art was most evident in the cataloguing and ordering of his own production, which was a fundamental aspect of his practice. No matter how expressionistic his use of color, movement, and found objects became, geometric form was at its core. Expressionism of a different sort lives comfortably with a reduced aesthetic in Bochner's art. As manifest in the halation of *Continuous/Dis/Continuous* and the dripping paint of *Language Is Not Transparent*, the New York School was important for him. (He says that the artist Eva Hesse pioneered the integration of their approach with minimalism and influenced him in this regard.[97])

The desire to redefine the relationship with the viewer propelled the artists in *Beyond Geometry* into radically new kinds of art making. If systems provided a methodology that gave precedence to process and thought, the need to connect with the beholder in unexplored ways mandated the creation of more interactive art forms. In different ways, minimalism, op and kinetic art, earthwork, installation, and book art satisfied this desire. Performance (a particularly important medium for Brazilians Oiticica, Clark, and Pape) literalized a relationship implicit in much of the work in *Beyond Geometry*: by partnering with the spectator in the creation of the work, painters like Morellet, installation artists like Stanisław Dróżdż, and conceptualists like Maria Nordman all made viewing itself a performance. Duchamp had pioneered the notion that the viewer completed the artwork in the 1910s, with his ready-mades.[98] Along with existentialism, structuralism, and other philosophies, phenomenology—in particular the work of Merleau-Ponty, with its idea of the perceiving body and insistence on the primacy of the viewer's dynamic experience of objects and phenomena—also supported it. In addition, theologies and ideologies that held the artist's ego in check—Buddhism and Gurdjieff's spiritualism for example—encouraged some to engage the spectator in the creative act.

In focusing on these common concerns, *Beyond Geometry* gives lie to the idea, prevalent in the United States during the period in question, that artists elsewhere who used geometric form were tied to an old and tired aesthetic. The French artist Daniel Buren bridles at the dominance of this view: "Although most agree that as a movement minimalism was created in the United States—even if its roots are certainly in Europe—it is absurd to maintain that post-minimalism was also born there, and even more idiotic to insinuate that conceptual art was an American-inspired movement, which it absolutely was not."[99] He is right. Evolving from varied combinations of sources in different locations, and encompassing among other trends process, installation, and performance art, as well as conceptualism, what Buren terms "post-minimalism" appeared in Europe and South America at the same time as in the United States.[100] In other regions these forms usually developed from geometric or informal painting rather than from a rigorous sculptural practice as in North America, and in some places they appeared earlier than in the U.S.[101]

In the late 1960s and early 1970s the coalescence of an intercontinental art world that supported experimentation was based not only on a shared concern with systems, temporality, contemporary philosophy, and Duchamp, but also on sociopolitical factors, including resistance to the Vietnam War and a rebellious international youth culture.[102] This was an expansive moment that supported the novel and unconventional in many aspects of Western society. Visual artists all over the West both responded to this moment and helped to shape it.

notes

1 It is not possible to identify a precise moment at which postmodernism becomes the dominant mode for visual art. Certainly there are fully postmodern figures such as Marcel Duchamp and Andy Warhol existing within a cultural field dominated by modernism, and much of the work in *Beyond Geometry* combines characteristically modern and postmodern elements. In a 1968 lecture Leo Steinberg used the term "post-modern" in relation to a work by Roy Lichtenstein; see Leo Steinberg, "Other Criteria," in *Other Criteria: Confrontations with Twentieth-Century Art* (London, Oxford, New York: Oxford University Press, 1972), 91. In June 1971, in an unpublished lecture delivered at the Institute for Contemporary Art, London, Mel Bochner referred to a new period called "postmodernism which begins with Jasper Johns who treated art as critical investigation" and interrogated the "relationship of language to art." See James Meyer, "The Second Degree: *Working Drawings and Other Visible Things on Paper Not Necessarily Meant to Be Viewed as Art*," in Richard S. Field, ed., *Mel Bochner: Thought Made Visible, 1966–1973* (New Haven: Yale University Press, 1995), 106, n. 36. In 1978, in her essay "Sculpture in the Expanded Field," Rosalind Krauss suggested that artists engaged in what she terms "site construction" (Morris, Robert Smithson, Michael Heizer, Richard Serra, Walter de Maria, Robert Irwin, Sol LeWitt, and Bruce Nauman among them) evidenced a historical rupture that she named postmodernism. See Rosalind Krauss, "Sculpture in the Expanded Field," in *The Originality of the Avant-Garde and Other Modernist Myths* (Cambridge: MIT Press, 1985), 287. However, if we include the idea of "pastiche" among the defining elements of postmodern culture, it seems correct to posit the group of visual artists that emerged around 1980 as the first fully postmodern generation. See Fredrick Jameson, "Postmodernism and Consumer Society," in Hal Foster, ed., *The Anti-Aesthetic: Essays on Postmodern Culture* (Port Townsend, Washington: Bay Press, 1983), 113–15.

2 See, for example, Germano Celant, *Arte Povera: Conceptual, Actual, or Impossible Art?* (London: Studio Vista, 1969); Guy Brett, *Kinetic Art: The Language of Movement* (London: Studio Vista; New York: Reinhold, 1968). Brett had curated *In Motion*, which toured England (but not London) in 1966–67, and which presented Lygia Clark and Jesús

Rafael Soto with a group of Europeans; Kynaston McShine, *Information* (New York: The Museum of Modern Art, 1970); Harald Szeemann, *Live in Your Head: When Attitudes Become Form: Works, Concepts, Situations, Information* (Bern: Kunsthalle Bern, 1969).

3 For example, the highly influential abstract expressionist Barnett Newman claimed that he and his U.S. contemporaries were freeing themselves of "the impediments of memory, association, nostalgia, legend [and] myth . . . that have been the devices of European painting." Quoted in Donald Judd, "Barnett Newman," in *Studio International*, February 1979, 66–69. The article, written in November 1964, was published for the first time here.

4 Bruce Glaser, "Questions to Stella and Judd," in *Minimal Art: A Critical Anthology*, ed. Gregory Battcock (Berkeley & Los Angeles: University of California Press, 1995), 154. To Judd's credit he modified these views, in 1988 mounting *Richard Paul Lohse, Paintings from the Richard Paul Lohse Stiftung, Zurich*, the first U.S. exhibition of the work of the Swiss concrete artist, at his Chinati Foundation in Marfa, Texas. In 1989 he presented *Jan Schoonhoven, Drawings from the Haags Gemeentemuseum, The Hague* at Chinati. See Lucile Encrevé, "Les développements de l'art concret aux États-Unis et en Europe dans les années soixante," in Serge Lemoine, *Art Concret* (Mouans-Sartoux: Espace de l'Art Concret, 2000), 44.

5 Glaser, "Questions to Stella and Judd," 149, 151.

6 Abstract expressionism was related to French *art informel*, and American pop had a British counterpart. There was no foreign art movement with as close a visual relationship to minimalism.

7 For example, there is no mention of van Doesburg in Gregory Battcock's *Minimal Art: A Critical Anthology*, although Duchamp comes up often.

8 Van Doesburg and his colleagues Otto Gustaf Carlsund, Jean Hélion, Léon Tutundijian, and an artist known simply as "Wantz" coined the term *art concret* in 1930 in the sole issue of *Art Concret*. See Willy Rotzler, *Constructive Concepts: A History of Constructive Art from Cubism to the Present* (Zurich: ABC Edition, 1977), 118. Among the precepts of the movement was: "A pictorial element has no other meaning than what it represents, consequently, the

painting possesses no other meaning than what it is by itself" (quoted in Joost Baljeu, *Theo van Doesburg* (New York: Macmillan, 1974), 181–82.

Max Bill traces the notion of the concrete in art to Wassily Kandinsky's 1910 painting *Première Oeuvre Concrète*. See *Konkrete Kunst: 50 Jahre Entwicklung* (Zurich: Helmhaus, 1960), 9.

9 See, for example, Maurice Tuchman, "The Russian Avant-Garde and the Contemporary Artist," in *The Avant-Garde in Russia, 1910–1930: New Perspectives* (Los Angeles: Los Angeles County Museum of Art, 1980). There is virtually no analysis in this article. It does not even mention Camilla Grey's groundbreaking *The Great Experiment: Russian Art, 1863–1922* of 1962, which introduced many younger artists to Russian constructivism. However, it does provide a compendium of quotes from them on the subject. Sol LeWitt says, "If you had to find a historical precedent, you had to go back to the Russians . . . [The] area of main convergence . . . was the search for the most basic forms, to reveal the simplicity of aesthetic intentions," while Mel Bochner credits the Russians with "essentially defin[ing] abstraction as having to deal with intellectual content" (119). Frank Stella saw Malevich's *White on White* as an "unequivocal landmark," an "iceberg" that "kept us going, as a focus of ideas" (120). Richard Serra believed that Russian constructivists "investigated material to find what would justify the structure rather than the other way around." The Russians had "[the] process make the form" (119).

10 The American Abstract Artists group, or AAA, was founded in 1936 to support modernist artists and combat what they believed was a prevalent art-world notion that social realism was the only appropriate mode for U.S. artists. It is still active today. In the 1930s and 1940s its members included Josef Albers, Ad Reinhardt, and Burgoyne Diller among many others.

11 Mel Bochner remembers as a very young man attending abstract expressionist Jack Tworkov's birthday party in 1966, shortly after his review of *Primary Structures* appeared in *Arts Magazine*. (It was his first published article.) Those present, many of them members of the first-generation New York School, were highly dismissive of the exhibition, the first comprehensive show to highlight minimalism, and of Bochner's review. They felt that this was "the old abstraction, coming back to haunt them"

(author's taped interview with Mel Bochner, April 28, 2003).

12 See Maurice Merleau-Ponty, "The Primacy of Perception," in *The Primacy of Perception* (Evanston: Northwestern University Press, 1964), 14.

13 For Judd and Stella on this subject see Glaser, "Questions to Stella and Judd," 151, 154.

14 "In the simpler polyhedrons, such as cubes and pyramids, one need not move around the object for the sense of the whole, the Gestalt, to occur. One sees and immediately 'believes' that the pattern within one's mind corresponds to the existential fact of the object." See Robert Morris, "Notes on Sculpture: Part I" (1966), reprinted in James Meyer, *Minimalism* (London: Phaidon Press, 2000), 218.

15 Alfred Barr, the founding director of the Museum of Modern Art in New York, posited two main trajectories in modernism, one evolving from Gauguin and including Matisse, Kandinsky, and the surrealists, and the other deriving from Cézanne, cubism, and constructivism. The first was based in intuition and emotion. The second, which for Barr was more important, was "intellectual, structural, architectonic, geometrical, rectilinear, and classical." Alfred Barr, *Cubism and Abstract Art* (New York: The Museum of Modern Art, 1974 [1936]), 19.

16 Briony Fer, *On Abstract Art* (New Haven: Yale University Press, 1997), 2–4.

17 See Hannah L. Hedrich, *Theo van Doesburg: Propagandist and Practitioner of the Avant-garde, 1909–1923* (Ann Arbor: UMI Press, 1973, 1980), 2.

18 Joost Baljeu, *Theo van Doesburg* (London: Studio Vista, 1974), 39.

19 Max Bill, "The Mathematical Approach in Contemporary Art," in *Biennale Nürnberg Konstruktive Kunst: Elemente und Prinzipen* (Nürnberg: Institut für Moderne Kunst, 1969), 110. Originally published in the review *Werk* (Winterthur) no. 3 (1949).

20 Ibid., 111.

21 Max Bense, *Max Bill*, trans. Dr. George Staempfli (London: Hannover Gallery, 1966), 16.

22 Ibid., 3.

23 James Elkins, *The Object Stares Back: On the Nature of Seeing* (New York: Harcourt, 1996), 11.

24 Ibid., 13.

25 Arguably with op and kinetic art, forms with real popular appeal, these artists achieved their vision of a democratic abstract art. *The Responsive Eye*, the first major U.S. museum exhibition to highlight this trend, was the most popular in the Museum of Modern Art's history in 1965. However, critics denigrated this work for its association with the crassness of commercialism (and implicitly the feminine) because of its absorption into fashion and home decor. Rather than seeing its physical effects as democratic, they experienced them as a fearsome endorsement of technological control. See Pamela Lee, "Bridget Riley's Eye/Body Problem," *October* 98 (fall 2001), 27–46.

26 For example see Glaser, "Questions to Stella and Judd," 149.

27 Ibid.

28 Morellet did not actually see Bill's work in Brazil because his show in São Paulo had closed before Morellet's arrival. He reports that he saw only some bad photographs and heard about Bill from the young Brazilian artists. Among them was Almir da Silva Mavignier, who would introduce Morellet to Bill, as well as to Ellsworth Kelly and many others. Stephanie Jamet, "Chronologie," in *Morellet* (Paris: Galerie nationale du Jeu de Paume, 2000), 150.

29 François Morellet in "On the *Discourse about Method*": "Yes, I confess it, in the fifties I have been tempted by this euphoric post-Cartesian rationalism of the admirers of progress and of pure and strict geometry. From that time I have always kept great confidence in logic, in system, in precision, in geometry." In *Morellet: Discourse de la methode*, exh. cat. (Mayence: Galerie Dorothea van der Koelen, 1996), 6.

30 See Serge Lemoine, "Blue and Sentimental," in *François Morellet* (Berlin: National Gallery, Staatliche Museen, 1977), 20–21.

31 Dieter Honish traces this attitude back to Malevich and his pupil Władysław Strzemiński, who advocated "the absolute unity and equality of all pictorial elements," thereby anticipating a utopian socialist society. "On the Form of Organization of Paintings by Stella and Morellet," in *François Morellet* (1977), 7.

32 P. D. Ouspensky, *In Search of the Miraculous* (New York: Harcourt, Brace & World, 1949), 27.

33 See, for example, Jacob Needleman, "G. I. Gurdjieff and His School," *http://bmrc.berkeley.edu/people/misc/School.html* (October 14, 2003).

34 Morellet has said, "I consider artists to be gruesome reactionaries who, voluntarily or not, cultivate the arbitrary[,] let others believe in the existence of secret justifications and . . . consider themselves to be revolutionaries of art." François Morellet, "Mise en condition du spectateur" (1967), in *Lumiere et mouvement* (Paris: Musée d'Art Moderne de la Ville de Paris, 1977), 69.

35 Unless otherwise noted, quotations and paraphrases of Morellet's ideas are from an interview with the author, June 25, 2003, Cholet, France. Morellet says that Buddhism was more important to him than Gurdjieff's spiritualism, which he now sees as suspect. He thinks that, for him, Buddhism in the early 1950s was in part an escape from the Catholicism with which he was raised. He writes, "I knew really, and loved, Zen later, after my most radical and minimalist period ('52–'57)." Fax to the author, August 29, 2003.

36 François Morellet, "Mise en condition du spectateur."

37 Michael Fried, "Art and Objecthood" (1967), reprinted in *Art and Objecthood* (Chicago: University of Chicago Press, 1998), 153.

38 He saw Mondrian's work for the first time in reproduction in Maurice Reynal's *Peintures di xxe siecle* (Skira, 1947). His friend Joël Stein introduced him to Duchamp. Stephanie Jamet, "Chronologie," in *Morellet* (2000), 148.

39 Francis Naumann, *Apropos of Marcel Duchamp: The Art of Making Art after Duchamp in the Age of Mechanical Reproduction* (New York: Curt Marcus Gallery, 1999), 8. Duchamp thus became the first artist purposely to appropriate another's work.

40 "The Great Trouble with Art in This Country," from an interview by James Johnson Sweeney with Marcel Duchamp, in Michel Sanouillet and Elmer Peterson, eds., *The Writings of Marcel Duchamp* (New York: Da Capo, 1989), 126.

41 Joseph Kosuth, "Art after Philosophy," *Studio International* 178, no. 915 (October 1969), 135.

42 See, for example, Ronaldo Brito, *Neoconcretismo: Vértice e rupture do projeto construtivo brasileiro* (São Paulo: Cosac & Naify Edições, 1999), 31–33.

43 Morellet, "The Choice in Present-Day Art" (1965), in *Data: Directions in Art Theory and Aesthetics* (London: Faber & Faber, 1968), 237.

44 Morellet also hated what he calls "the myth of Duchamp," admittedly cultivated by Duchamp himself, but also perpetrated by specialists of various stripes who have

extrapolated on art that (admirably, in Morellet's view) "has nothing to say." Morellet, "J'aime bien Duchamp" (1984), in Anthony Hill, ed., *Duchamp: Passim, A Duchamp Anthology* (London: Hordon and Breach, 1984), 62.

45 In 1951 Kelly made eight paintings titled *Spectrum Colors Arranged by Chance*, and numbered I–VIII.

46 "François Morellet: An Interview with Serge Lemoine," *CNAC Magazine* (November 1985), 11.

47 In the mid-1950s, Morellet did several paintings that seemed to forecast the designs in Stella's early canvases. For example, Morellet's *Concentric Right Angles* and *From Yellow to Purple*, both of 1956, closely resemble Stella's *Zambesi* of 1959 and *Le Rêve d'Alembert* of 1974. But the simple, striped patterns in question may have existed in many historical contexts. In fact, between 1955 and 1959 the Brazilian artist Lygia Pape created a series of woodcuts, one of which is configured almost identically to Stella's *Getty Tomb* (p. 77). (The Pape print is slightly squarer in proportion than the Stella and has fewer lines.) However, Pape's small, delicate work on paper is innovative for its combination of refined geometric pattern and rough-hewn woodcut. Intention and meaning in works utilizing stripped-down forms that in themselves are not particularly original are as much in the medium and scale of the work as in its design. The enormous size of Stella's paintings (*Le Rêve d'Alembert* is 360.7 x 721.4 centimeters), and his use of industrial colors on unprimed canvas, make them very different from Morellet's smaller works (*From Yellow to Purple* is 110 x 220 centimeters) made with oils.

48 The advertisement, taken out by Galerie M in Bochum, Germany, appeared in *Flash Art* no. 39 (February 1973), 33. LeWitt's reply was in *Flash Art* no. 41 (June 1973), 2.

49 Alicia Legg, *Sol LeWitt* (New York: The Museum of Modern Art, 1978), 120.

50 It is possible LeWitt gave up the grid that was similar to Morellet's because he had changed his approach to art making. He has said, "I reached a point in the evolution of my work at which the ideology and ideas became inhibiting. I felt that I had become a prisoner of my own pronouncements..." *Bomb*, no. 85 (fall 2003), 28.

51 Sol LeWitt, "Sentences on Conceptual Art," reprinted in Lucy Lippard, *Six Years: The Dematerialization of the Art Object from 1966 to 1972* (1973; repr., Berkeley and Los Angeles: University of California Press, 1997), 75.

52 LeWitt, "Paragraphs on Conceptual Art," ibid., 28.

53 From 1951 to 1956 Bill was cofounder and rector of the Hochschule für Gestaltung in Ulm, West Germany, where he headed the departments of architecture and product design. He also designed the school's buildings. See *Max Bill* (Buffalo: Buffalo Fine Arts Academy and the Albright-Knox Art Gallery, 1974), 187.

54 See Aracy Amaral, "Abstract Constructivist Trends," in *Latin American Artists of the Twentieth Century* (New York: The Museum of Modern Art, 1993), 91–92.

55 Ibid., 92.

56 Guy Brett, "The Experimental Exercise of Liberty," in *Hélio Oiticica* (Paris: Galerie Nationale du Jeu de Paume, et al., 1992), 222.

57 Brett gives as an example "Bolides," with the subcategory of "Glass bolides." See Guy Brett, "Note on the Writings," in *Hélio Oiticica*, 207.

58 Ibid. According to Brett, Oiticica even kept carbon copies of the letters he wrote to friends.

59 Oiticica rejected the notion of linear development: "I am against any insinuation of a 'linear process'..." ("Brazil Diarrhea," in *Hélio Oiticica*, 17). Yet in his work one development builds on another in a surprisingly orderly manner.

60 Hélio Oiticica, "April 21, 1961," in *Hélio Oiticica*, 44.

61 In integrating constructivist and dada ideas van Doesburg equated the notion of formlessness, which is associated more with dada (see Allan Doig, *Theo van Doesburg: Painting into Architecture; Theory into Practice* [Cambridge: Cambridge University Press, 1986], 111), with De Stijl, writing in a letter of December 29, 1922: "The right angle is the simplest and at the same time most expressive means of closure for a space, or drawing the boundary of a plane (colour-plane). It approximates 'formlessness' closely, because one cannot think the outer-most boundary-points through to the infinite" (Doig, 117). To a great extent he separated his involvements with De Stijl and dada, even maintaining aliases: I. K. Bonset was the dada poet and Theo van Doesburg the De Stijl painter, yet there are De Stijl–type paintings from 1920 signed "I. K. Bonset."

62 "Haroldo de Campos: Interview with Lenora de Barros," in *Hélio Oiticica*, 217.

63 Hélio Oiticica, "February 16, 1961," in *Hélio Oiticica*, 42. Brett notes that Oiticica wrote continually and that his writing is inseparable from his art. Early writings such as this one were usually unpublished entries in notebooks. Brett, "Note on the Writings," 207.

64 Oiticica, "Color, Time and Structure. November 21, 1960," in *Hélio Oiticica*, 36.

65 See Eric Matthews, *The Philosophy of Merleau-Ponty* (Chesham, England: Acumen, 2002), 133–34.

66 Alex Potts reports that by the end of the 1960s "the imperatives of the newly popular linguistic and semiotic models made a focus on perceptual processes seem old-fashionedly humanistic." Artists and critics tended to turn to Wittgenstein rather than the French existentialists or phenomenologists. *The Sculptural Imagination: Figurative, Modernist, Minimalist* (New Haven: Yale University Press, 2000), 210. Potts is discussing the Anglo-American cultural environment.

67 Merleau-Ponty, "The Primacy of Perception," 16.

68 Oiticica, "Subterranean Tropicália Projects" (1971), in *Hélio Oiticica*, 143.

69 This concern with the spectator began in 1959. In 1972 he declared that anything he made before then need not be taken seriously, dismissing his beautiful *Metaesquemas* of 1957–58 as existing at the border of representation; they were not new art, but transformation. Oiticica, "Metaesquemas 57/58" (written 1972), in *Hélio Oiticica*, 28.

70 Oiticica, "Bolides" (October 29, 1963), in *Hélio Oiticica*, 66.

71 Oiticica, "Fundamental Bases for the Definition of the *Parangolé*" (1965), in *Hélio Oiticica*, 85.

72 The *Parangolés* evolved from tentlike structures. For a detailed discussion of the *Parangolés*, see Inés Katzenstein, "Reality Rush: Shifts of Form, 1965–1968," in this volume.

73 Oiticica, "Notes on the *Parangolé*" (1965), in *Hélio Oiticica*, 93.

74 Oiticica, "General Outline of the New Objectivity," in *Hélio Oiticica*, 110.

75 Oiticica, in *Hélio Oiticica*, 42.

76 Hélio Oiticica, in *Information*, ed. Kynaston McShine (New York: The Museum of Modern Art, 1970), 103.

77 Bochner also began publishing art criticism in *Arts Magazine* in 1966.

78 Unless otherwise indicated, Bochner quotations are from an April 28, 2003,

taped interview with the author in New York City. Regarding Bochner and minimalism, see also Richard S. Field, "Mel Bochner: Thought Made Visible," in *Mel Bochner: Thought Made Visible, 1966–1973* (New Haven: Yale University Press, 1995), 18.

79 See James Meyer, "The Second Degree: *Working Drawings and Other Visible Things on Paper Not Necessarily Meant to Be Viewed as Art,*" in *Mel Bochner: Thought Made Visible*, 95–106.

80 Author's telephone conversation with Bochner, May 31, 2003.

81 Bochner is referring here to the philosophical "principle of parsimony" also known as Occam's Razor. Associated with William of Occam, a fourteenth-century Franciscan monk, it stipulates, "posit no more entities than are necessary" (see Bochner, "Serial Art," *Arts Magazine* 41 [summer 1967], 40–41). Bochner is also referring to twelve-tone music, which used permutation, progression, rotation, and reversal to create a potentially extensive but finite system.

82 See Scott Rothkopf, "'Photography Cannot Record Abstract Ideas' and Other Misunderstandings," in *Mel Bochner Photographs, 1966–1969* (New Haven and Cambridge: Yale University Press and Harvard University Art Museums, 2002), 1–2.

83 Yve-Alain Bois, "The Measurement Pieces: From Index to Implex," in *Mel Bochner: Thought Made Visible, 1966–1973*, 170.

84 Ibid., 171.

85 Mel Bochner, "Notes on *Continuous/Dis/Continuous*" (1972). Unpublished MS, 1993.

86 Ibid.

87 Ibid.

88 James Meyer, "How Can You Defend Making Paintings Now: A Conversation between Mel Bochner and James Meyer," in Philip Armstrong, Laura Lisbon, and Stephen Melville, *As Painting: Division and Displacement* (Columbus, Ohio and Cambridge, Massachusetts: Wexner Center for the Arts, Ohio State University, and MIT Press, 2001), 199.

89 Mel Bochner, "Barnett Newman: Writing Painting/Painting Writing," unpublished lecture, 1992/2002.

90 Bochner recalls that Annalee Newman, the artist's widow, called and offered him the studio about a year after Newman died.

91 The notion of "hereness" appears in Newman's work in the painting *Not There, Here* (1962) and three sculptures, *Here I*

(p. 45), *II*, and *III* (1950 [cast 1962; base 1971], 1965, 1966). It can refer to North America versus Europe, or to the idea of being present in the moment. In a conversation with critic Thomas Hess, Newman associated "hereness" with the concept of "making the viewer present." Hess believes that Newman was referring to "the Jewish concept of Makom, meaning place, location, or site." See Thomas Hess, "Not There—Here," in *Barnett Newman* (New York: The Museum of Modern Art, 1971), 73.

92 For him the *Evergreen Review* was a continuing source for much of this material.

93 Bochner, "The Serial Attitude" (1967), reprinted in James Meyer, *Minimalism*, 227. Bochner is writing here about minimalism.

94 Roland Barthes, "Writing Degree Zero," in *A Roland Barthes Reader* (New York: Hill and Wang, 1982), 31, 35.

95 See, for example, Gregory Battcock, "Painting Is Obsolete," in Alexander Alberro and Blake Stimson, *Conceptual Art: A Critical Anthology* (Cambridge: MIT Press, 1999), 88–89.

96 Willoughby Sharp, "Luminism and Kineticism," in Battcock, ed., *Minimal Art*, 318.

97 For Hesse, as for Morris, the crucial figure was Jackson Pollock. For Bochner, of course, it was Newman, as it was for Donald Judd. See Robert Morris, "Anti-Form," originally in *Artforum* (April 1968), reprinted in Meyer, *Minimalism*, 243–44. Morris discusses Pollock and Morris Louis.

98 Marcel Duchamp, "The Creative Act" (1957), in Michel Sanouillet and Elmer Peterson, eds., *Salt Seller: The Writings of Marcel Duchamp* (New York: Oxford University Press, 1973), 138. In a talk given at a meeting of the American Federation of the Arts in Houston, Texas, in April 1957, Duchamp made his position explicit: "The creative act is not performed by the artist alone; the spectator brings the work in contact with the external world by deciphering and interpreting its inner qualifications and thus adds his contribution to the creative act."

99 Daniel Buren, "The Ineffable—About Ryman's Work," in *As Painting: Division and Displacement*, 244. Reprinted from Daniel Buren, *The Ineffable—About Ryman's Work*, trans. Lisa Davidson (Paris: Editions Jannick, 1999). "Post-Minimalism," a term coined by the critic Robert Pincus-Witten in the early 1970s, originally referred to art of the middle and late 1960s in the United States

that consciously strayed from the minimalist camp, whether it emphasized sensuality and process or existed primarily as concept. It was also known as "Anti-Minimalism," but with the passage of time it became clear that it shared qualities with the trend it first appeared to oppose. See Robert Pincus-Witten's introduction to *Minimalism into Maximalism: American Art, 1966–1986* (Ann Arbor: UMI Press, 1987), 1–2. Buren's use of the term exemplifies the problem at hand. Pointing to the need for a new category, it inadvertently reinforces the notion of U.S. primacy.

100 One early example of a non-U.S. presentation of what Peter Selz termed "Anti-Form" (encompassing process art, earthwork, and other kinds of "Post-Minimalism") was *19:45–21:55*, curated by Paul Maenz at the Galerie Dorothea Loehr in Frankfurt, which opened on September 9, 1967. Maenz maintains that he had no interest in happenings or Fluxus and that the show was a response to "a European artistic situation . . . an attempt to overcome the 'esoteric purity' of the *nouvelle tendance* movement around Yves Klein." Suzaan Boettger, *Earthworks: Art and the Landscape of the Sixties* (Berkeley & Los Angeles: University of California Press, 2002), 10.

101 Manzoni is particularly early with his conceptual and performance-based work, and by the early 1960s Oiticica had moved directly from painting into installation and performance without going through sculpture.

102 In 1972 curator Harald Szeeman mentioned "a reaction to the overwhelming Geometry of recent years with a subjective art, . . . Duchamp, the intensity of Pollock's gesture, . . . 'Hippietum'-'Rockerexistence,' the use of drugs." Harald Szeemann, "Introduction," in *Live in Your Head: When Attitudes Become Form: Works—Concepts—Processes—Situations—Information* (Bern: Kunsthalle Bern, 1969).

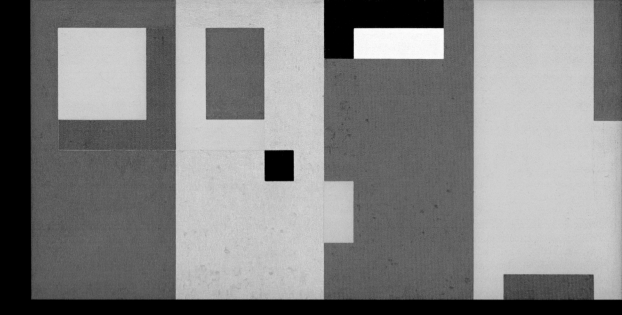

Beyond Geometry is divided into six sections identifying concepts and strategies employed by artists who were developing new forms from a geometric and/or systematic basis. As many artists used several of these ideas over time—or even within a given work—they may appear in more than one section.

New and influential modes of abstraction emerged in the first two decades after World War II. During these years Swiss artist Max Bill came to embody the "concrete art" movement, which sought to recontextualize the supposed objectivity and spare, geometric compositions of prewar abstraction for a postwar world. His theoretical orthodoxy both inspired and repelled artists in Europe as well as in North and South America. In the late 1950s Brazilians Hélio Oiticica and Lygia Clark were among those in Rio de Janeiro who rejected Bill's theories. As "neoconcretists" they continued to work with reduced form but also embraced expressiveness and subjectivity. Abstract expressionist

Barnett Newman, who made radically simplified art that rejected European constructivist traditions, strongly influenced the generation of minimalists that emerged in New York around 1960. Living in France from 1948 to 1954, U.S. artist Ellsworth Kelly shunned the relational balancing of one element against another that defined traditional composition. Instead he aligned same-sized panels covered with commercially dyed cloth (not painted canvas) to create a single work. His conversion of "paintings" into what would later be called "objects," and his use of modular repetition, presaged strategies that would be used by artists on all three continents.

Section 1
The 1940s
and 1950s

Richard Paul Lohse, *Dreissig Systematische Farbtonreihen (Thirty Systematic Color Series)*, 1950–55

opposite page: Camille Graeser, *Progression in Four Spaces*, 1952

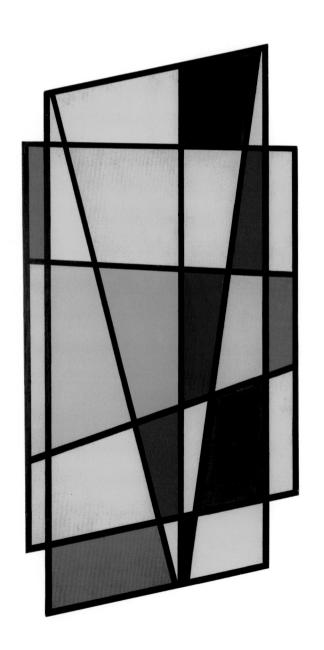

opposite page, left:

Manuel Espinosa, *Painting*, 1945

right:

Juan Melé, *Concrete Planes, No. 35*, 1948

Raúl Lozza, *Painting 82, or Yellow Structure*, 1945

this page, left:

Rhod Rothfuss, *Madí Painting*, 1946

right:

Gyula Kosice, *Madí Painting, Liberated Color Planes*, 1947

Carmelo Arden Quin, *Mercurial*, 1945

Ellsworth Kelly, *Painting for a White Wall (EK 54)*, 1952

opposite page: Victor Vasarely, *Langsor II*, 1952–56

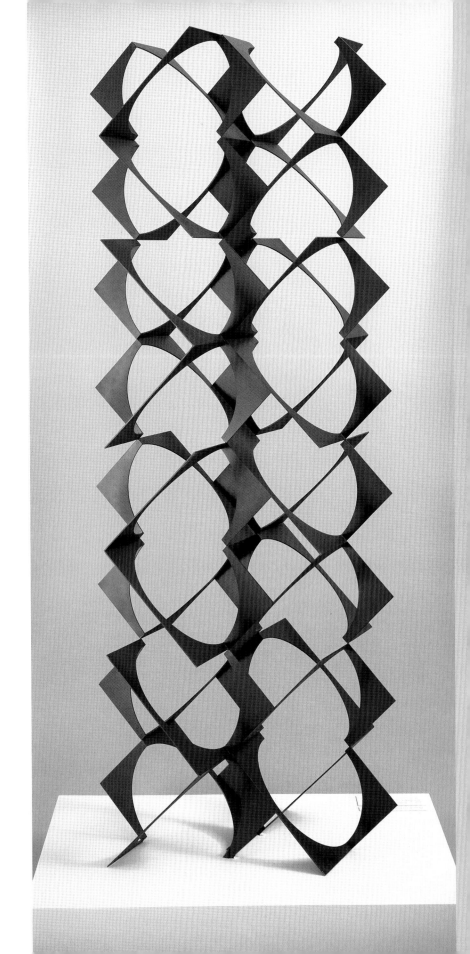

opposite page: Lygia Pape, *Neoconcrete Ballet No. 1*, 1958

Franz Weissmann, *Tower*, 1957

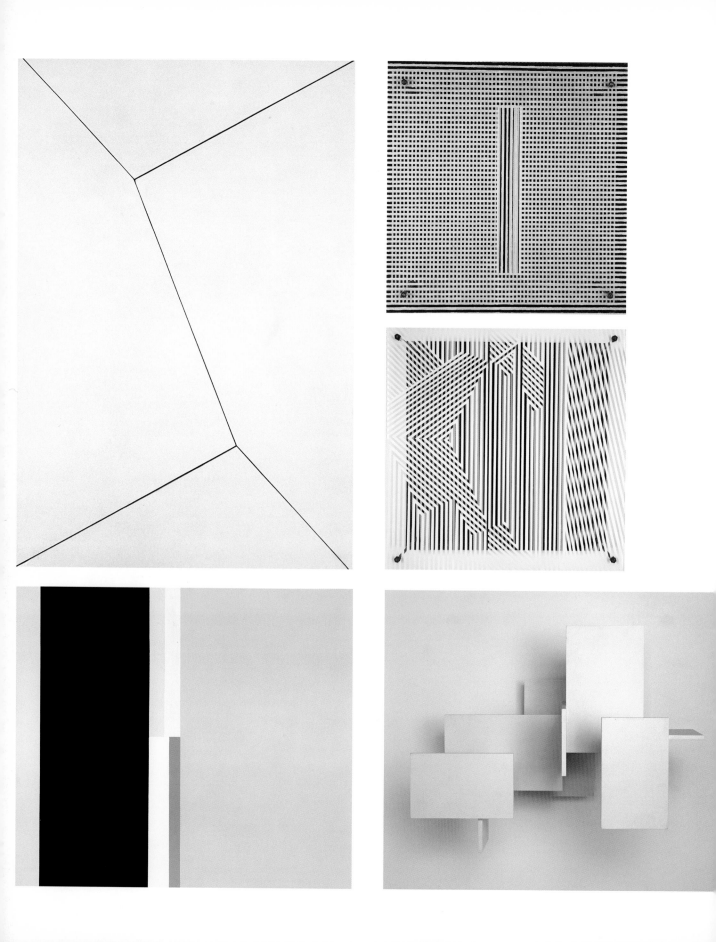

opposite page, left:

Lygia Clark, *Planes on Modulated Surface No. 1*, 1957

John McLaughlin, *Untitled*, 1953

right:

Jesús Rafael Soto, *Horizontal-Vertical Kinetic Structure*, 1957

Jesús Rafael Soto, *Kinetic Structure with Geometric Elements*, 1955

Joost Baljeu, *Synthetic Construction, W-II*, 1957

this page:

Agnes Martin, *Untitled*, 1962

Mira Schendel, *Untitled*, 1954

44

David Smith, *Circle IV*, 1962

opposite page: Barnett Newman, *Here I (to Marcia)*, 1950

Maurício Nogueira Lima, *Rhythmic Object No. 2*, 1952 (second version, 1970)

Verena Loewensberg, *Untitled*, 1944

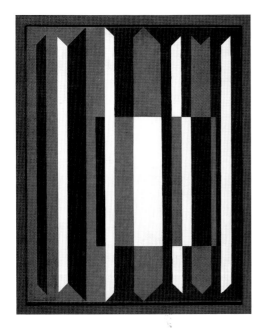

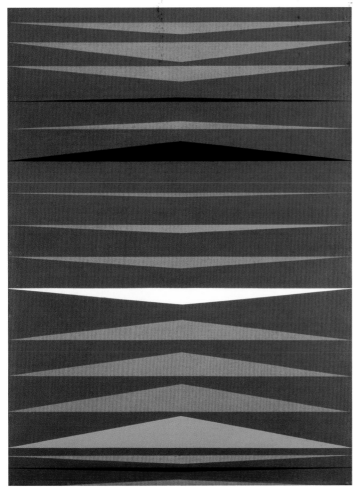

top:

Victor Vasarely, *Hotomi II*, 1956–59

Ad Reinhardt, *Abstract Painting, Blue*, 1952

bottom:

Ivan Serpa, *Rhythmic Bands*, 1953

Richard Paul Lohse, *Thema in Zwei Verschieden Gerichteten Dimensionen (Theme Oriented in Two Dimensions)*, 1945–46

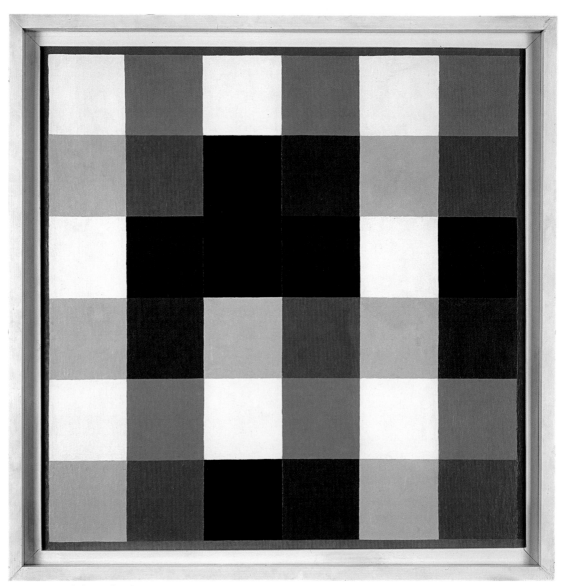

Max Bill, *One Black to Eight Whites*, 1956

concrete territory

Geometric Art, Group Formation, and Self-Definition

Valerie L. Hillings

Nomenclature structures the study of art history. Such defining labels as "concrete art" originate from a variety of sources—critics, art historians, dealers, artists—with a diversity of agendas, and their meaning and significance tend to change over time. Brazilian poet Ferreira Gullar has discussed this problem:

> What is concrete art? Whenever we are looking to respond honestly to a question of this type . . . we bump into a series of difficulties. Of principal concern is the fact that these denominations encompass complex and at times contradictory experiences. Moreover, the origin of these movements is almost always ambiguous and their meaning many times remains enigmatic to the artists engaged with them . . . From this arises the impossibility of giving a prompt and immediate answer. . .[1]

Gullar's choice of concrete art as the focus of his discussion reflects his own relationship with its history. He became the self-appointed theorist for the neoconcrete movement (1959–61) based in Rio de Janeiro, which defined itself in opposition to concrete art as elaborated by the Swiss architect, painter, sculptor, industrial and graphic designer, teacher, and art historian Max Bill and as developed in São Paulo by the members of Grupo Ruptura (1952–59).[2] In the postwar period Bill had come to embody concrete art, and he both inspired and repelled artists in Europe, North America, and South America from the 1940s to the 1970s.

In South America concrete art's influence became strong in the late 1940s and 1950s, a time when Juan Péron's government came to power in Argentina on a pro-labor, "new Argentina" platform, and Brazil's elected president Getúlio Dorneles Vargas undertook the modernization of his country. Buffered from the war, South American countries entered an optimistic period of economic growth. Argentine artists saw concrete art as a universal approach suitable to the workers' revolution. In Brazil, concrete art suggested an ideal match with the country's goals of objectively planning society through technology and of forging a marriage of art and industry.

In Europe during this period most countries were trying to recover from the decimation of World War II and were responding to the rise of the Soviet empire. In the wake of the war the European art world, with the exception of Paris, stood in tatters. In Germany the history of modern art had disappeared, and

there were no institutions or galleries dedicated to experimental art. Eastern Europe was subjected to the official Soviet policy of socialist realism, with the exception of Yugoslavia, whose leader Tito severed ties with Moscow in 1948 and subsequently allowed limited freedoms to artists. A pessimistic, expressionist strain of abstraction triumphed across Western Europe in the late 1940s, but by the mid-1950s, advocates of a constructive geometric vocabulary had begun waging war against these subjectivist trends. They proposed a model for a new world through fresh interpretations of the visual language pioneered by prewar artists associated with constructivism, the Bauhaus, and neoplasticism.

The United States became the center of the art world after the war, and the subjectivist, existentialist strains of abstraction known variously as action painting and abstract expressionism ultimately became its cultural export. By the late 1950s, however, many North American artists were challenging the domination of this movement. Though concrete art had never been widely practiced in the United States, by the 1960s a "minimal" art that owed a debt to the European tradition became one of several tendencies to succeed abstract expressionism and to redefine international geometric art.

The sociopolitical and cultural conditions in which these artists emerged differed greatly. The majority, however, faced resistance and hostility to their reductive aesthetic, which failed to attract popular and, in many instances, institutional support. They therefore had to stake out their territory through publications, exhibitions, and manifestos. Many, especially those in the early stages of their careers, formed supportive alliances ranging from duos, to loose associations with shared aesthetic concerns, to tightly knit teams promoting a coherent platform. The more loosely organized, democratic groups tended to endure longer and find greater success than did the doctrinaire, often Marxist-oriented groups, but none lasted long. As American artist George Rickey has pointed out, "Groups tend to dissolve as members achieve success and fame, or change purpose or lose fire . . . With maturation individual differences sharpen, horizons broaden . . ."[3]

Max Bill and the Propagation of Concrete Art

The term "concrete art" had its origin in 1930, when Dutch artist Theo van Doesburg adopted the word "concrete" as an alternative to "abstract." In the single-issue journal *Art Concret: AC*, he defined concrete art as painting "entirely conceived and formulated . . . before its execution"; constructed of purely plastic elements (lines, planes, surfaces, and colors); devoid of references to nature, lyricism, symbolism, and the unconscious; and with no signification beyond itself.[4] He glossed this definition by describing concrete art as analogous to a typewritten as opposed to handwritten note; it is clearer, more scientific, tied to technology, and universal instead of individual. He claimed that the clarity implied by such art would provide "the basis of a new culture."[5]

Following van Doesburg's untimely death in 1931, the fate of the term "concrete art" remained uncertain. Beginning in the late 1930s Max Bill assumed the task of defining, promoting, and canonizing concrete art as a movement through exhibitions, publications, and pedagogy in both Europe and South

America. In 1936 Bill articulated a concept in line with van Doesburg: "We call those works of art concrete that came into being on the basis of their own innate means and laws—without borrowing from natural phenomena, without transforming those phenomena, in other words: not by abstraction."[6] He identified color, space, light, and movement as its formal "instruments."[7] And he noted that it "tends towards the universal and . . . rejects individuality."[8]

In 1944 he organized *Konkrete Kunst* at the Kunsthaus in Basel, Switzerland, which brought together a core group of fifty-six artists working in a nonfigurative visual language.[9] In the catalogue Bill described concrete art as the striving for absolute clarity and the universal. The Swiss artist Jean Arp argued that works should remain unsigned, artists should work together "as the artists of the Middle Ages," and the term should encompass fields other than painting, including architecture, furniture, design, cinema, and typography.[10] A few months after *Konkrete Kunst* Bill, Arp, and others further theorized the "concrete" as distinct from the "abstract" in the newly founded journal *Abstrakt + Konkret*.[11]

Bill also tried to advance the cause by organizing exhibitions outside of Switzerland. In 1947 he helped to plan the first major show of concrete art in Italy, *Arte Astratta e Concreta* at the Palazzo Reale in Milan. In a catalogue essay Bill described concrete art as the realization of a form-idea through "the pure rapport of color and form on a surface."[12] And, echoing van Doesburg, he claimed that abstract art represented "the end of an epoch," while concrete art proffered the "technical and social possibility of a new world, a path towards a harmonious order, that is to say towards the collaboration of forces of diverse species in a vast and comprehensive unity."[13] This exhibition contributed to the formation in Milan in December 1948 of the artists' group Movimento Arte Concreta (MAC) (1948–58).[14] MAC member and art critic Gillo Dorfles explained that he and his colleagues intentionally selected the word "concrete," which they defined as van Doesburg, Bill, and Arp had.

In the early 1950s Bill developed important relationships with artists in Brazil. He had a 1950 exhibition at the recently founded Museu de Arte in São Paulo, he participated in the first Bienal de São Paulo in 1951 and won the international prize for sculpture, and he delivered a series of lectures on architecture and society in Rio de Janeiro and São Paulo in 1953, at the invitation of the Brazilian government. The Museu de Arte Moderna in São Paulo had sponsored the 1949 show *Do Figurativismo ao Abstracionismo* as well as a series of lectures in the late 1940s that inspired many Brazilian artists to initiate experiments with abstraction.[15] But it was Bill, along with the Brazilian critic Mário Pedrosa (author of important studies on art and gestalt theory), who generated a widespread interest among young Brazilian artists in systematic geometric art.[16]

Grupo Ruptura, which formed in São Paulo shortly after the first Bienal, embraced Bill's theories. In its Manifesto Ruptura (1952) the group rejected naturalism and advocated "the renovation of the quintessential values of visual art (Space-time, movement, material)."[17] In the text "O Objeto," published by Ruptura leader Waldemar Cordeiro in 1956, the author claimed in line with Bill that art was a product, a "qualitative fact" and not an expression, and therefore he felt that art "ought to base itself on [its] independent and specific existence."[18]

Also in the early 1950s, Bill helped to found the Hochschüle für Gestaltung (1953–68) in Ulm, Germany, and from 1953 to 1956 he served as rector.[19] This technical/design school was modeled on the Dessau Bauhaus, which Bill attended from 1927 to 1929. He called for a curriculum concentrated on visual communication instead of art per se. His dedication to the integration of art into society led to an emphasis on design-related issues and to the inclusion of political science, sociology, and information theory.[20] Inviting a number of former Bauhaus members to teach in Ulm, among them Josef Albers,[21] he attracted students from both Europe and South America.[22]

Tomás Maldonado met Bill in Europe in 1948, came to teach at the Hochschüle in 1954, and served as its rector from 1964 to 1966.[23] In the early 1940s Maldonado belonged to a circle of young Argentine and Uruguayan artists who regularly convened at a café in Buenos Aires. In the summer of 1944 they produced a single-issue magazine, *Arturo: Revista de Artes Abstractas*, in which the contributing authors attacked surrealism, calling for invention instead of automatism, and expressed their support for Marxism and dialectical materialism.[24] Soon thereafter, those associated with the magazine formed two major artists' groups, Asociación Arte Concreto-Invención and Grupo Madí (both 1945–47).[25]

In their Manifiesto Invencionista (1946) the members of the former group advocated "scientific aesthetics" based on invention instead of the illusion of representation.[26]

Tomás Maldonado, *Untitled*, 1945

In opposition to surrealism's calls to "kill the optical," they exalted the optical in precise geometric paintings and sculptures such as Maldonado's *Untitled* of 1945 (p. 53).[27] In the first of two issues of the group's self-named journal, Maldonado charted a historic lineage for concrete art that included Kazimir Malevich (whose influence is evident in *Untitled*), Alexander Rodchenko, Naum Gabo, Antoine Pevsner, Piet Mondrian, Georges Vantongerloo, Jean Arp, Kurt Schwitters, László Moholy-Nagy, and Bill.

Maldonado and his colleagues also favored a positive outlook that contrasted with the "gloom, resentment and secrecy" of existentialism and romanticism.[28] Unlike these two subjectivist tendencies, Arte Concreto-Invención emphasized the value of collective action, of engaging in conflict "on the front line" to "help man act within his society."[29] In contrast to Bill, who sought to realize a social-democratic concept for art but did not theorize an overtly political agenda, Arte Concreto-Invención made explicit its equation of Marxist-Leninist politics with concrete art: "United by dialectical materialism, which is the living philosophy of Marx, Engels, Lenin, and Stalin . . . we arrive at formulating a materialist or concrete aesthetic."[30] Maldonado and his colleagues regarded the scientific objectivity implied by concrete art as an ideal tool for combating capitalism.

A number of Maldonado's former colleagues on *Arturo* founded Grupo Madí, which in 1947 split into two factions, one led by Hungarian-born Gyula Kosice, and the other by Argentine Martín Blaszko and Uruguayan Carmelo Arden Quin.[31] In 1946 Kosice authored the *Manifiesto Madí*, in which he echoed Arte Concreto-Invención in his emphasis on the term "invention." He acknowledged that concrete art "began the great period of nonfigurative art," and he recognized the Madí's affinity with Bill by calling for the creation of "an art of mathematical, cold," and "cerebral spirit."[32]

Kosice also drew several key distinctions between Madí and concrete art, which he argued "lacked universality and organization."[33] The Madí, like the Arte Concreto-Invención artists, rejected the picture frame on the grounds that it reinforced art's representational nature by conceiving of painting as a window onto another reality.[34] Members of these two groups produced irregularly shaped canvases, such as Rhod Rothfuss's *Madí Painting* of 1946 (p. 37); additionally they made a series of shaped paintings arranged together with the wall as support such as Juan Melé's *Concrete Planes, No. 35* of 1948 (p. 36) and frame-only works such as Diyi Laañ's *Painted Frame* of 1946.

The Madí artists departed from both Arte Concreto-Invención and concrete art in their strong emphasis on dynamism. Kosice

Diyi Laañ, *Painted Frame*, 1946
35 7/8 x 18 1/2 in. (91 x 47 cm)
Enamel on wood
Private collection, Buenos Aires

Gyula Kosice, *Röyi*, 1944
Wood; 39 x 31½ x 6 in. (99.1 x 80 x 15.2 cm)
Private collection

Gyula Kosice, *Luminous Madí Sculpture*, 1952
Neon lighting on wood support; 24 x 15.7 x 7.9 in. (61 x 40 x 20 cm)
Private collection, Buenos Aires

explained: "We inaugurate the invention of a new kinetic geometry. Kinetic architecture, sculpture, and painting."[35] Despite the fact Bill advocated in writing the dynamic content of art, he mostly produced static paintings and sculptures made of traditional materials.[36] The Madí created not only works that implied movement but also works that could literally be made to move or change appearance through manual manipulation, as for example Kosice's "articulated sculpture" *Röyi* of 1944. The Madí were among the earliest to reconsider the kinetic art of the 1920s as exemplified by László Moholy-Nagy and Alexander Calder.[37] They admired kinetic works for resisting the stability of static compositions and for their dadaist sense of random playfulness, absent in the rigorous geometry and preconceived compositions of canonical concrete art. Kosice's pioneering use of artificial light, specifically neon, in works such as *Luminous Madí Sculpture* of 1952 also exemplifies the Madí penchant for nontraditional methods and materials to enliven geometric art.

Like their colleagues in Arte Concreto-Invención, the Madí stressed a relationship between abstract-concrete art and Marxism. Arguing that "all art is dialectic," Kosice equated "Marxist materialism" with "aesthetic materialism."[38] While neither the Madí nor Arte Concreto-Invención offered a clear plan for realizing this relationship, the Madí did map out strategies for collective activity in the arts. As Arp had in 1944, they supported collaboration among a wide range of disciplines, and in the 1951 issue of their journal

Arte Madí Universal they introduced a section devoted to exchanges with colleagues outside Argentina. Among those who contributed were members of MAC in Italy, Bill and other faculty members at the Hochschüle für Gestaltung, and Paris-based artists who gathered around the journal *Art d'Aujourd'hui*.[39]

The New Generation Challenges Bill's Terminology

The editorial staff of *Arte Madí Universal* made clear its view that an international roster of artists followed the "abstract-concrete" approach to art—a point Bill had made a decade earlier and would reiterate in 1960 in the form of a fifty-year retrospective exhibition of concrete art at the Helmhaus in Zurich, *Konkrete Kunst: 50 Jahre Entwicklung*.[40] He undertook the organization of the show in response to Documenta 2 in 1959, which "treated concrete art as a matter of peripheral importance" in relation to abstract expressionism, tachism, and *art informel*.[41] Bill argued that concrete art continued to thrive, while the art shown at Documenta had already "reached its high point" and was on the decline.[42] As proof of his thesis that concrete art had both a long history and a viable future, he presented the work of one hundred fourteen artists representing three generations (born between 1866 and 1937) and twenty-four countries on three continents. A majority of the works were produced in the late 1950s by both the prewar generations and young artists born between the mid-1920s and mid-1930s, who were experimenting with monochrome painting, serial structure, and kinetic and light art.

Bill continued to describe invention, structure, and universality as the primary characteristics of concrete art,[43] but he loosened his previously rigid distinction between abstract and concrete, writing "Concrete art can equally use a-geometric, 'amorphous' elements; its depictive means can be drawn from intellectual spheres other than geometry or mathematical thinking, and so far as it is the realization of a specific, objectively established idea—formed with its appropriate means—it is concrete painting or sculpture."[44]

He further confused the parameters by including U.S. artist Mark Tobey and French artists Georges Mathieu and Jean Dubuffet, and by arguing that the drip paintings of Jackson Pollock could be regarded as concrete art because they exhibited a structure that tended toward the universal.[45] Such work had no relationship to van Doesburg's typewritten note, or to the objective art theorized by Bill and his colleagues over a period of more than twenty years. Bill's expansion of the meaning of the term raised serious questions about the continued validity of the concept.

Moreover, some of the artists included in the show, especially those of the generation born in the 1920s and 1930s, openly criticized concrete art as defined by Bill. By 1959 Ferreira Gullar had written the Manifesto Neoconcreto on behalf of a group in Rio de Janeiro that shared Bill's negative appraisal of tachism and informalism, which they regarded as "conservative and reactionary,"[46] and endorsed a geometric visual vocabulary. But in the manifesto Gullar stated that they had adopted the term "neoconcrete" to differentiate their work from "nonfigurative 'geometric' art (neoplasticism, constructivism, suprematism, the school of Ulm) and particularly the kind of concrete art that is influenced by a dangerously acute rationalism."[47] They also chose the name to distinguish their approach to art from that of Grupo Ruptura.

Gullar asserted that the equation of art and machine, of artist and engineer and physicist, implied by Bill and Grupo Ruptura represented a dead end for art, which required creativity, not verifiability. He took issue with concrete art's emphasis on the purely visual and mental. Gullar contended that the formalist works of its proponents lacked novelty, as they often looked like little more than illustrations of perceptual problems or optical games designed to demonstrate a priori concepts.[48] He argued that art should not be reduced to an investigation of "objective problems of composition, of chromatic reactions, of the development of serial rhythms, of lines or surfaces."[49]

Instead, the neoconcretists proposed an expressive geometric visual vocabulary. Gullar suggested that "the so-called geometric forms lose the objective character of geometry and turn into vehicles for the imagination."[50] This entailed the "reaffirm[ation] of the creative possibilities of the artist, independent of science and ideologies."[51] Thus they rejected adherence to a coherent, rigidly defined program like the members of Grupo Ruptura.

Gullar identified the affinity among the neoconcretist artists' work by the term "non-object." He theorized that non-objects differed from other works of art in that they facilitated a complex engagement of the senses, thus generating an experience that unfolds in real time and space through the active participation of the viewer, who was "asked to *use*" them.[52] Non-objects burst out of the frames and jumped off the bases; non-objects resisted "permanent form" through both their mutable structure and their reliance on viewer participation:[53] "a work exists only as potential, waiting for a human gesture to realize it."[54]

For example, Lygia Clark created a series of interactive works called *Animals* (see p. 58). These hinged metal objects, made of a series of connected geometric planes, called upon the viewer to move them into various configurations. In the act of manipulating the non-object, the viewer experienced its process of becoming, its transformation over time. As Gullar noted, "It demands of the spectator an integral participation, a will to knowledge and apprehension."[55] Clark intended the viewer to regard the *bichos* as living organisms: "The interlinking of the spectator's action and the 'animal's' immediate answer is what forms this new relationship, made possible precisely because the 'animal' moves—i.e. has a life of its own."[56] Such non-objects functioned as an extension of the spectator's body; they drew heavily on senses other than sight for their realization. And they left meaning ambiguous, variable according to individual experiences of them.

Another group of young artists included in the 1960 exhibition, the Düsseldorf-based group Zero (1958–66), shared the neoconcretists' critical appraisal of concrete art.[57] Zero played a major role in the creation of an experimental art scene in postwar Germany. In the late 1950s, members Otto Piene and Heinz Mack held a series of one-night exhibitions in their studios and published three issues of a journal in which they and their contemporaries articulated their positions.[58] They chose the word "zero" because it did not have nationalist associations and could indicate "a zone of silence and of pure possibilities for a new beginning as at the count-down when rockets take off—zero is the incommensurable zone in which the old state turns into the new."[59]

Lygia Clark, *Animal (Machine)*, 1962

In 1964 group member Otto Piene wrote a history of Zero, which by then constituted both a three-person German group (including Günther Uecker) and an international postwar tendency that encompassed artists of diverse interests from Belgium, Brazil, France, Germany, Italy, Japan, the Netherlands, the United States, and Venezuela. In it he made clear Zero's rejection of concrete art as defined by Max Bill: "But most of us (except [the Brazilian artist Almir] Mavignier who had been Bill's student) succeeded in remaining on our feet as artists who do not want their spirit (and sensation) to be overwhelmed by the mind or even by intellectual visual research."[60] In a 1962 lecture Piene compared the emphasis on thinking and logic in concrete art to the "cult of feeling" of the subjectivist, expressionist movements, which he and his colleagues actively sought to combat.[61] Both movements, he contended, were one-sided, limited the freedom of the artist, and therefore did not provide suitable models for contemporary artists.

At a 1959 exhibition in Antwerp of the work of European and South American artists born in the 1920s and 1930s, Mack and Piene had learned that "artists from various parts of the world were exhibiting for the first time who did not know each other before or hardly at all and whose works agreed to an astonishing extent in their artistic intention."[62] These artists shared a rejection of both the gesture implicit in tachism and *art informel* and the "mannerism of geometric abstraction," and they endorsed a nonfigurative visual language that used color, space, light, and movement as its means. In particular they explored monochrome painting, kinetic and light art, and the implication of the viewer.[63] They felt that motion, achieved variously through the play of light, optical illusions, and motors, could generate visual vibration that would involve the viewer in the completion of the work as well as providing an apt metaphor for a world in constant flux.

By the end of 1959 Mack and Piene, already close to the French artist Yves Klein and the Swiss Jean Tinguely, had forged connections with a group of artists in Milan that gathered around Piero Manzoni, Enrico Castellani, and Lucio Fontana. In 1959 Manzoni and Castellani founded the Galleria Azimut and the journal *Azimuth* (modeled in part on Mack and Piene's journal *Zero*), and the French, German, and Italian artists converged to promote what they called "The New Artistic Conception" through exhibitions, publications, and the informal exchange of ideas.[64]

One manifestation of the "new conception" was monochrome painting, which differed significantly from the structured geometry and relational compositions of concrete art.[65] While Malevich and Rodchenko had experimented with monochrome painting as early as the 1910s and early 1920s, Klein reinvented it for a generation of European artists.[66] In 1957 he famously showed eleven intensely blue paintings at the Galleria Apollinaire in Milan and, a few months later, at the Galerie Schmela in Düsseldorf. Klein's paintings conveyed a sense of the infinite while also emphasizing their physical presence to the viewer; they had an impact on the work of Manzoni, Castellani, Fontana, Mack, Piene, and many others.

The Zero artists imposed a serial structure on their monochrome surfaces: Piene by using a stencil to render a grid, Mack by imprinting a gridlike pattern in relief on aluminum sheets, and Günther Uecker by hammering patterns of nails into usually white panels. They thought that the visual vibration thereby generated would enable such works "to arouse pure feeling" in the viewer; in this they echoed the views of the German romantic painters regarding the spiritual nature of light.[67] Light also represented "the

Piero Manzoni, *Achrome*, 1960

Ad Dekkers, *Beginning of the Equal Division of a Double Square*, 1972

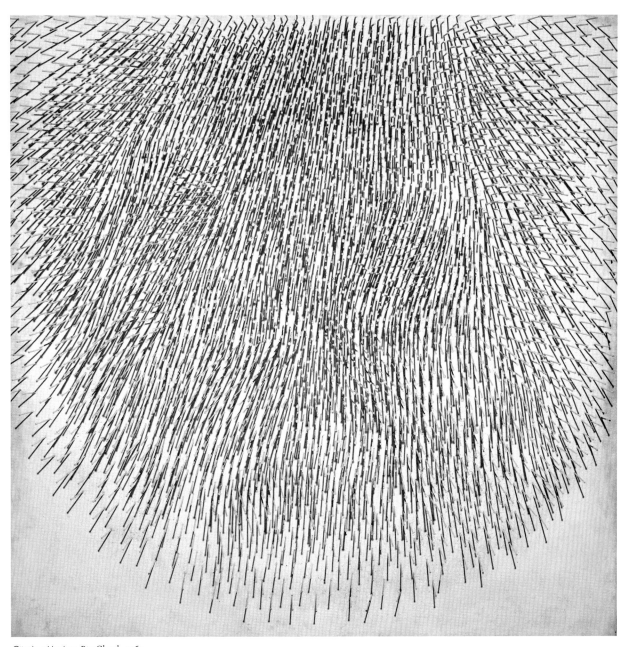

Günther Uecker, *Big Cloud*, 1965

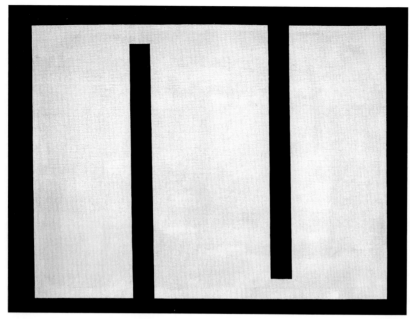

Julije Knifer, M.5.60
(Meander n. 5), 1960

space of action and movement, of life itself"; it provided a link between nature, technology, and humankind and the means of seeing and being in the world.[68]

In 1961 Almir Mavignier organized an exhibition in Zagreb of artists associated with Zero, Azimut, and the newly formed groups Groupe de Recherche d'Art Visuel (GRAV; Paris, 1960–68) and Gruppo N (Padua, 1959–64).[69] Mavignier collaborated on the show with Matko Meštrović, an art critic for Zagreb Radio, who shared Mavignier's enthusiasm for this type of art. Because of Yugoslavia's relative liberalism Meštrović was able to stay abreast of the latest developments by traveling to shows like the Venice Biennale, the Milan Triennale, and Documenta.[70] At home he benefited from the efforts in the early 1950s of a group of young Yugoslav artists and architects known as Exat 51 (1951–56). This group helped to initiate a debate concerning art in the highly conservative culture of the period and to gain acceptance of abstraction, specifically constructivism, in their country.[71] However, in the early 1960s the cultural climate in Yugoslavia remained resistant to experimental art. Meštrović explained, "It was a real struggle against conservative or official mentality in public life. My voice was heard attentively. Sometimes that provoked unpleasant reactions."[72]

Mavignier initially sought to include in the show members of Grupo Ruptura and the neoconcretists, whose work he rightly saw as related to that of the Zero group, but in the end it included only Europe-based artists. Initially he proposed *Konkrete Kunst: Avant-Garde 1961* as the title. In the end, instead of selecting a name linked to Bill's concrete art, they chose *Nove Tendencije* (New Tendencies), which was indicative of their conviction that the young artists were exploring novel territory.

Nonetheless, in the catalogue the Yugoslav curator Radoslav Putar wrote, "The term 'concrete art' is suitable for their work in the general sense, the common sense of the word."[73] He linked the artists to the precedents of neoplasticism, Russian constructivism, and the Bauhaus, and lauded them for demonstrating "the self-confidence of tenacious researchers, the wisdom of mathematicians, the sobriety of technicians, the scrupulousness of workers" who did not "impose the sovereignty of their personality."[74]

Just as the 1959 show had led to a series of collaborations between Zero and like-minded colleagues in France and Italy, *Nove Tendencije* inspired the members of GRAV to try to organize new efforts among an international group of artists under the banner Nouvelle Tendance. Their preliminary attempts to define this trend culminated in a 1962 text in which the group admitted it did not have a definitive character.[75] They nonetheless defined Nouvelle Tendance in opposition to Nouveau Réalisme and neo-dada, on the grounds its proponents emphasized extravisual appeal. They cited as an example Manzoni's work seen in Zagreb, his infamous *Merde d'Artista* (Shit of the Artist), which "appeal[ed] to the imagination of the spectator so that he feels an intellectual pleasure in knowing that this hermetically sealed can contains . . . the author's shit (above all do not open it)."[76] The group also decried the predetermined work of concrete artists.

This document made clear GRAV's intention to isolate the members of Zero—both the group and the growing international trend—from this new movement, which in 1962 assumed the name Nouvelle Tendance–recherche continuelle (New Tendency–continual research; NTrc). Following the second exhibition in Zagreb in 1963, *Nove Tendencije 2*, a bulletin was produced that summarized the goals of the NTrc. The document listed sixteen artists excluded from this new, "international movement," among them Mack, Piene, and Uecker.[77] The explanations given were vague, but the bulletin's outline of the movement's objectives made clear the distinction between Zero and NTrc.

New Tendency modeled itself on scientific research teams, who work collectively to test and verify results, thereby replacing the model of the individual artist still embraced by Zero and the neoconcretists. They envisioned a team of workers producing "an ensemble of visualized ideas and common theories that could bring about the anonymous work."[78] NTrc demonstrated an affinity with concrete art in the utilization of geometry, the incorporation of systems and seriality, and the use of the term "clarity" to define their objective. Like Madí, Zero, and the neoconcretists, NTrc artists strove to create dynamic works that emphasized instability and change. But their use of geometry, light, and movement engaged the viewer on a physiological level, not an emotional one; their project was related more to science than to poetry.

For example, in his work *Pulsating Structure* (p. 64), Italian artist and member of the Milan-based Gruppo T (1959–67) Gianni Colombo inserted a serial grid of white Styrofoam blocks into a wooden frame.[79] A motor activated by the viewer made the blocks randomly and slowly move out of the frame and into the space of the spectator. This unstable work allowed the artist to create a sense of "perceptive ambiguity in the components to prevent the observer from launching himself on a single known interpretation."[80]

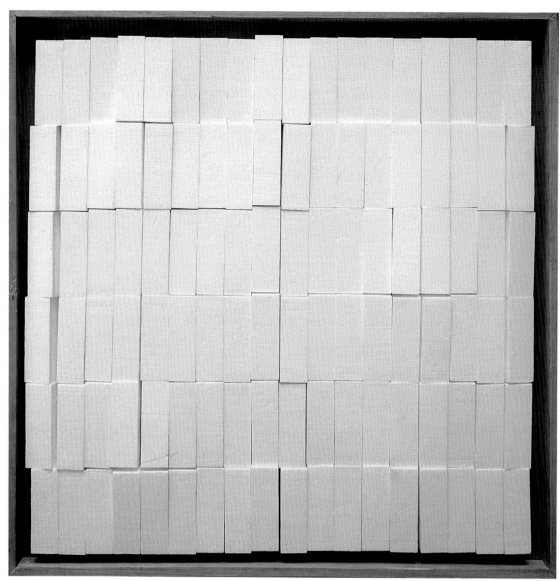

Gianni Colombo, *Pulsating Structure*, 1959/1971

In the catalogue for *Nove Tendencije 2*, Meštrović explained that New Tendency regarded collaboration as a means of combating the corruption and alienation inherent in the capitalist art system by "ris[ing] up against individualism and towards a spirit of collective work . . ."[81] In theory, the artists' emphasis on the purely visual would strengthen the perceptive capabilities of the viewer, allowing the development of "a mental attitude which . . . will permit him to perceive reality with greater clarity, a more lucid awareness of its meanings, and above all the opportunities which it offers to act."[82] Thus, like the Argentine groups before them, the artists associated with NTrc believed that an objective geometric visual vocabulary, rendered dynamic and unstable and activated by the viewer, offered the most effective artistic analogue for sociopolitical change based on Marxist and socialist principles.

The Geometrizing of American Art: A Battle over Terminology

By the mid-1960s, members of the defunct groups Arte Concreto-Invención, the Madí, and the neoconcretists, and members of the still-extant groups Zero, GRAV, Gruppo N, Gruppo T, and NTrc found themselves grouped by the art market, museums, galleries, and critics as a tendency variously known as kinetic, light, programmed, or op art.[83] In 1964 both the 32nd Venice Biennale and Documenta 3 recognized the importance of this trend, and in 1966 Julio Le Parc of GRAV won the international prize for painting at the 33rd Venice Biennale.[84] The decision to confer an award on Le Parc and not GRAV underscored the fact that the market and the official art system almost categorically refused to endorse groups.

Official recognition added to the pressures already threatening the survival of the remaining groups. By 1963 nearly all of them suffered from internal frictions caused by struggles over leadership, disagreements over theory, diverging artistic goals, varying degrees of political fervor among members, and jealousy over the recognition of some and not others. This was true of both the looser groups such as Zero and the more coherent groups such as NTrc. The need to make a living as an artist also entered the picture. As Alberto Biasi, a member of Gruppo N, cogently argued: "These problems of survival resulted in competitive battles among the operators living in capitalist countries, since they were all directly dependent on an arch-capitalist marketing system. From this time on even those who had hung back before all joined in the race for success."[85]

The spirited efforts of these artists to capture a wider audience culminated in the 1965 Museum of Modern Art exhibition *The Responsive Eye*. At the inception of the project in 1962, the show's curator William Seitz intended to organize a historical survey of art with a visual emphasis from impressionism to the present. On the advice of the American kinetic artist and art historian George Rickey (at that time working on a book on the history of constructivism) and the influential Parisian dealer Denise René, Seitz visited studios of artists working across Europe, among them members of Zero and NTrc.[86] His travels led to a flurry of letters from artists advocating for their own inclusion and for the consideration of like-minded colleagues; many indicated their willingness to create new works for the exhibition.[87] Prior to 1964, postwar European and South American geometric art had received very limited attention in the

United States, so for these artists the show represented a major opportunity to gain recognition in the international art capital of New York.[88]

Seitz subsequently decided to limit his show to contemporary abstract works that served as both "generators of perceptual responses in the eye and the mind of the viewer" and vehicles for redefining the viewer–work of art relationship.[89] The show included one hundred artists from nineteen countries associated with a plethora of approaches: optical, hard-edge painting, visual research, new abstraction, color imagery, programmatic art.[90] In addition to problems inherent in the inclusion of such a diversity of styles, the exhibition suffered from the premature identification and celebration by the popular press of "op art" (a term eschewed by the majority of the exhibiting artists) as the successor to pop art.[91] The combination of these two factors contributed to an overwhelmingly negative response by the U.S. art world.

Critics of all persuasions argued against the inclusion in the same exhibition of European and American artists working in an abstract, antipainterly style. *The Responsive Eye* coincided with the emergence of a variety of new approaches by American artists to geometric art. As American artist and critic Sidney Tillim argued in 1959, from the 1930s to the 1950s only a limited number of Americans had explored a geometric visual vocabulary. This type of art "never embodied itself in an autonomous style" and had been utterly "eclipsed by Abstract Expressionism."[92] The American art critic Hilton Kramer testified to the relative lack of attention for this mode in the U.S. as late as 1960 in his review of the show *Construction and Geometry in Painting: From Malevitch to "Tomorrow,"* which opened at the Galerie Chalette in New York (contemporaneously with *Konkrete Kunst*). He noted, "The virtue of this exhibition is that . . . it presents us with the *fact* of an entire modern tradition we have tended to lose sight of."[93]

From 1962 to 1965 a series of exhibitions in New York and Los Angeles demonstrated that this situation had begun to change.[94] Ben Heller, curator of the 1963 Jewish Museum show *Toward a New Abstraction*, hailed a new group of artists, among them Ellsworth Kelly, Morris Louis, Kenneth Noland, and Frank Stella, who took a more conceptual approach to painting; deemphasized the self, intuition, and automatism; and reduced the work to a minimal formal statement.[95] Heller defined this approach — which encompassed staining, color field, and hard-edge painting, among other techniques — with the words "clarity" and "precision"—terms reminiscent of Bill's definition of concrete art.[96]

The American critic Clement Greenberg likewise saw clarity as a key feature of what he termed "Post-Painterly Abstraction." Greenberg, who had been the most vocal and effective advocate of many artists associated with abstract expressionism, rejected it in the 1960s on the grounds it had become a mannerism, practiced by mostly second-rate artists. He praised artists who had embraced "linear clarity" and "physical openness of design" in their work, in large part because such an approach underscored flatness, one of Greenberg's primary criteria for successful modernist painting.[97]

While he acknowledged precedents in the 1920s and 1930s, Greenberg vehemently rejected the notion that these American artists came out of prewar European geometrical painting as practiced by Mondrian, the Bauhaus, the suprematists, "or anything else that came before."[98] He wanted to distinguish the formalism

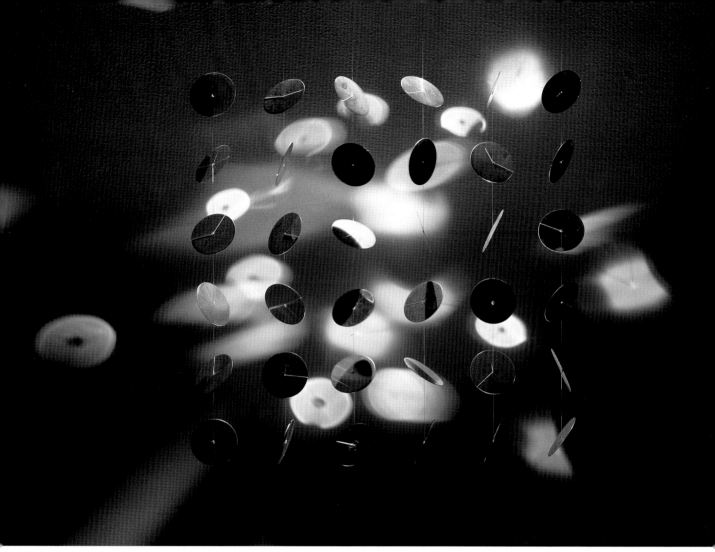

Julio Le Parc, *Continual Light*, 1960–67

of American postwar geometric abstraction from the prewar strain, which tended to embrace various spiritual, philosophical, and sociopolitical affiliations. He emphatically stated that while it reacted against subjectivity, loosely rendered form, and the painterliness characteristic of abstract expressionism, this new abstraction came out of an American context. These artists maintained the large scale, anti-illusionism, and intense color of predecessors such as Barnett Newman, Mark Rothko, and Clyfford Still.

Tillim echoed Greenberg when he defined "European-type" and "American-type" optical art, contending that the former remained linked to cubism, while the latter grew out of abstract expressionism.[99] Like Tillim, the American critics Barbara Rose and Rosalind Krauss regarded European op art as representative of a tradition lacking the promise for the future embodied in the art of Americans such as Larry Poons.[100] Rose went even further by stating that "in many ways the European art seemed like a showcase

for the American work which by contrast shone like so many diamonds in a field of synthetic brilliants."[101] She asserted that the work of "the European visual research groups" did not even constitute art, in large part because of its similarity to "textbooks and laboratory experiments."[102]

Critics sympathetic to European op art also took issue with Seitz's decision to group them with contemporary Americans: Rickey criticized the "enormous preponderance of Americans" on the grounds that "optical art is not an American province."[103] Denise René contended that pressure was brought to bear on Seitz to place greater emphasis on American artists:

> Artists and directors of American galleries attacked him, reproaching him for not having invited enough American artists. He clashed with the nationalist lobbies which saw there a European invasion. At the last minute, Seitz was obliged to include some American works made especially for the exhibition.[104]

Rickey noted that forty-eight of the sixty-three American works were made in 1963 and 1964—evidence of the veracity of René's claims—which was surprising to him given that "as recently as 1961 the Americans making art with some sort of retinal impact could be counted on one hand."[105]

Another central issue raised by critics sympathetic to both European and American art was the representation in the popular press of op art as the newest avant-garde movement. Rose and critic Thomas Hess lambasted op for its proximity to popular forms of entertainment, especially to the passive, mindless immediacy of television.[106] Hess asserted that real art kept a distance from the viewer and invited critical thinking. Op art had an inescapable direct impact on the viewer, and it captured the attention of both the mass media and the public: "In Op they sense[d] that art, at long last, [wa]s not only meeting the audience half-way . . . Op will actually come down off the walls and shake your hand."[107]

Hess and other American art critics regarded such populism in art as anathema, a stance codified by Greenberg's influential 1939 argument concerning the distinction between avant-garde art and kitsch. In the late 1960s, Greenberg revisited his earlier work, railing against the dual menace of Novelty Art and Good Design, both of which op art was seen to exemplify.[108] Rickey concurred with Greenberg that the equation of art with "the new" had transformed it into fashion. Consequently, questions of quality became irrelevant, as museums, dealers, collectors, and artists saw the translation of publicity into "fantastic inflations and scandalous successes."[109] In the eyes of the New York art world, the fact that op art became the darling of mainstream publications, a model for aspiring artists, and the basis of clothing and interior design rendered it impotent as avant-garde art.

Within a few months of *The Responsive Eye*, American critics and curators directed their attention to young painters and sculptors producing an impersonal, literal geometric art variously referred to as cool art, ABC art, and minimal art.[110] By 1966 this type of work spawned two major exhibitions, *Systemic Painting* and *Primary Structures*.[111] The art in these shows challenged basic categories: paintings such as Frank Stella's *Getty Tomb* (p. 77) seemed more like sculpture, and sculpture like Donald Judd's freestanding stainless-steel boxes (p. 144) evoked architecture.

Critics took issue with the artists' renunciation of personal physical involvement when they had their works or parts thereof industrially fabricated or purchased them ready-made (a method their European and South American contemporaries wanted to employ but generally lacked the means for). Such an approach reflected the artists' anticraft, antisubjective stance. The use of synthetic materials further underscored their rejection of manual labor considered as a sign of artistic accomplishment.

Critics also questioned the lack of "art-content" in such work. For example, Carl Andre's aluminum plates (p. 14–15) resembled ordinary floor covering, while Dan Flavin's series of fluorescent tubes (p. 76) seemed to render the normal light source useless. These artists emphasized the literal, material presence of their art, which they underscored by producing stationary works on a large scale. In this, the Americans differed significantly from their European and South American counterparts, who were producing dematerialized kinetic and light art. Moreover, American artists did not believe that abstraction should be suggestive of anything outside itself; in this they clearly departed from the European and South American groups, who took a more social and utopian approach to geometric art.

Despite the shared goals, stylistic similarities, and personal friendships among artists associated with minimalism, they never constituted a group in the manner of the Europeans and South Americans.[112] While NTrc proclaimed itself to be an international movement, produced a bulletin, and organized exhibitions, minimalism was a critical and art historical invention. The years 1966–68 constituted minimalism's moment, although as Greenberg pointed out, while it "swept the magazines and the art buffs, it d[id]n't sell commensurately" because of its large scale and difficulty to install.[113]

In a 1969 article for *Studio International* Donald Judd acknowledged that "very few artists receive attention without publicity as a new group," and he criticized magazines and exhibitions for prioritizing groups over individuals.[114] He explained that he agreed to write the article in order to keep the magazine "from calling [him] a minimalist," as he felt minimal art should never have been invented.[115] He took issue with critics and curators who lumped him together with colleagues such as Robert Morris (citing as an example Michael Fried's influential essay "Art and Objecthood").[116] Morris emphasized the perceptual, bodily encounter of the viewer with the work, and his writing was informed by gestalt psychology and phenomenology. He infused his art with a dadaist playfulness utterly absent in the formalism of Judd.

The depersonalized geometric art produced by artists on all three continents had much in common yet remained encoded with signs of its makers' identities. The obsession with creating categories and finding commonality reflects both a human desire for understanding through structure and capitalism's need for marketable brands. Yet artists continue their individual development, evolving beyond the parameters of the groups with which they were once associated. They are recognizable both categorically and individually. The fascination with and power of the individual artistic voice explains why, despite the efforts of Bill and his descendents, no universal model for art has emerged, and why answering questions such as "What is concrete art?" continues to be so challenging.

notes

I would like to acknowledge Getulio Alviani, Alberto Biasi, Udo Kultermann, Julio Le Parc, Heinz Mack, Manfredo Massironi, Almir Mavignier, Matko Meštrović, François Morellet, Ivan Picelj, Otto Piene, and Gabriele De Vecchi, without whose generosity this essay would not have been possible.

1 Ferreira Gullar, "Arte Concreta," *Jornal do Brasil* (Rio de Janeiro), 25 June 1960. Reprinted in *Projeto Construtivo Brasileiro Na Arte (1950–1962)*, ed. Aracy Amaral (Rio de Janeiro and São Paulo: Museu de Arte Moderna and Pinacoteca de Estado, 1977), 105. My translation.

2 Grupo Ruptura included Lothar Charoux, Waldemar Cordeiro, Geraldo de Barros, Kazmer Féjer, Leopold Haar, Luís Sacilotto, and Anatol Wladyslaw. The members of the neoconcrete movement were Hércules Barsotti, Lygia Clark, Aluísio Carvão, Amílcar de Castro, Willys de Castro, Hélio Oiticica, Lygia Pape, and Franz Weissmann. For more on these groups see Guy Brett, "A Radical Leap," in Dawn Ades, *Art in Latin America: The Modern Era, 1820–1980* (New Haven and London: Yale University Press, 1999), 252–83; Aracy Amaral, "Abstract Constructivist Trends in Argentina, Brazil, Venezuela and Columbia," in *Latin American Artists of the Twentieth Century*, exh. cat., ed. Waldo Rasmussen (New York: The Museum of Modern Art, 1993), 86–99; Maria Alice Milliet, "From Concretist Paradox to Experimental Exercise of Freedom," and Agnaldo Farias, "Apollo in the Tropics: Constructivist Art in Brazil," in *Brazil Body & Soul*, exh. cat., ed. Edward J. Sullivan (New York: Solomon R. Guggenheim Museum, 2001), 388–403; and Mary Schneider Enriquez, "Mapping Change: A Historical Perspective on Geometric Abstraction in Argentina, Venezuela, and Brazil," in *Geometric Abstraction: Latin American Art from the Patricia Phelps de Cisneros Collection* (New Haven and London: Yale University Press, 2001), 12–37.

3 George Rickey, "The New Tendency (Nouvelle Tendance–Recherche Continuelle)," *Art Journal* 23, no. 4 (summer 1964): 278.

4 Theo van Doesburg, "Base de la peinture concret," *Art Concret: AC* (April 1930): 1. My translation. The journal acted as a manifesto for a group of the same name founded and disbanded in 1930. The other members of the group were Otto Gustaf Carlsund, Jean Hélion, Léon Tutundjian, and Marcel Wantz. A facsimile of this journal appears in the excellent exhibition catalogue *Arte Abstracto, Arte Concreto: Cercle et Carré, Paris, 1930* (Valencia: IVAM Centre Julio González, 1990).

5 Theo van Doesburg, "Commentaires sur la base de la peinture concrète," *Art Concret: AC* (April 1930): 4. My translation.

6 Max Bill, "Konkrete Gestaltung," in *Zeitprobleme in der Schweizer Malerei und Plastik*, exh. cat. (Zurich: Kunsthaus, 1936). Trans. by Judith Rosenthal in Margit Weinberg Staber, "Quiet Abodes of Geometry," in *Konkrete Kunst in Europa nach 1945: Die Sammlung Peter C. Ruppert / Concrete Art in Europe after 1945: The Peter C. Ruppert Collection*, exh. cat. (Ostfildern-Ruit, Germany: Hatje Cantz Verlag, 2002), 82.

7 Ibid.

8 Bill, "Konkrete Gestaltung," trans. by Peter Selz in Kristine Stiles and Peter Selz, eds., *Theories and Documents of Contemporary Art: A Sourcebook of Artists' Writings* (Berkeley: University of California Press, 1996), 74.

9 *Konkrete Kunst*, exh. cat. (Basel: Kunsthalle, 1944). The show included Bill, Jean Arp, Walter Bodmer, Vasily Kandinsky, Paul Klee, Leo Leuppi, Richard Paul Lohse, Piet Mondrian, Sophie Taeuber-Arp, and Georges Vantongerloo, among others. It ran from 18 March to 16 April and was accompanied by a catalogue, the cover of which Bill designed. It should be noted that in 1945 van Doesburg's widow Nelly helped to organize the show *Art Concret* at the Galerie René Drouin in Paris.

10 Jean Arp, "Art concret," in *Konkrete Kunst* (1944), 11. My translation.

11 Twelve issues of the journal appeared between October 1944 and June 1945. Among those who contributed were Jean Arp, Vasily Kandinsky, Leo Leuppi, Richard Paul Lohse, Camille Graeser, and Verena Loewensberg.

12 Max Bill, "Dall'arte astratta all'arte concreta," *Arte Astratta e Concreta* (Milan: Palazzo Reale, 1947), 14. My translation.

13 Ibid.

14 The first exhibition of MAC opened at the Libreria Salto di Milano on 22 December 1948. Its founders were Gillo Dorfles, Gianni Monnet, Bruno Munari, and Atanasio Soldati. An excellent source on the movement is Luciano Caramel, *MAC: Movimento Arte Concreta 1948–1958*, exh. cat. (Florence & Sienna: Maschietto & Musolino, 1996). Within Italy MAC came to include chapters in Milan, Genoa, Rome, Turin, and Florence. MAC published twenty-four issues of the journal *Arte Concreta* (November 1951–June 1954), which chronicled the activities of the group and other related groups and artists in Europe and South America, among them the Italian artist and founder of *Spatialismo* Lucio Fontana. For more on Fontana, see Sarah Whitfield, *Lucio Fontana*, exh. cat. (London: Hayward Gallery, 1999).

15 The show was organized by the Belgian art critic Léon Dégand, the first director of the Museu de Arte Moderna in São Paulo. Of particular import were the series of lectures by the Argentine art historian Jorge Romero Brest in 1948.

16 Brazilian artists Almir Mavignier, Ivan Serpa, and Abraham Palatnik constituted the first group to advance geometric abstract art in their country. Importantly, in the early 1950s Pedrosa contributed essays to the Paris-based journal *Art d'Aujourd'hui*. (For more on this journal, see note 39.)

17 Grupo Ruptura, "Manifesto Ruptura," São Paulo, 1952. Repr. and trans. in *Geometric Abstraction*, 152.

18 Waldemar Cordeiro, "O Objeto," *Revista Arquitetura Decoração* (São Paulo), December 1956, repr. in *Projeto Construtivo Brasileiro*, 74–75. My translation.

19 Inge Scholl and Otl Aicher founded the Hochschüle für Gestaltung in order to revive the teaching methods of the Bauhaus. The name refers to the Dessau years of the Bauhaus, which had been known by the same name ("College of Design"). They appointed Max Bill as architect of the school's building and as its first director (1951–56). The school became operational in 1953 but did not officially open until October 1955, and it closed in 1968. It offered a multidisciplinary approach to art making that focused on the study of art and science, especially as applied to design of items for everyday use. For an informative discussion of the Hochschüle see Donald Drew Egbert, *Social Radicalism and the Arts* (New York: Alfred A. Knopf, 1970), 700–6, and two more recent books, René Spitz, *HFG Ulm: The View behind the Foreground: The Political History of the Ulm School of Design 1953–1968* (Stuttgart and London: Edition Axel Menges, 2002) and *Ulm Method and Design: Ulm School of Design 1953–1968*, ed. Ulmer Museum/HfG Archiv (Ostfildern: Hatje Cantz, 2003). Spitz sheds light in particular on the role played

by Americans in the establishment of the school.

20 Spitz, *HFG Ulm*, 77, 156.

21 Having immigrated to the United States in 1933 and become a citizen in 1939, Albers taught at the Black Mountain College in North Carolina (1933–48), and he served as the director of the Yale University Department of Design from 1950 to 1959. His pedagogy in the U.S., coupled with his famed series "Homage to the Square" (begun in 1949), gave American artists a direct link to the prewar European avant-garde, and to the tradition of the Bauhaus in particular. Albers served as a visiting professor in Ulm for a short period during the 1954–55 school year.

22 In particular, a number of Brazilians came to study there, among them Almir Mavignier (1953–57), Mary Vieira (1952–54), and Geraldo de Barros, a member of Grupo Ruptura.

23 In September 1948 Maldonado met Ernesto Rogers, the Italian architect and editor of the magazine *Domus*, when he delivered a series of lectures in Buenos Aires. Rogers met Bill during World War II, when he lived in exile in Switzerland and taught at the University of Winterthur. Rogers both encouraged and facilitated the meeting between Bill and Maldonado.

24 They founded the magazine largely at the urging of the Uruguayan artist Joaquín Torres-García, one of the founders of the Paris-based group of abstract artists formed in 1930 in opposition to surrealism, known as Cercle et Carré. Torres-García is a key figure in the development of avant-garde art in South America. For an introduction to his activities upon his return to South America from Europe in 1934 see Florencia Bazzano Nelson, "Joaquín Torres-García and the Tradition of Constructive Art," in *Latin American Artists of the Twentieth Century*, 72–85.

For more on *Arturo* see Nelly Perazzo, *El Arte Concreto en la Argentina en la Década del 40* (Buenos Aires: Ediciones de Arte Gaglianone, 1983). For an account of relationships among the participants see Jorge B. Rivera, *Madí y La Vanguardia Argentina* (Buenos Aires: Editorial Paidos, 1976), 11–29. Authors in *Arturo* included Argentine Carmelo Arden Quin, Hungarian-born Gyula Kosice, Uruguayan Rhod Rothfuss, Torres-García, and Argentine poet Edgar Bayley. A number of artists contributed illustrations, among them Tomás Maldonado, Lydy Prati, Rhod Rothfuss,

Maria Vieira, Augusto Torres, and Torres-García. Works by Mondrian and Kandinsky were also reproduced.

25 See the exhibition catalogues *Arte Concreto-Invención–Arte Madí* (Basel: Edition Galerie von Bartha Basel, 1991), with essays by Margit Weinberg Staber, Nelly Perazzo, and Tomás Maldonado; and *Argentina: Arte Concreto-Invención 1945; Grupo Madí 1946* (New York: Rachel Adler Gallery, 1990). Arte Concreto-Invención published two issues of their self-named journal in 1946. Under the guidance of Gyula Kosice, the journal *Arte Madí Universal* appeared from 1947 (issue 0) to 1954. *Perceptismo*, ed. by Raúl Lozza, formerly of Arte Concreto-Invención, lasted from 1950 to 1953.

26 Manifiesto Invencionista (18 March 1946), written on the occasion of Arte Concreto-Invención's first exhibition, held at the Salon Peuser, Buenos Aires, and published in *Revista Arte Concreto-Invención* no. 1 (August 1946): 8. The manifesto is repr. and trans. in *Geometric Abstraction*, 146. Arte Concreto-Invención counted among its members Edgar Bayley (poet), Antonio Carduje, Simón Contreras (poet), Manuel Espinosa, Alfredo Hlito, Enio Iommi, Obdulio Landi, Raúl Lozza, Tomás Maldonado, Alberto Molenberg, Primaldo Mónaco, Oscar Nuñez, Lydi Prati, Jorge Souza, and later Juan Melé, Virgilio Villalba, and Grégorio Vardanega. In 1948 former members of Arte Concreto-Invención led by Argentine artists Raúl Lozza and Alberto Molenberg formed the group Perceptismo.

27 *Geometric Abstraction*, 146.

28 Ibid.

29 Ibid.

30 Tomás Maldonado, "Lo abstracto y lo concreto en el arte moderno," in *Revista Arte Concreto-Invención* no. 1 (August 1946): 7. My translation.

31 Among the members of the Madí were Gyula Kosice, Carmelo Arden Quin, Rhod Rothfuss, Martín Blaszko, Diyi Laañ, and Esteban Eitler. The faction led by Kosice was known as the Madinemsor movement. Arden Quin left for Paris in 1948, when he and many other Argentine and Uruguayan artists participated in the third Salon des Réalités Nouvelles, an annual show of international artists working in abstract, concrete, and constructivist vocabularies (begun in Paris in 1946 by the French dealer Fredo Sidès and former Abstraction-Création artists including Auguste Herbin and Félix Del Marle). For a good introduction to the

Salon des Réalités Nouvelles, see Domitille d'Orgeval's "Le Salon des Réalités Nouvelles: pour et contre l'art concret," in *Art Concret: Espace de l'Art Concret*, exh. cat. (Paris: Espace de l'Art Concret & Réunion des Musées Nationaux, 2000), 24–39. In Paris Arden Quin formed a new Madí group called Madí Internacional, which held a number of exhibitions in the 1950s.

32 The Manifiesto Madí was read by Arden Quin in August 1946 at the exhibition at the Instituto Francés de Estudios Superiores in Buenos Aires; repr. and trans. in Ades, *Art in Latin America*, 330. Bill laid out his argument for a mathematical approach to art in a 1949 text, "Die mathematische Denkweise in der Kunst unserer Zeit," originally published in *Werk* 3 (1949).

33 Ades, *Art in Latin America*, 330.

34 Rhod Rothfuss, "El Marco: Un problema de la plástica actual," in *Arturo* no. 1 (1944), trans. in *Geometric Abstraction*, 140.

35 Kosice text printed on the back of the pamphlet for a show at the Teatro del Pueblo in Buenos Aires, 1948. My translation.

36 In his canonical 1949 text, "The Mathematical Approach in Contemporary Art," he wrote: "And despite the fact the basis of this Mathematical Approach to Art is in reason, its dynamic content is able to launch on astral flights which soar into unknown and still uncharted regions of the imagination." Stiles and Selz, *Theories and Documents of Contemporary Art*, 77. While here I am only referring to Bill's visual art, it is important to note that he also worked as an architect, graphic artist, and designer. In the 1950s the French artist Yves Klein and the German artist Otto Piene made similar statements regarding art and the cosmos.

37 In a speech read by Arden Quin at the home of the psychoanalyst Enrique Pichon-Rivère in 1945, "El Móvil," he acknowledged the influence of these earlier artists, among others. The text of his talk is repr. and trans. in *Geometric Abstraction*, 142–44.

38 Gyula Kosice, text in catalogue for the first international Madí exhibition, Aiape, Montevideo, Uruguay, December 1946. My translation.

39 There were eight issues of *Arte Madí Universal* produced between 1947 and 1954. The French artist and architect André Bloc founded the influential journal *Art d'Aujourd'hui*, which focused on both historic movements such as neoplasticism, suprematism, constructivism, and the Bauhaus, and contemporary abstract art throughout Europe and the Americas.

Bloc also used the magazine to promote the synthesis of the arts, a theme espoused by him and fellow members of the Groupe Espace (which formed in 1951 and merged with MAC in Italy in 1954). Groupe Espace was founded with the intention of getting artists and architects to work together to improve the living and social spaces of the masses. The group published its manifesto in the first issue of the Milan-based journal of the Movimento Arte Concreta (MAC), *Arte Concreta* no. 1 (November 1951). They had a multinational membership (England, Belgium, Italy, Switzerland, Sweden), but the two main exhibitions took place in France in 1954 (Biot) and 1955 (St. Cloud). Espace and MAC shared many of the same goals and decided to merge in 1954 to form MAC/Espace. For more on this history, see the recent catalogue for an exhibition held at Acquario Romano in Rome, *MAC/Espace, Arte Concreta in Italia e in Francia, 1948–1958* (Bologna: Bora 1999).

40 *Konkrete Kunst: 50 Jahre Entwicklung*, exh. cat. (Zurich: Helmhaus, 1960). Describing the 1948 Salon des Réalités Nouvelles, the editorial staff of *Arte Madí Universal* wrote: "117 countries and 260 exhibitors participate in said exhibition that reflected the extraordinary vitality of international abstract-concrete art." *Arte Madí Universal* no. 2 (October 1948). In the issue inaugurating the collaborative section (no. 4, October 1951), the editors stated that it "reflects the vitality of the non-figurative plastic arts of our epoch." My translations. Bill mentioned the international nature of concrete art in an essay on Kandinsky published in *Abstrakt + Konkret* no. 8 (1945).

41 Hans Curjel, "Konkrete Kunst: Fünfzig Jahre Entwicklung, Helmhaus, 8 Juni bis 14 August," *Werk* vol. 47, no. 8 (August 1960): 160. My translation. Arnold Bode, painter and professor at the Art Academy in Kassel, Germany, wanted to stage a major event to reconnect Germany with modern art and with the international art scene. Under the auspices of the Society of the Occidental Art of the 20th Century he presented shows of "classical modern art" in the still-ruined Museum Fredericianum, a building in the classical tradition. He founded the series of exhibitions known as Documenta in 1955. The first show was *Presentation of the Art of the 20th Century*, a survey of cubism, expressionism, and futurism, with artists including Picasso, Matisse, Ernst, Kandinsky, Klee, Schlemmer,

Beckmann, and Moore. More than 130,000 people attended. Bode staged a second show in 1959, which transformed this international art event, held approximately every five years, into a major exhibition of contemporary art. Two useful sources on Documenta are: *Documenta: Idee und Institution*, ed. Manfred Schneckenburger (Munich: Bruckmann, 1983) and *Documenta: Dokumente 1955–1968* (Kassel: Georg Wenderoth Verlag, 1972).

42 Max Bill, "Einleitung zur Ausstellung," in *Konkrete Kunst: 50 Jahre Entwicklung* (1960), 8. My translation.

43 For insight into Bill's definition of concrete art, see *Konkrete Kunst* (1944) and the twelve issues of the journal *Abstrakt + Konkret: Bulletin der Galerie des Eauxvives*, Zürich, produced between October 1944 and October 1945.

44 Max Bill, "Vom Sinn der Begriffe in der neuen Kunst," in *Konkrete Kunst: 50 Jahre Entwicklung* (1960), 60. My translation.

45 Bill, "Einleitung zur Ausstellung," 8.

46 Ferreira Gullar, "Teoria do Não-Objeto," *Jornal do Brasil*, 21 November–20 December 1960, repr. in *Projeto Construtivo Brasileiro*, 94. My translation.

47 Neoconcrete Manifesto, repr. and trans. in *Geometric Abstraction*, 152. The manifesto was originally published in the Rio paper *Jornal do Brasil* on 22 March 1959. It and many other related articles and documents can also be found in *Projeto Construtivo Brasileiro* (see note 1).

48 Neoconcrete Manifesto, *Geometric Abstraction*, 152.

49 Gullar, "Arte neoconcreta: uma contribuição brasileira," *Revista Crítica de Arte* (Rio de Janeiro) no. 1 (1962), repr. in *Projeto Construtivo Brasileiro*, 118. My translation.

50 Neoconcrete Manifesto, *Geometric Abstraction*, 154–55.

51 Gullar, "Da Arte concreta à Arte neoconcreta," *Jornal do Brasil*, 18 July 1959, repr. in *Projeto Construtivo Brasileiro*, 112. My translation.

52 Gullar, "Teoria do Não-Objeto," *Projeto Construtivo Brasileiro*, 94. My translation.

53 Gullar, "Arte neoconcreta: uma experiência radical," in *Neoconcretismo/ 1959–1961: Ciclo de Exposições sobre Arte no Rio de Janeiro* (Rio de Janeiro: Galeria de arte BANERJ, 1984), n.p. My translation.

54 Gullar, "Teoria do Não-Objeto," *Projeto Construtivo Brasileiro*, 94. My translation.

55 Gullar, "Arte neoconcreta: uma contribuição brasileira" (1962), repr. in *Projeto Construtivo Brasileiro*, 94. My translation.

56 Lygia Clark, in *Signals Newsbulletin* 1, no. 7 (May–July 1965). Cited in Guy Brett, *Kinetic Art: The Language of Movement* (London and New York: Studio Vista and Reinhold, 1968), 61.

57 The three members of Group Zero were Heinz Mack, Otto Piene, and Günther Uecker, though Uecker did not officially become a member until 1961. An excellent source on the history of Zero is Anette Kuhn's *Zero: Eine Avantgarde der Sechziger Jahre* (Berlin: Propyläen Verlage, 1991). See also *Zero aus Deutschland 1957–1966. Und Heute*, exh. cat., ed. Renate Damsch-Wiehager (Ostfildern-Ruit, Germany: Hatje Cantz Verlag, 1999).

58 The three issues were *Zero* no. 1 (April 1958); *Zero* no. 2 (October 1958); *Zero* no. 3 (July 1961). A facsimile of all three was included in Heinz Mack and Otto Piene, *Zero*, trans. Howard Beckman (Cambridge: MIT Press, 1973).

59 Otto Piene, "The Development of the Group Zero," *Times Literary Supplement*, 3 September 1964: 812–13, repr. in Mack and Piene, *Zero*, xx.

60 Ibid.

61 Piene delivered the talk at the opening of a Lucio Fontana exhibition in January 1962 at the Museum Schloß Morsbroich in Leverkusen, Germany. Otto Piene, "Rede zur Eröffnung, 'Lucio Fontana,'" repr. in the exhibition catalogue *Zero aus Deutschland 1957–1966. Und Heute* (1999), 245–47. My translation.

62 Heinz Mack and Otto Piene, "Dynamo," *Nota* no. 4 (1960). Trans. in *Zero aus Deutschland*, 33. Subtitled "Student Magazine for Fine Arts and Literature," the journal *Nota* was founded in Munich by German artist Gerhard von Graevenitz and art historian Jürgen Morschel in 1959; they served as editors of the five issues that appeared between 1959 and 1960. A gallery of the same name opened in Munich in September 1960 and closed in 1961. It presented solo shows of Mack, Piene, Morellet, and Mavignier. In March 1959 the exhibition *Vision in Motion–Motion in Vision* opened at the Hessenhuis in Antwerp. A group of young Antwerp artists, G.58 (1958–62), took over the second floor of a port storehouse in 1958 and transformed it into an avant-garde space for art exhibitions, performances of experimental theater and music, film screenings, and debates. Among those with whom Mack and Piene shared exhibition space were Yves Klein, Jésus Raphael

Soto, Pol Bury, Daniel Spoerri, and Jean Tinguely.

63 Heinz Mack, "Die neue dynamische Struktur," *Zero* no. 1 (April 1958), repr. and trans. in Mack and Piene, *Zero*, 12, 14.

64 Manzoni and Castellani founded the Galleria Azimut in December 1959, and it closed in July 1960. The third exhibition, "La nuova concezione artistica," opened in January. *Azimuth* had two issues, one in December 1959 and the other, which served as a catalogue for *The New Artistic Conception*, in January 1960.

65 In the second issue of *Azimuth* the German art historian and then-curator at the Städtisches Museum Leverkusen, Schloß Morsbroich, Udo Kultermann published the article "A New Conception of Painting." At the same time, he was organizing an important exhibition of monochrome painting, *Monochrome Malerei* (18 March–8 May 1960), which was accompanied by a catalogue with artists' texts and an essay by Kultermann.

66 In the United States Robert Rauschenberg had a similar impact on young artists.

67 Otto Piene, "Über die Reinheit des Lichts," *Zero* no. 2 (October 1958), repr. and trans. in Mack and Piene, *Zero*, 47.

68 Otto Piene, "Darkness and Light," *Azimuth* no. 2 (1960): n.p.

69 The members of GRAV included the French artists François Morellet, Joël Stein, and Jean-Pierre Vasarely (Yvaral), the Argentine artists Julio Le Parc and Horacio García Rossi, and the Spanish artist Francisco Sobrino. It should be noted that Argentines Hugo Demarco and Hector García Miranda, Hungarians François and Vera Molnar, the French Servanes, and the Spanish Moyano signed the group's "Act of Foundation" in July 1960, but by December 1960 they had all left the group. (At the time of the document's writing the group went by CRAV, the Center for Visual Arts Research.) Heavily influenced by Victor Vasarely, they advocated visual exploration as a team and eschewed the terms "art" and "artist." Throughout their eight years together the group's primary objective was the transformation of the spectator from passive observer to active participant. Materials such as Plexiglas, nylon thread, artificial light, and motors helped them to create visually unstable compositions that encouraged the viewer to focus on the physiological experience generated by such works, not on the formal structure of the object. GRAV also called

attention to the context in which the viewer encounters the work of art by designing a series of labyrinths and playrooms. An excellent source on the group is the exhibition catalogue *Stratégies de Participation: Grav–Groupe de Recherche d'Art Visuel 1960/1968* (Grenoble: Centre d'Art Contemporain de Grenoble, 1998). The members of Gruppo N included Alberto Biasi, Manfredo Massironi, Edoardo Landi, Ennio Chiggio, and Toni Costa. They strongly believed that the concept of indeterminacy elaborated in science should be applied to art, and they were dedicated to the study of the psychology of perception. They sought a social, ethical, and political role for art, achieved in part through viewer participation and collective work, and manifest in their signing of works with the name of the group. They owed a strong debt in their early work to the neo-dada experiments of Manzoni, and they participated in the activities at Galleria Azimut. They also opened a studio in their native Padua, which became a center for avant-garde art, music, and poetry. For more on N, see Italo Mussa's *Il Gruppo Enne: La Situazione dei Gruppi in Europa degli Anni 60* (Rome: Bulzoni Editore, 1976), and the exhibition catalogues *Zero Italien: Azimut/Azimuth 1959/60 in Mailand. Und Heute.*, ed. Renate Damsch-Wiehager (Ostfildern, Germany: Cantz Verlag, 1996) and *Enne & Zero: N & 0: Motus, Etc.* (Vienna and Bozen/Bolzano: Folio Verlag, 1996). All of these groups, plus Zero, Exat 51 in Yugoslavia, Equipo 57 in Spain, and Nouvelle Tendance–recherche continuelle are discussed in detail in the author's unpublished doctoral dissertation, Valerie Lynn Hillings, "Experimental Artists' Groups in Europe, 1951–1968: Abstraction, Interaction and Internationalism" (Ph.D. diss., Institute of Fine Arts, New York University, 2002).

70 Matko Meštrović, letter to author, 5 July 2001.

71 This group consisted of six architects, Bernardo Bernardi, Zdravko Bregovac, Zvonimir Radić, Božidar Rašica, Vjenceslav Richter, and Vladimir Zarahovič, and three visual artists, Vlado Kristl, Ivan Picelj, and Aleksandar Srnec. For more on Exat 51 see the exhibition catalogue *Exat 51: 1951–1956*, trans. Janko Paravić (Zagreb: Galerija Nova, 1979).

72 Matko Meštrović, letter to author, 5 July 2001.

73 Radoslav Putar, untitled text, *Nove Tendencije*, exh. cat. (Zagreb: Galerija

Suvremene Umjetnosti, 1961): n.p. French translation from the original Serbo-Croatian by Branka Fabecic, provided to the author by Matko Meštrović. My translation from the French.

74 Putar, untitled text (1961), n.p. My translation.

75 Groupe de Recherche d'Art Visuel, "Nouvelle Tendance," in *Groupe de Recherche d'Art Visuel* (Paris: Galerie Denise René, 1962), n.p. My translations.

76 Ibid.

77 The list of excluded artists included: Marc Adrian, Marta Boto, Carlos Cruz-Diez, Piero Dorazio, Garcia Miranda, Rudolf Kämmer, Julije Knifer, Heinz Mack, Herbert Oehm, Henk Peeters, Otto Piene, Aleksander Srnec, Helje Sommerack, Miroslav Sutej, and Günther Uecker.

78 Nouvelle Tendance–recherche continuelle, "Bulletin No. 1" (August 1963): 3. Courtesy of Julio Le Parc and Ivan Picelj. My translation. The Hungarian Victor Vasarely, who greatly influenced the formation of GRAV, wrote that "The 'star' artist or the 'solitary genius' is out-of-date; groups of experimental workers collaborating with the aid of scientific and technical disciplines will be the only true creators of the future." Statement made in 1960 by Vasarely, cited in Stephen Bann, Reg Gadney, and Groupe de Recherche d'Art Visuel, "The Groupe de Recherche d'Art Visuel, Paris: Texts 1960–1965," trans. Stephen Bann and Reg Gadney, *Image* (Cambridge) 2, no. 6 (winter–spring 1966): 15.

79 Gruppo T was founded in 1959 by Giovanni Anceschi, Davide Boriani, Gianni Colombo, and Gabriele De Vecchi; Grazia Varisco became a member in 1960. They called their series of twelve exhibitions *Miroriorama*, a combination of Indian words meaning thousands and images; it was meant to denote the group's belief in the infinite possibilities of an art rooted in the interrelationship between time (hence the T) and space. Thus, like the members of Gruppo Enne and GRAV, Gruppo T artists supported an art based on instability. More than the others, this group dedicated itself to kinetic art, as they believed that movement provided a means of actualizing the concept of time. They had close relationships with the artists that gathered at Galleria Azimut as well as with Lucio Fontana, who in many respects served as an artistic father to the group.

80 Gianni Colombo, "Statement" (November 1965), in Peter Selz, *Directions*

in Kinetic Sculpture, exh. cat. (Berkeley: The University Art Museum, 1966), 32.

81 Matko Meštrović, untitled text, in *Nove Tendencije 2*, exh. cat. (Zagreb: Galerija suvremene umjetnosti, 1963), n.p. French translation from the original Serbo-Croatian by Branka Fabecic, provided to the author by Matko Meštrović. My translation from the French.

82 Giulio Carlo Argan, introductory essay in *Grupa N*, exh. cat. (Łódź: Muzeum Sztuki, 1967), n.p., trans. by Jeff Jennings in *Trent'anni Dopo: L'avanguardia Gestaltica degli Anni Sesanta*, exh. cat. (Bergamo: Baleri Italia Editore, 1993), 32.

83 In March 1965 the Scottish Committee of the Arts Council of Britain sponsored *Art and Movement: An International Exhibition*. The show *Licht und Bewegung = Lumière et Mouvement = Luce e Movimento = Light and Movement: Kinetische Kunst* appeared at four different venues over the course of a nine-month period: the Kunsthalle Bern (3 July–15 September 1965), Palais des Beaux Arts in Brussels (14 October–14 November 1965), Kunsthalle Baden-Baden (20 December 1965–January 1966) and the Kunstverein für die Rheinlande und Westfalen, Düsseldorf (2 February–13 March 1966). In May 1965 the Galerie Denise René sponsored the show *Art et Mouvement: Art Optique et Cinétique* at the Musée de Tel Aviv. In May 1967 the exhibition *Lumière et Mouvement* opened at the Musée d'Art Moderne de la Ville de Paris.

84 For more on this subject see Frank Popper, "Le Parc and the Group Problem," *Form* (Cambridge) no. 2 (September 1966): 5–9.

85 Alberto Biasi, quoted in Caroline Tisdall, "Kinetic Groups," *Studio International* 180, no. 926 (October 1970): 133.

86 George Rickey, *Constructivism: Origins and Evolution* (New York: Braziller, 1967). Rickey's archive, which contains his research materials for this book, is in the Museum of Modern Art Archives, New York. In 1944 Denise René opened her gallery, which is still today committed to geometric abstraction. For more on the exhibitions René organized see *Denise René Présente: Mes Années 50*, exh. cat. (Paris: Galerie Denise René, 1988). A very informative source on the history of this gallery and of René is Catherine Millet's *Conversations avec Denise René* (Paris: Éditions Adam Biro, 1991). René discussed her role in organizing *The Responsive Eye* in an interview with the author in Paris, 24 June 1998. The author

also referred to René's handwritten notes for the show in her gallery's archive in Paris, Klarform.

87 The letters from the artists are located in the Museum of Modern Art Archives, New York: *The Responsive Eye* (MoMA Exh. #757, February 25–April 25, 1965), Department of Painting and Sculpture exhibition files.

88 In 1964–65 the Howard Wise Gallery and the Contemporaries held a series of shows that introduced Europe-based kinetic artists, including Zero and GRAV, to a New York audience, but it cannot be said these artists were widely known in the U.S. prior to the MoMA exhibition. Among the shows were *On the Move*, a kinetic group show, and *Zero: Mack, Piene, Uecker* at Howard Wise in 1964. The Contemporaries held a second show of GRAV (the first was in 1962) at the same time as *The Responsive Eye*, in April 1965. In 1964 the recently founded Institute of Contemporary Art at the University of Pennsylvania sponsored a Zero show, which included an international roster of affiliated artists. Also significant was the show *Arte Programmata*, sponsored by the Italian company Olivetti, which the Smithsonian circulated in various U.S. venues in 1963.

89 Press release for MoMA exhibition *The Responsive Eye* (MoMA Exh. #757, February 25–April 25, 1965), The Museum of Modern Art Archives, New York: Department of Public Information Records, II.B.423.

90 Ibid.

91 Among the most important such articles are "Op Art: Pictures that Attack the Eye," *Time*, 23 October 1964: 78–86, and Warren R. Young, "Op Art," *Life*, 11 December 1964: 132–40.

92 Sidney Tillim, "What Happened to Geometry?," *Arts Magazine* 33, no. 9 (June 1959): 38. For a description of Tillim's career and positions on art, see "Katy Siegel on Sidney Tillim: Critical Realist," *Artforum* 42, no. 1 (September 2003): 208–11. The American Abstract Artists (AAA) formed in 1936 to promote abstract art in the U.S.; they held exhibitions in New York from 1936 to 1956; see *American Abstract Artists* (New York: RAM Press, 1946) and American Abstract Artists, ed., *The World of Abstract Art* (New York: George Wittenborn, 1957). The most active period for AAA was during the 1940s, when they benefited from the participation of European émigré artists including Joseph

Albers (1933), Naum Gabo (1947), Fritz Glarner (1936), László Moholy-Nagy (1937), and Piet Mondrian (1940).

93 *Construction and Geometry in Painting: From Malevitch to "Tomorrow"* (New York: Galerie Chalette, 1960). The show also traveled to the Contemporary Art Center, Cincinnati, The Arts Club of Chicago, and the Walker Art Center in Minneapolis. Hilton Kramer, "Constructing the Absolute: Reflections on the Exhibition 'Construction and Geometry in Painting,' at the Galerie Chalette in New York," *Arts Magazine* 34, no. 8 (May 1960): 39.

94 Among these shows were *Geometric Abstraction in America*, Whitney Museum of American Art (1962); *Toward a New Abstraction*, The Jewish Museum, New York (1963); *Post-Painterly Abstraction*, Los Angeles County Museum of Art (1964); and *Concrete Expressionism*, Loeb Student Center, New York University (1965). Also important in a historical sense was the 1960 show *Construction and Geometry in Painting*.

95 Ben Heller, "Introduction," *Toward a New Abstraction*, exh. cat. (New York: Jewish Museum, 1963), 8.

96 Ibid., 9.

97 Clement Greenberg, "Post-Painterly Abstraction," in *Post-Painterly Abstraction*, exh. cat. (Los Angeles: Los Angeles County Museum of Art, 1964), n.p.

98 Ibid.

99 Sidney Tillim, "Optical Art: Pending or Ending?" *Arts Magazine* 39, no. 4 (January 1965): 16. In 1955 Greenberg wrote the influential article "'American-Type' Painting" for *Partisan Review*.

100 Barbara Rose, "Beyond Vertigo: Optical Art at the Modern," *Artforum* 3, no. 7 (April 1965): 30–33; Rosalind Krauss, "Afterthoughts on Op," *Art International* 9, no. 5 (June 1965): 75–76. Nearly every American critic singled out Poons as one of the best artists in the show.

101 Rose, "Beyond Vertigo," 33.

102 Ibid., 30–31.

103 George Rickey, "Scandale de Succès," *Art International* 9, no. 4 (May 1965): 16, 17.

104 Millet, *Conversations avec Denise René*, 93. My translation.

105 Rickey, "Scandale de Succès," 16. Chief among these American artists producing optical art was Richard Anuszkiewicz, a former student of Josef Albers at Yale.

106 Thomas B. Hess, "You Can Hang It in the Hall," *ArtNews* 64, no. 2 (April 1965): 41–43, 49–50.

107 Hess, "You Can Hang It in the Hall," 49. The show had up to 6,300 visitors on the weekends—a record for MoMA up to that time. Pamela M. Lee, "Bridget Riley's Eye/Body Problem," *October* 98 (fall 2001): 30. Also, the local CBS affiliate's show *Eye on New York*, hosted by Mike Wallace, ran a half-hour special on the exhibition on 20 April 1965.

108 Clement Greenberg, "Recentness of Sculpture," in Maurice Tuchman, ed., *American Sculpture of the Sixties* (Los Angeles: Los Angeles County Museum of Art, 1967), 24–26.

109 Rickey, "Scandale de Succès," 23.

110 Irving Sandler criticized "cool art" in his essay in the exhibition catalogue *Concrete Expressionism* (New York: New York University Art Collection Committee, 1965). Barbara Rose coined the term "ABC art" in her article of that name published in *Art in America* 53, no. 5 (October–November 1965): 57–69. And the term "minimal art" came out of an article of that title by Richard Wollheim, published in *Arts Magazine* 39, no. 4 (January 1965): 26–32, which did not specifically address the work of the artists labeled minimalists but did set forth a definition that applied to aspects of their work.

111 Kynaston McShine, *Primary Structures*, exh. cat. (New York: Jewish Museum, 1966). Lawrence Alloway, *Systemic Painting*, exh. cat. (New York: The Solomon R. Guggenheim Museum, 1966).

112 For more on the interpersonal relationships among the minimalists see James Meyer's outstanding book *Minimalism: Art and Polemics in the Sixties* (New Haven and London: Yale University Press, 2001).

113 Clement Greenberg, interview conducted with Edward Lucie-Smith, *Studio International* (January 1968). Repr. in John O'Brian, ed., *Clement Greenberg: The Collected Essays and Criticism: Modernism with a Vengeance, 1957–1969* (Chicago: The University of Chicago Press, 1993), 281. James Meyer has pointed out that minimal art had its greatest commercial success among European collectors in the late 1960s and early 1970s; Meyer, *Minimalism*, 215.

114 Donald Judd, "Complaints I," *Studio International* 177, no. 910 (April 1969): 184.

115 Ibid., 183, 184.

116 Michael Fried, "Art and Objecthood," *Artforum* 5, no. 10 (June 1967): 12–23.

Most artists represented in *Beyond Geometry* were seeking a more interactive relationship with the viewer. One way to accomplish this was to move from painting, which had dominated modernism until the 1960s, to objects, defined by artist Donald Judd as a new category that was neither painting nor sculpture. Objects were "whole" forms that shunned the traditional balancing of one element against another, which now seemed an unacceptable compromise. Frank Stella's *Getty Tomb* qualifies as an object because of its minimal illusionism and chunky stretchers that impart a box-like physicality. Most objects, however, are more fully three-dimensional. Francesco Lo Savio's black relief seems to peel itself off the wall, the curve at its bottom underscoring its objectness. Made of parts (a grouping of yellow rectangles), Hélio Oiticica's *Nucleus 6* is not an object in Judd's terms. However, it can actually encircle the spectator. Robert Morris's large three-dimensional forms without pedestals also share the viewer's territory. Their physical presence encourages her to interact with them as a body in space, not just a pair of eyes and a mind.

Section 2
The Object
and
the Body

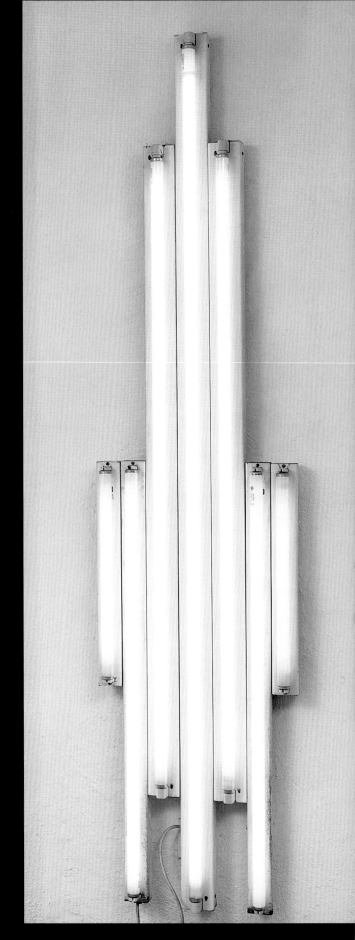

opposite page: Dan Flavin, *Monument for V. Tatlin*, 1969

Frank Stella, *Getty Tomb*, 1959

Bruce Nauman, *Walk with Contrapposto*, 1968

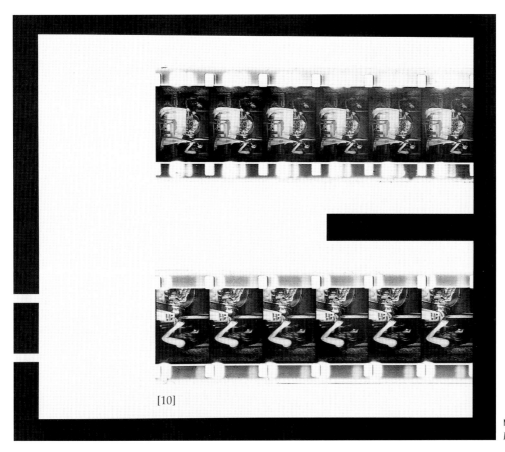

[10]

Maria Nordman, *EAT Film Room*, 1967

EAT

FILM ROOM 1967 - PRESENT
(1ST REALIZATION - LOS ANGELES 1/'67)

TIME & SITE OF FILMING
TWO PERSONS EATING A DINNER SEATED AT A TABLE WITH A WHITE CLOTH
TWO LIVE CAMERAS

ONE WITH A HELD FOCUS ON THE WHOLE SCENE (A)
ANOTHER BEING FOCUSED ON RANDOM DETAILS (I)

TIME & SITE OF PROJECTION: A WALL IS BUILT INTO THE ROOM: MAKING 3 CONJOINT ROOMS
2 PROJECTION ROOMS - - WITH THE FULL IMAGE PROJECTED ON THE GIVEN WALLS

2 SUBROOMS AS PROJECTION THEATERS
1 LARGER TOUCHING ROOM FOR THE ACTORS / OBSERVERS & FOR THE 2 PROJECTORS

THE TWO ORIGINAL ACTORS ARE THE FILM'S OBSERVERS

YET ANY OTHER TWO PERSONS COULD TAKE THEIR PLACES

TWO PROJECTORS WITH WIDE ANGLE LENSES ARE SET INTO THE ROOM

USING THE BACK WALL WITH THE TABLE AND WHITE CLOTH FOR
THE FULL IMAGE PROJECTION (A)
THE RANDOM IMAGE IS ON THE CONJUNCT WALL (I)
AND MAY OR MAY NOT BE SYNCHED WITH THE OTHER—

A FILMROOM WITH THE SOUNDS PRESENTLY MADE BY THE VIEWERS
& THE RUNNING PROJECTORS

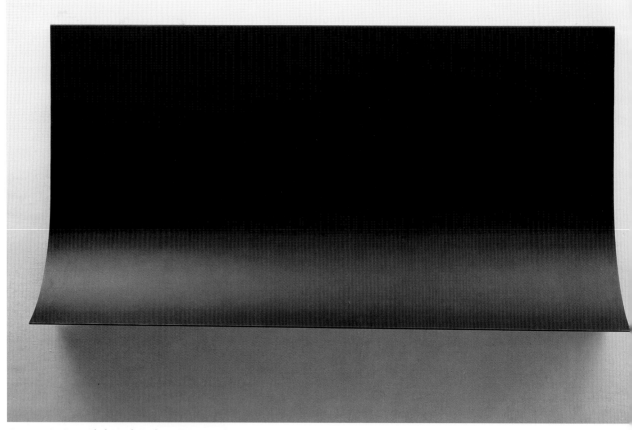

Francesco Lo Savio, *Black Metal, Uniform, Opaque*, 1961

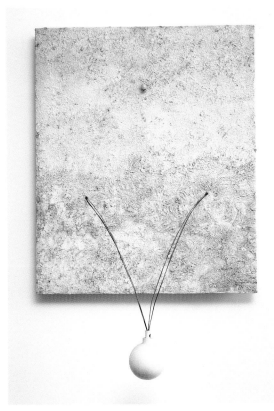

top:

Eva Hesse, *C-Clamp Blues*, 1965

Cildo Meireles, *The Southern Cross*, 1969–70

bottom: Robert Morris, *Floor Slab*, 1961

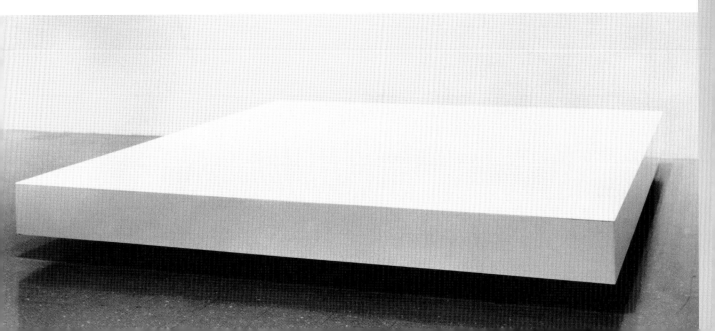

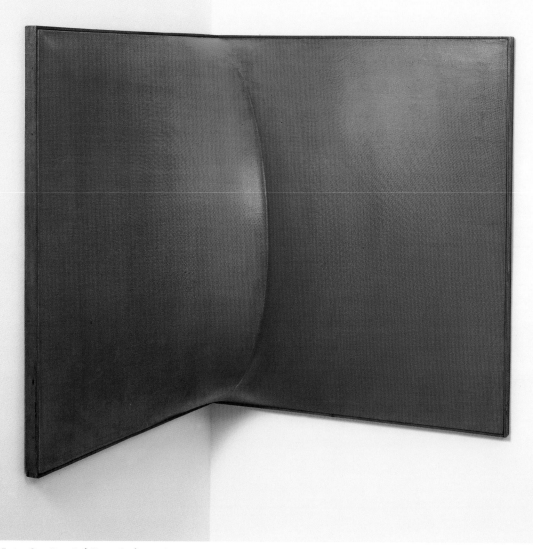

Enrico Castellani, *Red Corner Surface*, 1963

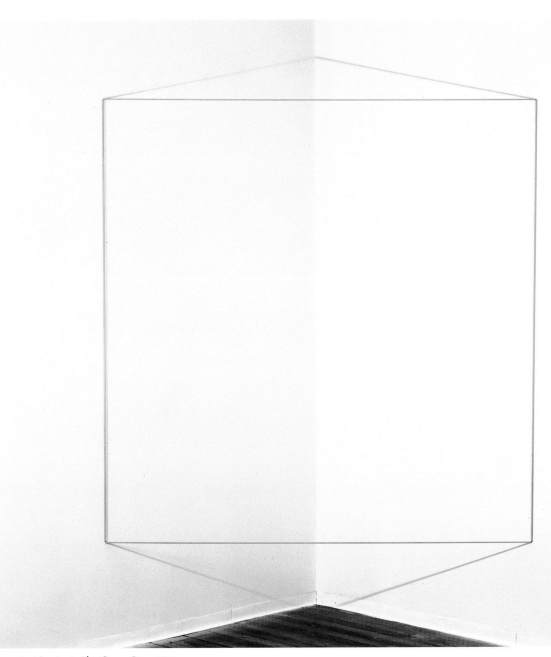

Fred Sandback, *Blue Corner Piece*, 1970

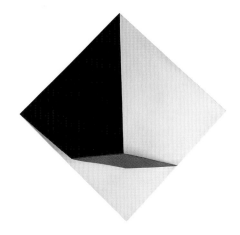

left:

Lygia Clark, *Cocoon*, 1959

Aluísio Carvão, *Color Cube*, 1960

right:

Franz Erhard Walther, *Projection Sculpture*, 1962–63

left:

Dadamaino, *Volume*, 1958

Tony Smith, *Black Box*, 1962

right:

John McCracken, *Don't Tell Me When to Stop*, 1966–67

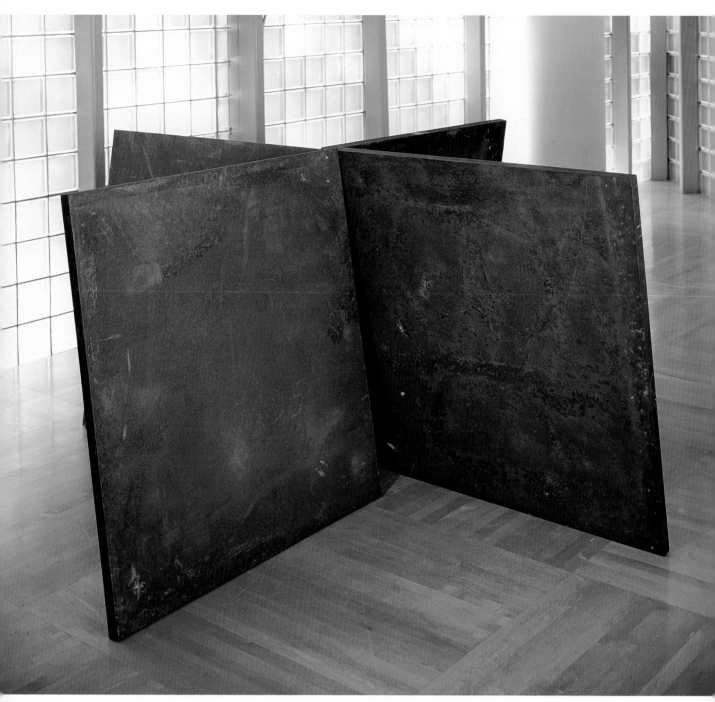

Richard Serra, *Inverted House of Cards*, 1969

opposite page: Joel Shapiro, *Untitled*, 1979

François Morellet, *Neon 0° 90°, Switching with 4 Interfering Rhythms*, 1965

art, research, experiment

Scientific Methods and Systematic Concepts

Miklós Peternák

When we bracket the artistic diversity of the middle third of the twentieth century, regardless of what we call the initial and ultimate stages—concrete to conceptual, kinetic to electronic, cybernetic to computer, "abstract" to "minimal" art—we must note certain features common to the time and the formation of these stances. This was a period in part permeated by a creative despair, where a loss of illusions could be the basis of creativity, and the dissolution of previous paradigms became the object of research. Structure was discovered in disorder, and tautology became a thesis ("art as art," the meaning of meaning); the zero point was seen as origin, creating as it were something out of nothing; instead of (self-) expression the categories of research, experiment, and invention were adopted. According to the Inventionist Manifesto, published in the first issue of *Arte Concreta* (Buenos Aires, 1946): "It is evident, then, that 'expression' can no longer dominate the spirit of current artistic composition, nor can a representation, or magic, or a sign. Its place has been taken by INVENTION, by pure creation." Or, in the words of the Madí Manifesto, written by Gyula Kosice, also in 1946: "Invention is an internal, superable 'method,' and creation is an unchangeable totality."[1]

Let us try to define what we mean by the terms "research" and "experiment," keeping in mind that they are employed in different ways within the discourses of science and art. "The essence of that which we call science today is research," stated Heidegger in his 1938 essay "The Age of the World Picture." He characterized research as advanced procedure and method, accompanying the opening up of a specific new territory and its exploration according to a strict methodology. This is succeeded by the process of clarification, the "interpretive shedding of light" upon the field, that is, investigation, the other important criterion of research: "In the physical sciences investigation takes place by means of experiment, always according to the kind of field of investigation and according to the type of explanation aimed at. But physical science does not first become research through experiment; rather, on the contrary, experiment first becomes possible where and only where the knowledge of nature has been transformed into research."[2] The philosopher Maurice Merleau-Ponty writes analogously about the work of the painter: "His quest is total even where it looks partial. Just when he has reached proficiency in some area, he finds that he has reopened another one where everything he said before must be said again in a different way. The upshot is that what he has found he does not yet have. It remains to be sought out; the discovery itself calls forth still further quests."[3]

installation view:

Lawrence Weiner

Red in Lieu of Green in Lieu of Blue, 1972

Red in Relation to Green in Relation to Blue, 1972

Red Over and Above Green Over and Above Blue, 1972

Red and Green and Blue More or Less, 1972

Green as Well as Blue as Well as Red, 1972

The artist's research by its very nature is irrefutable, for it results in the finished oeuvre. It is always total and final; but at the same time every discovery is a closure it is an opening of new paths as well: the movement of art in the twentieth century is such that reflection and acknowledgment of earlier works does not emerge as style but appears as a characteristic awareness that assumes the totality of preceding works as antecedents, and shapes its "statement" accordingly. Or, as Ad Reinhardt puts it: "The one subject of a hundred years of modern art is that awareness of art of itself, of art preoccupied with its own process and means, with its own identity and distinction, art concerned with its own unique statement, art conscious of its own evolution and history and destiny, toward its own freedom, its own dignity, its own essence, its own reason, its own morality and its own conscience."[4]

A notable feature of scientific research is the characteristic relation of theory to experiment, the relatively long time span between a theoretical hypothesis and its subsequent validation and utilization. For example, the existence of antiprotons could be verified only well after their theoretical prediction by Paul Dirac, when the suitable detection instruments were developed. Similarly, Dennis Gábor's discovery of the principle of holography remained a purely theoretical construct until the development of lasers allowed the requisite concentration of phased light. "As We May Think," the prescient essay by Vannevar Bush on the future of information technology, was published in the July 1945 issue of *Atlantic Monthly*. It has since provided inspiration for creators of information storage and retrieval philosophies and systems that are still being developed.

In the case of a work of art, if a connection between theory and practice can be created at all, the relationship seems to be the reverse—as if the experimental work, which is both proposal and end result, could somehow serve as the basis for some theory that may elaborate, interpret, or even complete it. When Josef Albers published *Interaction of Colors* in 1963 he included, in addition to the original Bauhaus course material, material based on his *Homage to the Square* series, underway since 1950. There are similar examples of art combined with theory in the oeuvre of almost any conceptual artist, such as, for example, Lawrence Weiner, who refers to his artworks as a series of empirical facts. His frequently cited 1968 statement—"1. The artist may construct the piece. 2. The piece may be fabricated. 3. The piece need not be built."—established the work of art as something hovering between possibility and object.[5]

Hanne Darboven, K: 15 x 15 – F: 15 x 15 (Organizer: 1), 1972–73 (detail)

Facing the unknown, the artist follows a strategy different from that of the scientist: generally the artist's discoveries occur not on the formal level, employing the rules of language or mathematics, but on the level of the sensations and the condition of proprioception, creating new rules that fit, instead of some relatively permanent coherent system, into the ever changing process that is art. The work of art stands in necessary contact with the unknown, whereas scientific discovery constantly annexes the unknown to the known. It was a novel phenomenon of art in the period under consideration that experimentation adopted elements of mathematical forms and proofs, geometric figures and systematic regularities.

"Presque rien"

"Everyone is tormented and anxious." Thus Klaus Mann characterized Europe in the years after World War II in his 1949 essay "The Trials of the European Spirit." After the devastating inauguration of the atomic age an entirely different note could be heard in Heidegger's question at the end of his 1929 lecture "What Is Metaphysics?": "Why are there beings at all, and why not rather nothing?"[6] as well as in the famous closing sentence of Wittgenstein's *Tractatus Logico-Philosophicus* (1921): "Whereof one cannot speak, thereof one must be silent."[7] This new condition was alluded to in 1949 by physicist and philosopher Carl Friedrich von Weizsäcker: "The dissolution of traditional concepts of space, time, matter and determinacy have evoked, in every person who takes these matters seriously, a feeling of being confronted by nothingness. I take this to be the characteristic experience of our age. Theoretical physics has long ago played out the drama that has since become apparent for everyone as a consequence of political catastrophes. And Nothingness is the explicit theme of Heidegger's philosophy."[8]

Here one could propose an analogy: just as physics investigated elemental particles, art occupied itself by identifying and exploring its own constituent elements. Views of galaxies, photographs made in cloud chambers, visual representations, respectively, of the nucleus of the atom and of the DNA helix—the scientific image inspires not so much by its visual appearance as by its intellectual content. Any superficial comparison of outward form would undoubtedly lead to misinterpretation. Nonetheless, by delving deeper we may discover structural or conceptual parallels linking shifts in the scientific world view and changes in the forms of art, for example the approaches stemming from biologism and the holistic tendencies of gestalt psychology (exemplified by the Aspects of Form symposium accompanying a 1951 London ICA exhibition, or *The New Landscape in Art and Science* of 1956, edited by Gyorgy Kepes).

The White Manifesto, proclaimed by Lucio Fontana and his students in Buenos Aires in 1946, contains a call characteristically addressed to scientists, demanding new discoveries that bear significance for artists, and includes the following sentence: "The discovery of new physical forces and the control of matter and space will gradually impose new conditions that have not been previously known to man . . . Painted canvas and standing plaster figures no longer have any reason to exist."[9]

The artistic criteria reflecting these interests are: mobility, change, synthesis, a clean slate, a new and elemental attribution of meaning, a recontextualization, a "cleansing," of the categories of space,

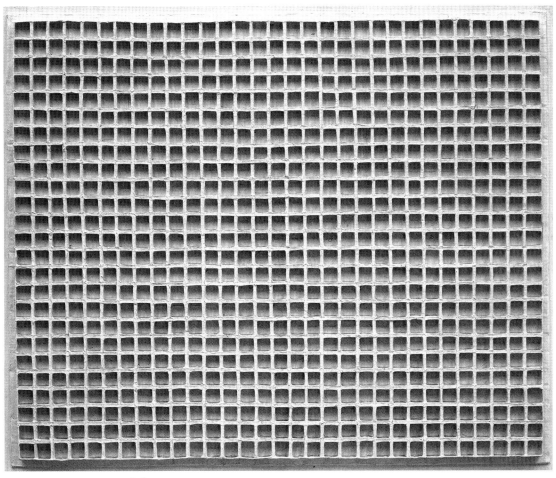

Jan Schoonhoven, *Big Square Relief*, 1964

light, motion, and temporality—all in all, the attempt to mark the zero point of a new origin. This process is signaled by the formation of the group Movimento Arte Concreta in Milan (1948), by Espace in Paris (1951), Exat 51 in Zagreb, Gutai in Japan (1954), Equipo 57 in Spain, the group Zero in Düsseldorf (1958), and the rise of Nul in Holland (1961). The experiments undertaken by these groups share a disengagement from artistic forms describable in a dramaturgical literary manner.

Such works are often organized on the basis of light, motion, and vision, are process-oriented, unfolding in space and time ("Vision in Motion," as proclaimed by Moholy-Nagy's posthumous volume, published in 1946), or else they share a tendency toward a reductionism emphasizing (homogenous) color, (geometric) form, and (optical) patterning. These are the unifying factors underlying Max Bill's series *15 Variations on a Single Theme*, Albers's color squares, the machines of Jean Tinguely or Nicolas Schöffer, the light/projection compositions by Otto Piene, the images by Jesús Rafael Soto and François Morellet based, respectively, on interference patterns or random numbers. A more extreme result of thinking through these issues would be to aim at a practical zero point, a special form of nothingness, such as John Cage's "silent" composition *4' 33"*, Lucio Fontana's punctures and slashes through empty canvas, or Yves Klein's 1958 exhibition *The Void* at the Iris Clert Gallery in Paris, where there was only a single, empty display cabinet painted white, standing in the empty gallery space that was also painted white. The shift in art, in the wake of equivalent changes in philosophy, physics, and history, toward an aesthetic of the zero point, was glossed by philosopher Hannes Böhringer in a Budapest lecture: "This 'almost nothing' is often referred to as that certain 'je ne sais quoi' (literally, 'I know not what'), in other words that 'certain something'—'whatever.' This concept originates in the rhetorics of antiquity and is a translation of the Latin 'ne scio quit' (something I know not). As for this 'ne scio quit,' we may take it to be a pithy Socratic formulation, designating an acknowledged ignorance . . . 'Presque rien' is a concept that serves to indicate something that is conceptually nearly inconceivable. We may trace it further in Mies van der Rohe's famous slogan, 'less is more,' as well as in the minimalism of minimal art. This, one might say, is the aesthetics of the blank white space, where you can install whatever you want, any trifle whatsoever, which is then seen as beautiful. This 'presque rien' may exist in the charm of a sketch, a rapid, unfinished, improvised drawing, as opposed to one that is elaborate and finished. This 'presque rien,' this 'je ne sais quoi' constitutes a remarkably paradoxical category, being the concept of that which is non-conceptualizable."[10]

Naturally this is not exactly the way artists and theoreticians, writers and filmmakers worded the matter in the 1950s and 1960s, and most probably the differences between individual approaches were much more apparent at the time,[11] even in some cases that, by now, impress us with their similarities. These zero-locations, concrete nothings, have rightfully fallen into the categories of artistic expansion (or its alternate face, reductivism) as manifestations of the "aesthetics of silence," playing simultaneously scornful and revelatory roles as "texts for nothing,"[12] sometimes to the point of potentially forcing upon the audience or critic an alleged or actual boredom. When a work of art creates space this way within the recipient[13] it simultaneously redefines its sphere of jurisdiction, which is in itself an experimental situation where the previous, fully developed receptive habits or theoretical-interpretive categories no longer apply, or in

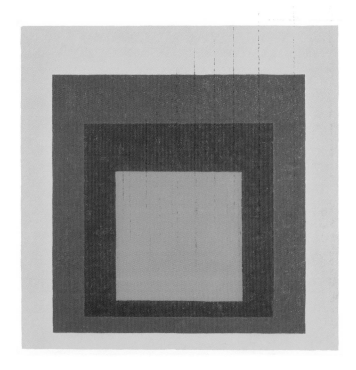

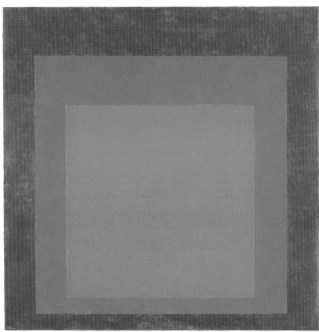

Josef Albers, *Homage to the Square*, 1951–55

Josef Albers, *Homage to the Square: Dissolving/Vanishing*, 1951

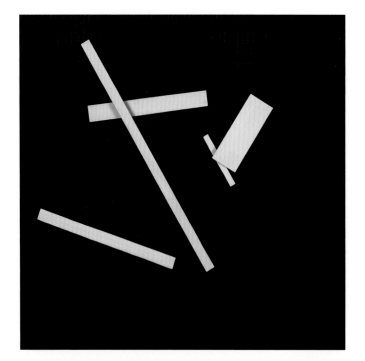

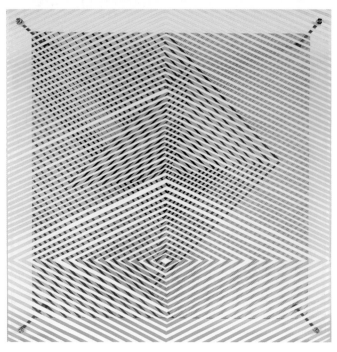

Jean Tinguely, *Machine Picture Haus Lange*, 1960

Jesús Rafael Soto, *Kinetic Structure with Geometric Elements*, 1955

opposite page: Otto Piene, *Light Ballet*, 1967–69

Lucio Fontana, *Spatial Concept—Waiting (59 T 104)*, 1959

fact yield negative results. (Let me point out here as a curiosity the fact that, during the existence of the two opposing world systems, especially during the Cold War period, socialist realist aesthetics applied with a noble simplicity the comprehensive blanket term "nihilism" to cover the newest developments of "Western" art.)

In the 1952 Television Manifesto by Lucio Fontana and others we find the following: "Our artistic expressions multiply the lines of the horizon to the infinite and in infinite dimensions. They are a research for an aesthetic in which a painting is no longer painted, a sculpture no longer sculpted, and in which the written page leaves behind its typographical form."[14] This document of spatialism—a movement Fontana founded in 1948 with his Manifesto Spazialismo—is especially significant inasmuch as it proposes, in connection with a new telecommunication device, the notion of creating dematerialized works, or, more accurately, the idea of works created conceptually, independent of materials.

In 1965 Roman Opalka began his series of number paintings (*OPALKA 1965/1–∞*) and in this continuing work he effaces the boundaries between painting and writing, daily work and meditation, documentation and creative endeavor. We may say about this heroic project, which will be completed only at the artist's death, that it depicts nothing, much in the same way as On Kawara's Today series of date paintings, a sequence of monochromatic

Roman Opalka:

OPALKA 1965/1–∞ (detail 3578634–3595782), 1965–?

OPALKA 1965/1–∞ (detail 1006398), 1965–?

OPALKA 1965/1–∞ (detail 5163823), 1965–?

On Kawara, *7 Fev. 1969* (from Today series), 1969

images, each bearing the date of its creation, depicts nothing. However, we may also say that Opalka has reached the maximal concreteness possible within the limits of art.

How can the aims and directions of this sort of artistic research be defined? If the goal of art has been the expansion of consciousness, then what do we make of its choosing such a seemingly narrow area of competence? When an artist preempts the act of painting the date, then this field is no longer free; there is no need for any further exploration by another. The result is the evidential nature of the given oeuvre or form. In carrying out such systematic researches, artists adopt the mantle of scientists.

Minimal and conceptual art, the intellectual and artistic innovations of the 1960s, in part parallel, in part interpenetrating, achieved a characteristic conquest of new territory on behalf of art and the designation of a new mental region on the intellectual relief map of cognition. In part this was the result of an unprecedented focus on the transmitting medium, the tool, which came to occupy the center of attention; consequently the first attempts at categorizing the new artistic forms were reflexive acknowledgments employing media/materials/technology–determined expressions (such as land art, earthwork, body art, video art, idea art, etc.). The proliferation of genres that undertook the analysis of the unmistakably unique characteristics of a given medium, that as it were constructed closed-circuit feedback loops, can be attributed to an understanding of the altered role of the medium.

Cybernetics and Informatics

Alongside the proliferation of artistic forms, terminologies, and means of expression, we can discern similar phenomena occurring in the sciences. Paralleling the reflexive concretizing of artistic processes and mediums are analogous developments, such as the issues raised by the critical philosophy of science, the theories of Thomas Kuhn regarding the structure of scientific revolutions and paradigm shifts, Michel Foucault's archaeologies of knowledge, and Paul Feyerabend's anarchist epistemology, delineated by the title of his best-known book, *Against Method*. There are numerous concrete instances of collaborations between the arts and new scientific disciplines arising in the period under discussion, such as computer science and its far-reaching consequences, cybernetics, systems theory, communication and information theory.

Kuhn, in his monograph *The Structure of Scientific Revolutions* (first published in 1962 and reissued with a new afterword in 1970), designates two phases in the development of science. "Normal" science occurs when, on the foundations of an accepted body of data and a coherent world view, scientific research proceeds without any anomalies or radical theoretical innovations. When a sufficient number of new facts are established that do not fit into the given framework, scientists begin to question the accepted world view, and a decisive paradigm change results, which defines a particular phase of scientific revolution.

In the postscript to the second edition, written in 1969, Kuhn notes that his concept of paradigm shift in the natural sciences was drawn from the similar analytic-descriptive methods employed in the

writing of literary and art history. He highlights the idea of "a paradigm as a concrete achievement," and goes on to suggest "that some of the notorious difficulties surrounding the notion of style in the arts may vanish if paintings can be seen to be modeled on one another rather than produced in conformity to some abstracted canons of style."[15] It is thus both easy and meaningful to draw a parallel between Kuhn's discussion of the processes of science and the radical changes in the art of the 1960s.

Claude E. Shannon's groundbreaking essay "A Mathematical Theory of Communication" and Norbert Wiener's monograph inaugurating the new science of cybernetics (which he defined as "control and communication in the animal and machine") both appeared in 1948.[16] The latter half of the 1940s was also the era of the development of the first computers. Whereas Shannon's work was significant primarily for its practical value to specialists, the works of Wiener exerted an influence in cultural circles outside of science, including the arts, where "cybernetics" was a popular scientific buzzword from the time of its introduction through the late 1960s.

The first simple robots—cybernetic machines—appeared in the late 1940s and early 1950s. These contraptions, functioning as models for the execution of some simple task (the Szeged "ladybug," for example, "knew" to keep moving toward a light source until the stimulus became too intense, whereupon it would turn away), were not experimental in the traditional sense, nor were they "utilitarian" machines or toys: instead, theory had become embodied in functional mechanisms.

An analogous development in art, beginning in the 1950s, was the series of kinetic works based on the concepts of space, motion, and light.[17] (Their direct intellectual successors, from the 1960s on, were the increasing number of projects emerging from artist-engineer collaborations.) The categories of motion, light, and space provided the interpretive contexts for works by Jesús Rafael Soto, Lygia Clark, Gyula Kosice, and Julio Le Parc, as well as European artists' collectives. The authors of these works, collective or individual, interpret them as systematic research projects. This is illustrated by the activity of the GRAV (Groupe de Recherche de l'Art Visuel) group, formed in Paris by French and South American artists, whose first public appearance took place at the 1961 Nove Tendencije exhibition in Zagreb. According to their manifesto Image—Motion—Time, instead of art they preferred to speak of "visual experience," the creation of new cognitive situations, and the employment of such means as combinatorials, probability, and statistics.

Contemporaneously with the birth of GRAV, Gyorgy Kepes proposed the establishment of a research group based on the collaboration of scientists and artists at MIT. His concept—the creation of contacts among the visual arts, natural sciences, and various technological fields—eventually led to the establishment of CAVS (Center for Advanced Visual Studies) in 1967.[18] In 1968 Frank J. Malina founded the periodical *Leonardo* in Paris, with the express agenda of strengthening the contacts between the arts and sciences. In the same year the exhibition *Cybernetic Serendipity—The Computer and the Arts* was organized by Jasia Reichardt at the ICA in London. This large-scale show constitutes today a unique point of reference for how much could be foreseen regarding the potential contact of computer and art at a time when this was not evident at all.

François Morellet, *Random Distribution of 40,000 Squares Using the Odd and Even Numbers of a Telephone Directory*, 1960 Oil on canvas; 39 ³/₈ x 39 ³/₈ in. (100 x 100 cm) Collection of the artist

Dr. Béla Julesz, *Basic Random-Dot Stereogram*, 1960 Courtesy of the artist

Let us now compare two pictures created contemporaneously in 1960, offering similar images, but made with fundamentally different aims, one scientific, the other artistic. François Morellet's painting *Random Distribution of 40,000 Squares Using the Odd and Even Numbers of a Telephone Directory* shows a chaotic pattern similar to the RDS (Random-Dot Stereogram) pictures of Béla Julesz that contain sets of dots randomly generated by computers at Bell Laboratories in the early 1960s. The latter are accidental masses of dots prepared for two different kinds of viewing: if we direct our gaze at the picture plane in the usual manner, we see random disarray, whereas if we focus, as if squinting, behind the picture plane, the two sets of dots, mentally superimposed, reveal a hidden, three-dimensional figure floating in space.

Julesz's scientific discovery opened up new paths in the investigation of vision, for in these pictures the "conscious" gaze, looking at the pattern in the customary manner, is unable to evoke the stereoscopic effect. Morellet's painting and Julesz's pictures differ from each other not only by virtue of their labels, or the manner and aim of their making; they differ in the directions of their experimentation. For both are experimental works: the first in the field of art and aesthetics, the second in sensory psychology. The apparent similarities between the two pictures offer no help in their interpretation, or in comprehending their function. Although we may consider both to be "aesthetic," even equally pleasurable to view, still, to understand them we need the title in one case, and instructions for use in the other. We have juxta- posed a painting containing a direct artistic statement and a picture containing an indirect scientific state- ment. The scientifically decipherable "meaning" of the latter can be experienced only after a conscious alteration in our manner of perception, in other words, we must view the image in a special manner, not as a work of art. The artist's painting does not have two different ways of viewing in this sense—but are we prepared to say that it makes no sense to view the scientific picture simply as artwork, on the level of primary information (especially if we encounter the pictures in an exhibition hall)? As Julesz himself

Bridget Riley, *Polarity*, 1964

commented: "In June 1965 I took part in the very first 'computer art' exhibit (with another engineer colleague from Bell Labs, Mike Noll) in the Howard Wise Gallery in New York. Although there was a disclaimer below my computer-generated stereograms that these were merely the results of scientific experiments, and that their creator did not regard them as pieces of art, the newspapers disregarded it. I have many clippings with headlines such as 'Cold computer art!' and 'Computers take over arts!'"[19]

Thus it is not in the superficial similarity of the two images that we should look for the meaning or "lesson" to be learned. In Morellet's painting the artist is concerned with a systematic method of image making; he consistently employs this method and is interested in its results, the painting that is being created. In Julesz's experiment on the other hand, the author "knows" the results in advance, and in practice any image will do, as long as it produces the illusion. Such an image may still be considered beautiful, but it is by no means singular, in the sense of the foregoing. While the work of art helps us to understand, see, and appreciate the scientific work, as it were legitimizing its usefulness, the scientific image helps to clarify the process of visual perception—something that may influence our interpretation of the work of visual art. It is this, and not their superficial similarities, that constitutes their true relationship.

The 1960s were a period of readjustment in the conventional ways of seeing, when certain long-accepted, seemingly final views faded and new perspectives appeared. A way of thinking became discernible that considered the visual arts especially instructive.[20] The concept of "illusion" was paramount, while the "creative eye" was replaced by "the intelligent eye": Richard Gregory's monograph of that name made it clear that the eye is part of the brain. The concept of op art, the generic term that emerged following *The Responsive Eye* exhibition in New York in 1965, allowed the perhaps unfounded grouping of all works employing regular patterns, interference effects, high contrast, dimensional figures, mirror images, and various other mathematical and geometric procedures. Optical illusions that had long been familiar from psychological and sensory research—the Necker cube, the Müller-Lyer illusion, the Rubin goblet, the Benham disc, the Poggendorf illusion—were now joined by works of optical art. Gregory commented in his book on works by Bridget Riley and Victor Vasarely, noting that physiological explanations—or lack thereof—do not diminish the aesthetic merits of the paintings. The denigration of *The Responsive Eye* by critics, however, underscored fundamental differences in aesthetic approach.

If there were no difference between the world of vision constructed by the brain and the pictures created by means of our various instruments, then there would never be any changes in pictorial conventions, in the forms of depiction. We see what we know, or rather, that which we know, we see as such. The structure superimposed on the reality of the seen image is a hypothesis, an attempt at a description, no matter if the "realistic" figure emerges on a superfine network of pixels in a digital image, or if we see a pattern (as in Morellet and Julesz, or Riley and Vasarely) that we cannot identify with any other direct visual experience.

"Let us imagine a white surface with irregular black spots," Wittgenstein writes. "We now say: Whatever kind of picture these make I can always get as near as I like to its description, if I cover the surface with a sufficiently fine square network and now say of every square that it is white or black. In this

way I shall have brought the description of the surface to a unified form. This form is arbitrary, because I could have applied with equal success a net with a triangular or hexagonal mesh."[21] Wittgenstein uses this as an example of the world picture implied by Newtonian mechanics. However, in the case of the new types of imaging made possible by the technology of the second half of the twentieth century, such as the stereogram, or better yet the hologram, the picture surface is indecipherable until we observe it in the right way, or with the right equipment. Works of art cannot be deciphered by such technical means.[22]

Idea, Concept, Meaning

More than one observer has pointed out that the new types of artworks from the mid-twentieth century are characterized by a peculiar semiotic openness, that they are process-oriented in nature (process art, serial art, systematic art), and that a special need for dialogue, a call for interaction, or for execution and even completion by the viewer, are frequent ingredients of the work.

In "The Serial Attitude" Mel Bochner not only marshals historical precedents (as is customary in scientific discourse) for a demonstration of the new medium and method he is describing, but he also undertakes the task of categorizing and the laying down of definitions; he finds the historical precedent for this new method in the discovery and systematic use of perspective. Seen from this point of view, the works of art may be analyzed as thoughts made visible, or as representations of ideas and theories. For instance, he describes a work by Sol LeWitt as follows: "The complexity and visual intricacy of this work seems almost a direct refutation of Whitehead's dictum that the higher the degree of abstraction the lower the degree of complexity."[23] Of course it is easy to find examples of interpretations differing from this, even regarding the very same work, and by its creator, no less: "This kind of art is not theoretical or illustrative of theories . . . Different people will understand the same thing in a different way."[24]

Umberto Eco's concept of the "open work" is the most suitable term for analyzing this phenomenon. In his volume *The Open Work*, in the section titled "Informal Art as an Epistemological Metaphor" Eco calls our attention to the fact that in a situation where there cannot exist a unified and closed, coherent (world)view of phenomena, art proposes an alternative way of viewing the world, in this case not merely by providing an image, but by completely becoming one with the discontinuity. Art's mediating role is thus destined to be not so much the description of phenomena as, on the one hand, the offering of phenomena, and, on the other hand, investigating the mediation, the medium itself: "The open work assumes the task of giving us an image of discontinuity. It does not narrate it; it *is* it."[25]

In 1965 Donald Judd wrote: "Half or more of the best new work in the last few years has been neither painting nor sculpture. Usually it has been related, closely or distantly, to one or the other. The work is diverse, and much in it that is not in painting and sculpture is also diverse. But there are some things that occur nearly in common."[26] Judd notes as a new phenomenon the transformation of the boundaries of known media, and goads us to investigate what is the shared feature, without relying on the traditional categories of art media. Given these points of view, what is considered to be a medium?

Here it is the material and the manner of the work's creation (including everything: the means, the technology, the idea, and possible prototypes) that all together combine to provide the prevailing meaning. The term "intermedia" refers to the territory in between the existing, known, fully developed modes of formative activity; as the introduction of an intermediary ground, it is thereby an extension of the concept of art. From this point it is only a short distance to the concept as medium, which may in part explain why a new international art movement, eventually to be called conceptual art, could arise independently in so many different parts of the world in the mid-1960s.[27]

According to Sol LeWitt, "In conceptual art the idea of concept is the most important aspect of the work" ("Paragraphs on Conceptual Art," 1967). In another frequently cited writing ("Sentences on Conceptual Art," 1969) he makes a clear distinction between "idea" and "concept." When Hilton Kramer wrote the aphorism "the more minimal the art, the more maximum the explanation"[28] in June 1966, even he would probably not have imagined that the relationship of art to theory would become even more extreme, to the point where the work of art seems to disappear inside language. "Faulty language can only lead to mistakes," wrote Miklós Erdély, perhaps the most significant artist of the Hungarian avant-garde, who performed numerous conceptual actions as responses to discoveries in the natural sciences during the late 1960s. The search for a new language, and the linguistic formation of the communication as a concern in visual art (beyond the poetic-literary points of reference), has found a model in the aesthetics of scientific, algorithmic wording.

In an era that saw the genesis of new forms of "language" for machine instruction (FORTRAN: FORmula TRANslation, 1955; ALGOL: ALGOrithmic Language, 1958) and of explorations in structural linguistics and the philosophical critique of language, we find many artists expressing such concerns. Robert Smithson, in his text "A Museum of Language in the Vicinity of Art," characterized the situation by paraphrasing Blaise Pascal: "Language becomes an infinite museum, whose center is everywhere and whose limits are nowhere." It is obvious that the algorithmic structure of early computer languages, as well as the axiomatic forms of philosophical, logical, and scientific communications, have formal relationships to the scripts for conceptual events and other written artistic statements. An essential element of the proposals and sets of instructions for conceptual works is that the presence of the artist making the proposal is not needed for their execution, which in fact may be accomplished by anyone.

thing [θiη] n. Chose *f.*; objet *m.*; *the big things in the room,* les gros objets de la pièce. ‖ Pl. Vêtements, habits *m. pl.*; affaires *f. pl.* (clothes). ‖ Pl. Outils, ustensiles *m. pl.* (implements); *tea things,* service à thé. ‖ JUR. Pl. Biens *m. pl.*; *things personal,* biens mobiliers. ‖ COMM. *It's not the thing,* ça ne se fait pas, c'est passé de mode; *the latest thing in hats,* chapeau dernier cri. ‖ FIG. Chose *f.*; *as things are,* dans l'état actuel des choses; *for one thing,* tout d'abord, et d'une; *for another thing,* d'autre part, et de deux; *it's just one of those things,* ce sont des choses qui·arrivent; *it would be a good thing to,* il serait bon de; *not a thing has been overlooked,* pas un détail n'a été négligé; *the thing is to succeed,* la grande affaire (or) le tout c'est de réussir; *that's the very thing,* c'est juste ce qu'il faut; *to expect great things of,* attendre monts et merveilles de; *to make a good thing out of,* tirer profit de. ‖ FAM. Etre *m.* (person); *poor little thing,* pauvre petite créature. ‖ FAM. Truc, machin *m.* (thingumabob). ‖ FAM. *How are things?,* alors comment ça va?; *not to feel quite the thing,* se sentir patraque; *to know a thing or two,* connaître le bout de gras, être à la coule.

Joseph Kosuth, *Definition ("Thing"),* 1968

It is only natural that in situations such as these the role of the observer becomes greatly upgraded. An unforeseen trap of the open work at its most extreme, where it turns into pure idea, may be that we either understand it without thinking of it as art, or else we consider it to be art, but wonder where the artwork has gone. The problem was first articulated in 1607 by Federico Zuccari, who "proceeds from the premise that that which is to be revealed in a work of art must first be present in the mind of the artist. This mental notion Zuccari designates as *disegno interno*, or *idea* . . . The actual artistic representation . . . he designates as *disegno esterno*."[29] Conceptual art, as it were, places the *disegno interno* on a pedestal, taking the inner vision, idea, and ideal to be the work's essence, even to the point of dispensing with the actual execution. (It is worthwhile to note that in the case of minimal art the tendency of representation, of "design" in general, is toward *disegno esterno*.) Regarding this we may add that minimal art is the concept seen from another viewpoint; it is as if idea and form were seemingly separated in the reciprocity of conceptual and minimal art, so that the same abstract ideal is approached in the latter case from the direction of form, and in the former from the direction of the idea. Lucy Lippard, looking back on the heyday of conceptual art, has commented, "For me, [it] offered a bridge between the verbal and the visual."[30]

It is surprising to see that, even as artists consistently attempt to create works that are factual statements independent of any ideology or system of thought or worldview, the arts still end up as a heap of theorems, in part because of critical interpretation, and in part because the works themselves, as it were, go beyond a certain characteristic point of inflection. Here I refer not only to those works that take writing as their form.

Let us compare Dennis Oppenheim's *Reading Position for Second-Degree Burn* and Michael Heizer's *Double Negative*, two giant rectangular cuts (and the space between) in the edge of a desert mesa. It is easy to understand how similar their structures are, in spite of all outward appearances (material, technique, dimensions). The viewer is required to create the notion of time elapsed between two states (posited as the initial and final stages of a process) and observe both passing into his or her own actual present. As the intentionally created trace of physical transformations, an undefinable interval appears, which the work now occupies as if it were its own "eternity." Juxtaposed, these two kinds of intervals, that of the work and that of any given viewer's own time, create another interval, the space of all possible interpretations. The skin exposed to light, the rock exposed to weather, the work exposed to the viewer visualize the physical and metaphysical dimensions of cognition, the inseparable reciprocity of "intellectual" and "material" being. The work does not demand interpretations; it finds them.

The question remains, why is the quality of these two works evident for me—instantly, unequivocally, and without a shadow of doubt? Furthermore, why am I able to accept someone else's similarly self-evident experience of another work? Here we cannot avoid our subjective reaction, for it is the reciprocal response to the special research methodology of art, which is specifically an inquiry into how contact is made by the work and its viewer with the unknown. And the answer is: precisely this way, by making this condition palpable and lasting, by insisting on the possibility of such contact.

READING POSITION FOR SECOND DEGREE BURN.
Stage I, Stage II. Book, skin, solar energy.
Exposure time: 5 hours. Jones Beach, 1970.

Dennis Oppenheim, *Reading Position for Second-Degree Burn*, 1970

Art upholds and strengthens the validity of personal knowledge of the unknown. This revelatory aspect of cognition is absent from everyday life. Science has confined itself to the gathering of information, its study and acceptance, and the comprehension of its results has — rightfully — excluded direct experience, or else presents it as an exception. Science has forfeited the condition of providing occasion for the sensory insight that constitutes private knowledge, beyond the academy — whereas art has proved capable of taking on that role, even as it adopts scientific terms and systematic concepts.

Translated from the Hungarian by John Bátki

notes

Three books were indispensable throughout the writing of this essay: Gerhard Leistner and Johanna Brade, *Kunst als Konzept: Konkrete und geometrische Tendenzen seit 1960 im Werk deutscher Künstler aus Ost- und Südeuropa* (Regensburg: Museum Ostdeutsche Galerie, 1996); James Meyer, *Minimalism* (London and New York: Phaidon, 2000); and Peter Osborn, *Conceptual Art* (London and New York: Phaidon, 2002).

1 The manifestos may be seen in their original languages and in English translation at: http://coleccioncisneros.org/st_writ.asp

2 Martin Heidegger, "The Age of the World Picture," in *The Question Concerning Technology and Other Essays*, trans. William Lovitt (New York: Harper and Row, 1977), 121.

3 Maurice Merleau-Ponty, *L'oeil et l'esprit* (1960) (Paris: Gallimard, 1964), trans. in *The Merleau-Ponty Aesthetics Reader: Philosophy and Painting*, eds. Galen A. Johnson and Michael B. Smith (Evanston, IL: Northwestern University Press, 1994).

4 Ad Reinhardt, "Art-as-Art," *Art International* (Lugano), December 1962; repr. in *Art-as-Art: The Selected Writings of Ad Reinhardt*, ed. Barbara Rose (1975; Berkeley and Los Angeles: University of California Press, 1991), 53.

5 Lawrence Weiner, text cited in Lucy R. Lippard, *Six Years: The Dematerialization of the Art Object from 1966 to 1972* (1973; Berkeley and Los Angeles: University of California Press, 1997), 73.

6 Martin Heidegger, "What Is Metaphysics?" Text "based on a translation by David Farrell Krell," posted by Tom Bridges at: http://www.msu.org/e&r/content_e&r/texts/heidegger/heidegger_wm2.html

7 Ludwig Wittgenstein, *Tractatus Logico-Philosophicus* (London: Routledge and Kegan Paul, 1921), § 7.

8 C. F. Weizsäcker, "Beziehungen der theoretischen Physik zum Denken Heideggers" (1949), in Weizsäcker, *Zum Weltbild der Physik* (Stuttgart: S. Hirzel Verlag, 1970), 243–45.

9 "Manifesto blanco," trans. Guido Ballo, in Ballo, *Lucio Fontana* (New York: Praeger, 1971), 185–89; repr. in Kristine Stiles and Peter Selz, eds., *Theories and Documents of Contemporary Art* (Berkeley and Los Angeles: University of California Press, 1996), 48.

10 Hannes Böhringer, "Almost Nothing," lecture at the Hungarian Academy of Fine Arts, fall 1993; *Balkon* 1994.2: 6–8.

11 Roland Barthes calls the proliferation of styles of writing a modern phenomenon in his 1953 essay "Le degré zéro de l'écriture."

12 These phrases are titles of texts by Susan Sontag and Samuel Beckett. Sontag, "The Aesthetics of Silence," (1967) in *Styles of Radical Will* (New York: Farrar, Straus and Giroux, 1969); Beckett, *Stories and Texts for Nothing* (New York: Grove Press, 1967), *Nouvelles et textes pour rien* (Paris: Les Editions de Minuit, 1958).

13 Cf. Miklós Erdély, "Art as an Empty Sign" (excerpt):

o The message of a work of art is its inherent emptiness.

oo The receptive mind receives this emptiness.

ooo The work of art creates a space within the recipient's mind when the latter 'understands' its message.

This text appears in Laura Hoptman and Tomás Pospiszyl, eds., *Primary Documents: A Sourcebook for Eastern and Central European Art since the 1950s* (New York: The Museum of Modern Art, 2003), 101; trans. by John Bátki.

14 "Television Manifesto of the Spatial Movement," 17 May 1952: http://www.cwd.co.uk/391/manifestos/televisionmanifesto.htm

15 Thomas Kuhn, *The Structure of Scientific Revolutions*, 2nd ed. (Chicago: University of Chicago Press, 1970), 208–9.

16 Norbert Wiener, *Cybernetics, or Control and Communication in the Animal and the Machine* (Cambridge: MIT Press, 1948); C. E. Shannon, "A Mathematical Theory of Communication," in *Bell System Technical Journal* 27 (July, October 1948): 379–423, 623–56.

17 The history of kinetic art has been comprehensively related by Frank Popper in *Naissance de l'art cinéatique* (Paris: Gauthier, 1970) and *Origins and Development of Kinetic Art* (New York: New York Graphic Society, 1968). A more recent systematic account is Hans-Jürgen Buderer, *Kinetische Kunst: Konzepzionen von Bewegung und Raum* (Worms: Wernersche Verlag, 1992).

18 Otto Piene, "In Memoriam George Kepes, 1906–2002," *Leonardo* 36, no. 1 (2003): 3–4.

19 Béla Julesz, *Dialogues on Perception* (Cambridge: MIT Press, 1994), 96. It may be worthwhile to append another brief quote here, applicable not so much to the topic under discussion as to the questions raised by this essay as a whole: "Are mathematical structures and theorems (e.g. the

Mandelbrot set, with its striking self-similarities, or analytical functions with their amazing properties, or twin-prime numbers and their distributions) discovered or invented?" (83).

20 A brief list of books reflecting this concern would include: Rudolf Arnheim, *Art and Visual Perception: A Psychology of the Creative Eye* (Berkeley: University of California Press, 1954); E. H. Gombrich, *Art and Illusion: A Study in the Psychology of Pictorial Representation* (London and New York: Phaidon, 1960); R. L. Gregory, *Eye and Brain: The Psychology of Seeing* (London: Weidenfeld and Nicolson, 1966); R. L. Gregory, *The Intelligent Eye* (London: Weidenfeld and Nicolson, 1970).

21 Wittgenstein, *Tractatus*, § 6.341.

22 Dennis Gábor described holographic information in his Nobel lecture: "The appearance of such a 'diffused' hologram is extraordinary; it looks like noise. One can call it 'ideal Shannon coding,' because Claude E. Shannon has shown in his Communication Theory that the most efficient coding is such that all regularities seem to have disappeared in the signal: it must be 'noise-like.' But where is the information in this chaos? It can be shown that it is not as irregular as it appears. It is not as if grains of sand had been scattered over the plate at random. It is rather a complicated figure, the diffraction pattern of the object, which is repeated at random intervals, but always in the same size and same orientation.

"A very interesting and important property of such diffused holograms is that any small part of it, large enough to contain the diffraction pattern, contains information on the whole object, and this can be reconstructed from the fragment, only with more noise. A diffuse hologram is therefore a *distributed memory*, and this [h]as evoked much speculation whether human memory is not perhaps, as it were, holographic, because it is well known that a good part of the brain can be destroyed without wiping out every trace of a memory" ("Holography, 1948–1971," Nobel Lecture, 11 December 1971: http://www.nobel.se/physics/laureate/1971/gabor-lecture.pdf [page 23]).

23 Mel Bochner, "The Serial Attitude," *Artforum*, December 1967.

24 Sol LeWitt, "Paragraphs on Conceptual Art," repr. in *Conceptual Art: A Critical Anthology*, eds. Alexander Alberro and Blake Stimson (Cambridge: MIT Press, 1999), 12, 14.

25 Umberto Eco, *The Open Work* (Cambridge: Harvard University Press, 1989), 90.

26 Donald Judd, "Specific Objects," *Arts Yearbook 8* (1965); repr. in Stiles and Selz, *Theories and Documents.*

27 *Global Conceptualism: Points of Origin 1950s–1980s* (New York: Queens Museum of Art, 1999).

28 Hilton Kramer, "An Art of Boredom?" in *The Age of the Avant-Garde: An Art Chronicle of 1956–1972* (London: Secker and Warburg, 1974), 412.

29 Erwin Panofsky, *Idea: A Concept in Art Theory* (Columbia: University of North Carolina Press, 1968), 85.

30 Lippard, *Six Years*, x.

Like scientists and philosophers, artists throughout the twentieth century explored notions of relativity. For those in this section, movement represented a dynamism that engaged viewers' shifting vantage points. This development broke with traditional perspective, which presumed a static universe observed by a single, all-seeing eye. In the most compelling kinetic art, movement is integral, emphasizing the actual time required to take in a three-dimensional object, our changing perceptions of it, and the space in which it resides. Motion could be actual, as in Pol Bury's reliefs and Robert Breer's sculptures, or virtual, as in the optically active paintings of Bridget Riley and José Rafael Soto. It could be driven by machines, as in François Morellet's mutating grids, or by humans, as in Lygia Pape's street performance. Or it could be created by the play of natural light over a monochrome white surface, as in reliefs by Sergio de Camargo and Günther Uecker. The fleeting nature of light parallels the immediacy of the viewing experience, a relationship isolated and intensified in Douglas Wheeler's installation.

Mary Vieira, *Polyvolume: Plastic Disc*, 1953/62

opposite page: Keith Sonnier, *Spot Circle*, 1970

Section 3
Light and
Movement

François Morellet, *4 Self-Distorting Grids*, 1965

opposite page: George Rickey, *Four Lines Oblique Gyratory—Square*, 1973

Lygia Pape, *Divider* (performance), 1968

Gego, *Sphere No. 2*, 1976

Sérgio de Camargo, No. 259, 1969

Robert Breer, *Float*, 1973

left: Pol Bury, *Untitled*, 1967

above:

Peter Alexander, *Pink Green Cube*, 1967

Larry Bell, *Cube*, 1966

Grazia Varisco, *Gnomons*, 1970s

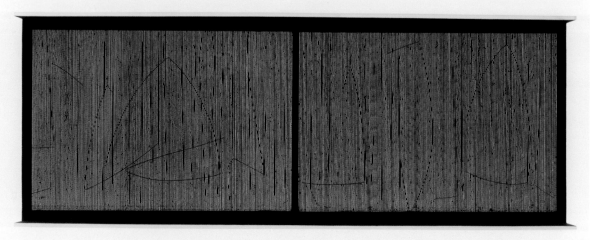

top:

Milan Grygar, *Sound-Plastic Drawing*, 1972

Milan Grygar, *Sound-Plastic Drawing*, 1972

bottom:

Jesús Rafael Soto, *Almost Immaterial Vibration*, 1963

Robert Irwin, *Untitled*, 1964–66

opposite page: Doug Wheeler, *Untitled (Light Encasement)*,
1968 (installation view)

Wojciech Fangor, *M 15 1968*, 1968

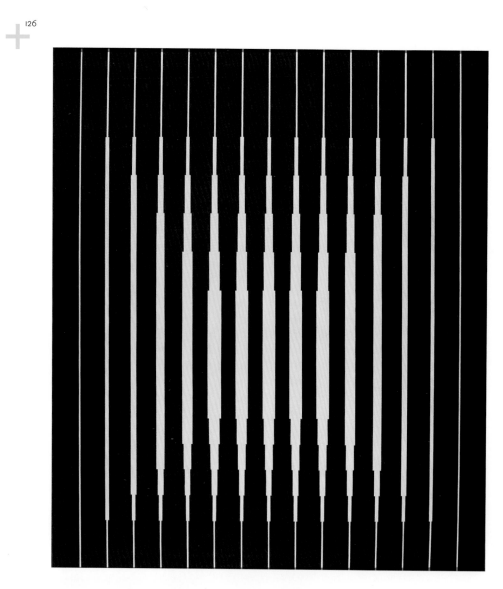

Victor Vasarely, *Bora II*, 1964

Carlos Cruz-Diez, *Optical Structure*, 1958

Karl Benjamin, *No. 27*, 1968

1	2	3	4
3	4	1	2
4	3	2	1
2	1	4	3

1/1234

2	1	3	4
3	4	2	1
4	3	1	2
1	2	4	3

7/2134

3	1	2	4
2	4	3	1
4	2	1	3
1	3	4	2

13/3124

4	1	2	3
2	3	4	1
3	2	1	4
1	4	3	2

19/4123

1	2	4	3
4	3	1	2
3	4	2	1
2	1	3	4

2/1243

2	1	4	3
4	3	2	1
3	4	1	2
1	2	3	4

8/2143

3	1	4	2
4	2	3	1
2	4	1	3
1	3	2	4

14/3142

4	1	3	2
3	2	4	1
2	3	1	4
1	4	2	3

20/4132

1	3	2	4
2	4	1	3
4	2	3	1
3	1	4	2

3/1324

2	3	1	4
1	4	2	3
4	1	3	2
3	2	4	1

9/2314

3	2	1	4
1	4	3	2
4	1	2	3
2	3	4	1

15/3214

4	2	1	3
1	3	4	2
3	1	2	4
2	4	3	1

21/4213

1	3	4	2
4	2	1	3
2	4	3	1
3	1	2	4

4/1342

2	3	4	1
4	1	2	3
1	4	3	2
3	2	1	4

10/2341

3	2	4	1
4	1	3	2
1	4	2	3
2	3	1	4

16/3241

4	2	3	1
3	1	4	2
1	3	2	4
2	4	1	3

22/4231

1	4	2	3
2	3	1	4
3	2	4	1
4	1	3	2

5/1423

2	4	1	3
1	3	2	4
3	1	4	2
4	2	3	1

11/2413

3	4	1	2
1	2	3	4
2	1	4	3
4	3	2	1

17/3412

4	3	1	2
1	2	4	3
2	1	3	4
3	4	2	1

23/4312

1	4	3	2
3	2	1	4
2	3	4	1
4	1	2	3

6/1432

2	4	3	1
3	1	2	4
1	3	4	2
4	2	1	3

12/2431

3	4	2	1
2	1	3	4
1	2	4	3
4	3	1	2

18/3421

4	3	2	1
2	1	4	3
1	2	3	4
3	4	1	2

24/4321

Drawing by Sol LeWitt used by Laurie Anderson to generate
musical note values for *Quartet for Sol LeWitt*, 1977
Courtesy Laurie Anderson and Canal St. Communications

Brandon LaBelle

performing geometry

Music's Affair with Numbers, Systems, and Procedures

The relationship of music to mathematics has long been remarked. Music history could in fact be traced in terms of a mathematical evolution, from early Greek theories of rhythm as "musical motion," and Pythagorean formulations of musical ratios, to esoteric meditations on the "music of the spheres," which used arithmetical proportions derived from celestial bodies as guides for musical understanding. As Charles Fourier posited in the eighteenth century, "Mathematics and music are the principles of the measured harmonies known to us."[1] Such a link is due in part to sound's inherent physical properties of vibration, wave propagation, and acoustical resonance, but more so to musical tuning and the "measured harmonies" to which Fourier refers. Tuning is essentially a mathematical proposition: the strings of an instrument are tightened or loosened to achieve various harmonic intervals. Harmony is thus determined by the mathematical ratio of one interval, or frequency, to another.

Tunings are not without complications. Pure intervals don't precisely correspond with perfect octaves. The ancient Pythagoreans attempted to rectify this by "tempering" the musical scale, that is, by adjusting the intervals between notes. This procedure has been charged with limiting musical resources by approximating pitch. Tempering the scale actually simplifies acoustical facts by eliminating fractional nuances or details between frequencies. Tonal potential is neatly packaged.

Yet the fractional nuance has not gone unnoticed. Composers of the past century sought to exploit the potential of freer tunings. (American composer and instrumentalist Harry Partch, for example, replaced the even-tempered Western tuning system with one containing forty-three tones.) Musicality has been extended into the realm of an experimental sonics incorporating electronics, custom instruments, and microtonal scales. Through such processes, mathematics itself has served a heightened role, for to unpack the musical scale, to extend its range and the experience of listening, requires precision. It is this overriding concern with systems and numbers that constitutes the secret history of twentieth-century music.

Serialism

Arnold Schoenberg's twelve-tone system, or serial method (developed in 1921), sought to lend structure to his atonal works, which developed from the musical dynamics of late romanticism exemplified in

Wagner and Liszt. The method of serial composition is based on the organization of rows of notes, applied as a kind of "plastic material" to musical construction. As Paul Griffiths explains: "The twelve notes of the chromatic scale are arranged in a fixed order, the series, which can be used to generate melodies and harmonies, and which remains binding for a whole work."[2] Schoenberg articulates: "The possibilities of evolving the formal elements of music—melodies, themes, phrases, motives, figures, and chords—out of a basic set are unlimited. One has to follow the basic set; but, nevertheless, one composes as freely as before."[3] The development of serialism in the 1920s must be seen as a radical shift not only in compositional methodology, but also in attitudes toward musicality: the implementation of systematic procedures introduces a reliance on process-oriented rather than strictly imaginary decisions. Thus, the "magic" of music is found not solely in the inspirational intuition of the composer, or in the actual sound event, but in the implementation of a logical structure based on ordered systems.

The sweep of serialism across European avant-garde music is testament to the general move toward new strategies of composition. Composers such as Anton Webern, Alban Berg, and Olivier Messiaen developed serialism further and greatly influenced younger composers of the postwar period. Similar procedures were applied to other compositional elements, such as note length, silence, and volume. The advent of such "total serialism" in the work of Karlheinz Stockhausen and Pierre Boulez (both students of Messiaen), and others such as Bruno Maderna and Luigi Nono in Italy and Milton Babbitt[4] in the United States, reveals an increasing reliance on systematic procedures often based on geometry, mathematical laws, and numerical structures. Historically, total serialism can also be understood as an aesthetic response to the social chaos stemming from World War II, insofar as it provides an ordered and technical logic to the inherent instability of the times. As Boulez summarizes: "From the very outset our generation was determined to restore to its proper place this problem of technique, which had been despised, ignored, corrupted and distorted. We considered this the most urgent of our tasks and one on which not only our own future, but the whole future of music depended."[5]

Fibonacci and Bernoulli: A Universe of Numbers

The logic of total serialism lent itself to the proliferation of other strategies based on mathematical principles. Iannis Xenakis's seminal *Metastasis* (1953–54) was written according to rules of probability based on Bernoulli's law describing the behavior of fluids under pressure. Working as an assistant to Le Corbusier through the 1950s, Xenakis created music more by calculation than composition. Through his mathematically regulated, architecturally structured, engineered sonic intensities he sought to "make art through geometry, thereby giving it reasoned sustenance, which is less perishable than the impulse of the moment, and therefore more serious, more worthy of that struggle for higher things which exists in all domains of the human intelligence."[6]

In the late 1950s the Argentinean composer Mauricio Kagel developed a technique for writing music that was determined by geometric form. By drawing a quadrilateral shape across the musical stave, then

reversing and rotating it, Kagel realized he could essentially "design" music. Other composers throughout the fifties, such as Babbitt, Nono, Bo Nilsson, and Luciano Berio, formed methods of structuring music according to various mathematical, geometric, and number systems. The Fibonacci series (in which each number is the sum of the preceding two numbers), the Golden Section, Pascal's Triangle, logarithms, and square roots have all been used as structuring techniques.

Aleatory Music

Compositional systems can also be employed in the subversion of order. By the mid-1950s, questions of structure and methodology edged into the domain of aleatoric composition. John Cage explored chance operations and "nonintention" using various methods, most notably by throwing coins in the manner of consulting the *I Ching*. This allowed him to escape authorship, to relinquish the control of composition by introducing randomness into the order of music. Cage used the procedures of the *I Ching* essentially to produce a series of numbers, which determined pitch, duration, instrumentation, volume, and other aspects of his musical works. Like serialism, aleatory music, from Cage and the New York School (Christian Wolff, Morton Feldman, and Earle Brown) to Pierre Boulez, relies upon systems. Yet the use of chance signaled a radical shift away from serial technique, insofar as it replaced a structuring blueprint with the continual discovery and unfolding of musical form.

Minimalism: Repetition and Static Tonality

The development of systems as conceptual structures for generating musical composition found further expression in the minimalist music of the 1960s and 1970s. The works of Terry Riley, La Monte Young, Philip Glass, Tony Conrad, Steve Reich, and Frederic Rzewski sought to develop a new language for music based on extended durations, drones, and repetition. The minimalist aesthetic, while often recuperating a heightened and enriched tonal range, is starkly systematic and relies heavily on process, however flexible in performance. Terry Riley's *In C*, from 1964, is exemplary. Scored for any ensemble, the composition is based on a series of musical progressions, or "figures" (fifty-three in all), which performers are asked to play in sequence. Yet Riley invites individual interpretation by suggesting that performers repeat each figure as many times as they wish before moving on. The variation within repetition creates a sonic euphoria of subtle movements that seem to continually dissolve then reappear through their own momentum.

Repetition finds a harder edge in Steve Reich's procedural structures. *Drumming*, from 1972, is scored for a percussion ensemble and written as a series of modular sections that shift in and out of unison. The alteration of rhythm leads to a continual transformation of accented beats, creating a dynamic syncopation. *Drumming* is thus a numerical unfolding of rhythmic modulation, as one pattern of beats shifts into another. What we hear is tantamount to mathematics in operation.

The Body and Math

The often procedural and performance-based operations of minimalism run parallel to the development of conceptual and performance art in the late 1960s and early 1970s. The employment of systematic strategies for the production of art reached a radical point with conceptual works, such as Douglas Huebler's *Duration* series or Sol LeWitt's serial pieces (theorized in his influential "Paragraphs on Conceptual Art" from 1967). Such strategies adhere to a predetermined instruction, either physical or mental, thereby forcing the artist into automatic actions. These actions often implied or produced sound. In *Quartet for Sol LeWitt* (p. 128), for example, Laurie Anderson created a score by assigning note values to the numbers in a drawing by LeWitt. In Bruce Nauman's 1969 *Rhythmic Stamping (Four Rhythms in Preparation for Video Tape Problems)* the artist stomps around his studio space in a steady rhythm for a fixed duration, "performing" the acoustical space through physical gesture. His actions underscore the artist's body as medium in the making of sound.

Such positioning of the body can also be heard in Pauline Oliveros's music and theater works since the mid-1960s. Organizing singers and instrumentalists according to the points and sections of mandalas, Oliveros creates a three-dimensional musical geometry in which the positions of performers and audience are part of a heightened listening experience.

The use of systems and numerical strategies in the making of music has dramatically increased the diversity of music throughout the twentieth century. Examining these leads to a deeper consideration of music's inherent relation to mathematical understanding and geometric proportion, along with the physics of acoustical events and the psychology of hearing. Schoenberg proposed that "in music there is no form without logic."[7] What the twentieth century has shown is that forms and their logic are never simple affairs. To appropriate and incorporate mathematical and systematic structures in the writing and performing of music is to underscore music as an opportunity to make more than just sound.

notes

1 Quoted in Jocelyn Godwin, *Music and the Occult* (Rochester, NY: University of Rochester Press, 1995), 79.

2 Paul Griffiths, *Modern Music* (New York: Thames and Hudson, 1994), 82.

3 Quoted in Donald Mitchell, *The Language of Modern Music* (London: Faber and Faber, 1993), 15.

4 Milton Babbitt was the son of a mathematician, and himself taught mathematics at Princeton during World War II; musically, he developed his own vocabulary in applying logical processes to Schoenbergian pitch techniques.

5 Pierre Boulez, *Orientations*, trans. Martin Cooper (Cambridge: Harvard University Press, 1986), 66.

6 Quoted in Reginald Smith Brindle, *The New Music: The Avant-Garde since 1945* (Oxford and New York: Oxford University Press, 1995), 51. It is worth noting that Xenakis formed the Center for the Study of Mathematical and Automated Music in Paris in 1966.

7 Quoted in Otto Karolyi, *Introducing Modern Music* (London: Penguin Books, 1995).

Checklist for the Beyond Geometry Sound Room

Milton Babbitt (USA)
Three Compositions for Piano (1948)

John Cage (USA)
Music of Changes (1951); *Williams Mix* (1951)

Morton Feldman (USA)
Intersections I (1951); *Durations* (1960)

Pierre Boulez (USA)
Structures Ia (1952)

Karlheinz Stockhausen (Germany)
Studie II (1953); *Zykus* (1960); *Mixtur* (1961); *Telemusik* (1966)

Earle Brown (USA)
Four Systems (1954)

Iannis Xenakis (Greece/France)
Metastasis (1954)

Mauricio Kagel (Argentina/Germany)
Transición I (1961–62)

Pauline Oliveros (USA)
Pieces of 8 (1964), courtesy of the artist

Terry Riley (USA)
In C (1964)

Bernard Heidsieck (France)
Démocratie II (1968)

José Luis Castillejo (Spain)
The Book of I's (1969)

Bruce Nauman (USA)
Rhythmic Stamping Four Rhythms in Preparation for Video Tape Problems (1969), courtesy of the artist

Steve Reich (USA)
Drumming (1971)

Paul Panhuysen (Holland)
Clock (1974), courtesy of the artist

Jon Gibson (USA)
Melody III (1975)

Tom Johnson (USA)
Nine Bells (1975)

Laurie Anderson (USA)
Quartet for Sol LeWitt (1977), courtesy of the artist

Christina Kubisch (Germany)/ **Fabrizio Plessi** (Italy)
Tempo Liquido (1978), courtesy of the artists

Harry Bertoia (USA)
Unfolding (1979)

Systematically produced art had great currency in the postwar era, and repetition constituted the most basic of systems. With its analogies to industrial production, repetition emphasized process over product, undermining the uniqueness on which the art market depended. Artists like Donald Judd, who sent plans of their objects to fabricators for production, challenged the value placed on technical facility. By downplaying the authority of the inventive genius, such strategies not only reflected the social mores of a politically turbulent time, but also allowed viewers a more active role in the creative endeavor. For example, Carl Andre's floor pieces were meant to be so "recessive" that someone could walk across one and not see it; in identifying such works as art, the beholder completed them. Repetition was also a means of avoiding traditional composition. Serial order was another system that artists employed to similar ends, using numbers or images in sequence, as in works by Hanne Darboven and Eleanor Antin. Although the term "system" implies calculation and emotional remove, systematic art was extremely flexible, and by the middle 1960s it had accommodated overtly organic, emotive, and lyrical references in works by artists such as Eva Hesse and Mira Schendel.

Lygia Pape, *Box of Cockroaches*, 1967

Section 4
Repetition
and Seriality

Peter Roehr, *Untitled (FO-74)*, 1965
Peter Roehr, *Untitled (FO-87)*, 1966

opposite page: Eva Hesse, *Constant*, 1967

Yayoi Kusama, *Accumulation of Nets*, 1962

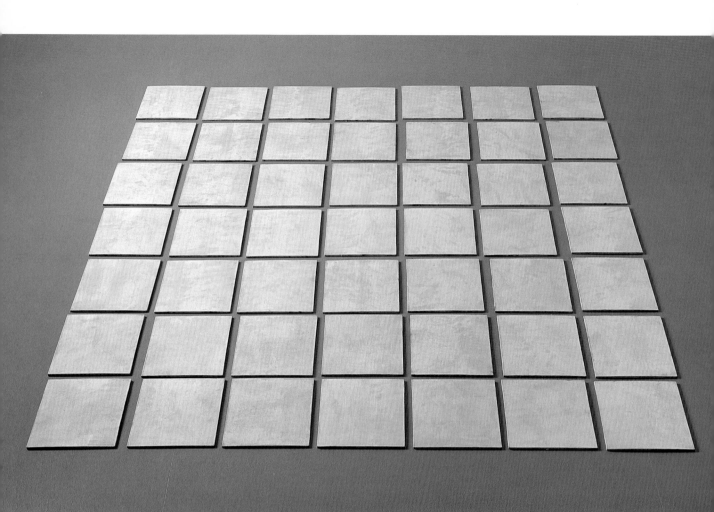

Franz Erhard Walther, *49 Panels*, 1963
(alternate installation views)

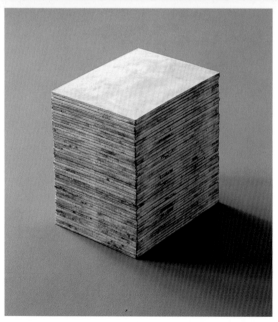

Left: Herman de Vries, *aio (Random Structured Semiotic Fields: Malayalam Types)*, 1971

Right: Peter Roehr, *Untitled (ST-7)*, 1962 (detail)

futura 2

klaus burkhardt

coldtypestructure

edition hansjörg mayer 1965

klaus burkhardt wurde 1928 in frölingen geboren seine
familienverhältnisse zwänge zunächst wärmeneinsatz verband
zur textil handwerk und handwerklich anbilden und
wandte sich der typografie zu nach einer leinenen
angestellten in die gefühle der malerei im war es
rechtigsteder einer galerien sind der fotografie betätigt
er sich heute beruflich als lehrer für typografie an der
grafischen technischule in stuttgart (seit 1958) und
selbstständlich als originaller drucker (seit 1958) und
originaler druckkünstler (seit 1959)

neuere biografie
als originaller drucker wandte er sich allem die offduke
und zur guten deinend ichbildlerbilder sls originaler
druckkünstler erband er vor allem die
druck ichnachdruckbilder (1959-62) und seit 1963 die
sogenannten coldtypestructures der weg von den
druck ichnachdruckbilder zu den coldtypestructures ist
direkt im spongeraktur sin weg von einer seit
informell zu einer art concret so ist der weg vom
zufälligen oft unfällig-subjektiven durch ichnachdruckbild
der bearbeitbare am konkreten konstruktionsstruktur seit
leffte der faktoren dann klaus burkhardt bei der
intensiven beschäftigung mit dem ichbruete zugleich auch
dessen ästhetische möglichkeiten seit und nutzte dazwättigt
seinen wie eines material standardize und
materialtheoretischen händelen so ist inwieden an der seit
dass die trend wieder zum happening zum handwerk
zurückflucht

poeterpiros
von klaus burkhardt erschienen zu 1961 das buch
typeteraria 1962 die mappe vitris erinnen sprachen
degagese einer der stret ist völlig zweiter und 1965 eine
mappe coldtypestructures

reinhard döhl

Carl Andre, *Stillanovel*, 1972

Brion Gysin, "Junk Is No Good Baby," in *Brion Gysin Let the Mice In*, 1973

SENATORSTANFORDTELEGRAPHINGMUYBRIDGEFROMHISSACRAMENTOHOMEIN1872
SENATORSTNNFORDTELGGRAPHINGUUYBRIDGEHROMHISSARRAMENTOHMMEIN1872
NNNATORSTPFFORDTELRRRAPHINGYYYBRIDGEOOOMHISSAAAAAMENTOHHEEIN1872
AAAATORSTOOOORDTELAAAAPHINGBBBBBRIDGEMMMMHISSAAMMMMENTOHIIIIN1872
TTTTTORSTRRRRRDTELPPPPPHINGRRRRRRIDGEHHHHHHISSAAEEEEENTOHNNNNN1872
OOOOOORSTDDDDDDDTELHHHHHHINGIIIIIIDGEIIIIIIDGEIIIIIISSANNNNNNTOHIIIIII1872
RRRRRRRSTTTTTTTTELIIIIIIINGDDDDDDDDGESSSSSSSSATTTTTTOH888888872
SSSSSSSSTEEEEEEEELNNNNNNNGGGGGGGGGESSSSSSSSAOOOOOOOOH7777777772
TTTTTTTTTLLLLLLLLLGGGGGGGGGGEEEEEEEEEAAAAAAAAAHHHHHHHH222222222

```
SENATORST  ANFORDTEL  EGRAPHING  MUYBRIDGE  FROMHISSA  CRAMENTOH  OMEIN1872
SENATORST  NNFORDTEL  GGRAPHING  UUYBRIDGE  HROMHISSA  RRAMENTOH  MMEIN1872
NNNATORST  FFFORDTEL  RRRAPHING  YYYBRIDGE  OOOMHISSA  AAAMENTOH  EEEIN1872
AAAATORST  OOOORDTEL  AAAAPHING  BBBBRIDGE  MMMMHISSA  MMMMENTOH  IIIIN1872
TTTTTORST  RRRRRDTEL  PPPPPHING  RRRRRIDGE  HHHHHISSA  EEEEENTOH  NNNNN1872
OOOOOORST  DDDDDDTEL  IIIIIIING  IIIIIIDGE  IIIIIISSA  NNNNNNTOH  111111872
RRRRRRRST  TTTTTTTEL  IIIIIIING  DDDDDDDGE  SSSSSSSSA  TTTTTTTOH  888888872
SSSSSSSST  EEEEEEEEL  NNNNNNNNG  GGGGGGGGE  SSSSSSSSA  OOOOOOOOH  777777772
TTTTTTTTT  LLLLLLLLL  GGGGGGGGG  EEEEEEEEE  AAAAAAAAA  HHHHHHHH   222222222
```

```
SENATORST              MMMMMMMMMMMMMMMMMM
ENATORSTS              MUUUUUUUUUUUUUUUM
NATORSTSE              MUYYYYYYYYYYYYYUM
ATORSTSEN              MUYBBBBBBBBBBBYUM
TORSTSENA              MUYBRRRRRRRRRBYUM
ORSTSENAT              MUYBRIIIIIIIRBYUM
RSTSENATO              MUYBRIDDDDDIRBYUM
STSENATOR              MUYBRIDGGGDIRBYUM
TSENATORS              MUYBRIDGEGDIRBYUM
                       MUYBRIDGBGDIRBYUM
                       MUYBRIDDDDDIRBYUM
SSSSSSSSSAAAAAAAAA     MUYBRIIIIIIIRBYUM
SKEEEEKEENNNNNNNA      MUYBRRRRRRRRRBYUM
SENNNNNNFFFFFFFNA      MUYBBBBBBBBBBBYUM
SENAAAAAAOOOOOOFNA     MUYYYYYYYYYYYYYUM
SENATTTTTRRRRROFNA     MUUUUUUUUUUUUUUUM
SENATOOOODDDDROFNA     MMMMMMMMMMMMMMMMMM
SENATORRRTTTDROFNA
SENATORSSTTEDROFNA
SENATORSTEETDFRONA
```

```
MAJORLARK
YNSLODGIN
GATWILLIA
MSTUARTSH
OUSENEART
HEYELLOWJ
ACKETMINE
```

JUNK IS NO GOOD BABY

JUNK IS NO GOOD BABY	IS JUNK NO GOOD BABY
JUNK NO IS GOOD BABY	NO IS JUNK GOOD BABY
IS NO JUNK GOOD BABY	NO JUNK IS GOOD BABY
JUNK IS GOOD NO BABY	IS JUNK GOOD NO BABY
JUNK GOOD IS NO BABY	GOOD JUNK IS NO BABY
IS GOOD JUNK NO BABY	GOOD IS JUNK NO BABY
JUNK NO GOOD IS BABY	NO JUNK GOOD IS BABY
JUNK GOOD NO IS BABY	GOOD JUNK NO IS BABY
NO GOOD JUNK IS BABY	GOOD NO JUNK IS BABY
IS NO GOOD JUNK BABY	NO IS GOOD JUNK BABY
IS GOOD NO JUNK BABY	GOOD IS NO JUNK BABY
NO GOOD IS JUNK BABY	GOOD NO IS JUNK BABY
JUNK IS NO BABY GOOD	IS JUNK NO BABY GOOD
JUNK NO IS BABY GOOD	NO JUNK IS BABY GOOD
IS NO JUNK BABY GOOD	NO IS JUNK BABY GOOD
JUNK IS BABY NO GOOD	IS JUNK BABY NO GOOD
JUNK BABY IS NO GOOD	BABY JUNK IS NO GOOD
IS BABY JUNK NO GOOD	BABY IS JUNK NO GOOD
JUNK NO BABY IS GOOD	NO JUNK BABY IS GOOD
JUNK BABY NO IS GOOD	BABY JUNK NO IS GOOD
NO BABY JUNK IS GOOD	BABY NO JUNK IS GOOD
IS NO BABY JUNK GOOD	NO IS BABY JUNK GOOD
IS BABY NO JUNK GOOD	BABY IS NO JUNK GOOD
NO BABY IS JUNK GOOD	BABY NO IS JUNK GOOD
JUNK IS GOOD BABY NO	IS JUNK GOOD BABY NO
JUNK GOOD IS BABY NO	GOOD JUNK IS BABY NO
IS GOOD JUNK BABY NO	GOOD IS JUNK BABY NO
JUNK IS BABY GOOD NO	IS JUNK BABY GOOD NO
JUNK BABY IS GOOD NO	BABY JUNK IS GOOD NO
IS BABY JUNK GOOD NO	BABY IS JUNK GOOD NO
JUNK GOOD BABY IS NO	GOOD JUNK BABY IS NO
JUNK BABY GOOD IS NO	BABY JUNK GOOD IS NO
GOOD BABY JUNK IS NO	BABY GOOD JUNK IS NO
IS GOOD BABY JUNK NO	GOOD IS BABY JUNK NO
IS BABY GOOD JUNK NO	BABY IS GOOD JUNK NO
GOOD BABY IS JUNK NO	BABY GOOD IS JUNK NO
JUNK NO GOOD BABY IS	NO JUNK GOOD BABY IS
JUNK GOOD NO BABY IS	GOOD JUNK NO BABY IS
NO GOOD JUNK BABY IS	GOOD NO JUNK BABY IS
JUNK NO BABY GOOD IS	NO JUNK BABY GOOD IS
JUNK BABY NO GOOD IS	BABY JUNK NO GOOD IS
NO BABY JUNK GOOD IS	BABY NO JUNK GOOD IS
JUNK GOOD BABY NO IS	GOOD JUNK BABY NO IS
JUNK BABY GOOD NO IS	BABY JUNK GOOD NO IS
GOOD BABY JUNK NO IS	BABY GOOD JUNK NO IS
NO GOOD BABY JUNK IS	GOOD NO BABY JUNK IS

NO BABY GOOD JUNK IS	BABY NO GOOD JUNK IS
GOOD BABY NO JUNK IS	BABY GOOD NO JUNK IS
IS NO GOOD BABY JUNK	NO IS GOOD BABY JUNK
IS GOOD NO BABY JUNK	GOOD IS NO BABY JUNK
NO GOOD IS BABY JUNK	GOOD NO IS BABY JUNK
IS NO BABY GOOD JUNK	NO IS BABY GOOD JUNK
IS BABY NO GOOD JUNK	BABY IS NO GOOD JUNK
NO BABY IS GOOD JUNK	BABY NO IS GOOD JUNK
IS GOOD BABY NO JUNK	GOOD IS BABY NO JUNK
IS BABY GOOD NO JUNK	BABY IS GOOD NO JUNK
GOOD BABY IS NO JUNK	BABY GOOD IS NO JUNK
NO GOOD BABY IS JUNK	BABY GOOD IS NO JUNK
NO BABY GOOD IS JUNK	BABY NO GOOD IS JUNK
GOOD BABY NO IS JUNK	BABY GOOD NO IS JUNK

Bernd and Hilla Becher, *Typology of Water Towers*, 1972

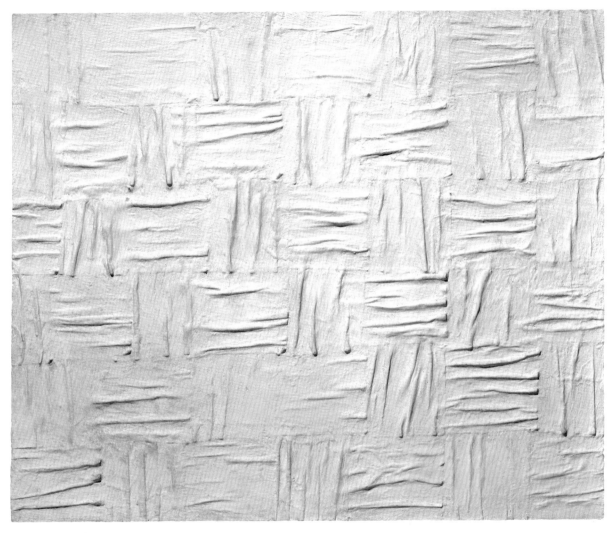

Piero Manzoni, *Achrome*, 1959

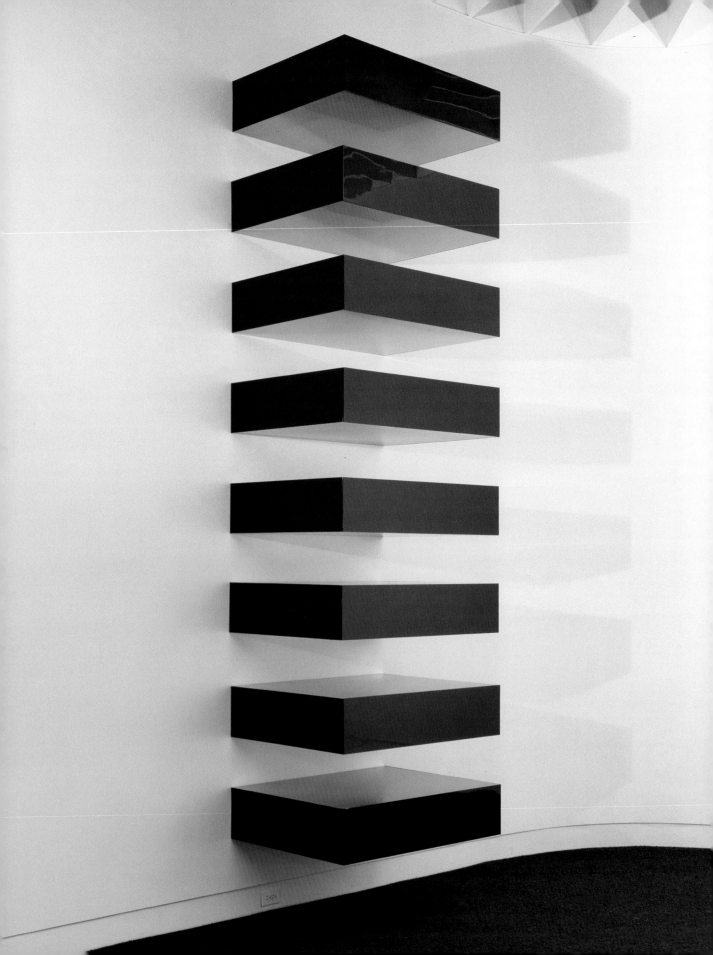

opposite page: Donald Judd, *Untitled*, 1969

Dadamaino, *Volume of Displaced Modules*, 1960

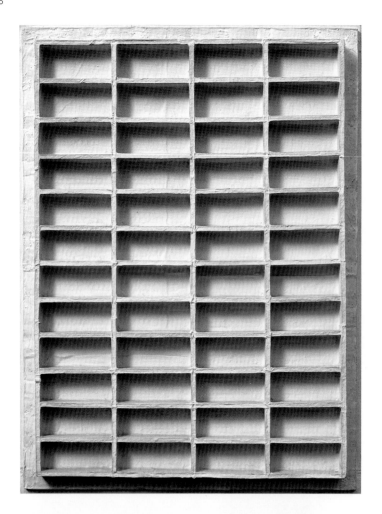

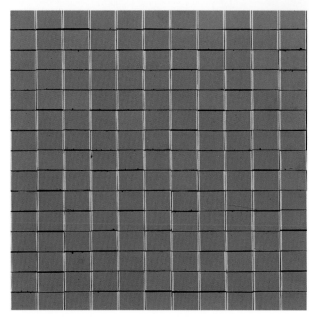

Jan Schoonhoven, *R 62-16*, 1962

Peter Roehr, *Untitled (OB-1)*, 1963

opposite page: Cildo Meireles, *Webs of Liberty*, 1976/98

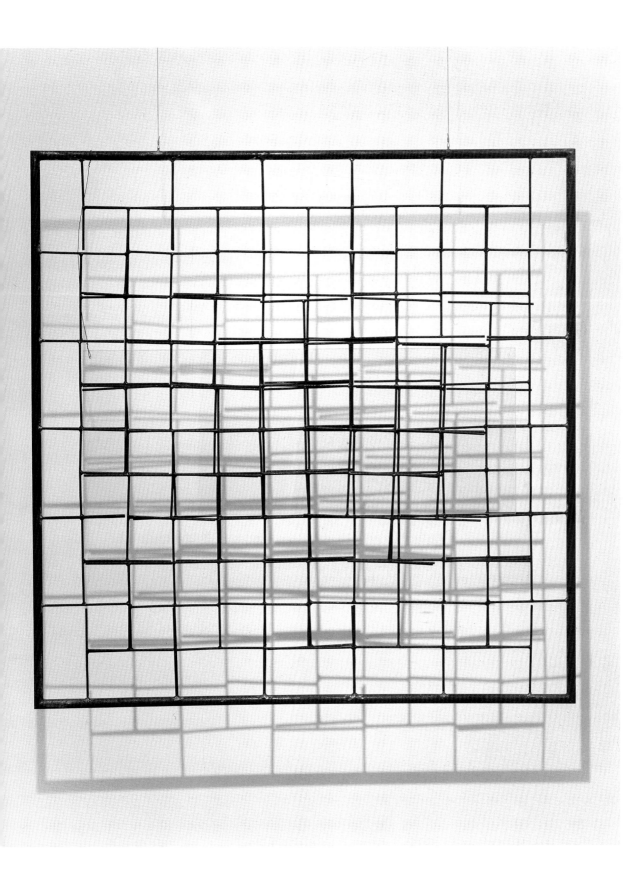

Jan Dibbets, *Shortest Day at the Guggenheim Museum New York 1970 from Sunrise to Midday Photographed Every 5 Minutes*, 1970

opposite page: Jan Schoonhoven, *Slanting Rectangular Planes*, 1966

Jan Schoonhoven, *Relief of Squares with Double Inclined Planes Diametrically Broken*, 1967

Eleanor Antin, *Carving: A Traditional Sculpture*, 1972

opposite page: Mira Schendel, *Train*, c. 1965

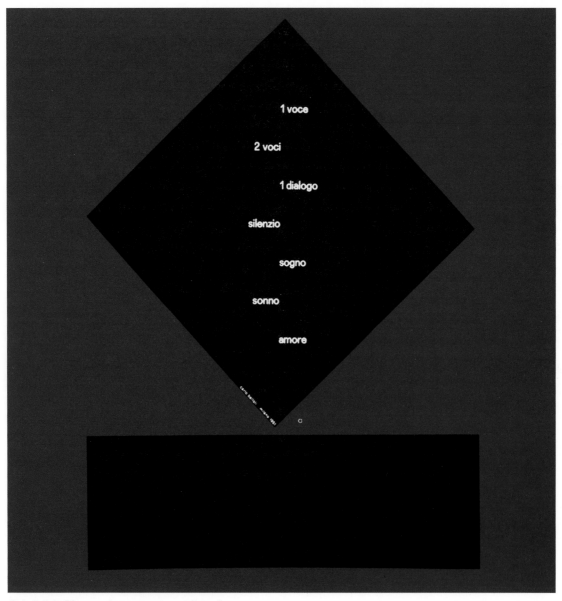

Carlo Belloli, "Corpo poético numero 3: voce/Amore"
(Poetic body number 3: voice/Love), 1951

ǫe□metric literature

From Concrete Poetry to Artists' Books

Peter Frank

Some ten years after World War II, concrete poetry emerged as a radical but durable attempt to apply to poetic practice, in a systematic manner, formal principles generated within the discourse of an entirely different art form. There had been numerous examples throughout early twentieth-century modernism of poetry "expanded" through the application of principles imported from visual art; concrete poetry's own theorists and practitioners have always cited work such as Stéphane Mallarmé's *Un Coup de Dés* and the *parole in libertà* of the Italian futurists as their direct antecedents. But these and other typographically adventurous landmarks of the classic avant-garde embodied the individual interpretation of ideological, politically inflected programs, programs that drove specifically formal praxis. By contrast, concrete poetry—like its geometric counterparts in visual art, design, architecture, and even music, film, and live performance—manifested the individual interpretation of formal models, models that engaged the world beyond artistic practice by addressing the audience's sensibility and altering its perception. Thus, in response to a 1995 questionnaire about his group's original intentions, Augusto de Campos, Brazilian cofounder of the prototypical concrete-poetry group Noigandres, wrote that

in view of the specific historical context in which it occurred, Concrete poetry obviously did not participate either in the ideology of Symbolism, which still underlies Mallarmé's poetics, or in the mecanopolitical Futurist utopias, or in Dadaist nihilism. Concrete poetry took a position as a poetics of objectivity, attempting simply to place its premises at the roots of language, with the intention of creating new operational conditions for the elaboration of a poem in the sphere of technological revolution. Technically, Concrete poets can be distinguished from their antecedents by the radicalisation and condensation of the means of structuring a poem, on the horizon of the means of communication of the second half of the century. That implies, among other characteristics, the following: greater constructive rigor in relation to the graphic experiences of Futurists and Dadaists; greater concentration of vocabulary; emphasis on the nondiscursive character of poetry, suppression or relativisation of syntactic links; making explicit the materiality of language in its visual and sonorous dimensions; free passage between verbal and nonverbal levels.[1]

Concrete poetry, along with the visually conditioned poetry that preceded and inspired it, emerged coincidentally with it (e.g., Lettrism), and followed it (e.g., *poesia visiva* and other forms of visual, and sound, poetry), clearly constitutes an intermedium, a hybrid whose characteristics are derived from discrete art forms and are fused to the point of inseparability. Thus the visual and verbal — and in many cases sonic — aspects of a concrete poem are codependent and coefficient; the poem is not simply reduced with the removal of any of these aspects, it ceases to exist. "Intermedia" per se is a concept formulated in the 1960s, in response to the burgeoning appearance of formally hybrid work throughout the Western world from the mid-1950s onward.[2] In this light, concrete poetry can be seen as a star — one of the older and, arguably, brighter — in the intermedia constellation.

But is the concrete poetry "star" actually that of all visual poetry? Or might that bright orb actually be a cluster of stars, each a different manifestation of intermediation between the verbal, the visual, and/or the sonic? For the longest time, the term "concrete poetry" was employed, synecdochally, to connote all forms of poetry realized with an integral visual component.[3] "Visual poetry" would function better here as the overarching term; especially given the ramifications of the term "concrete," the label "concrete poetry" has much more historically and practically specific connotations.[4] Indeed, in the introduction to the *Anthology of Concrete Poetry* he compiled and published in 1967, Emmett Williams wrote that "the makers of the new poetry in the early fifties [i.e., the actual concrete poets, including Williams himself] were not . . . specifically seeking the intermedium between poetry and painting, the apparent goal of so many of their followers.

> The visual element in their poetry tended to be structural, a consequence of the poem, a "picture" of the lines of force of the work itself, and not merely textural. It was a poetry far beyond paraphrase, a poetry that often asked to be completed or activated by the reader, a poetry of direct presentation — the *word*, not *words, words, words* or expressionistic squiggles — using the semantic, visual and phonetic elements of language as raw materials in a way seldom used by the poets of the past. It was a kind of game, perhaps, but so is life. It was born of the times, as a way of knowing and saying something about the world of *now*, with the techniques and insights of *now*.[5]

In the 1956 "Concrete Poetry: A Manifesto" Augusto de Campos made clear the elemental and structural preoccupations of concrete poetry as it was originally conceived by Noigandres writers and their cohorts (as well as, it turns out, by contemporaneous poets who were not then in contact with or even known to the Brazilians):

- the concrete poem or ideogram becomes a relational field of functions.
- the poetic nucleus is no longer placed in evidence by the successive and linear chaining of verses, but by a system of relationships and equilibria between all parts of the poem.

silencio silencio silencio
silencio silencio silencio
silencio silencio
silencio silencio silencio
silencio silencio silencio

```
VVVVVVVVVV
VVVVVVVVVE
VVVVVVVVEL
VVVVVVVELO
VVVVVVELOC
VVVVVELOCI
VVVVELOCID
VVVELOCIDA
VVELOCIDAD
VELOCIDADE
```

```
                o
                bo
                blow
                blow blow
                blow blow blow
                blow blow
                blow
                bo
o               o
go              so
grow            show
grow grow       show show
grow grow grow o show show show
grow grow       show show
grow            show
go              so
o               o
lo
flow
flow flow
flow flow flow
flow flow
flow
lo
o
```

```
sem um numero
  um numero
     numero
       zero
        um
          o
           nu
            mero
             numero
              um numero
               um sem numero
```

Emmett Williams, *Sweethearts*, 1967 Décio Pignatari, "Life," 1956

- graphic-phonetic functions-relations ("factors of proximity and likeness") and the substantive use of space as an element of composition maintain a simultaneous dialectic of eye and voice, which, allied with the ideogrammatic synthesis of meaning, creates a sentient "verbivocivisual" totality. In this way words and experience are juxtaposed in a tight phenomenological unit impossible before.[6]

In other words, the structure of the poem *is* the diction of the poem, the basic unit of the poem is the word, and the principles by which those units are structured are inferentially geometric, given the orderly (even gridded) nature of basic typography and the aesthetic model(s) of abstract visual art commonly grouped under the rubric of "constructivism."

Practiced through much of the 1950s by a few widely scattered writer-artists and groups, including the (Bolivian-born) Swiss-German Eugen Gomringer, the Noigandres poets, Öyvind Fahlström in Sweden,[7] Iceland's Dieter Roth (aka Diter Rot),[8] the Darmstadt circle (including Daniel Spoerri, Claus Bremer, and Emmett Williams), and the Wiener Gruppe and its associates in Austria (including Gerhard Rühm, Friedrich Achleitner, H. C. Artmann, Konrad Bayer, Ernst Jandl, and Friederike Mayröcker), concrete poetry proliferated throughout the Western world in the following decade, helping to spawn more

Dieter Roth, "Tomato, Potato," 1959

elaborately conceived and hybridized (and less formally ordered) kinds of visual, sound, and otherwise intermedial poetry. This expansion of the word was accompanied with an expansion of its supporting media; that is to say, as artists and writers experimented with typography and with the very idea of an imaged literature, they visited similarly radical changes on the page and even on the book.

In 1968 Jean-François Bory wrote that

> up until the present time, the book had only been used as a support, a base. Writing was presented as a line that could be extended for several miles. The fact that literature had passed from the scroll to the book had not been a sign of progress. The rational utilization of paperbacks creates the desire to see other books, books whose interest is as much visual as literary. "The age of the book has yet to come. The book is not a sinking ship, but one that needs a new course, and is waiting for the captain who will chart this new direction for it. Authors who do not take an interest in it denounce it as being simply a lumber room of compositional incapability" ([Ferdinand] Kriwet).[9]

Here, in response to the proliferation of cheaply produced, mass-formatted "print-art" in the 1960s, Bory projected the artists' books movement of the subsequent decade.[10]

Edward Ruscha, *Every Building on the Sunset Strip*, 1966 (detail)

That proliferation, of course, resulted from, and fed into, the surge in left-populist activism among artists throughout the Western world. Modeling their approaches loosely on examples of art designed for mass production and distribution to the "proletariat"—from José Guadalupe Posada's broadsides in mid-nineteenth-century Mexico to the productivist designs and projects of the early Soviet Union—artists sought to make their art physically and economically accessible to as broad an audience as possible. The art itself, however, remained hermetic and self-referential. Recognizing that the ideas and effects conveyed by their art were not readily grasped by so wide an audience, artists of the 1960s hoped that such ideas and effects would gain currency—and would escape the discursive and commercial confines of the art world—by assuming formats that the art world could not commodify and exploit. Not incidentally, went the thinking, this would return control of the artwork—its production, its distribution, and its relation to its audience—to its makers. As Lucy Lippard wrote in 1977,

> The "artist's book" is a product of the 1960s which is already getting its second, and potentially permanent, wind. Neither an art book (collected reproductions of separate art works) nor a book on art (critical exegeses and/or artists' writings), the artist's book is a work of art on its own, conceived specifically for the book form and often published by the artist him/herself. It can be visual, verbal, or visual/verbal. With few exceptions, it is all of a piece, consisting of one serial work or a series of closely related ideas and/or images—a portable exhibition. But, unlike an exhibition, the artist's book reflects no outside opinions and thus permits artists to circumvent the commercial gallery system as well as to avoid misrepresentation by critics and other middlepeople. Usually inexpensive in price, modest in format, and ambitious in scope, the artist's book is also a fragile vehicle for a weighty load of hopes and ideals: it is considered by many the easiest way out of the art world and into the heart of a broader audience.[11]

It is significant that Lippard identifies the prevailing organization of the (typical) artist's book as "serial" or "a series of closely related ideas and/or images." It can be argued that, formally, the artist's book grew out of, and was even necessitated by, the surge in interest among artists in repetition and serial imagery. This interest was itself central to the minimalist reconsideration of geometric form, a reconsideration that sought to free the elemental shape from constructivism's relational approach to composition. As Lippard inferred, the serial sequencing of even representational imagery (not least in photographic form) provided a nonrelational visual experience—one in which narrative relationships, however elemental, could emerge instead. Ed Ruscha's books, realized as far back as 1962, are perfect examples of this "protoconceptual" condition.[12]

The most advanced structures—movements, really—for realizing the Marxian redistribution of art-world means described by Lippard were Fluxus and conceptual art. While presuming realms of art devoted to entirely ephemeral gestures and presentations in which no tangible, subsequently negotiable object was produced,[13] these movements also prompted the production of myriad objects, books prime among

individualista

```
IIIIIIIIIIIII
IIIIIIIIIIIII
IIIIIIIIIIIII
IIIIIIIIIIIII
IIIIIIIIIIIII
IIIIIIIIIIIII
IIIIIIIIIIIII
IIIIIIIIIIIII
IIIIIIIIIIIII
IIIIIIIIIIIII
IIIIIIIIIIIII
```

PHOTOGRAPH OF XEROX MACHINE USED

16

RB 13

A part of a piece.

It could be with other things, or it could be alone. It could be part of
something else and be dependent on it. It can be distinguished from other things
and it could effect them.

It has some variety and an origin.

It has been arranged, but it could be changed. It is interrelated. It has some
continuity, possibilities and limitations.

It can be appreciated, defended and repeated. It can also be avoided, isolated,
restricted, removed, replaced and destroyed.

It has been influenced. So far it has been preserved.

It may seem familiar or strange or uncertain. It might be discussed, being
rejected or accepted. It is vulnerable.

Robert Barry
1972

top:

Ladislav Novák, "Individualista," 1966

Joseph Kosuth, "Photograph of Xerox Machine Used,"
1968 (detail)

left:

Robert Barry, *A Part of a Piece*, 1972

them, whose production values were simple and based on mass-distribution formats and techniques.[14] Extended forms of literature figured centrally in this production. Several concrete poets, including Williams, Dick Higgins, Jackson MacLow, and Bici (Forbes) Hendricks, were directly affiliated with Fluxus. The conceptual artists eschewed soi-disant poetry as such, but the typographic emphasis, including the relational composition of words on a page, central to concrete poetry recurs in the work of such conceptualists as Robert Barry, Lawrence Weiner, Martin Maloney, and Peter Downsborough.

The relationship of Fluxus to conceptual art was itself problematic, and remains so to this day.[15] But both movements pioneered the production of books conceived not (only) as documents of artwork, ephemeral or otherwise, but as artworks themselves. The examples of certain other books-as-artworks, produced by artists and designers such as Bruno Munari[16] and Ed Ruscha at some geographic and/or philosophical distance from (and in some cases earlier than) Fluxus and conceptual art alike, also spurred the proliferation of "artists' books" during the 1970s.[17] The commitment of certain conceptualists— most notably Sol LeWitt and Lawrence Weiner—to the book format led this proliferation, and their spare, often serially ordered organization of images and/or text provided a stylistic model for other conceptually oriented artists.[18] As the 1970s progressed, however, fewer and fewer artists engaged in the book format emulated such qualities of austerity, rigor, and self-referentiality, preferring instead to investigate and elaborate the narrative, lexical, and pictorial traditions associated with the book.

The purely visual resemblance of volumes of concrete poetry by such as Gomringer and the Noigandres poets to the books published nearly two decades later by the early conceptualists is not simply a recurring coincidence. The concretists and the conceptualists drew upon the same tradition of geometric formal language, diverging only in the former's acceptance and the latter's rejection of semantic resonance—a divergence that recapitulated the distinction that existed between *art concret* and minimalism. This divergence, in fact, was diminished in the book format by the intimate scale and limited technical capabilities of the printed page. In the postwar era, the book was the matrix where the strains of "rational" art converged beyond geometry.

Bruno Munari, *Unreadable Book, N.Y., I*, 1949 (detail)

Goran Trbuljak, *The Exercises of an Artist*, 1975 (details)

1 Augusto de Campos, "Questionnaire of the Yale Symposium on Experimental, Visual and Concrete Poetry since the 1960s," *Litteraria Pragensis* 11, no. 22: 12.

2 The term "intermedia" was coined (or, more accurately, isolated from the writing, c. 1810, of Samuel Taylor Coleridge) by Dick Higgins in a 1965 essay by that name. A polemical screed that conflated descriptive example with tendentious social and political reference, the essay still introduced a vital rubric, one that Higgins and others quickly substantiated in subsequent commentary. "Intermedia" is reprinted, among other places, in Higgins, *A Dialectic of Centuries* (New York: Printed Editions, 1978), 12–17. The book also contains more trenchant writings on this subject.

3 In the anthology *Concrete Poetry: A World View* (Bloomington: Indiana University Press, 1968) editor Mary Ellen Solt attempted to deal with this confusing conflation of terminologies: "There are now so many kinds of experimental poetry being labelled 'concrete' that it is difficult to say what the word means." She achieved a reasonable distillation of the characteristics of concrete poetry: "... concentration upon the physical material from which the poem or text is made. Emotions and ideas are not the physical materials of poetry... Generally speaking the material of the concrete poem is language: words reduced to their elements of letters (to see) [and] syllables (to hear). Some concrete poets stay with whole words. Others find fragments of letters or individual speech sounds more suited to their needs. The essential is *reduced language* ... In addition to his preoccupation with the reduction of language, the concrete poet is concerned with establishing his linguistic materials in a new relationship to space (the page or its equivalent) and/or to time (abandoning the old linear measure). Put another way this means the concrete poet is concerned with making an object to be perceived rather than read" (7).

4 The term "concrete art" was associated with Theo van Doesburg's attempt to bring the various strains of constructivism and geometric art under one rubric, *art concret*, in 1930. Stephen Bann in his *Concrete Poetry: An International Anthology* (London: London Magazine Editions, 1967), 7, and Emmett Williams in his *Anthology of Concrete Poetry* (New York: Something Else Press, 1967), vi, described how poets working in this vein independently of one another in the early 1950s appropriated the term "concrete." Bann noted the meeting of Eugen Gomringer and Noigandres poet Décio Pignatari at the Hochschüle für Gestaltung in Ulm in 1955: "Both had in fact considered using the word 'concrete' in connection with their work, but they had been entirely unaware of each other's existence. The meeting at Ulm not only opened up a channel of communication between Gomringer and the Noigandres poets, but also led to an agreement that their work should henceforth be identified by one common title." Bann did not mention that the Hochschüle für Gestaltung, the design school established in the postwar Bundesrepublik as a kind of successor to the Bauhaus, was directed at the time by Max Bill, the Swiss geometric artist and participant in Doesburg's Art Concret group. (Gomringer was in fact Bill's secretary at the Hochschüle.) Other Swiss artists— Richard Paul Lohse, Karl Gerstner—who identified themselves as "concrete" (as opposed to "abstract") artists frequented the Hochschüle as well. The prevailing aesthetic, even ethos, at the Hochschüle was identified, even self-identified as "concrete," so the emergence of a "concrete poetry" made perfect sense in the context of a school for "concrete" art and design. Mary Ellen Solt (op. cit., 8) did note that Gomringer, based in Switzerland in the 1940s, "saw the international exhibition of concrete art in Basel, organized by Max Bill, in 1944; and he made the acquaintance of Bill, Lohse and [Camille] Graeser at the Galerie des Eaux Vives in Zürich, a special gallery for concrete paintings."

5 Williams, op. cit., vi.

6 Augusto de Campos, "Concrete Poetry: A Manifesto," *Litteraria Pragensis* 11, no. 22: 10–11.

7 Williams (op. cit., vi) noted that Fahlström "had published the first manifesto of Concrete poetry—*manifest for konkret poesi*—three years earlier in Stockholm." But English concrete poet Bob Cobbing, writing in Liesbeth Crommelin et al., *Concrete Poetry?* (Amsterdam: Stedelijk Museum, 1971), the catalogue for the exhibition of the same name, noted that Fahlström "related [the term] more to concrete music than to concrete 'art'" (23)—i.e., to *musique concrète*, the collaging of tape-recorded sounds introduced as a viable means of composition by Pierre Schaeffer and others working at ORTF Radio in Paris in 1948. (Among other things, *musique concrète* provided a formal and technical model for the development of concrete poetry's audial equivalent, sound poetry.) According to Cobbing, Fahlström "emphasised rhythm as 'the most elementary, directly physically grasping means of effect' because of its 'connection with the pulsation of breathing, the blood, ejaculation.' He opened the way not only for the structural aspects of concrete poetry which play such a prominent part in the theory and practice of Eugen Gomringer (Switzerland), the Brazilians and the Germans, but for the expressionist aspects which a second generation of concrete poets has found so potent."

8 Solt (op. cit., 8) remarked that Gomringer and Diter Rot were close friends in Berne. Rot—who was born Karl-Dietrich Roth in Hannover, Germany, and moved to Switzerland as a teenager before relocating to Iceland in the mid-1950s—planned with Gomringer and Marcel Wyss "a magazine to be called SPIRALE, whose contents would 'embrace poetry, the plastic arts, graphics, architecture, and industrial design.' Gomringer was made literary editor. 'It was my task,' he writes, 'to find a suitable form of poetry for our magazine, or myself to devise and produce one.'" (Gomringer's quotes were taken from the reminiscence, "The First Years of Concrete Poetry," that he published in *Form* 4: 17–18.) *Spirale* appeared from 1953 to 1964.

9 Jean-François Bory, *Once Again* (New York: New Directions, 1968), 11. (Ferdinand Kriwet is a German second-generation concrete poet known for his vibrant orbital poems.) In both its French and American editions, it should be noted, *Once Again* appeared as a relatively low-priced, mass-market paperback, in contrast to Williams's, Bann's, and Solt's anthologies (although Williams's *Anthology of Concrete Poetry* did appear in reasonably priced paper as well as library editions). It should also be noted that, again as opposed to the other books, the anthological function of *Once Again* is deliberately compromised by the small physical size of the book and by Bory's subjective selection and arrangement, putting the illustrated works at the service of his polemical (as opposed to historical-analytical) narrative rather than vice versa. At this time Bory was transiting from an early involvement with strictly typographical, i.e., concrete, poetry to a more expansive visual-verbal fusion, and would shortly become associated with the Franco-Italian *poesia visiva* group.

10 Bory was not alone in predicting that the transformation of the page would necessarily lead to the transformation of the book. In the afterword to Eugene Wildman's *Chicago Review Anthology of Concretism* (Chicago: Swallow Press, 1968), 153, which he assembled even while Bory was assembling *Once Again*, Wildman wrote that the "book is an invention that is ideally suited for narrative material; therefore, the problem was to make it work also for non-narrative material. The book had to become an environment, had to be made transformable, out of its structure as a book, into a kinetic and generative art object." Wildman perceived his anthology as such an object, declaring that "the concept employed here is simply this: a book is something that unfolds itself." Wildman's anthology presents its contents with the same tidy discretion found in Williams's, Bann's, and Solt's anthologies, but there is a visual drama to the sequence of the material that points to the subjective dynamic employed by Bory, a dynamic that seeks to create a whole from the sum of its parts. In *This Book Is a Movie* (New York: Dell, 1971) editors Jerry G. Bowles and Tony Russell presume such integration and regard their publication as an "exhibition"—in this case of sequential (that is, multiple-page) pieces—of "language art and visual poetry" by Anglophone poets, painters, and intermedialists, from Emmett Williams and Mary Ellen Solt to Jasper Johns and Arakawa and "orthodox conceptualists" such as Sol LeWitt, Robert Barry, Lawrence Weiner, and Mel Bochner (as well as early postconceptualists such as Vito Acconci). In intermingling word-painters with image-writers, Bowles and Russell followed the lead of Richard Kostelanetz's *Imaged Words & Worded Images* (New York: Outerbridge and Dienstfrey, 1970), which brought Robert Indiana and Claes Oldenburg—and John Cage and Merce Cunningham—together with Bory, Kriwet, and Williams. Interestingly, the Bowles-Russell anthology is ordered much more traditionally—in fact, alphabetically—than the Kostelanetz anthology of a year earlier, reasserting the "objective" anthologizing mode employed by Williams.

11 Lucy Lippard, "The Artist's Book Goes Public," reprinted in Lyons, *Artists' Books: A Critical Anthology and Sourcebook* (Rochester, NY/Layton, UT: Visual Studies Workshop Press/Gibbs M. Smith, 1985), 45.

12 As Lippard (op. cit., 46) wrote, "The new artists' books . . . have disavowed surrealism's lyrical and romantic heritage and have been deadpan, anti-literary, often almost anti-art. Ed Ruscha's *Twentysix Gasoline Stations* (1962), followed by his *Various Small Fires* (1964), *Some Los Angeles Apartments* (1965), *Every Building on the Sunset Strip* (1966), *Colored People*, and so forth, initiated the 'cool' approach that dominated the whole conception of artists' books for years."

13 Of course, salable artifacts were produced as by-products, souvenirs, and/or documents of such performances. At best, according to the populist ethos, these items were produced in relatively large editions and reasonably priced (e.g. the booklets Allan Kaprow published as documentation of happenings and performances that were witnessed live only by their participants). See Paul Schimmel, et al., *Out of Actions* (Los Angeles/New York: Museum of Contemporary Art/Thames and Hudson, 1998) for a theoretically close but historically broad examination of this general phenomenon.

14 In fact, the production methods associated with conceptual art and especially Fluxus were in large part hands-on and even craftsmanly. While many of the individual artists associated with both movements were content to have little involvement in the production of objects and books of their design, their earliest publishers (figures central to the coordination of the movements, such as George Maciunas of Fluxus and conceptual art's Seth Siegelaub) manufactured their compeers' works with exquisite care. Maciunas, in particular, made a fetish of hand-assembling Fluxboxes, producing filmstrips, and printing books and booklets to the point where he rarely produced announced works on time or in sufficient quantity. In directing his Fluxus-associated Something Else Press, Dick Higgins also employed (and prided himself on employing) great technical discretion and sense of design, as well as durable, attractive print materials and a production schedule that honored the expectations of a professionally interested clientele (e.g., libraries). See Higgins, "Two Sides of a Coin: Fluxus and the Something Else Press," in *Visible Language* 26, no. 1/2, and Peter Frank, *Something Else Press: An Annotated Bibliography* (New Paltz, NY: McPherson & Company/Documentext, 1983).

15 Henry Flynt, an artist-musician associated with Fluxus (although avowedly not a "Fluxus artist" per se), coined the term "concept art" several years before Sol LeWitt put the term into general circulation. But most conceptual artists—at least those working in New York—regarded their Fluxus contemporaries with disdain or hostility, and have until now denied much awareness of, much less any influence from, their work. Benjamin Buchloh wrote on this issue in 1989 (in *October* 55), seeming then to accept the conceptualists' protestations; his position since has grown more skeptical. See also Peter Frank, "Fluxus Fallout: New York in the Wake of the New Sensibility" (*Visible Language* 26, no. 1/2).

16 In their essay "The Page as Alternative Space, 1950 to 1969," Barbara Moore and Jon Hendricks describe Munari as "a painter, sculptor, photographer, and graphic and industrial designer working out of Milan" who "began in the late forties to make a variety of 'Libro Illegible' [sic], which were handmade combinations of stitched and cut pages, using different colors and textures of paper, that were bound as a book. In the fifties he rejected 'craft' and successfully adapted some of his ideas to the manufacturing process, as in his cut-page *Quadrat Print* produced in an edition of 2000 in 1953 or, a few years later, his mass-market children's books, which contain different-size pages, die-cuts, overlays, and books-within-books, very much an extension of his handmade works" (in Lyons, op. cit., 89).

17 Moore and Hendricks (in Lyons, op. cit., 89–90), as well as Johanna Drucker in *The Century of Artists' Books* (New York: Granary Books, 1995), 73–75, also identify Dieter Roth as a prolific early maker of books-as-art, well beyond—if influenced by—his engagement with concrete poetry.

18 Clive Phillpot discusses LeWitt's and Weiner's, as well as Ruscha's, contributions and their influence on and dialogue with other conceptualists' bookmaking in "Some Contemporary Artists and Their Books" (in Lyons, op. cit., 96–132). Phillpot's article usefully includes an exhaustive bibliography. Also in Lyons (206–22), Robert C. Morgan's "Systemic Books by Artists" looks at LeWitt's relationship to nonconceptualist artists' books that still engage serial organization.

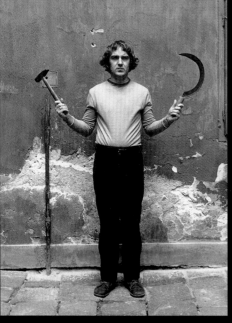
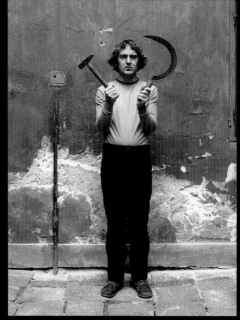
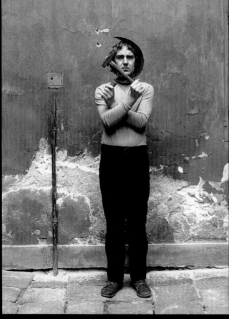

Sándor Pinczehelyi, *Sickle and Hammer I–IV*, 1973/2002

In the mid-1960s, certain artists began to highlight the intellectual elements of artistic production and reception. The result was a diverse form called "conceptual art," which strongly reflected the antimaterialist values of the Vietnam War era. For example, Lawrence Weiner made works consisting exclusively of descriptive but open-ended phrases painted on a wall. These pieces were contingent on the viewpoint of the individual observer, because they were fully realized only in her imagination. Sales of such dematerialized works were difficult if not impossible. Sol LeWitt, who coined the term "conceptual art," also made temporary wall drawings, following a predetermined plan that denied the need for intuition as well as rational thought. Such undermining of the traditional art object also promoted genre-crossing hybrids: literature and visual art, theater and visual art, dance and visual art. In much of the work in this section, text takes priority, but a critique of the object also permeated the performances of Lygia Clark and Hélio Oiticica, installation works by Daniel Buren, and earthworks by Robert Smithson.

Section 5
The Object
Redefined

From an economic standpoint, such involvement in the arts can mean direct and tangible benefits.

It can provide a company with extensive publicity and advertising, a brighter public reputation, and an improved corporate image.

It can build better customer relations, a readier acceptance of company products, and a superior appraisal of their quality.

Promotion of the arts can improve the morale of employees and help attract qualified personnel.

David Rockefeller

Perhaps the most important single reason for the increased interest of international corporations in the arts is the almost limitless diversity of projects which are possible.

These projects can be tailored to a company's specific business goals and can return dividends far out of proportion to the actual investment required.

C. Douglas Dillon

The excellence of the American product in the arts has won worldwide recognition.

The arts have the rare capacity to help heal divisions among our people and to vault some of the barriers that divide the world.

Richard M. Nixon

But the surprising thing is that increasing recognition in the business world that the arts are not an art apart, that they have to do with all aspects of life, including the business, that they are, in fact, essential to business.

Frank Stanton

EXXON'S support of the arts serves the arts as a social lubricant.

And if business is to continue in big cities, it needs a more lubricated environment.

Robert Kingsley

My appreciation and enjoyment of art are esthetic rather than intellectual.

I am not really concerned with what the artist means; it is not an intellectual operation—it is what I feel.

Nelson Rockefeller

Hans Haacke, *On Social Grease*, 1975

Walter de Maria, *Mile-Long Drawing*, 1968

opposite page: Carl Andre, *Secant*, 1977

Richard Kostelanetz, "Third Avenue" and "Second Avenue," 1974

Jaroslaw Kozlowksi, "He Has a Cigarette in His Mouth," 1972

opposite page: David Lamelas, *Antwerp–Brussels (People + Time)*, 1969

ANNY DE DECKER ANTWERP 1.20 P.M.

HERMAN DALED BRUSSELS 1.50 P.M.

BERND LOHAUS ANTWERP 1.30 P.M.

DAVID LAMELAS BRUSSELS 1.55 P.M.

MARCEL BROODTHAERS BRUSSELS 2.13 P.M.

MARIA GILISSEN BRUSSELS 2.40 P.M.

PANAMARENKO ANTWERP 3.50 P.M.

ILKA SCHELLENBERG ANTWERP 2.45 P.M.

KASPER KÖNIG ANTWERP 3.30 P.M.

opposite page: Sol LeWitt, *Wall Drawing #295: Six Superimposed Geometric Figures*, 1976

Channa Horwitz, *Eight*, 1979 (details)

COMPOSING ON A CANVAS.

STUDY THE COMPOSITION OF PAINTINGS. ASK YOURSELF QUESTIONS WHEN STANDING IN FRONT OF A WELL COMPOSED PICTURE. WHAT FORMAT IS USED ? WHAT IS THE PROPORTION OF HEIGHT TO WIDTH ? WHAT IS THE CENTRAL OBJECT ? WHERE IS IT SITUATED ? HOW IS IT RELATED TO THE FORMAT ? WHAT ARE THE MAIN DIRECTIONAL FORCES ? THE MINOR ONES ? HOW ARE THE SHADES OF DARK AND LIGHT DISTRIBUTED ? WHERE ARE THE DARK SPOTS CONCENTRATED ? THE LIGHT SPOTS ? HOW ARE THE EDGES OF THE PICTURE DRAWN INTO THE PICTURE ITSELF ? ANSWER THESE QUESTIONS FOR YOURSELF WHILE LOOKING AT A FAIRLY UNCOM - PLICATED PICTURE.

opposite page: John Baldessari, *Composing on a Canvas*, 1966–68

Luis Camnitzer, *Sentence Reflecting the Sentence that States the Reflection*, 1975

Douglas Huebler, *Variable Piece #506/Tower of London Series*, 1975

top: Dan Graham, *Eleven Sugar Cubes*, 1970

bottom:

Bruce Nauman, *Microphone/Tree Piece*, n.d.

Waltércio Caldas, *The Collector*, 1974

Otto Piene, *Milky Ways*, 1964–65

Walter de Maria, *The Lightning Field*, 1971–77

opposite page:

Robert Smithson, *The Spiral Jetty*, 1970

Dennis Oppenheim, *Maze*, 1970

this page:

Heinz Mack, *Mirror between Sky, Earth, and Sea*, 1963
Three Ilfochrome photographs; each 27 $\frac{1}{2}$ x 33 $\frac{7}{8}$ in.
(70 x 86 cm)
(no longer extant)

Michael Asher, *Untitled*, 1971 (installation view and plan)

top:

Piero Manzoni, *Line of Infinite Length*, 1960

Piero Manzoni, *Line 15.81 m*, 1959

Piero Manzoni, *Line 6 m*, 1959

bottom: Antonio Manuel da Silva Oliveira,
Hot Ballot Box, 1975

Hélio Oiticica, *Counter Bolide to Return Earth unto the Earth*, 1979

Antonio Dias, *The Invented Country*, 1976

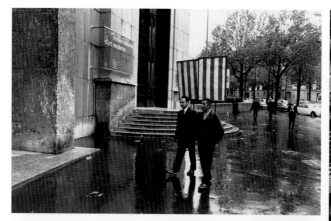

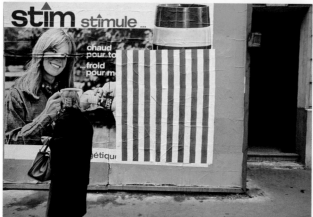

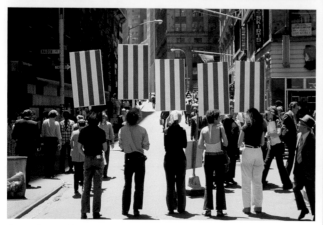

Daniel Buren, *Photo-souvenirs*, (details, clockwise from top right):

"Seven ballets in Manhattan," work in situ, May 27/June 2, 1975, New York

"Solo exhibition on the limits of the artist's freedom in relation to society," work in situ, without invitation at the opportunity of the exhibition *When Attitudes Become Form*, March 1969, Berne

"Seven ballets in Manhattan," work in situ, May 27/June 2, 1975, New York

"Affichage sauvage," work in situ, April 1968, Paris

"Hommes/Sandwichs," work in situ, April 1968, Paris

reality rush

Shifts of Form, 1965–1968

Inés Katzenstein

The object of this text is to analyze the ways in which the ruptures characteristic of the 1960s manifested themselves in the field of geometric abstraction. If politics was the dominant perspective of the period, the analysis would show how a spirit of ethical questioning gradually entered artistic discourse, pushing for the breakup of the autonomy of various cultural spheres, and, by the end of the decade, compromised the modernist project's chances for survival.

The artists I have chosen in order to map this historical crossroads—the Frenchman Daniel Buren, the Argentine David Lamelas, the Brazilian Hélio Oiticica, and the North American Robert Smithson— are perhaps not obvious examples of these ruptures. They were never involved in political activity or even in making explicitly political art. But it is precisely this condition that seems to me productive for my purposes. I propose to explore the complexity that arises from cases in which artists working with geometric forms in various ways were actively related to the historical crisis within the contexts of their respective practices without giving up the logic of that form. I am interested in critical repositionings of the status of the image and of the figure of the artist that take place *inside* the limits of art, so I have not chosen artists who proclaimed a specific political commitment.

This text focuses instead on four itineraries that developed between 1965 and 1968 in very different contexts.[1] In these itineraries, form would be altered so that from a classic modernist viewpoint it would seem "impure," sullied by the street, the information media, popular culture, and the postindustrial landscape. These points of historical inflection coincide with the rejection of the conventions of painting and sculpture by artists who were focused on connecting their practices to the real, considered as a space of both urgency and freedom. More often than not these movements led to an extension of artistic practice beyond the confines of the museum, and to work with new "materials" saturated with social implications.

Two circumstances in the intellectual life of the period will prove essential to tracing these four itineraries. In the first place, during the 1960s artists and intellectuals had to reexamine their roles. Especially in industrialized countries, the left faced the consummate fact that "an oppressively stable, monolithically industrial, capitalist civilization was now in place."[2] The preeminence of what in 1967 Guy Debord characterized as "the society of the spectacle" fueled the various debates enflaming the

decade and obliged many artists to rethink the validity of their practice. The force of the struggles for the rights of minorities, and the violence of the processes of de- and recolonization emerging from the Third World, obliged these artists to question the encapsulation of different artistic languages and media as well as their own aspiration to represent social problems in an abstract code.[3]

Secondly, the "discovery" of structure took place, or what Frederic Jameson defines as "the opacity of the institution." It consisted of "a realm of impersonal logic in terms of which human consciousness is itself little more than an effect of structure."[4] In art as in theory, the real began to be monopolized by the sign, and not by the referent or the material. The command of language over the subject was postulated, and institutions confronted as ideological apparatus. Thus one of the axes characterizing the position of many artists of the period was the tension between making the work correspond to the aesthetics of the structure (i.e., to the supposed neutrality of the so-called aesthetic of administration,[5] with the apparatus and strategies of the communications and advertising media) and simultaneously maintaining the vocation of awakening critical consciousness about the ideology implicit in these structures.

Changing the Point of View: Daniel Buren

The political dimension emerged in the career of the French artist Daniel Buren between 1965 and 1970, when he constructed his artistic program in a perfect (Althusserian) joining of theory and object. During these five years, in a Paris in upheaval, Buren undertook a questioning of painting that led him successively to distill the basic elements of the medium, to move the artwork from the museum to the street, and to initiate a critical theory of the interrelation of artwork and museum.

While Buren was producing these shifts, Roland Barthes pointed out that for the modern writer "the hand, cut off from any voice, borne by a pure gesture of inscription (and not of expression) traces a field without origin—or which, at least, has no other origin than language itself, language which ceaselessly calls into question all origins."[6] Barthes proposed rethinking the history of writing not as a history of authors considered as psychological entities but as the history of the subjects of enunciation, and he considered that writing was fundamentally about reaching a point where it is not the author but the language that is acting. During the great insurrection of May 1968 the young Buren achieved that theoretical disconnection between the artist and the work in the realm of painting.

The road to bringing about this rupture was twofold: On one hand, it consisted in producing an image through a method that excluded any compositional decision. On the other hand, "the neutrality of the statement"[7] had to be achieved, not only to avoid the supposed "freedom" implicit in the figure of the artist, but also to stop producing something "significant." In 1966, after two years of experimentation, Buren arrived at what would be, from then on, his only "visual tool": a design, on canvas or paper, of white stripes alternating with stripes of some other color, each 8.7 centimeters wide. This image satisfied Buren's formal quest: there is no composition, no figure or ground, no material. The image is for him the manifestation of the absolutely concrete. Out of this "ground zero" of painting

would grow a constant alternation between the most stifling reduction and repetition and the most surprising expansion and variation.

From the standpoint of his demystification of the artist as a creative genius, Buren took part in a group endeavor with Olivier Mosset, Michel Parmentier, and Niele Toroni. In a climate of "militant" art and activism against the Vietnam War, the group participated in the Salon de Jeune Peinture in 1967 with an action that highlighted the picture-making process as a mechanical task devoted to producing an "almost null" object. The spectacle resembled, in its vacuity and irony, certain Fluxus actions.[8] The artists constructed a kind of reduced catalogue of actions/signs: they simply scratched, folded, and made a circle in the middle of a canvas, or in Buren's case covered the outside bands of a striped industrial fabric with white paint. Manifestos announcing that they were not painters accompanied the happening. They denounced painting for serving to "illustrate 'interiority' by means of aestheticism, flowers, women, eroticism, the everyday environment, art, dada, psychoanalysis, the Vietnam War."[9] In a second action the group set up their works in a theater to be looked at by the audience for one hour. After other actions of this type,[10] they explained in a letter informing the Salon's organizers of their withdrawal from the event that their decision was due to the fact that painting "is by vocation objectively reactionary." Buren pointed out, "The flyer for Jeune Peinture is pretty close to the situationist spirit: it questions the place in which something is done and its very practice."[11]

If the streets of Paris had been a privileged artistic space since the beginning of the decade for the work of the *affichistes* (poster artists) as well as for the more playful experiences of GRAV (Groupe de Recherche d'Art Visuel), the agitation of the end of the decade and the need to take the floor in the public sphere through graffiti and posters gave the city and its walls a thoroughgoing political resonance. It is in this milieu that Buren extrapolated his sign from pictorial space into the space of the street. He placed it on sandwich boards worn by a group of demonstrators (in the performance *Hommes/Sandwichs*, 1968) and pasted it in places originally intended for advertising posters.

Shortly after 1968 Jean Baudrillard maintained that "the real revolutionary media during May were the walls and their speech, the silk-screen posters and the hand-painted notices, the street where speech began and was exchanged."[12] In Buren's case, at the same time that his work was drawn along by the magnet that was the city at that moment, the vacuity of the striped sign declared a firm refusal to reproduce the codes of public space. He was not operating in the communications register but rather in the register of the anti-illusionistic concrete, opposing himself radically to the rhetoric of content implicit in the political slogan. This de-territorialization of painting from museum to street emphasized painting's "reactionary" charge[13] and signaled the inauguration of a new type of theoretical approach to the problem of art on behalf of the artist. The banality of Buren's sign, contrasted with the density of social space, reveals the sign as an entity that functions in relation to that which encircles or supports it. The artist can thus begin to see that such exteriority can be penetrated ideologically. Painting ceases to be an analyzable projection screen and instead functions as a shallow frame highlighting the real as material for excavation. As Buren commented in conversation, "Even today, the viewer who stops in front of the

vertical stripes, even if they are important, constitutive, does not understand anything in my work . . . It is the classic case of the man pointing at the moon and the idiot who looks at his finger."[14]

Buren's next step would be to reenter the confines of the museum, no longer considered a neutral space but rather an institutional territory with an aesthetic, economic, and mythic role that his works would aspire to reveal. From this point on, his images would become instruments to expound on the conditions of their own visibility. This would be the start of his long involvement in what is today known as "institutional critique."

David Lamelas: Form as Media and Media as Form

The development of David Lamelas's work is less programmatic than that of the others examined in this text, and the artist created it more intuitively than theoretically. But a look at his key works of these years reveals his progressive distancing from geometric sculpture and his adoption of a conceptualism based on an analytical examination of the ways in which reality is constructed and perceived.

By the middle of the decade these works increasingly exhibited a formal simplification, but at the same time they took on a deictic function, as signs pointing out concrete spatial situations. Lamelas explained: "I wanted to concentrate on the elements by which *perception itself* is produced. Analyzing the perception system itself was enough art matter for me."[15] His strategy for this consisted in organizing simple forms (what today he calls a basic "grade school" geometry[16]) in such a way that the viewer would observe them in connection with things outside of them, especially the architecture of the exhibition spaces. This interest is present in his *Untitled (Corner Piece)*, proposed around 1965 but first realized for *Beyond Geometry*, and in *Limits of a Projection* (1967).[17] In a small, dark room a spotlight on the ceiling projects a sharply defined beam of light, creating a white circle on the floor. The spotlight in this work (which was made in the same year theorist Oscar Masotta characterized current Argentine art by the term "dematerialization"[18]) does not illuminate anything. The work is a signal made with one element of the exhibition system, which only points at itself as (an empty) form.

During these years Lamelas was close to a group of young artists who were simultaneously exploring a phenomenology of immediacy through actions and happenings, and an "art of the mass communications media." Lamelas realized that he could not keep conceiving of the geometric forms he had been working with as entities separate from the media apparatus surrounding contemporary subjects. He consequently devoted himself to what Benjamin Buchloh, in a text about the artist, called the "fusion of the techno-logical and the cultural object."[19]

Situation of Time was the first work to incorporate communications media to explore the notion of time while maintaining the same reductive, serial, and geometric aesthetic of his earlier works. It con-sisted of an installation in a dark room in which seventeen television monitors were lined up along the four walls of the room. The televisions were tuned to a nonexistent signal and displayed simply the "snow effect" of the blank screen. The minimalist[20] aesthetic, combined with the use of media technology,

David Lamelas, *Untitled (Corner Piece)*, c. 1965/2004

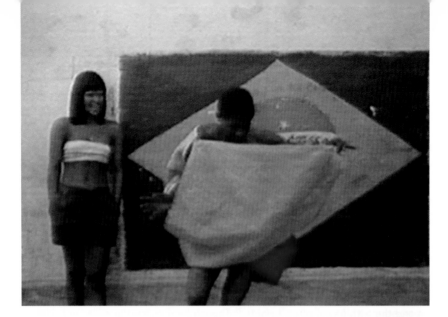

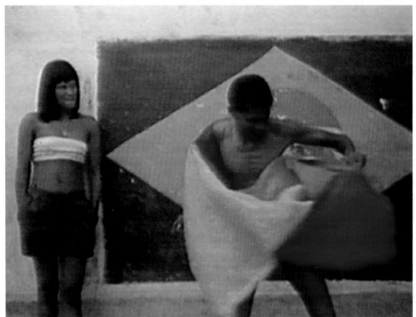

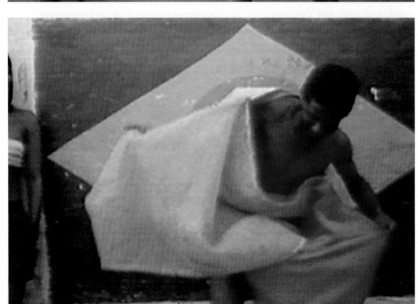

Hélio Oiticica, *Parangolé*, 1964

David Lamelas, *Untitled (Corner Piece)*, c. 1965/2004

produced "a free information area," an environmental experience that contrasted drastically with the fragmented or narrative temporal experience traditionally offered by the media.

At this point Lamelas's experiences, as well as those of other artists in the group, did not engage either the critical potential of the media or their specific contents, but rather focused on the media as media, on different instances of communication as a system. Nonetheless, the growing oppression and restriction of individual freedoms in Argentina since the 1966 military coup, along with the news of student uprisings all over the world, pushed for a politicization of artistic expression that was exacerbated at the start of 1968, when Lamelas left Argentina to study in London.[21]

The first work that Lamelas showed abroad was an installation for the 1968 Venice Biennale entitled *Office of Information about the Vietnam War on Three Levels: Visual Image, Text, and Audio*. This work marks a radical point in his career: the break with sculpture in formal terms and the start of an analytical approach to the social world. The piece consisted of a desk, a telex connected to the ANSA news agency in Rome, a tape recorder, and a microphone, separated from viewers by a glass wall. During the months of the Biennale the telex continuously received cables with news about the Vietnam War, which were read by a secretary inside the cubicle in different languages to the audience, wearing headphones. With *Office of Information* Lamelas transformed the phenomenological search associated with geometry into a different type of phenomenology that concentrated on the systems of reception of information, considered one of the privileged experiences of the perception of the real. The work involved visual information, sound, and political "content." Its formal features reflected the ideology of mass media: the "encapsulation" of the informative space behind glass underlined the architecture of power implicit in the distribution of information and the passivity of the act of reception.

Lacanian theoretician and critic Oscar Masotta wrote on the subject of media art in 1968: "The problems of contemporary art reside less in the search for new content than in analysis of the media used for the transmission of those contents. 'Media' here means generally what it means in advertising jargon: the information media (television, film, magazines, and newspapers). And if now there is talk of not concerning oneself with content it does not mean that avant-garde art is moving toward a new purism or a worse formalism. What occurs today in the best pieces is that the contents are fused with the media used to convey them. This concern—demonstrated explicitly for the first time by pop art—is inseparable from a true sociological concern, that is, of a new way of returning to 'content.'"[22] Although *Office of Information* operated with extreme distance and "objectivity," the fact that the information it transmitted was exclusively about the Vietnam War gave it an undeniable political content; it also broke through the Biennale's isolation with regard to the conflicts of the historical moment. Proof of the work's effective political stance is the fact that the piece's title was censored by the Biennale's organizers, who changed it to *Information Complex on a Chosen Theme on Three Levels: Visual, Written, and Oral*.[23]

Alleging a pseudonaive interest in "the media as media," Lamelas penetrated the structure of the Biennale with political news, and abandoned sculpture. Some time later he said, "After *Office of Information* . . . I became interested in social context."[24]

Hélio Oiticica: Political Poetics

An active participant in the Brazilian neoconcrete movement, young Hélio Oiticica combined a neoplasticist and concrete heritage with a search for a nonalienated subjectivity. Since the beginning of the 1960s he had dedicated himself to dismantling the conventions of painting through an elaborately articulated program devoted to the spatial unfolding of form and color. This included two-sided suspended paintings, reliefs, environments, and penetrable structures, and culminated in the formulation of what he called *Parangolés*.

In order to discuss the politics implicit in Oiticica's work during this decade I will concentrate on a series of *Parangolés* made between 1964 and 1968, specifically a series of capes that included slogans and political-poetic proclamations. Oiticica left Brazil four days before the military dictatorship established widespread censorship and the withdrawal of civil rights.[25] Though he remained in exile, in London and New York, until 1978, one prior experience was fundamental for his work in general: his discovery in 1964 of the slums of Mangueira and his participation in the samba school there. This deliberate social deconditioning dramatically affected his ethical views and the manner in which he continued to work on the problem of form. His European modernist heritage—including the very idea of the work of art— would find itself dismantled.[26]

Parangolés are capes, banners, or tents to wear or carry. Oiticica defined this invention as an "environmental art par excellence,"[27] in which color, poetry, dance, photography, and painting are integrated in a total experience. The *Parangolé* is not a static object or a complete form for contemplation in a museum, but an inconclusive formation conceived as a vehicle of pure experiential and aesthetic potential to be unfurled in a collective improvisation.

In its evolution, first the *Parangolé* was a banner, a sort of bundle that opened like a placard without a message. Later it became a kind of cape, which afforded the participant a greater involvement with the object as well as greater control over its movement. The capes are made of several layers of material, whose colors and prints are seen fleetingly as the wearer moves and dances. Their common materials are transmuted into elegant ritual robes.

Some *Parangolés* include brief sentences, half poetry and half slogan, departing definitively from the purist history of abstraction. One of them reads, "Incorporo la revuelta" (I embody revolt). This *Parangolé* has a sandwich-board structure, but the text is hidden between layers of cloth and wicker. The first-person-singular voice of the secret message would be that of the participant, muffled by the dance. It is not, therefore, a direct denunciation or a protest, but rather a clandestine assertion referring directly to the circumstances of its own subordination, or perhaps a mantra capable of sticking to the wearer and transforming him.

Enjoyment of the body, involvement in collective experience, and the assertion of an identity outside the productivist morality of industrialized societies: these were just a few of the paradigmatic topics of the 1960s. In Latin America the situation was complicated by the crisis of developmental programs

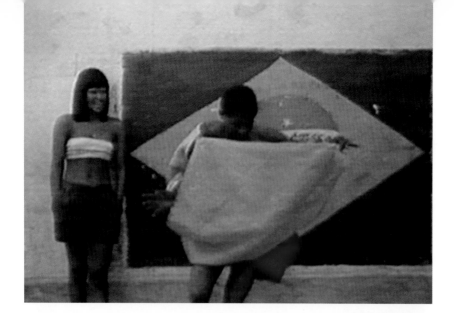

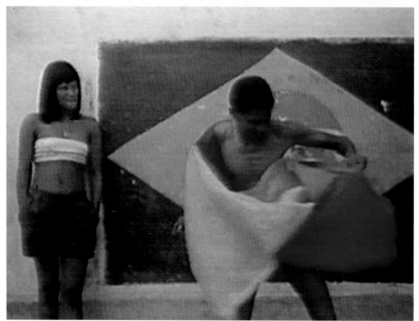

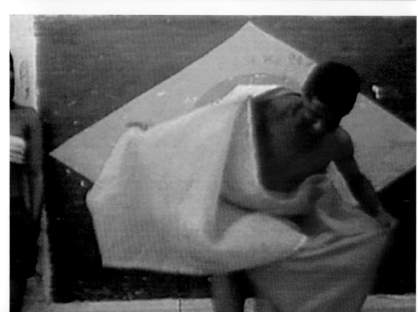

Hélio Oiticica, *Parangolé*, 1964

and the political polarization that emerged after the Cuban Revolution. Adding to this complexity, toward the end of the decade the formulation of the "theory of dependence" explained the supposed "delay" in the region's development as a consequence of a structural dependence on central economies.[28] Oiticica synthesized these ideas in *Parangolé 16*, which included the sentence "Through adversity we live." He would repeat this sentence later in the conclusion to his "General Outline of the New Objectivity": "The condition for the Brazilian avant-garde, the motto, the cry of alarm for the New Objectivity would be, 'Through adversity we live!'"[29] Oiticica thus inverted the discourse of development, which mandated the eradication of all antimodern elements in the Third World to achieve economic and political progress. On the contrary, he proclaimed that only by working through the conditions of subordination was it possible to achieve an avant-garde truly integrated in the social field.

In 1966, in collaboration with the artist Ruben Gerchman, Oiticica created two "social Parangolés." One repeated the "sandwich man" structure and bore the words "freedom cape" hidden among the layers of cloth. Once again the artist staged the ambiguity between subjection—since in theory "the sandwich man" would be the objectified subject on the verge of literally becoming a sign—and revolt, since that very subject was hiding an amulet-text in his *Parangolé* that would endow him with inner freedom.

In 1965 Oiticica was invited to participate in the show *Opiniao 65* at the Museum of Modern Art of Rio de Janeiro. He appeared on the day of the opening with a group of dancers from the samba school, but the museum would not let them in. Not only did they constitute a social class that does not usually attend museums, but in addition to their costumes they wore *Parangolés*, lending the event the dual nature of a vibrant party and a popular protest. Oiticica explained, "This was the decisive principle: vitality, individual or collective, would be the emergence of something solid and real despite underdevelopment and chaos. The future will arise from that Vietnamesque chaos, not out of conformity or stupidity. Only by razing furiously will we be able to raise something valid and palpable: our reality."[30]

Robert Smithson: The Other Side of the Tracks

In the United States Robert Smithson was one of the most influential opponents of the confinement of the artwork in museums and galleries. But since his rejection of the art establishment was always double-sided, his political position escapes simple classification. While he held firmly that "the museum undermines one's confidence in sense data and erodes the impression of textures upon which our sensations exist,"[31] at the same time he considered the art space a terrain in which to affirm the importance of the material element in the conceptual operation. They were also fundamental places from which to expand the "siting" of his work dialectically. In this sense, especially from 1966 to 1968, Smithson aspired to "disclose the confinement rather than make illusions of freedom."[32]

Already in 1965 his sculptures inspired by geological crystalline formations questioned their own physical limits through the incorporation of mirrors. The viewer's gaze on the reflective surfaces covering these works was immediately redirected outward. This triangulation of the gaze was a first indication of

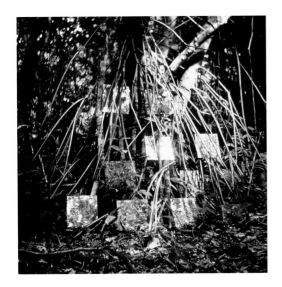

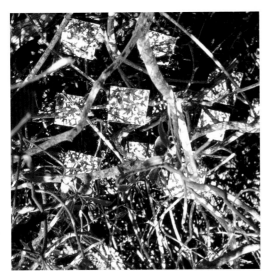

Robert Smithson, *Yucatan Mirror Displacements (1–9)*, 1969

the artist's interest in exploring the temporal dimension of his work. It also alluded to a notion that would be fundamental to his practice: that which is "outside of the field." At the same time, he pondered the material sources hidden behind the minimalist "boxes" his colleagues were making. Thus, beginning in 1966 Smithson (who was born in New Jersey and studied geology) investigated the New York area, the suburban landscape, abandoned quarries, garbage dumps, and highways.

In 1967 he wrote "A Tour of the Monuments of Passaic, New Jersey," which was published in *Artforum*. This essay combined an account of a walk through New Jersey and a series of black-and-white photographs of "monuments" along the way: a bridge over the Passaic River, a crane with a long attached pipe running along the bank of the river, six pipes emerging from the ground gushing water (Smithson described these in a Duchampian manner as "desiring machines"), an enormous parking lot, and a children's sandbox.

Smithson ironically "elevated" these banal images to monumental status in order to accentuate their structural resonance with minimalism. But his purpose in this and other such expeditions was not the reestablishment of a unity between the postindustrial landscape as the original and minimalist works as the reflection, but rather to propose their mutual separation, which he qualified as "mannerist." He treated the subject in a Borgesian way, keeping the specular tension between metropolis/suburb and inside/outside visible. As a consequence of these excursions Smithson abandoned sculpture in the formal sense; in 1968 he created his first non-sites, which set up a counterpoint between a place located beyond urban space and its reflection within an exhibition, where a collection of maps, photographs, and concrete materials from that place was presented.

Nor did Smithson's walks aspire to revolutionize everyday life like the urban situationist *dérive*.[33] He was more like an exalted apocalyptic (hence his obsession with the idea of entropy) who is interested in knowing the geographic places most affected by civilization. The Passaic tour was fieldwork for him, a reconnaissance mission on which he found nature resignified by a new industrial picturesqueness, but also reality (and its gaze) crossed by representation. "I have been wandering in a moving picture that I couldn't quite picture," he concluded.[34]

The French philosopher George Didi-Huberman analyzed the emergence during the Renaissance of a suspicion about the "low materialism" of sculpture. If painting was "*una cosa mentale*" (a thing of the mind) according to Leonardo's famous phrase, sculpture seemed linked to the unfinished, the discarded, the dirty. Something of this old argument seems to have survived in what Smithson called the "purism" of the critic Clement Greenberg. Smithson's interest in materials from half-abandoned suburban landscapes meant a return to the origin and a polemical way of counteracting the restrictions of Greenberg's model, who would not have hesitated to attack the places chosen by the artist on aesthetic and political grounds as "kitsch." On the other hand, his interest in materiality placed Smithson in conflict with the "dematerialization" of the work of art, an idea that was spreading among conceptual artists, and that he viewed as a relapse into idealism.[35] Because he translated spatial information into different systems of representation (the photograph, the map, the diagram, the sculpture) and proposed a system of

Robert Smithson, *Monuments of Passaic*, 1967 (details)
24 gelatin-silver prints; each: 10 x 10 in. (25.4 x 25.4 cm)
Estate of Robert Smithson

displacements and infinite echoes, his approach can be connected to the conceptual insistence on the primacy of language. But two things separated him from his conceptual colleagues: first, that he rejected any self-referentiality, and second, that material presence is fundamental to his work. The latter became ever more explicit starting with the non-sites.[36]

Despite these characteristics, the social direction in Smithson's work is not historically isolated.[37] A line of thinking emerged during the 1960s that, in contrast to modernist orthodoxy, proposed the North American commercial/industrial vernacular as a subject of study: parking lots, gas stations, and billboards, though considered "the ugly and the ordinary"[38] were beginning to be intuited as the only landscape relevant to present conditions. Pop art, Jack Kerouac's *On the Road*, the books and photos of Ed Ruscha, Tony Smith's famous negative epiphany while driving along the New Jersey Turnpike, *Learning from Las Vegas* by Robert Venturi and Denise Scott Brown: all of these framed and stimulated Smithson's exit to the fringes.

The progressive movement of Smithson's work outside the institutional limits of art was not an act of ecological militancy, but an act of cryptic romanticism placated by a firm pragmatism. He was capable of writing, "The Establishment is a nightmare from which I am trying to awake . . . All individual power is undermined and wasted as vague institutions of 'culture,' 'education' and 'sport' spread into departments of delusion,"[39] but also of saying, "I agree with Flaubert's idea that art is the pursuit of the useless, and the more vain things are the better I like it, because I'm not burdened by purity."[40] Later, in the early 1970s, the ironic relationship between the inaccessibility of his earthworks and the circulation of their art-world documentation confirmed the complexity and the realism of his project.

In the geographically dispersed trajectories of Daniel Buren, David Lamelas, Hélio Oiticica, and Robert Smithson the period between 1965 and 1968 marks a clear change of direction. Afterward, a concern about the real as a social construct began to challenge the plausibility of thought as form, which had defined these artists' previous approaches. Thought, for them, subsequently became thought about forms in which aspects of the world—actions, words, institutions, and media—began to play an increasingly important role, shaking the modernist sovereignty of abstract form.

Translated from the Spanish by Linda Phillips

1 The choice of two South American artists stems from the desire to present the Brazilian and the Argentine contexts as two different situations. Although there are clearly conditions that affect the whole region simultaneously, the intellectual and ideological conditions of Oiticica's and Lamelas's careers are quite different.

2 Perry Anderson, *A Zone of Engagement* (London: Verso, 1994), 37.

3 A paradigmatic example of this progressive self-questioning can be found in the following declaration by the writer Julio Cortázar, in a letter to his Cuban colleague Roberto Fernández Retamar in May 1967: "Incapable of political action, I will not relinquish my sole vocation of culture, my stubborn ontological search, the games of the imagination in the most vertiginous realms; but all of this does not revolve on its own and for its own sake, it no longer has anything to do with the comfortable humanism of the Mandarins of the West. In the most unwarranted thing I could write, a desire for contact with the historical present of man would always appear, a taking part in man's long march towards his personal best as a collective and as humanity." "Acerca de la situación del intelectual latinoamericano" ("Regarding the Situation of the Latin American Intellectual"), letter to Roberto Fernández Retamar, May 10, 1967.

4 Frederic Jameson, "Periodizing the Sixties," in *The Ideologies of Theory*, vol. 2 (Minneapolis: University of Minnesota Press, 1988), 190.

5 Benjamin Buchloh, "Conceptual Art 1962–1969: From the Aesthetic of Administration to the Critique of Institutions," *October* 55 (winter 1990), 105–43.

6 Roland Barthes, "The Death of the Author" (1968), in *Image, Music, Text* (New York: Hill and Wang, 1978), 146. This argument of Barthes continued the ideas developed in *Writing Degree Zero* (1953).

7 Daniel Buren, "It rains…," in *Five Texts* (New York: John Weber Gallery, 1973).

8 For example, La Monte Young *Composition 1960 #10 to Bob Morris*, which consisted simply of the following phrase: "Draw a straight line and follow it," or his *Piano Piece for David Tudor #2*: "Open the keyboard cover without/making, from the operation, any/sound that is audible to you./Try as many times as you like./The piece is over either when/you succeed or when you decide/to stop trying. It is not/necessary to explain to the audience…" (1962).

9 Daniel Buren, Michel Parmentier, *Propos deliberes* (Brussels: Palais des Beaux Arts, 1991), 154.

10 The group's third action consisted of a presentation of their paintings with a recording saying: "Art is illusion, not the paintings by Buren, Mosset, Parmentier, Toroni…" The fourth and final demonstration was to consist of each artist painting the work of the other, but it was never executed.

11 *Propos deliberes*, 43.

12 Jean Baudrillard, *For a Critique of the Political Economy of the Sign* (Saint Louis: Telos, 1981), 176.

13 Buren wrote: "There is not an art which is political and an art which is not. All art is political and as a whole art is reactionary."

14 Daniel Buren, *Conversations avec Anne Baldassari* (Paris: Musée des Arts Decoratifs, Flammarion, 1987).

15 David Lamelas, undated ms.

16 Telephone interview by the author, July 2003.

17 Exhibited in *Beyond Geometry: An Extension of Visual-Artistic Language in Our Time*, at the Instituto Torcuato Di Tella, Buenos Aires, 1967.

18 Oscar Masotta, "Después del pop, nosotros desmaterializamos," in *Conciencia y estructura* (Buenos Aires: Editorial Jorge Alvarez, 1969).

19 Benjamin Buchloh, "Structure, Sign and Reference in the Work of David Lamelas," in *David Lamelas: A New Refutation of Time* (Rotterdam: Kunstverein München, Witte de With, 1997), 131.

20 Due to his emphasis on modular ordering and the use of artificial light as a plastic element.

21 With Lamelas already absent, the *Experiencias 68* carried out at the Instituto Di Tella in Buenos Aires included perhaps the first art of media work by Roberto Jacoby, which incorporated explicitly political contents: an antiracist proclamation, a text questioning the artistic function, and a telex receiving information about the student uprising in France in May of 1968. Lamelas participated in *Experiencias 68* with a work called *Proyección* that consisted of two slide projectors placed back to back emitting blank images. One of them projected the image of a wall (showing a rectangle of white light) and the other projected the image onto a window so that it was lost in infinity. At the same time, Lamelas was preparing his work for the Venice Biennale.

22 Oscar Masotta, "Después del pop," 223.

23 The 1968 Venice Biennale was thrown into an upheaval by the presence of students who occupied the Academia building for one hundred days and set up pickets around the pavilions to protest the "bourgeois and fascist" character of the exhibition. Today Lamelas reflects on the moment: "The '68 Biennial was very politicized. But that situation did not surprise me, I was used to that kind of action from my experience with the Argentine Left and because I knew that within the Biennale I was making work that was ultimately more antiestablishment than the pickets." Telephone interview by the author, July 2003.

24 David Lamelas, undated ms.

25 In December 1968 the dictatorship was intensified, decreeing the "Acto Institucional No. 5."

26 The 1960s were a period of awakening interest in popular culture and the discrediting of the culture of the elite in all of Latin America. On one hand, the discovery of life on the fringes of Los Morros, in Rio de Janeiro, had already been aesthetically explored by the filmmaker Nelson Pereira dos Santos, particularly in his 1955 film *Rio 40 grados*. On the other hand, the poet Ferreira Gullar, author of the Neoconcrete Manifesto, also went through a political restructuring of his task as an intellectual and an artist at the beginning of the decade. In his 1963 "Cultura puesta en cuestión" he writes that there are "three routes to follow: to devote oneself to an activity with no valid cultural function for economic gain, protected by the dealers; resist the pressures of the market, go against it, enclosing oneself in a solipsism that will drive one to madness or suicide and lastly, break with the current conception of art in order to discover its effectively revolutionary social function." Quoted by Aracy Amaral in *Arte para que?: a preocupacao social na arte brasileira, 1930–1970* (São Paulo: Nobel, 1987), 328.

27 Hélio Oiticica, *Aspiro ao grande labirinto* (Rio de Janeiro: Rocco, 1986), 55. This expansion of the work toward the environmental was an attitude that was simultaneously being theorized by the Brazilian critic Mário Pedrosa, who held in those years that "one can hardly see any more without also touching and feeling." "Mundo, homen, arte em crisis," in *Mário Pedrosa, textos escolhidos* (São Paulo: Edusp, 1995), 217.

28 Fernando Henrique Cardoso and Enzo Faletto, *Dependencia y subdesarrollo en América Latina* (México DF: Siglo Veintiuno Editores, 1969).

29 "Esquema general de la nueva objetividad," in Oiticica, *Aspiro*, 98.

30 *Aspiro*, 83.

31 Robert Smithson, "Some Void Thoughts on Museums," in *Robert Smithson: The Collected Writings*, ed. Jack Flam (Berkeley and Los Angeles: University of California Press, 1996), 41.

32 Robert Smithson, quoted by Lucy R. Lippard in "Breaking the Circle: The Politics of Prehistory," in *Robert Smithson: Sculpture* (Ithaca: Cornell University, 1981), 33.

33 For an analysis of the relationship between Smithson's suburban walks and situationism, see Robert Linsley, "Minimalism and the City: Robert Smithson as a Social Critic," in *Res* no. 41 (Cambridge, Mass.), 2002.

34 Smithson, "A Tour of the Monuments of Passaic, New Jersey," in *Collected Writings*, 72.

35 Nonetheless, his work has been largely documented in the primary anthology of artistic dematerialization: Lucy R. Lippard, *Six Years: The Dematerialization of the Art Object…*" (1973; Berkeley and Los Angeles: University of California Press, 1997).

36 Another difference between Smithson's work and the most canonical conceptual work stems from the complexity of the rhetorical figures implicit in his work. See Stephen Melville, "Aspects," in *Reconsidering the Object of Art, 1965–1975* (Los Angeles and Cambridge: Museum of Contemporary Art and MIT Press, 1995), 229–45.

37 By "social" I do not mean a concern with the organization of human life in itself, but rather a concern with contemporary geography, considered to be the knowledge of the space inevitably conditioned by forms of social organization.

38 Robert Venturi, Denise Scott Brown, Stephen Izenour, *Learning from Las Vegas* (Cambridge: MIT Press, 1972).

39 Smithson, "The Establishment," *Collected Writings*, 97.

40 Smithson, "What Is a Museum," *Collected Writings*, 47.

in the late 1960s and 1970s conceptualism was widely considered an endgame—the logical conclusion of the modernist tendency toward formal reduction—and painting was proclaimed "dead," the province of an older time and generation. Both ideas were erroneous. Artists never ceased painting, and conceptualism proved extremely generative, inflecting much of the art that followed. Even as conceptualism emerged, artists were using its strategies as a path back to painting.

In 1965 Roman Opalka began a lifelong project of inscribing numbers on canvas, from one to infinity. As he painted he recorded himself counting in Polish, and on most days he photographed himself in the same position, wearing the same clothes and blank expression. Each element underscores the project's concern with the relentlessness of time. Blinky Palermo and Robert Ryman dissected the components of painting. In

the works presented here, Palermo examines the nature of the support and medium, while Ryman investigates the support, surface, and fastening devices. Raymundo Colares's pop-up books constitute ever-changing constructivist paintings in a more dynamic form. Artists such as Colares, Oiticica, and Bochner explore traditional issues of painting—composition, color, form—in modes that were more acceptable to the artistic vanguard of the time.

Martin Barré, *65-S-3-88 x 82*, 1965

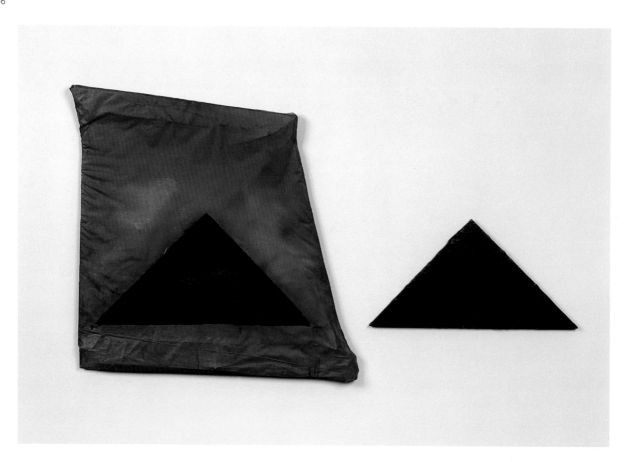

top: Blinky Palermo, *Daydream I*, 1965

bottom:

Blinky Palermo, *Untitled*, 1970

Blinky Palermo, *Gray Disk*, 1966

opposite page: Blinky Palermo, *Softspeaker*, 1965

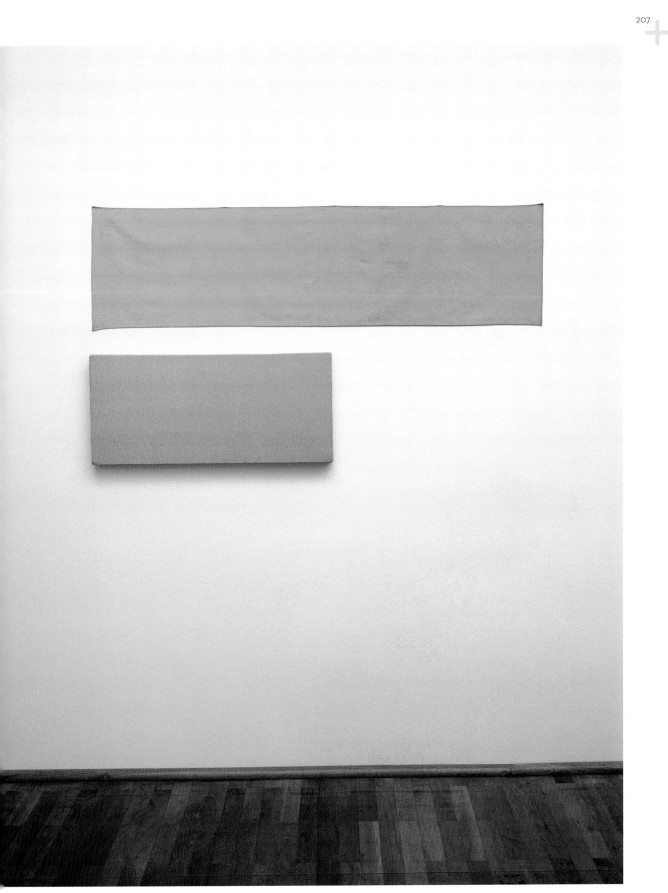

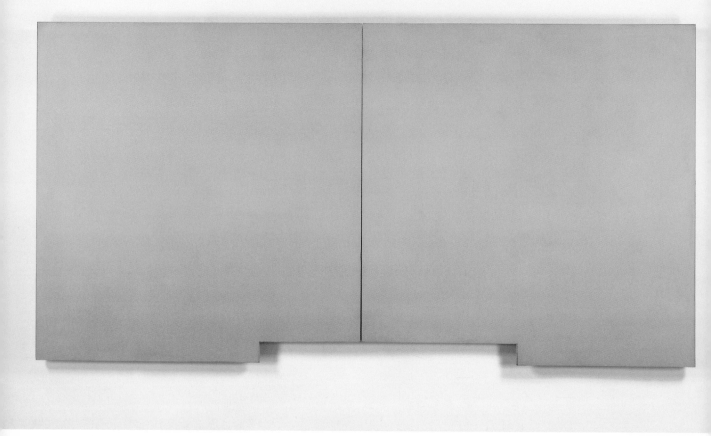

Robert Mangold, *Neutral Pink Area*, 1966

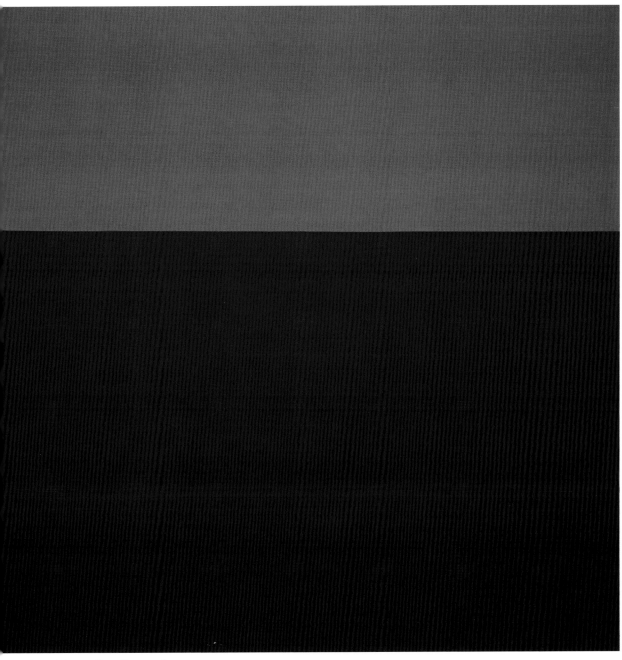

Blinky Palermo, *Green/Green*, 1967

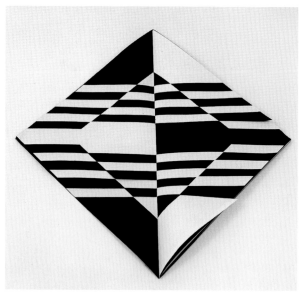

top: Raymundo Colares, *Gibi*, 1970 (details)

Raymundo Colares, *Gibi*, 1972 (details)

Jo Baer, *Untitled (Stacked Horizontal Diptych–Aluminum)*, 1966–74

Alan Charlton, *Channel Painting*, 1974

Giulio Paolini, *Duoblure*, 1972–73

Giulio Paolini, *Untitled (Plakat Carton)*, 1962

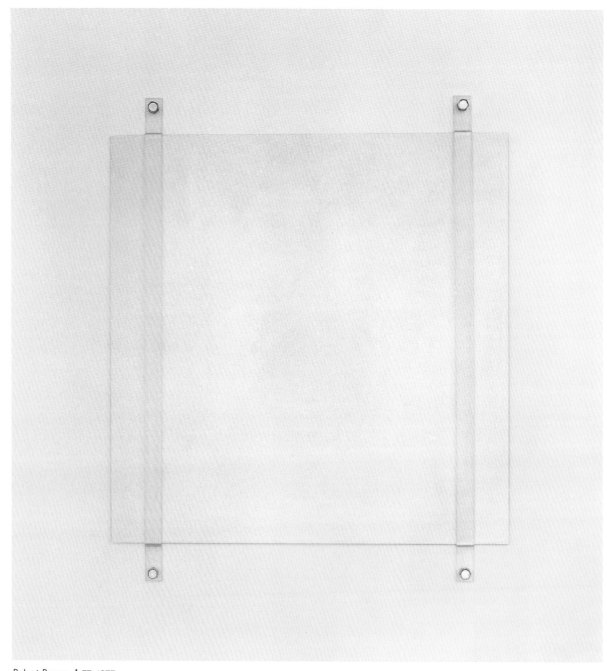

Robert Ryman, *A 77*, 1977

opposite page: Karen Carson, *Untitled*, 1971

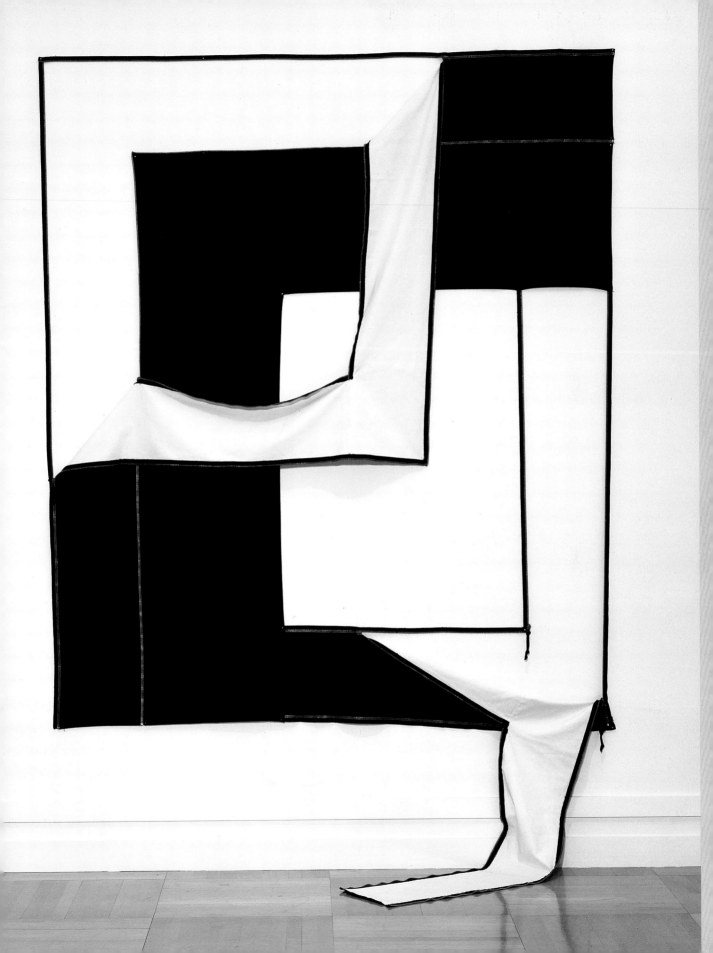

checklist of the exhibition

Numbers in square brackets indicate the thematic sections of the exhibition in which the works were displayed (see table of contents).

Josef Albers (Germany, active United States, 1888–1976)
Homage to the Square: Dissolving/Vanishing, 1951 [1]
Oil on Masonite; 24 x 24 in. (61 x 61 cm)
Los Angeles County Museum of Art, gift of Mrs. Anni Albers and the Josef Albers Foundation, Inc.

Homage to the Square, 1951–55 [1]
Oil on Masonite; 24 x 24 in. (61 x 61 cm)
Los Angeles County Museum of Art, gift of Mrs. Anni Albers and the Josef Albers Foundation, Inc.

Peter Alexander (United States, born 1939)
Pink Green Cube, 1967 [3]
Cast polyester resin; 8 x 8 x 8 1/2 in. (20.3 x 20.3 x 21.6 cm)
Collection of the artist, Los Angeles

Carl Andre (United States, born 1935)
144 Pieces of Aluminum, 1967 [4]
Aluminum; each piece: 12 x 12 x 3/8 in. (30.5 x 30.5 x 1 cm)
Norton Simon Museum, Pasadena, anonymous gift, 1969

Stillanovel, 1972 [4]
Clothbound book; 11 1/4 x 8 3/4 x 3/4 in. (28.6 x 22.2 x 1.9 cm)
Los Angeles County Museum of Art, gift of Paula Cooper

Secant, 1977 [5]
Photodocumentation of earthwork; 10 sections of Douglas fir timber laid in a line following the rise and fall of a landscape in Roslyn, New York; 1 x 1 x 300 ft. (.3 x .3 x 91.4 m)
Courtesy Paula Cooper Gallery, New York

Eleanor Antin (United States, born 1935)
Carving: A Traditional Sculpture, 1972 [4]
144 black-and-white photographs and text panel; each photo: 7 x 5 in. (17.8 x 12.7 cm); text panel: 15 1/2 x 10 1/4 in. (39.4 x 26 cm)
Collection of Tracy and Gary Mezzatesta, Los Angeles

Carmelo Arden Quin (Uruguay, born 1913)
Mercurial, 1945 [1]
Oil on card; 16 1/4 x 12 1/4 in. (41.3 x 31.1 cm)
Adler & Conkright Fine Art, New York; Galerie von Bartha, Basel

Michael Asher (United States, born 1943)
Untitled, 1971 [5]
Photodocumentation and plan of site-specific ephemeral installation comprising 3 painted wood walls; 15 x 5 ft. (4.6 x 1.5 m); 15 x 10 ft. (4.6 x 3 m); 15 x 20 ft. (4.6 x 6.1 m)
Los Angeles County Museum of Art, Contemporary Art Council Purchase, New Talent Award

Ronaldo Azeredo (Brazil, born 1937)
"Velocidade" (Velocity), in *Noigandres 4*, 1957 [1]
Printed broadsheet in portfolio; 16 x 11 3/4 in. (40.6 x 29.9 cm)
Research Library, The Getty Research Institute, Los Angeles

Jo Baer (United States, born 1929)
Untitled (Stacked Horizontal Diptych–Aluminum), 1966–74 [6]
Oil on canvas; 126 1/2 x 84 x 2 1/2 in. (321.3 x 213.4 x 6.4 cm)
Courtesy Paula Cooper Gallery, New York

John Baldessari (United States, born 1931)
Composing on a Canvas, 1966–68 [5]
Acrylic on canvas; 114 x 96 in. (289.6 x 243.8 cm)
Collection Museum of Contemporary Art San Diego; gift of the artist

Joost Baljeu (Netherlands, 1925–1991)
Synthetic Construction, W-II, 1957 [1]
Oil on wood; 22 1/8 x 28 3/4 x 12 5/8 in. (56 x 73 x 32 cm)
Collection Van Abbemuseum, Eindhoven, The Netherlands

Martin Barré (France, 1924–1993)
65-S-3-88 x 82, 1965 [6]
Acrylic on canvas; 34 5/8 x 32 1/4 in. (88 x 82 cm)
Musée national d'art moderne, Centre Georges Pompidou, Paris

Robert Barry (United States, born 1936)
A Part of a Piece, 1972 [5]
Typed page; 11 x 8 1/4 in. (27.9 x 21 cm)
The Panza Collection, Milan

Bernd and Hilla Becher (Germany, born 1931, 1934)
Typology of Water Towers, 1972 [4]
54 black-and-white photographs; each: 15 3/4 x 11 3/4 (40 x 29.8 cm)
The Eli and Edythe L. Broad Collection, Los Angeles

Larry Bell (United States, born 1939)
Cube, 1966 [3]
Vacuum-coated glass; 12 1/8 x 12 1/8 x 12 1/8 in. (30.8 x 30.8 x 30.8 cm)
Los Angeles County Museum of Art, gift of the Frederick R. Weisman Company

Carlo Belloli (Italy, 1922–2003)
"Corpo poético numero 3: voce/Amore" (Poetic body number 3: voice/Love), 1951 [1]
In Mary Ellen Solt, *Concrete Poetry: A World View*, 1969; open: 10 x 8 1/2 in. (25.4 x 21.6 cm)
Private collection, Los Angeles

Karl Benjamin (United States, born 1925)
No. 27, 1968 [3]
Oil on canvas; 79 x 79 in. (200.7 x 200.7 cm)
Los Angeles County Museum of Art, gift of the artist, courtesy of the Jefferson Gallery

Max Bill (Switzerland, 1908–1994)
Tripartite Unity, 1948–49 [1]
Stainless steel; 44 7/8 x 34 3/4 x 38 5/8 in. (114 x 88.3 x 98.2 cm)
Museu de Arte Contemporânea da Universidade de São Paulo, Brazil

One Black to Eight Whites, 1956 [1]
Oil on linen; 39 3/8 x 39 3/8 in. (100 x 100 cm)
Chantal and Jakob Bill, Switzerland

Mel Bochner (United States, born 1940)
Continuous/Dis/Continuous, 1971–72 [6]
Pencil, red and black felt-tipped pens, and blue carpenter's chalk on torn masking tape and wall; approximately 2 in. (5.1 cm) high, length variable
The Museum of Modern Art, New York, Committee on Painting and Sculpture Funds, 1997

Robert Breer (United States, born 1926)
Float, 1973 [3] (refabrication)
Painted Fiberglas box, motor, 2 car batteries; 17 x 31 in. (43.2 x 78.7 cm)
Courtesy of the artist, Tappan, NY

Float, 1973 [3] (refabrication)
Painted Fiberglas box, motor, 2 car batteries; 17 x 31 in. (43.2 x 78.7 cm)
Courtesy of the artist, Tappan, NY

Daniel Buren (France, born 1938)
Photo-souvenirs, 1968–75 [5]
Photo- and videodocumentation of performances and site-specific ephemeral works
Courtesy of the artist, Paris

Klaus Burkhardt (Germany, 1928–2001)
"Coldtypestructure," in *Futura 2*, 1965 [4]
Folded broadsheet; open: $18^{3}/4$ x $18^{3}/4$ in.
(47.6 x 47.6 cm)
Research Library, The Getty Research
Institute, Los Angeles

Pol Bury (Belgium, born 1922)
Untitled, 1967 [3]
Wood, string, motors; $39^{1}/2$ x 20 x 10 in.
(100.3 x 50.8 x 25.4 cm)
The Grinstein Family, Los Angeles

Waltércio Caldas (Brazil, born 1946)
The Collector, 1974 [5]
Unique artist's book; open: $17^{1}/2$ x 26 in.
(44.5 x 66 cm)
Coleçao Gilberto Chateaubriand MAM,
Rio de Janeiro

Sérgio de Camargo (Brazil, 1930–1990)
No. 259, 1969 [3]
Painted wood; $39^{3}/8$ x $39^{3}/8$ in. (100 x
100 cm)
Andréa and Jose Olympio Pereira
Collection, São Paulo

Luis Camnitzer (Uruguay, born 1937)
*Sentence Reflecting the Sentence that States
the Reflection*, 1975 [5]
Wood, bronze, glass; $13^{3}/4$ x $9^{3}/4$ x 2 in.
(35 x 24.9 x 5 cm)
Colección Cisneros, Caracas

Karen Carson (United States, born 1943)
Untitled, 1971 [6]
Cotton duck and industrial zippers; approx.
95 x 83 in. (241.3 x 210.8 cm), variable
depending on installation
Los Angeles County Museum of Art,
purchased with funds provided by the
Pasadena Art Alliance and the Rosamund
Felson Gallery

Aluísio Carvão (Brazil, 1918–2001)
Color Cube, 1960 [2]
Pigment and oil on cement; $6^{1}/2$ x $6^{1}/2$ x
$6^{1}/2$ in. (16.5 x 16.5 x 16.5 cm)
Private collection, Rio de Janeiro

Enrico Castellani (Italy, born 1930)
Red Corner Surface, 1963 [2]
Ink and wax on shaped canvas;
$31^{7}/8$ x $39^{3}/8$ x $27^{1}/2$ in. (81 x 100 x 70 cm)
Collezione Prada, Milan

Alan Charlton (England, born 1948)
Channel Painting, 1974 [6]
Acrylic on canvas; 56 x $55^{7}/8$ in.
(142.2 x 141.9 cm)
Solomon R. Guggenheim Museum,
New York; Panza Collection, 1991;
91.3696.a.b

Lygia Clark (Brazil, 1920–1988)
Planes on Modulated Surface No. 1, 1957 [1]
Industrial paint on wood; $34^{1}/4$ x $23^{5}/8$ in.
(87 x 60 cm)
Col. Adolpho Leirner, São Paulo, Brazil

Cocoon, 1959 [2]
Industrial paint on aluminum; 12 x 12 x 2 in.
(30.5 x 30.5 x 5 cm)
João Sattamini Collection, Rio de Janeiro

Cocoon, 1959 [2]
Industrial paint on aluminum; 12 x 12 x 2 in.
(30.5 x 30.5 x 5 cm)
João Sattamini Collection, Rio de Janeiro

Animal (Machine), 1962 [3]
Aluminum pieces with hinges; 22 x 26 in.
(55.9 x 66 cm)
Col. Adolpho Leirner, São Paulo, Brazil

Raymundo Colares (Brazil, 1944–1986)
Gibi, 1970 [6]
Unique artist's book; $25^{5}/8$ x $17^{3}/4$ in.
(65 x 45 cm)
Andréa and Jose Olympio Pereira
Collection, São Paulo

Gibi, 1972 [6]
Unique artist's book; $11^{1}/4$ x $8^{5}/8$ in.
(28.5 x 22 cm)
Francisco Terranova, Rio de Janeiro

Gianni Colombo (Italy, 1937–1993)
Pulsating Structure, 1959/1971 [3]
Wood, Styrofoam, electric motor; $47^{1}/4$ x
$47^{1}/4$ in. (120 x 120 cm)
Courtesy Sergio Casoli

Carlos Cruz-Diez (Venezuela, born 1923)
Optical Structure, 1958 [3]
Duco on wood; $21^{5}/8$ x $23^{5}/8$ in.
(55 x 60 cm)
Courtesy of the artist, Paris

Dadamaino (Italy, born 1935)
Volume, 1958 [2]
Raw canvas on stretcher; $35^{3}/8$ x $23^{5}/8$ in.
(90 x 60 cm)
A arte Studio Invernizzi, Milan

Volume of Displaced Modules, 1960 [4]
Layered plastic with holes; 59 x $39^{3}/8$ in.
(150 x 100 cm)
A arte Studio Invernizzi, Milan

Hanne Darboven (Germany, active
United States, born 1941)
K: 15 x 15 – F: 15 x 15 (Organizer: 1),
1972–73 [4]
46 handwritten pages; each: $11^{5}/8$ x $16^{1}/2$ in.
(29.5 x 41.9 cm)
The Panza Collection, Milan

Augusto de Campos (Brazil, born 1931)
"Sem um numero" (Without a number)
in *Noigandres 4*, 1957 [1]
Printed broadsheet in portfolio;
16 x $11^{3}/4$ in. (40.6 x 29.8 cm)
Research Library, The Getty Research
Institute, Los Angeles

Walter de Maria (United States, born 1935)
Mile-Long Drawing, 1968 [5]
Photodocumentation of earthwork; two
3-inch-wide chalk lines, 12 feet apart and
1 mile long, Mojave Desert
Dia Art Foundation, NY

The Lightning Field, 1971–77 [5]
Photodocumentation of earthwork;
400 polished stainless-steel rods
in a 1-mile x 1-kilometer grid
Dia Art Foundation, NY

Herman de Vries (Netherlands, born 1931)
*aio (Random Structured Semiotic Fields:
Malayalam Types)*, 1971 [4]
Newsprint; $7^{3}/4$ x 13 in. (19.7 x 33 cm)
Research Library, The Getty Research
Institute, Los Angeles

Ad Dekkers (Netherlands, 1938–1974)
*Beginning of the Equal Division of a Double
Square*, 1972 [6]
Oil on board; $23^{5}/8$ x $47^{1}/4$ in.
(60 x 120 cm)
Collection of Stuart and Judy Spence,
Los Angeles

Antonio Dias (Brazil, born 1944)
The Invented Country, 1976 [5]
Satin, bronze pole with patina; pole length:
196 7/8 in. (500 cm)
Courtesy of the artist, Rio de Janeiro

Jan Dibbets (Netherlands, born 1941)
*Shortest Day at the Guggenheim Museum
New York 1970 from Sunrise to Midday
Photographed Every 5 Minutes*, 1970 [4]
Color photographs in frame;
55 1/8 x 102 3/4 in. (140 x 261 cm)
Courtesy of the artist and Barbara
Gladstone Gallery, New York

Burgoyne Diller (United States,
1906–1965)
Untitled (Wall Relief), c. 1950 [1]
Painted wood; 80 x 30 x 3 in. (203.2 x
76.2 x 7.6 cm)
Courtesy of Michael Rosenfeld Gallery,
New York

Stanislaw Dróżdż (Poland, born 1939)
Między (Between), 1977 [4]
Ephemeral installation; letters of the Polish
word *między* ["between"] arranged system-
atically and painted in black on the floor,
ceiling, and walls of a white room; 128 x
206 3/4 x 275 5/8 in. (325 x 525 x 700 cm)
Courtesy of the artist and Foundation
Gallery Foksal, Warsaw

Manuel Espinosa (Argentina, born 1912)
Painting, 1945 [1]
Oil on wood; 34 5/8 x 18 1/2 in. (88 x 47 cm)
Private collection, Buenos Aires

Öyvind Fahlström (Brazil, active Sweden,
1928–1976)
"Den Svara Resan (for blandad talkor),"
in *Bord: Dikter 1952–1955*, 1966 [1]
Book; open: 16 3/4 x 11 3/4 in. (42.5 x
29.8 cm)
Research Library, The Getty Research
Institute, Los Angeles

Wojciech Fangor (Poland, born 1922)
M 15 1968, 1968 [3]
Oil on canvas; 56 x 56 in. (142.2 x
142.2 cm)
Bohdan W. Oppenheim, Santa Monica

Dan Flavin (United States, 1933–1996)
Monument for V. Tatlin, 1969 [2]
Cool white fluorescent bulbs; 96 x 24 in.
(243.8 x 61 cm)
The Grinstein Family, Los Angeles

Lucio Fontana (Italy, active Argentina,
1899–1968)
Spatial Concept—Waiting (59 T 104),
1959 [2]
Oil on canvas with incisions; 49 1/4 x
39 9/16 in. (125 x 100.5 cm)
Musée national d'art moderne, Centre
Georges Pompidou, Paris

Gego (Germany, active Venezuela,
1912–1994)
Sphere No. 2, 1976 [3]
Stainless-steel wire; diam: 40 1/2 in.
(103 cm)
Colección Banco Mercantil, Caracas

Mathias Goeritz (Germany, active Mexico,
1915–1990)
The Towers of Satellite City, 1957–58 [1]
Photodocumentation of architectural instal-
lation; 5 painted reinforced-concrete struc-
tures in a suburb of Mexico City, realized
in collaboration with architects Mario Pani,
Luis Barragán, and Jesús Reyes; heights
range from 121 to 187 ft. (36.9 to 57 m)

"Mensajes del Oro" (Messages of Gold)
in *Futura 1*, 1960 [4]
Folded broadside; open: 18 3/4 x 18 3/4 in.
(47.6 x 47.6 cm)
Research Library, The Getty Research
Institute, Los Angeles

Eugen Gomringer (Bolivia, active
Switzerland, born 1925)
"Flow Grow Show Blow," in
33 Konstellationin, 1954 [1]
Book; open: 7 1/4 x 14 1/4 in. (18.4 x 36.2 cm)
Research Library, The Getty Research
Institute, Los Angeles

"Silencio" (Silence) in *Die Konstellationen,
Les Constellations, The Constellations,
Las Constelaciones*, 1954 [1]
Book; open: 8 1/4 x 16 in. (21 x 40.6 cm)
Research Library, The Getty Research
Institute, Los Angeles

Camille Graeser (Switzerland,
1892–1980)
Progression in Four Spaces, 1952 [1]
Synthetic polymer on linen; 15 3/4 x 31 1/2 in.
(40 x 80 cm)
Camille Graeser-Stiftung, Zurich

Dan Graham (United States, born 1942)
Eleven Sugar Cubes, 1970 [5]
Two-page spread in *Art in America*
(May–June 1970); grid of 24 color
photographs and a text by the artist; open:
12 x 18 x 1/4 in. (30.5 x 45.7 x .7 cm)
Courtesy of the artist and Marion Goodman
Gallery, New York

Milan Grygar (Slovak Republic, active
Czech Republic, born 1926)
Sound-Plastic Drawing, 1972 [3]
Ink on paper; 34 5/8 x 24 5/8 in. (88 x
62.5 cm)
Courtesy of the artist, Prague

Sound-Plastic Drawing, 1972 [3]
Ink on paper; 34 5/8 x 24 5/8 in. (88 x
62.5 cm)
Courtesy of the artist, Prague

Brion Gysin (England, active Morocco
and France, 1916–1986)
"Junk Is No Good Baby," in *Brion Gysin
Let the Mice In*, 1973 [4]
Book; open: 9 1/4 x 13 in. (23.5 x 33 cm)
Research Library, The Getty Research
Institute, Los Angeles

Hans Haacke (Germany, active
United States, born 1936)
On Social Grease, 1975 [5]
6 magnesium units; each: 30 x 30 in.
(76.2 x 76.2 cm)
Gilbert and Lila Silverman Collection,
Detroit

Václav Havel (Czechoslovakia, born 1936)
"Filosof" and "Opcizeni," in *Protokoly*,
c. 1964 [4]
Book; open: 8 1/4 x 12 3/16 in. (21 x 31 cm)
Research Library, The Getty Research
Institute, Los Angeles

Bici Hendricks (United States, born 1945)
(, $, %, &, #, @, +, ¢, in *Punctuation
Poems*, 1960s [4]
8 typed index cards; each: 3 1/2 x 5 1/2 in.
(8.9 x 14 cm)
Research Library, The Getty Research
Institute, Los Angeles

Eva Hesse (Germany, active United States, 1936–1970)
C-Clamp Blues, 1965 [2]
Painted concretion, wire, painted metal bolt, and painted plastic ball on Masonite; $32\,^{7}/_{8} \times 21\,^{3}/_{4} \times 9\,^{1}/_{4}$ in. (83.5 × 55.2 × 23.5 cm)
Collection of Tony and Gail Ganz, Los Angeles

Constant, 1967 [4]
Acrylic and papier-mâché mixed with unidentified materials on plywood with rubber tubing; $60 \times 60 \times 5\,^{3}/_{4}$ in. (152.4 × 152.4 × 14.6 cm)
Collection of Tony and Gail Ganz, Los Angeles

Channa Horwitz (United States, born 1932)
Eight, 1979 [4]
Lithograph, $22\,^{1}/_{2} \times 21$ in. (57.2 × 53.3 cm)
Courtesy of the artist, Los Angeles

Douglas Huebler (United States, born 1924)
Variable Piece #506/Tower of London Series, 1975 [5]
Text, black-and-white and color photographs, and acrylic on paper
Four panels; each: 20 × 24 in. (50.8 × 60.9 cm)
Collection of Stuart and Judy Spence, Los Angeles

Robert Irwin (United States, born 1928)
Untitled, 1964–66 [3]
Oil on canvas on shaped wood veneer frame; $82\,^{1}/_{2} \times 84\,^{1}/_{2}$ in. (209.6 × 214.6 cm)
The Eli and Edythe L. Broad Collection, Los Angeles

Donald Judd (United States, 1928–1994)
Untitled (DSS 38), 1963 (fourth example, 1988) [2]
Light cadmium red oil on wood with violet Plexiglas; $19\,^{7}/_{8} \times 48 \times 48$ in. (50.5 × 122 × 122 cm)
Collection of the Judd Foundation

Untitled, 1969 [4]
Stainless steel with blue Plexiglas; 10 units total; overall: $172\,^{1}/_{4} \times 40\,^{1}/_{4} \times 31\,^{1}/_{4}$ in. (437.5 × 102.2 × 79.4 cm)
Norton Simon Museum, partial museum purchase, partial gift of the artist, 1969

On Kawara (Japan, active United States, born 1933)
Sep. 25, 1966 (from Today series, 1966...)
Liquitex on canvas in handmade cardboard box; 8 × 10 in. (20.3 × 25.4 cm)
Courtesy On and Hiroko Kawahara, New York

May 1, 1967 (from Today series, 1966...)
Liquitex on canvas in handmade cardboard box with newspaper clipping; 8 × 10 in. (20.3 × 25.4 cm)
Courtesy On and Hiroko Kawahara, New York

14 Ago. 1968 (from Today series, 1966...)
Liquitex on canvas in handmade cardboard box with newspaper clipping; 8 × 10 in. (20.3 × 25.4 cm)
Courtesy On and Hiroko Kawahara; David Zwirner, New York

7 Fev. 1969 (from Today series, 1966...)
Liquitex on canvas in handmade cardboard box with newspaper clipping; 8 × 10 in. (20.3 × 25.4 cm)
Courtesy On and Hiroko Kawahara, New York

31 Dec. 1970 (from Today series, 1966...)
Liquitex on canvas in handmade cardboard box; 8 × 10 in. (20.3 × 25.4 cm)
Courtesy On and Hiroko Kawahara, New York

Ellsworth Kelly (United States, born 1923)
Painting for a White Wall (EK 54), 1952 [1]
Oil on canvas, 5 joined panels; $23\,^{1}/_{2} \times 71\,^{1}/_{4}$ in. (59.7 × 181 cm)
Private collectiion

Julije Knifer (Croatia, born 1924)
M.5.60 (Meander n. 5), 1960 [1]
Oil on canvas; $26 \times 34\,^{5}/_{8}$ in. (66 × 88 cm)
Courtesy of the artist, Paris

Gyula Kosice (Hungary, active Argentina, born 1924)
Madí Painting, Liberated Color Planes, 1947 [1]
Enamel on wood; $27\,^{1}/_{2} \times 21\,^{5}/_{8}$ in. (70 × 55 cm)
Private collection, Buenos Aires

Richard Kostelanetz (United States, born 1940)
"Third Avenue" and "Second Avenue," in *Articulations*, 1974 [5]
Book; open: $10 \times 15\,^{1}/_{4}$ in. (25.4 × 38.7 cm)
Private collection, Los Angeles

Joseph Kosuth (United States, born 1945)
Definition ("Thing"), 1968 [5]
Photostat on Masonite; $39\,^{3}/_{8} \times 39\,^{3}/_{8}$ in. (100 × 100 cm)
Los Angeles County Museum of Art, Modern and Contemporary Art Council

"Photograph of Xerox Machine Used," in *Carl Andre, Robert Barry, Douglas Huebler, Joseph Kosuth, Sol LeWitt, Robert Morris, Lawrence Weiner*, 1968 [5]
Book; open: $11\,^{1}/_{4} \times 17\,^{3}/_{4}$ in. (28.6 × 45.1 cm)
Research Library, The Getty Research Institute, Los Angeles

Jaroslaw Kozlowksi (Poland, born 1945)
"He Has a Cigarette in His Mouth," in *Lesson*, 1972 [5]
Book; open: $8\,^{1}/_{2} \times 12\,^{3}/_{4}$ in. (21.6 × 32.4 cm)
Research Library, The Getty Research Institute, Los Angeles

Yayoi Kusama (Japan, active United States and Europe, born 1929)
Accumulation of Nets, 1962 [4]
Photocollage on paper; $23\,^{3}/_{8} \times 28\,^{1}/_{8}$ in. (59.4 × 71.4 cm)
Los Angeles County Museum of Art, purchased with funds provided by the Ralph M. Parsons Discretionary Fund, Blake Byrne, Tony and Gail Ganz, Sharleen Cooper Cohen, Stanley and Elyse Grinstein, and Linda and Jerry Janger

David Lamelas (Argentina, born 1946)
Untitled (Corner Piece), c. 1965/2004 [2]
Ephemeral installation made with painted plywood (realized for the first time in *Beyond Geometry* from c. 1965 drawing); 150 × 150 in. (381 × 381 cm)
Courtesy of the artist, Los Angeles

Antwerp–Brussels (People + Time), 1969 [5]
Folder with 9 black-and-white photographs mounted on aluminum; each: $12 \times 9\,^{1}/_{2}$ in. (30.5 × 24.1 cm)
Los Angeles County Museum of Art, promised gift of Stuart and Judy Spence

Julio Le Parc (Argentina, active France, born 1928)
Continual Light, 1960–67 [3]
36 stainless-steel discs, nylon wires, 2 painted steel boxes, electrical bulb; 39 3/8 x 39 3/8 x 6 7/8 in. (100 x 100 x 17.5 cm)
Musée d'art contemporain du Val-de-Marne, Vitry-sur-Seine

Sol LeWitt (United States, born 1928)
"Grids and Arcs from 3 Sides" and "Grids and Arcs from 4 Sides," in *Arcs from Corners and Sides, Circles and Grids and All Their Combinations*, 1972 [4]
Artist's book; open: 8 1/4 x 16 1/2 in. (21 x 41.9 cm)
Research Library, The Getty Research Institute, Los Angeles

Wall Drawing #295: Six Superimposed Geometric Figures, 1976 [5]
White chalk on black wall; 120 x 132 in. (304.8 x 335.3 cm)
Los Angeles County Museum of Art, purchased with matching funds of the National Endowment for the Arts and the Modern and Contemporary Art Council

Maurício Nogueira Lima (Brazil, born 1930)
Rhythmic Object No. 2, 1952 (second version, 1970) [1]
Ink and massa on Duratex; 15 3/4 x 15 3/4 in. (40 x 40 cm)
Col. Adolpho Leirner, São Paulo, Brazil

Francesco Lo Savio (Italy, 1935–1963)
Black Metal, Uniform, Opaque, 1961 [2]
Painted metal; 38 3/8 x 78 3/4 x 9 in. (97.5 x 200 x 22.9 cm)
Courtesy Studio Casoli, Milan

Verena Loewensberg (Switzerland, 1912–1986)
Untitled, 1944 [1]
Oil on linen; 23 5/8 x 23 5/8 in. (60 x 60 cm)
Collection of Henriette Coray Loewensberg, Zurich

Richard Paul Lohse (Switzerland, 1902–1988)
Thema in Zwei Verschieden Gerichteten Dimensionen (Theme Oriented in Two Dimensions), 1945–46 [1]
Oil on board; 19 5/8 x 19 5/8 in. (50 x 50 cm)
Museu de Arte Contemporânea da Universidade de São Paulo, Brazil

Dreissig Systematische Farbtonreihen (Thirty Systematic Color Series), 1950–55 [1]
Oil on linen; 23 5/8 x 23 5/8 in. (60 x 60 cm)
Richard Paul Lohse Foundation, on loan to Kunsthaus Zurich

Raúl Lozza (Argentina, born 1911)
Painting 82, or Yellow Structure, 1945 [1]
Enamel and cotton tape on panel; 20 7/8 x 13 3/8 in. (53 x 34 cm)
Private collection, Buenos Aires

Heinz Mack (Germany, born 1931)
TELE-MACK, 1968 [3]
A film by Heinz Mack and Hans Emmerling DVD format; German/English; 45 min.

Tomás Maldonado (Argentina, born 1922)
Untitled, 1945 [1]
Tempera on board attached to enamel on cardboard; 31 1/8 x 23 5/8 in. (79 x 60 cm)
Private collection, Buenos Aires

Robert Mangold (United States, born 1937)
Neutral Pink Area, 1966 [6]
Oil on Masonite; 48 x 96 in. (121.9 x 243.8 cm)
Solomon R. Guggenheim Museum, New York; Panza Collection, 1991; 91.3759.a.b

Antonio Manuel da Silva Oliveira (Portugal, active Brazil, born 1947)
Hot Ballot Box, 1975 [5]
Wood, sealing wax, tape; 23 5/8 x 13 x 7 5/8 in. (60 x 33 x 20 cm)
Courtesy of the artist, Rio de Janeiro

Piero Manzoni (Italy, 1933–1963)
Achrome, 1959 [4]
Kaolin on canvas; 47 x 39 in. (119.5 x 99 cm)
Private collection, New York

Line 6 m, 1959 [5]
Ink on paper in cardboard cylinder; height: 10 1/4 in. (26 cm), #924
Archivio Opera Piero Manzoni, Milan

Line 15.81 m, 1959 [5]
Ink on paper in cardboard cylinder; height: 12 3/8 in. (31.5 cm), #962
Archivio Opera Piero Manzoni, Milan

Achrome, 1960 [4]
Cotton on board; 15 3/4 x 12 in. (40 x 30.5 cm), #726
Archivio Opera Piero Manzoni, Milan

Line of Infinite Length, 1960 [5]
Black wood cylinder with label; 5 7/8 x 1 7/8 in. (15 x 4.8 cm), #980
Archivio Opera Piero Manzoni, Milan

Agnes Martin (Canada, active United States, born 1912)
Untitled, 1962 [1]
Acrylic primer, graphite, and colored pencil on canvas; 73 x 73 in. (185.4 x 185.4 cm)
Collection Museum of Contemporary Art, San Diego; museum purchase with matching funds from the National Endowment for the Arts with contributions from Dr. Vance E. Kondon

John McCracken (United States, born 1934)
Don't Tell Me When to Stop, 1966–67 [2]
Lacquer and Fiberglas on plywood; 120 1/4 x 20 3/16 x 3 1/4 in. (305.4 x 51.3 x 8.3 cm)
Los Angeles County Museum of Art, gift of the Kleiner Foundation

John McLaughlin (United States, 1898–1976)
Untitled, 1953 [1]
Oil on Masonite; 32 x 36 in. (81.3 x 91.4 cm)
Los Angeles County Museum of Art, promised gift of Fannie and Alan Leslie

Cildo Meireles (Brazil, born 1948)
The Southern Cross, 1969–70 [2]
(refabrication)
Pine, oak; $\frac{3}{8}$ x $\frac{3}{8}$ x $\frac{3}{8}$ in. (.9 x .9 x .9 cm)
Courtesy of the artist, Rio de Janeiro

Webs of Liberty, 1976/98 [4]
Iron, glass; 59 x 59 in. (150 x 150 cm)
Los Angeles County Museum of Art, pur-
chased with funds provided by Cecilia
Wong, Patricia Phelps de Cisneros, Carlos
and Rosa de la Cruz, and the Modern
and Contemporary Art Council

Juan Melé (Argentina, born 1923)
Concrete Planes, No. 35, 1948 [1]
Oil on Masonite; 25 $\frac{5}{8}$ x 17 $\frac{3}{4}$ x 1 $\frac{5}{8}$ in.
(65.1 x 45.1 x 4 cm)
Colección Cisneros, Caracas

François Morellet (France, born 1926)
From Yellow to Purple, 1956 [1]
Oil on canvas; 43 $\frac{1}{4}$ x 86 $\frac{5}{8}$ in.
(110 x 220 cm)
Musée national d'art moderne, Centre
Georges Pompidou, Paris

4 Self-Distorting Grids, 1965 [3]
Four aluminum grids, iron poles, motors;
each grid: 61 $\frac{3}{4}$ x 61 $\frac{3}{4}$ in. (157 x 157 cm)
Fundación Museo de Arte Moderno Jesús
Soto, Ciudad Bolivar, Venezuela

*Neon 0° 90°, Switching with 4 Interfering
Rhythms*, 1965 [3]
Neon tubes, wood panel; 31 $\frac{1}{2}$ x 31 $\frac{1}{2}$ in.
(80 x 80 cm)
Collection of the artist, Cholet, France

Robert Morris (United States, born 1931)
Floor Slab, 1961/2004 (reconstructed for
exhibition) [2]
Plywood; 96 x 96 x 18 in. (243.8 x
243.8 x 45.7 cm)
Courtesy of the artist, New York

Hanging Slab (Cloud), 1962/2004
(reconstructed for exhibition) [2]
Plywood; 90 x 90 x 18 in. (228.6 x
228.6 x 45.7 cm)
Courtesy of the artist, New York

Bruno Munari (Italy, 1907–1998)
Unreadable Book, N.Y., I, 1949 [1]
Artist's book; open: 8 $\frac{3}{4}$ x 17 $\frac{1}{2}$ in.
(22.2 x 45 cm)
Research Library, The Getty Research
Institute, Los Angeles

Bruce Nauman (United States, born 1941)
Walk with Contrapposto, 1968 [2]
Videotape (black and white, sound, 60
min.) documenting Nauman's attempt to
maintain *contrapposto* pose while walking
through a 20-inch-wide corridor of his
own construction
Los Angeles County Museum of Art;
partial funding provided by the Modern
and Contemporary Art Council

Microphone/Tree Piece, n.d. [5]
Typed page; 18 $\frac{1}{2}$ x 16 in. (47 x 40.6 cm)
The Grinstein Family, Los Angeles

Barnett Newman (United States,
1905–1970)
Here I (to Marcia), 1950 [1]
Bronze cast; sculpture with base: 107 $\frac{1}{8}$ x
27 $\frac{1}{4}$ x 28 $\frac{1}{4}$ in. (272 x 69 x 72 cm)
Los Angeles County Museum of Art, gift
of Marcia S. Weisman

Maria Nordman (Silesia, active
United States, born 1943)
EAT Film Room, 1967 [2]
1 box with 2 panels, collage with drawing:
each 28 $\frac{7}{8}$ x 73 $\frac{1}{2}$ in. (73.3 x 186.7 cm)
Courtesy of the artist, Los Angeles

Drawings for Alameda Project, 1970s [2]
2 framed two-sided drawings, pencil, ink,
and collage on paper, each in wooden box;
each drawing: 75 x 30 $\frac{1}{2}$ in. (190.5 x
77.5 cm); each box: 80 $\frac{1}{2}$ x 32 x 10 $\frac{1}{2}$ in.
(204.5 x 81.3 x 26.7 cm)
Courtesy of the artist, Los Angeles, and
Rosamund Felsen Gallery, Santa Monica

Ladislav Novák (Czechoslovakia, born 1925)
"Individualista," in *Pocta Jacksonu
Pollockovi: texty z let 1959–1964*, 1966 [1]
Book; open: 6 $\frac{3}{4}$ x 10 $\frac{1}{2}$ in. (17.1 x 26.7 cm)
Research Library, The Getty Research
Institute, Los Angeles

Hélio Oiticica (Brazil, 1937–1980)
Metaesquema No. 171 (seco 1), 1957–58 [1]
Gouache on paper; 14 $\frac{1}{8}$ x 16 $\frac{7}{8}$ in.
(36 x 43 cm)
Projeto Hélio Oiticica, Rio de Janeiro

Metaesquema No. 296, 1957–58 [1]
Gouache on paper; 21 $\frac{5}{8}$ x 25 $\frac{1}{4}$ in.
(55 x 64 cm)
Projeto Hélio Oiticica, Rio de Janeiro

Metaesquema No. 535, 1957–58 [1]
Gouache on paper; 21 $\frac{5}{8}$ x 25 $\frac{1}{4}$ in.
(55 x 64 cm)
Projeto Hélio Oiticica, Rio de Janeiro

Metaesquema No. 537, 1957–58 [1]
Gouache on paper; 21 $\frac{5}{8}$ x 25 $\frac{1}{4}$ in.
(55 x 64 cm)
Projeto Hélio Oiticica, Rio de Janeiro

Nucleus 6, 1960–63 [2]
Installation: 10 painted panels and ceiling
structure; approx. 72 x 90 x 78 in.
(182.9 x 228.6 x 198.1 cm)
Projeto Hélio Oiticica, Rio de Janeiro

Parangolé, 1964 [5]
Videodocumentation (color, 9 min.) of per-
formance; dancers in capelike *Parangolés*
Projeto Hélio Oiticica, Rio de Janeiro

Box Bolide 8, 1964 [6]
Two painted wooden boxes with fabric;
each approx. 18 x 12 x 9 in. (45.7 x 30.5 x
22.9 cm)
Projeto Hélio Oiticica, Rio de Janeiro

Box Bolide 1, 1965–66 [6]
Two painted wooden boxes with fabric;
each approx. 18 x 12 x 9 in. (45.7 x 30.5 x
22.9 cm)
Projeto Hélio Oiticica, Rio de Janeiro

*Counter Bolide to Return Earth unto the
Earth* in Kleemania, Cajú, Rio de Janeiro,
1979 [5]
Photodocumentation of performance;
Bolide container filled with earth from
elsewhere is deposited in grassy field
Projeto Hélio Oiticica, Rio de Janeiro

Roman Opalka (France, active Poland, born 1931)
OPALKA 1965/1–∞ (detail 1006398), 1965–? [6]
Black-and-white photograph; 12 x 9 ½ in. (30.5 x 24.1 cm)
Courtesy of the artist/Anthony Grant Inc., New York

OPALKA 1965/1–∞ (detail 3578634–3595782), 1965–? [6]
Acrylic on canvas; 77 ⅛ x 53 ⅛ in. (196 x 135 cm)
Private collection, OR

OPALKA 1965/1–∞ (detail 5163823), 1965–? [6]
Black-and-white photograph; 12 x 9 ½ in. (30.5 x 24.1 cm)
Courtesy of the artist/Anthony Grant Inc., New York

OPALKA 1965/1–∞, 1965–? [6]
Sound recording
Courtesy of the artist/Anthony Grant Inc., New York

Dennis Oppenheim (United States, born 1938)
Maze, 1970 [5]
Film documentation; maze contructed with hay bales in large field, Whitewater, Wisconsin; cattle stampeded through maze to locate corn placed along edge
Courtesy of the artist and Marlborough Gallery, New York

Reading Position for Second-Degree Burn, 1970 [5]
Photodocumentation of performance; skin, book, solar energy; duration of exposure: 5 hours, Jones Beach, New York; two color photos, 40 x 60 in. (101.6 x 152.4 cm); black-and-white photographic text, 6 x 60 in. (15.2 x 152.4 cm)
The Museum of Contemporary Art, Los Angeles; gift of Dennis Oppenheim

Blinky Palermo (Germany, 1943–1977)
Daydream I, 1965 [6]
Wall object in two parts; 1: oil on synthetic fabric; 2: raw cotton over wooden construction; overall: 23 ⅝ x 47 ¼ x 2 in. (60 x 120 x 5 cm)
Museum für Moderne Kunst, Frankfurt am Main; Ehemalige Sammlung Karl Stroher, Darmstadt

Softspeaker, 1965 [6]
Wall object in two parts; 1: dyed raw cotton fabric; 2: dyed raw cotton fabric underlaid with raw cotton over wood frame; overall: 38 ⅝ x 69 ½ x 1 ¾ in. (98 x 176.5 x 4.5 cm)
Museum für Moderne Kunst, Frankfurt am Main; Ehemalige Sammlung Karl Stroher, Darmstadt

Gray Disk, 1966 [6]
Wall object; synthetic resin on raw cotton over wood; 5 5/16 x 10 ⅜ x 1 in. (13.5 x 26.5 x 2.5 cm)
Museum für Moderne Kunst, Frankfurt am Main; Ehemalige Sammlung Karl Stroher, Darmstadt

Green/Green, 1967 [6]
Dyed stitched cotton fabric underlaid with raw cotton over wood frame; 78 ⅛ x 78 ⅛ x ¾ in. (198.5 x 198.5 x 2 cm)
Museum für Moderne Kunst, Frankfurt am Main; Ehemalige Sammlung Karl Stroher, Darmstadt

Untitled, 1970 [6]
Oil on canvas over wood; two panels; each: 6 x 6 x 2 in. (15.2 x 15.2 x 5.1 cm)
Collection Nicole Klagsbrun, New York

Giulio Paolini (Italy, born 1940)
Untitled (Plakat Carton), 1962 [6]
Cardboard, wood, polyethylene; 11 ¾ x 11 ¾ in. (30 x 30 cm)
Courtesy of the artist, Turin

Duoblure, 1972–73 [6]
Graphite on canvas; 15 ¾ x 23 ⅝ in. (40 x 60 cm)
Collezione Christian Stein, Turin

Lygia Pape (Brazil, born 1929)
Neoconcrete Ballet No. 1, 1958 [1]
Videodocumentation (color, 15 min.) of performance in collaboration with poet Reynaldo Jardim and composer Pierre Henry
Courtesy of the artist, Rio de Janeiro

Box of Cockroaches, 1967 [4]
Acrylic, cockroaches, mirror; 3 ⅞ x 13 ¾ x 9 ⅞ in. (10 x 35 x 25 cm)
Courtesy of the artist, Rio de Janeiro

Divider, 1968/2004 (recreated for exhibition by School of Dance, California Institute of the Arts) [3]
Videodocumentation of performance; a large cloth with holes for heads covers dancers moving beneath it; original cloth: 65 ½ x 65 ½ ft. (20 x 20 m)
Courtesy of the artist, Rio de Janeiro

Otto Piene (Germany, born 1928)
Milky Ways, 1964–65 [5]
Photodocumentation of light installations at City Opera House, Bonn, Germany
Courtesy of the artist, Boston

Light Ballet, 1967–69 [3]
Photodocumentation; projected light patterns move in response to music or sounds
Courtesy of the artist, Boston

Décio Pignatari (Brazil, born 1927)
"Life," in *Noigandres 4,* 1956 [1]
Printed broadsheet; 10 ⅝ x 9 in. (27 x 23 cm)
Research Library, The Getty Research Institute, Los Angeles

Sándor Pinczehelyi (Hungary, born 1946)
Sickle and Hammer I–IV, 1973/2002 [5]
Photodocumentation of performance; 4 photographs; each: 15 ¾ x 11 ¾ in. (40 x 30 cm)
Ludwig Museum, Budapest

Ad Reinhardt (United States, 1913–1967)
Abstract Painting, Blue, 1952 [1]
Oil on canvas; 30 x 25 in. (76.2 x 63.5 cm)
The Museum of Contemporary Art, Los Angeles; gift of Beacon Bay Enterprises

George Rickey (United States, 1907–2002)
Four Lines Oblique Gyratory—Square, 1973 [3]
Stainless steel; 240 x 136 in. (609.6 x 345.4 cm)
Los Angeles County Museum of Art, gift of Marion Smooke in memory of Nathan Smooke

Bridget Riley (England, 1931–1984)
Polarity, 1964 [3]
Emulsion on canvas; 70 x 70 in. (177.8 x 177.8 cm)
Los Angeles County Museum of Art, gift of Robert A. Rowan

Peter Roehr (Germany, 1944–1968)
Untitled (ST-7), 1962 [4]
Adding machine paper; 92 1/8 x 2 1/2 in. (234 x 6.4 cm)
Museum für Moderne Kunst, Frankfurt am Main

Untitled (OB-1), 1963 [4]
Matchboxes on wood; 22 3/8 x 22 7/8 in. (56.8 x 58 cm)
Museum für Moderne Kunst, Frankfurt am Main

Untitled (FO-74), 1965 [4]
Paper in plastic; 17 7/8 x 18 7/8 in. (45.5 x 48.1 cm)
Museum für Moderne Kunst, Frankfurt am Main

Untitled (FO-87), 1966 [4]
Paper in plastic; 15 1/8 x 14 7/8 in. (38.2 x 37.9 cm)
Museum für Moderne Kunst, Frankfurt am Main

Dieter Roth (Germany, 1930–1998)
"Tomato, Potato," in *Bok 1956–59,* 1959 [1]
Artist's book; open: 8 3/4 x 19 1/4 in. (22.2 x 48.9 cm)
Research Library, The Getty Research Institute, Los Angeles

Rhod Rothfuss (Uruguay, 1920–1972)
Madí Painting, 1946 [1]
Enduido and enamel on wood; 30 1/8 x 19 7/8 in. (76.5 x 50.5 cm)
Colección Museo de Arte Latinoamericano de Buenos Aires

Edward Ruscha (United States, born 1937)
Every Building on the Sunset Strip, 1966 [4]
Artist's book; gelatin-silver prints in fan-fold format; open: 7 x 275 in. (18 x 714 cm)
Los Angeles County Museum of Art, Library Acquisition Fund

Robert Ryman (United States, born 1930)
A 77, 1977 [6]
Varathane on Acrylivin panel with two rigid plastic bands and four cadmium-plated steel bolts; overall: 16 1/4 x 14 in. (41.3 x 35.6 cm), #773.74
Collection of the artist, New York

Fred Sandback (United States, 1943–2003)
Blue Corner Piece, 1970 [2]
Blue elastic cord; 72 x 72 in. (182.9 x 182.9 cm)
Collection of Virginia Dwan, New York

Mira Schendel (Switzerland, active Brazil, 1919–1988)
Untitled, 1954 [1]
Mixed mediums on paper; 20 1/8 x 26 x 1 5/8 in. (51 x 66 x 4 cm)
Col. Adolpho Leirner, São Paulo, Brazil

Train, c. 1965 [4]
Sheets of rice paper and nylon line; each sheet: 17 7/8 x 9 in. (45.5 x 23 cm)
Estate of Mira Schendel, São Paulo

Jan Schoonhoven (Netherlands, 1914–1994)
R 62-16, 1962 [4]
Wood, cardboard, emulsion paint; 32 1/8 x 24 1/4 in. (81.5 x 61.5 cm)
Stedelijk Museum, Amsterdam

Big Square Relief, 1964 [4]
Latex, papier-mâché on chipboard; 40 1/2 x 50 in. (103 x 127 cm)
Collection Van Abbemuseum, Eindhoven, The Netherlands

Slanting Rectangular Planes, 1966 [4]
Wood, cardboard, paper, emulsion paint; 51 5/8 x 34 7/8 in. (131 x 88.5 cm)
Stedelijk Museum, Amsterdam

Relief of Squares with Double Inclined Planes Diametrically Broken, 1967 [4]
Wood, cardboard, paper, emulsion paint; 40 7/8 x 40 7/8 in. (104 x 104 cm)
Stedelijk Museum, Amsterdam

Ivan Serpa (Brazil, 1923–1973)
Rhythmic Bands, 1953 [1]
Industrial paint on Eucatex; 48 x 32 1/8 in. (122 x 81.5 cm)
Col. Adolpho Leirner, São Paulo, Brazil

Richard Serra (United States, born 1939)
Inverted House of Cards, 1969 [2]
Steel; 49 x 88 1/2 x 88 1/2 in. (124.5 x 224.8 x 224.8 cm)
Los Angeles County Museum of Art, gift of Eli and Edythe L. Broad

Joel Shapiro (United States, born 1941)
Untitled, 1979 [2]
Cast iron, milled; 3 1/4 x 72 7/8 x 2 1/4 in. (8.2 x 185.3 x 5.8 cm)
Courtesy of the artist, New York

David Smith (United States, 1906–1965)
Circle IV, 1962 [1]
Painted steel; 85 x 59 3/4 x 15 in. (215.9 x 151.8 x 38.1 cm)
The Estate of David Smith, New York

Tony Smith (United States, 1912–1980)
Black Box, 1962 [2]
Painted steel; 22 1/2 x 33 x 25 in. (57.2 x 83.8 x 63.5 cm)
Courtesy of Joel Shapiro, New York

Robert Smithson (United States, 1938–1973)
Yucatan Mirror Displacements (1–9), 1969 [4]
Nine Cibachrome prints from 35 mm slides; each (framed): 6 5/8 x 6 5/8 in. (17 x 17 cm)
Solomon R. Guggenheim Museum, New York; purchased with funds contributed by the Photography Committee and with funds contributed by the International Director's Council and Executive Committee members: Edythe Broad, Henry Buhl, Elaine Terner Cooper, Linda Fischbach, Ronnie Heyman, Dakis Joannou, Cindy Johnson, Barbara Lane, Linda Macklowe, Brian McIver, Peter Norton Foundation, Willem Peppler, Denise Rich, Rachel Rudin, David Teiger, Ginny Williams, Elliot Wolk, 1999; 99.5269

The Spiral Jetty, 1970 [5]
Videodocumentation of earthwork; rocks, earth, salt crystals arranged in spiral 1.45 miles long, Great Salt Lake, Utah
Dia Art Foundation, New York

Keith Sonnier (United States, born 1941)
Spot Circle, 1970 [3]
1/2-inch glass, theatrical spotlight; diameter:
84 in. (213.4 cm)
Ace Gallery, Los Angeles

Jesús Rafael Soto (Venezuela, born 1923)
Kinetic Structure with Geometric Elements,
1955 [1]
Acrylic on Plexiglas and wood; 23 3/4 x
23 5/8 x 9 7/8 in. (60.3 x 60 x 25 cm)
Colección Banco Mercantil, Caracas

Kinetic Structure with Geometric Elements,
1955 [1]
Acrylic on Plexiglas and wood; 19 3/4 x
19 5/8 x 10 1/4 in. (50.2 x 50 x 26.2 cm)
Colección Banco Mercantil, Caracas

Horizontal-Vertical Kinetic Structure, 1957
[1]
Plexiglas, wood, and acrylic; 23 5/8 x
23 5/8 x 9 1/2 in. (60 x 60 x 24 cm)
Fundación Museo de Arte Moderno Jesús
Soto, Ciudad Bolivar, Venezuela

Almost Immaterial Vibration, 1963 [3]
Wood, wire, and paint; 23 1/4 x 63 in.
(59 x 160 cm)
Private collection courtesy Adler &
Conkright Fine Art, New York

Frank Stella (United States, born 1936)
Getty Tomb, 1959 [2]
Black enamel on canvas; 84 x 96 in.
(213.4 x 243.8 cm)
Los Angeles County Museum of Art,
Contemporary Art Council Fund

Jean Tinguely (Switzerland, 1925–1991)
Machine Picture Haus Lange, 1960 [1]
Painted wood and metal, wood pulleys,
rubber belts, electric motor; 25 5/8 x
25 5/8 x 7 7/8 in. (65 x 65 x 20 cm)
Galerie Renée Ziegler, Zurich, Switzerland

Goran Trbuljak (Yugoslavia, born 1948)
The Exercises of an Artist, 1975 [5]
Unique artist's book; 7 7/8 x 11 3/8 in.
(20 x 29 cm)
Courtesy of the artist, Zagreb

Günther Uecker (Germany, born 1930)
Big Cloud, 1965 [3]
Paint and nails on canvas and particle board;
68 5/8 x 68 3/4 x 2 7/8 in. (174.3 x 174.6 x
7.3 cm)
The Museum of Contemporary Art,
Los Angeles; gift of Lannan Foundation

Grazia Varisco (Italy, born 1937)
Gnomons, 1970s [3]
10 metal units; largest approx. 17 3/4 x
17 3/4 x 11 3/4 in. (45 x 45 x 30 cm)
Courtesy of the artist, Milan

Victor Vasarely (Hungary, active France,
1908–1997)
Langsor II, 1952–56 [1]
Oil on canvas; 76 3/4 x 47 1/4 in. (195 x
120 cm)
Galerie Denise René, Paris

Hotomi II, 1956–59 [1]
Oil on wood; 22 11/16 x 18 1/2 in.
(57.5 x 47 cm)
Los Angeles County Museum of Art, gift
of Dr. and Mrs. Morton H. Randall

Bora II, 1964 [3]
Acrylic on canvas; 73 1/4 x 63 in. (186 x
160 cm)
Galerie Denise René, Paris

Mary Vieira (Brazil, 1927–2001)
*Polyvolume: Plastic Disc, Idea for a Serial
Progression*, 1953/62 [3]
Movable anodized aluminum parts on
wooden base; 14 3/8 x 14 3/8 x 13 3/8 in.
(36.6 x 36.6 x 34 cm)
Museu de Arte Contemporânea da
Universidade de São Paulo, Brazil

Franz Erhard Walther (Germany, born 1939)
Projection Sculpture, 1962–63 [2]
Pieces of a mattress, white thread, clear
synthetic resin; 35 3/8 x 25 3/8 x 7 3/4 in.
(90 x 64.5 x 19.8 cm)
Collection of the artist, Hamburg

49 Panels, 1963 [4]
Wooden panels with white coating,
starch paste, cotton; 63 3/8 x 46 7/8 in.
(161 x 119 cm)
Collection of the artist, Hamburg

Lawrence Weiner (United States, born
1940)
Green as Well as Blue as Well as Red, 1972
[5]
Words painted on wall; variable dimensions
Collection Herbert, Ghent

Red and Green and Blue More or Less, 1972
[5]
Words painted on wall; variable dimensions
Collection Herbert, Ghent

Red in Lieu of Green in Lieu of Blue, 1972
[5]
Words painted on wall; variable dimensions
Collection Herbert, Ghent

Red in Relation to Green in Relation to Blue,
1972 [5]
Words painted on wall; variable dimensions
Collection Herbert, Ghent

*Red Over and Above Green Over and
Above Blue*, 1972 [5]
Words painted on wall; variable dimensions
Collection Herbert, Ghent

Franz Weissmann (Austria, active Brazil,
born 1914)
Tower, 1957 [1]
Industrial paint on iron structure; 77 1/2 x
30 3/8 x 16 7/8 in. (196.5 x 77 x 43 cm)
Colección Cisneros, Caracas

Doug Wheeler (United States, born 1939)
Untitled (Light Encasement), 1968 [3]
Adapted neon and plastic; 96 x 96 in.
(243.8 x 243.8 cm)
Collection of the artist, Los Angeles

Emmett Williams (United States, born
1925)
Sweethearts, 1967 [5]
Book; open: 6 1/2 x 10 1/4 in. (16.5 x 26 cm)
Research Library, The Getty Research
Institute, Los Angeles

La Monte Young (United States, born
1935)
"Composition 1960 #9," in *An Anthology*,
1963 [4]
Book; 7 3/4 x 8 7/8 in. (19.7 x 22.7 cm)
Gilbert and Lila Silverman Collection,
Detroit

1933
GERMANY

Nazis seize power. • Bauhaus in Berlin closes due to Nazi pressure. **Josef Albers** moves to newly opened Black Mountain College in North Carolina (future colleagues include **John Cage**, Buckminster Fuller, Willem de Kooning, Robert Motherwell).

1939

Germany invades Poland on September 1. Two days later, Britain and France declare war on Germany. • **Eva Hesse** and family flee Nazi persecution, settle in New York. • German **Gego** (Gertrudis Goldschmidt) moves to Caracas, works as freelance architectural designer.

1940
FRANCE

German troops occupy Paris in June (and control city for next four years).

ARGENTINA

Argentine-born **Lucio Fontana**, established in Italy, returns to Buenos Aires to escape the war (remains for six years, exhibiting and teaching).

US

Mondrian moves to New York. Joins American Abstract Artists, which protests MoMA's hostility to US abstraction. Members include **Ad Reinhardt**, **David Smith**, **Burgoyne Diller**, and Europeans in US such as **Albers** and Moholy-Nagy.

1941
ARGENTINA

Julio Le Parc begins studies at Academia de Bellas Artes, Buenos Aires, where **Fontana** teaches.

US

Japan bombs Pearl Harbor and US enters World War II. Many American artists join war effort, including **John McLaughlin**, **Ellsworth Kelly**, **Robert Breer**, **Reinhardt**. **D. Smith** studies welding at government school; works for American Locomotive Company assembling tanks and locomotives.

1942
US

In New York, **Cage** collaborates with choreographer Merce Cunningham; meets Marcel Duchamp.

1943
ITALY

Italy surrenders to Allies. • **Carlo Belloli** displays first visual poems (*Testi-Poemi Murali*) in Milan. Associated with Italian futurists, he describes his work as "unadorned verbal architecture . . . totally optical in typographical and structural layout." He is first postwar figure to produce what will be called concrete poetry (although he will disassociate himself with term in 1959).

1944
FRANCE

A month before Paris is liberated, Denise René opens gallery in her apartment with exhibit by Hungarian **Victor Vasarely**. (His second show the following year attracts attention.)

SWITZERLAND

Using term coined by Dutch artist Theo van Doesberg 14 years earlier, **Max Bill** organizes *Konkrete Kunst* at Kunsthalle, Basel; includes **Albers**, **Bill**, Doesburg, **Verena Loewensberg**, **Richard Paul Lohse**, Kandinsky, Mondrian, and others.

ARGENTINA

First and only issue of *Arturo: Revista de Artes Abstractas* published in Buenos Aires, with contributions by **Carmelo Arden Quin**, **Tomás Maldonado**, **Gyula Kosice**, **Rhod Rothfuss**, Joaquin Torres-García, and reproductions of works by Kandinsky, Mondrian, and others. Including painting, poetry, music, dance, *Arturo* declares art need not represent physical world, launching Argentine avant-garde. Spawns the group Arte-Concreto-Invención. • **Kosice** creates *Röyi* (p. 55), an abstract sculpture with movable parts requiring viewer's participation. He is among the first of his generation to experiment with kinetic art.

US

Mondrian, 72, dies in New York. • **Reinhardt** has first commercial show at Artists' Gallery, NYC.

1945

Germany surrenders, ending World War II in Europe. USSR controls much of Central and Eastern Europe and curtails communication with West.

ARGENTINA

Following disagreements among members, Arte-Concreto-Invención splinters into Asociación Arte Concreto-Invención, Grupo Madí, Perceptismo, other groups; this active avant-garde climate instigates exhibitions, publications, lectures, performances.

BRAZIL

Eight-year dictatorship ends. Brazil has constitutional government (until military coup in 1964). Art historian/critic Mario Pedrosa returns to Brazil after exile; organizes avant-garde in Rio.

1946
ARGENTINA

Colonel Juan Perón becomes president; improves conditions for workers but greatly restricts freedom of speech. • **Fontana** helps establish Academia Altamira, Buenos Aires. Brazilian **Sergio de Camargo** is one of his students. **Fontana** cowrites Manifiesto Blanco, initiating Spazialismo. Document promotes synthesis of color, sound, movement, time, space, and scientific techniques. (Will introduce these ideas to Europe in subsequent manifestos after return to Milan next year.) In this spirit **Kosice** creates *Luminous Madí Structure No. 1*, among first uses of neon as principal material. • Grupo Madí exhibits at Academia Altamira in October.

BRAZIL

Pedrosa establishes arts section for discussion of avant-garde in Rio newspaper *Correio da Manhá*.

US

Committed to young abstract painters such as **Reinhardt**, Betty Parsons opens gallery in New York. She represents abstract expressionists and later **Kelly**, **Agnes Martin**, and others.

1947
US

Dan Flavin attends seminary in Brooklyn (continues for next five years). • Venezuelan **Carlos Cruz-Diez** travels to New York to study advertising. • **Reinhardt** begins teaching art history at Brooklyn College. • Brazilian **Hélio Oiticica**, 10, moves to Washington DC for two years, where his father is Guggenheim Fellow at National Museum.

1948
FRANCE

Members of Argentine avant-garde (**Maldonado**, **Arden Quin**, **Kosice**, **Melé**) individually travel to Paris, meet leading abstract artists. Despite having dissolved a year earlier, Grupo Madí shows at 3rd Salon des Réalités Nouvelles • **Camargo** leaves Buenos Aires to study at Sorbonne (returns to Brazil in 1953).

ITALY

24th Venice Biennale is first since 1942.

BRAZIL

Established in US and Europe, Alexander Calder visits Brazil, exhibits at Instituto Brasil–Estados Unidos (IBEU); show organized by newly formed Museu de Arte Moderna, Rio (MAM–RJ), and travels to Museu de Arte São Paulo (MASP). Pedrosa

hosts conference on Calder's work, addresses abstract art for first time. (Pedrosa will become voice for concrete art in Rio.)

US

GI Bill of Rights allows many to study abroad. **Kelly** moves to Paris, becomes interested in abstraction. ◆ **Barnett Newman** paints *Onement*, initiating signature work that will influence US artists of the 60s. (Has two solo shows at Betty Parsons Gallery in 1950–51; gets negative reviews, and by 1955 stops painting for three years.)

1949
FRANCE

Cage and Cunningham visit **Kelly**'s studio in Paris. **Kelly** and **Cage** correspond (until **Kelly** returns to US in 1954). ◆ **Breer** arrives in Paris on GI Bill, stays for ten years painting and working with film; becomes affiliated with Galerie Denise René.

URUGUAY

Torres-García, father of South American constructivism, dies, age 75.

BRAZIL

Museu de Arte Moderna São Paulo (MAM–SP) opens with landmark show *Do Figurativismo ao Abstracionismo*; 95 works selected by French gallerists René Drouin and Denise René; included are Europeans Jean Arp, Calder, Kandinsky, **Vasarely**; only three Brazilians: Waldemar Cordiero, Samson Flexor, and Cicero Dias. No US artists due to financial constraints. Show travels to Buenos Aires; catalogue published in Portuguese, French, English.

US

Donald Judd studies at Art Students League by day, Columbia University at night (earns philosophy degree in 1953). ◆ Painting by **McLaughlin** included in Los Angeles County Museum painting and sculpture annual exhibition, his first public showing.

1950
FRANCE

Brazilian **Lygia Clark** travels to Paris, remains two years, studies with Fernand Léger. ◆ Established in Venezuela, **Jesús Rafael Soto** arrives in Paris; begins serial geometric paintings suggesting motion; associates with Galerie Denise René; studies **Albers**, Mondrian, Malevich; meets **Arden Quin**, other members of Grupo Madí. ◆ During visit to Arp's studio, **Kelly** encounters chance-based collages made by Arp and Sophie Taeuber-Arp; employs chance techniques shortly thereafter.

BRAZIL

Bill's large exhibition of concrete art at MASP influences young artists (who form Grupo Ruptura in São Paulo in 1952 and Grupo Frente in Rio in 1953).

US

Albers begins *Homage to the Square* (p. 95) series (continued until his death); appointed chairman of Yale design department.

1951
SWITZERLAND

Eugen Gomringer creates his first visual poems, "constellations" (p. 157), unaware of similar developments in Brazil and Sweden and of **Belloli**'s work. (He will publish them two years later.)

ITALY

Fontana creates neon works, including large ceiling installation for Triennale, Milan.

WEST GERMANY

Bill awarded commission to design and build Hochschüle für Gestaltung, Ulm; serves (1954–57) as rector and head of architecture, product design departments.

BRAZIL

1st Bienal do São Paulo includes works from 22 countries; puts Brazil on international art map. MAM–SP acquires many works. Show includes figures from US and Europe such as **Bill**, Picasso, Léger, **Lohse**, **Fontana**, **D. Smith**, Calder, Pollock, Torres-García. Brazil is represented by Almir Mavignier, **Ivan Serpa**, **Franz Weissmann**, and others. Prize awarded to **Bill** for *Tripartite Unity* (p. 51); **Serpa** wins Young Painter award. ◆ While visiting Brazil, **François Morellet** learns of **Bill**'s work through poor photographs. Befriends Mavignier (who introduces him to **Bill**, **Kelly**, and others in Europe the following year). **Morellet** experiments with geometric abstraction; does not see Bienal.

1952
FRANCE

Breer has first exhibit at Galerie Denise René. ◆ **Clark** shows first abstract paintings at Galerie de l'Institut Endoplastique, Paris; returns to Rio and begins showing there. ◆ Galerie Bourlaouën in Nantes presents *Abstractions*; organized by Mavignier, it includes works by him, **Morellet**, **Kelly**, others. ◆ **Kelly** creates *Red, Yellow, Blue, White* using commercially dyed fabric.

ITALY

Exhibition *Arte Mobile*, dedicated to physically and optically kinetic art, opens at Galleria Annunziata, Milan. (Inspires influential exhibition *Le Mouvement* at Galerie Denise René three years later.)

SWEDEN

Öyvind Fahlström begins making concrete poetry, using term three years before Noigandres poets in Brazil and **Gomringer** in Switzerland. Publishes manifesto.

BRAZIL

Décio Pignatari and **Haroldo** and **Augusto de Campos** found poetry review *Noigandres* in São Paulo (without knowledge of related activities in Switzerland, Italy, Sweden), become associated with concrete art movements in Brazil. ◆ Grupo Ruptura's first exhibition held at MAM–SP, includes concrete art manifesto. ◆ **Serpa** begins teaching at MAM–RJ. (Many of Brazil's most prominent artists study with him during next two decades.)

VENEZUELA

Architect Carlos Raúl Villanueva integrates artwork with design for Ciudad Universidad de Caracas; invites local emerging artists such as **Soto** as well as Calder, **Vasarely**, Arp, and Léger to contribute murals, theatre designs, other works, bringing many to Venezuela for first time.

US

Sol LeWitt moves to New York, attends Cartoonists and Illustrators School (which later becomes School of Visual Arts); works as graphic artist. ◆ **Reinhardt** begins symmetrical monochromatic paintings in blue and red.

1953
Stalin dies on March 5.

WEST GERMANY

Albers begins teaching at Ulm School (remaining there until 1955).

POLAND

Wojciech Fangor turns from state-endorsed social realism to poster and exhibition design (teaches in graphics department of Warsaw Academy of Fine Arts for next eight years).

FRANCE

Soto shows five paintings at the Salon des Réalités Nouvelles in Paris. Having read Moholy-Nagy's influential *Vision in Motion*, he creates his first optically kinetic works, "optical vibrations." ◆ **Morellet**'s parents offer **Kelly** temporary quarters when he is evicted from studio. **Kelly** travels to Rotterdam to see late Mondrian paintings.

BRAZIL

2nd Bienal do São Paulo hosts exhibits of futurism, Picasso, cubism, de Stijl and Mondrian, and Calder. **Bill** is a juror. ◆ **Bill** invited by Brazilian government to lecture on architecture and society in Rio and São Paulo; travels to Peru to meet former

Bauhaus colleague **Albers**. ◆ **Camargo** returns to Brazil after five years in Paris.

US

Robert **Ryman** works as guard at MoMA. (He remains for seven years, working alongside **Flavin**, **LeWitt**, and critic Lucy Lippard; produces first paintings; contributes to MoMA's employee exhibits.) ◆ **Bill** reads "Art, Business, Culture, Design" paper at International Design Conference, Aspen; travels to Chicago and New York to meet Charles Eames, Philip Johnson, Nikolaus Pevsner. ◆ **McLaughlin** has first solo exhibit, at Felix Andau Gallery, L.A.

1954

WEST GERMANY

Gomringer becomes **Bill**'s secretary at Ulm school; publishes first manifesto, "From Line to Constellation," concerning visual poetry. ◆ **Maldonado** returns to Europe, invited by **Bill** to teach at Ulm School. (He remains until 1967, serving on and off as rector.)

ITALY

27th Venice Biennale includes **D. Smith**. Pedrosa helps select **Clark** and **Serpa** as Brazilian representatives.

FRANCE

Soto meets **Tinguely** at latter's exhibit at Galerie Arnaud, Paris; they become close friends. ◆ **Kelly** reads review of **Reinhardt**'s show at Betty Parsons Gallery; thinks his own work could be well received in US; leaves France by boat in July.

BRAZIL

Oiticica studies with **Serpa** at Escola do MAM–RJ; inspired by European constructivists. ◆ Rio's concrete Grupo Frente's first exhibit opens at Galería IBEU, organized by poet/critic Ferreira Gullar, with works by **Clark**, **Carvão**, **Serpa**, **Pape**, and others.

US

Robert **Smithson**, age 16, wins scholarship to Art Students League, NYC.

1955

USSR establishes Warsaw Pact, holding many Central and Eastern European countries under Soviet control. Yugoslavia under Tito remains more independent and open. (When **Julije Knifer** graduates from Zagreb's Art Academy the next year, he is awarded trip to Venice Biennale.)

WEST GERMANY

Documenta I, Kassel: 570 works by 148 artists from six countries; features prewar modernism defamed by Nazis as well as contemporary art installed in ruins of Museums Fredericianum; **Albers**, Calder,

Léger, **Vasarely** represented. ◆ **Uecker** makes compositions of nails protruding from painted surfaces, creating play of light and shadow (p. 61). ◆ Brazilian poet/designer **Pignatari** visits Ulm school, meets **Gomringer**; discovering parallel projects, they agree to collaborate.

FRANCE

Influential exhibition of op and kinetic art, *Le Movement* at Galerie Denise René, includes works by Agam, **Bury**, Calder, Duchamp, Jacobsen, **Soto**, **Tinguely**, **Vasarely**. US artist **Breer** shoots film of exhibition.

BRAZIL

Kubitschek elected president of Brazil, initiates construction of Brasília, a planned city of striking architecture, to serve as capital. (**Cildo Meireles** is raised here from age 10.) ◆ Third Bienal do São Paulo. Marvin Ross, curator at Los Angeles County Museum, sends delegation of West Coast artists including Diebenkorn, Mullican, **McLaughlin**, June Wayne, and others. ◆ Grupo Frente has second exhibition at MAM–RJ, including **Clark**, **Oiticica**, Ferreira Gullar, **Pape**, **Carvão**, **Serpa**, **Weissmann**; Pedrosa writes catalogue text.

US

Bus boycott by African Americans launches civil rights movement.

1956

POLAND

With cultural liberalization and lifting of travel restrictions, **Fangor**'s paintings take radical turn, incorporating spatial illusion, blurred silhouettes, and geometric shapes.

FRANCE

German **Heinz Mack** meets future collaborators Yves Klein and **Tinguely** in Paris.

BRAZIL

First Exposição Nacional de Arte Concreta at MAM–SP (travels to MAM–RJ following year) includes concrete art by Grupos Frente and Ruptura, poster poems by Noigandres. **H. de Campos** essay outlines differences between his own more doctrinaire São Paulo group (Ruptura) and more expressive Rio group (Frente) (leading to official split in 1959). ◆ **Gomringer** and Noigandres poets mutually agree upon the term "concrete" to describe their poetry; international concrete poetry movement is launched at December exhibition.

US

Albers has first retrospective, at Yale University Art Gallery ◆ **Kelly** shows for first time at Betty Parsons Gallery, NYC. ◆ **Cage** gives occasional classes at the New School for Social Research, NYC (through 1960).

Many artists attend, **Flavin** among them. ◆ **Ed Ruscha** enters Chouinard Art Institute, L.A. (later called California Institute of the Arts; **Larry Bell** enrolls the following year). **Robert Irwin** is faculty member.

1957

A year after Jackson Pollock's death, MoMA organizes retrospective (it goes to Rome, Basel, Amsterdam, Hamburg, Berlin, London, and Paris). *The New American Painting*, a show of abstract expressionists including Pollock, **Newman**, de Kooning, Rothko, and others, begins European tour. The two shows highlight the importance of postwar US art.

WEST GERMANY

Newly opened Schmela Gallery, Düsseldorf, gives Klein his first show (later hosts artists who become affiliated with Group Zero, including **Fontana**, **Tinguely**, **Mack**, **Piene**, **Uecker**, **Soto**, **Haacke**, **Roth**).

FRANCE

Kosice moves to Paris; begins experimenting with light and water in large-scale acrylic sculptures.

THE NETHERLANDS

Schoonhoven has first show of serial reliefs at the Gallerie C.C.C. in Schiedam (p. 150–51).

ITALY

Yves Klein: Proposte Monochromes, Epoca Blu at Galeria Apollinare, Milan. **Manzoni** attends and meets Klein, whose blue paintings inspire him to create *Achromes*, monochrome paintings soaked in white clay (and later made of various white media).

BRAZIL

4th Bienal do São Paulo. The number of countries participating has increased to 44, including Canada, Israel, China, and South Africa. MoMA sends Pollock retrospective that toured Europe. **Cruz-Diez** and Alejandro Otero are part of Venezuelan delegation. Brazil is represented by **Carvão**, **Clark**, **Nogueira Lima**, **Oiticica**, **Serpa**, **Camargo**, **Weissmann**, **Pape**, and others. **Albers** and **Bill** are also included. ◆ **Oiticica** begins his *Metaesquemas* (p. 20–21), permutations of squares and rectangles on white ground in gouache. (He abandons them after 1958; doesn't name the series until 1972.) ◆ *Jornal do Brasil* adds a cultural supplement to Sunday edition. Although it covers all Western art, half of space is dedicated to concrete movement in Rio.

VENEZUELA

Encouraged by Otero and **Soto**'s works, **Gego** creates first three-dimensional pieces. ◆ **Cruz-Diez** returns to Caracas from Europe.

US

Kelly included in *Young America, 1957* at Whitney Museum, which buys work, his first museum sale. ◆ **Judd** has his first solo show, at Panoras Gallery, NYC.

Hesse studies at Yale School of Art and Architecture with **Albers**. ◆ *David Smith* exhibition opens at MoMA. ◆ **Robert Morris** has his first solo show, at Dilexi Gallery, San Francisco. ◆ Ferus Gallery opens in Los Angeles, run by Ed Kienholz, Walter Hopps, and later Irving Blum; combines local talent such as **Irwin**, **Bell**, and **Ruscha** with artists from Europe and NY, including **Albers**, **Newman**, and **Stella**. ◆ While a student at UC Berkeley and Santa Barbara, **Richard Serra** works in steel mills to support himself.

1958
FRANCE

Tinguely introduces **Soto** to Klein at latter's show in Paris. **Soto** abandons Plexiglas and begins suspending strips of metal against striped backgrounds. ◆ Argentine **Le Parc** moves to Paris; meets gallerist Denise René and artists she represents, including **Vasarely** and **Morellet**. ◆ **Morellet** makes his first *trame* (weave), a system of superimposed parallel lines (p. 17).

ITALY

Fontana begins *Tagli* (Cuts) series, slashed monochrome canvases (he makes them until death in 1968). ◆ **Gianni Colombo** makes first monochrome relief (shown at Galleria Azimut in Milan the following year).

WEST GERMANY

Artists **Otto Piene** and **Mack** begin Group Zero in Düsseldorf. **Uecker** joins as guest (and officially in 1961; group active until 1966). Combating expressionist abstraction, Zero abandons concrete forms to work with light and color, often in unconventional media. First *Zero* journal (of 3) published in April, includes texts by Klein, **Mack**, **Piene**. *Zero 2* published in October for exhibition called *Vibration*, which includes Brazilian Mavignier among others.

THE NETHERLANDS

Manzoni exhibits in Rotterdam and The Hague, meeting future Nul artists Henk Peeters and **Schoonhoven**, who introduce him to members of Group Zero.

VENEZUELA

Following successful revolt against dictator Marcos Perez Jimenez, many South American writers, poets, and artists flee their own dictatorships for Venezuela's freedoms. ◆ **Gego** teaches art at Universidad Central de Venezuela, Caracas (until 1967).

BRAZIL

Lygia Pape choreographs *Ballet Neoconcreto No. 1*; dancers inside red and white columns impart movement. Denise René sends **Vasarely** show to MAM–SP; travels to Buenos Aires, Montevideo.

US

Smithson travels through US and Mexico; relationship with landscape will influence his work. ◆ **Kusama** moves to New York, enrolls at Art Students League to satisfy visa requirements. Begins showing in galleries and has modest sales; first solo exhibit at Brata Gallery attracts attention from art community, including artist/critic **Judd**.

1959
FRANCE

Tinguely produces *Méta-matics* series of kinetic reliefs, shows one at First Paris Biennal.

WEST GERMANY

Bernd and **Hilla Becher** meet in Düsseldorf, begin collaborating on lifelong photo project documenting vernacular industrial and domestic architecture (p. 142). ◆ **Tinguely** drops 150,000 copies of his manifesto Für Statik over Düsseldorf. Group Zero holds three-day festival for **Tinguely** and Klein in **Uecker**'s studio. ◆ **Manzoni** travels to Düsseldorf; participates in Zero exhibitions (through 1962) in The Hague, Antwerp, Amsterdam, and Berne. ◆ Works by **Clark** included in exhibition of Brazilian artists at Haus der Kunst, Munich.

ITALY

Castellani and **Manzoni** open Galleria Azimut in Milan in conjunction with journal *Azimuth*, both featuring Group Zero and related artists. The inaugural show introduces **Manzoni**'s *Lines* (p. 185). (Both cease in 1960.) ◆ Gruppo T is formed in Milan. Members include **Colombo** and **Grazia Varisco**, among others. (**Fontana** exhibits their work at Galleria La Salita, Rome, 1961.) Many of their works are kinetic and require viewers' physical engagement. A companion group is established in Padua, Gruppo N. ◆ **Colombo** makes his first pulsating structures (p. 64).

THE NETHERLANDS

Tinguely, **Bury**, and Spoerri organize *Vision in Motion—Motion in Vision* at Hessenhuis, Antwerp. The title is an homage to Moholy-Nagy's influential book, published in 1947. Exhibition is international meeting place for artists included, such as **Mack**, **Piene**, **Uecker**, **Pol Bury**, **Soto**, **Tinguely**, Klein, **Dieter Roth**, **Bruno Munari**.

BRAZIL

Ist Exposição de Arte Neoconcreta opens at MAM–RJ. Represents official break of Grupo Frente artists, reacting against mathematical precision, from stricter Ruptura artists in São Paulo, launching important and influential neoconcrete movement in Brazil. Included were works by **Clark**, **Pape**, **Weissmann**, and poets Gullar, Jardim, and others. Manifesto Neoconcreto published in exhibition catalogue as well as *Jornal do Brasil*. ◆ **Oiticica** moves from conventional wall paintings to monochromatic reliefs suspended in space, and then to *Nuclei* series (p. 8), positing space as a medium. ◆ **Clark** produces three-dimensional paintings, *Contra-Relevos* (Counter-Reliefs) and *Casulos* (Cocoons) (p. 84), announcing "death of the plane" and integrating her work into architectural field.

US

Hesse returns to New York, having graduated from Yale. ◆ Two years after **Newman** suffers serious heart attack, Clement Greenberg invites him to inaugurate French and Co., NYC, with solo exhibition, which is a turning point. **Andre**, **Judd**, and **Stella** attend; **Newman** becomes an important example to younger artists. ◆ **Gego** spends year at Iowa State University working on sculpting and printmaking techniques. ◆ **Judd** becomes critic for *Arts Magazine*. ◆ **Breer** returns to New York after ten years in Paris. ◆ **Smithson** has first solo show of abstract paintings, at Artists Gallery, NYC. ◆ **Stella** and **Andre** share studio in New York. **Stella** works on Black Paintings. These nonreferential, symmetrical works greatly influence **Andre**. ◆ **Kelly** and **Stella** included in exhibition *Sixteen Americans* at MoMA. ◆ **Karl Benjamin** and **McLaughlin** included in *Four Abstract Classicists* at Los Angeles County Museum; show travels to San Francisco, London, and Belfast. ◆ **Walter de Maria** organizes "happenings" at UC Berkeley and at the California School of Art, San Francisco.

1960
ITALY

Galleria Azimut, Milan, hosts *La Nuova Concezione Artistica* including works by **Castellani**, Klein, **Mack**, **Manzoni**, Mavignier. Second issue of *Azimuth* published, devoted to this exhibit. ◆ **Uecker** has first solo show at Galleria Azimut. ◆ Gruppo T's first exhibit, *Miriorama 1*, opens in Milan. (By 1962 the group has organized 12 shows.) ◆ **Francesco Lo Savio** begins showing at Galleria La Salita, Rome (continues throughout career).

YUGOSLAVIA - CROATIA

Knifer begins *Meander* series (p. 62) (the motif dominates his career).

FRANCE

Groupe de Recherche d'Art Visuel (GRAV) founded by artists involved with Galerie Denise René including: **Le Parc**, **Morellet**, Yvaral (**Vasarely**'s son), others. GRAV adopts **Vasarely**'s belief that notion of individual genius is outdated, seeks to merge art with systematic and scientific disciplines. **Le Parc** makes first wooden mobiles, begins experimenting with light.

WEST GERMANY

Curator Udo Kultermann's international *Monochrome Malerei* opens at Städtisches Museum, Leverkusen, includes German Group Zero (**Mack**, **Piene**, **Uecker**), Italian Azimuth (**Castellani**, **Manzoni**), as well as **Fontana**, Klein, **Kusama**, **Lo Savio**, Mavignier, and others with common formal interests. (Many exhibit together all over Europe in next decade.) ◆ **Piene** displays *Light Ballet* (p. 97), projected light patterns moving in response to music or sound, during Zero's ninth evening exhibition.

THE NETHERLANDS

Dutch group Nul forms in response to *Monochrome Malerei* with four core members, including **Schoonhoven**. They represent space and light with uniform monochrome fields produced in series. (In 1961 will publish manifesto declaring "A painting has as much worth as no painting. An installation is as good as no installation." **Manzoni** signs both.)

SWITZERLAND

Konkrete Kunst: 50 Jahre Entwickwung opens at Helmhaus, Zurich. Organizer **Bill** broadens his once rigid definition to include 114 artists from US, South America, Europe: Mondrian, Doesburg, **Albers**, **Bill**, **Diller**, **Camille Graeser**, **Loewensberg**, **Lohse**, **Munari**, **Reinhardt**, **Mary Vieira**, **Vasarely**, **Kelly**, Mavignier, **Nogueira Lima**, **Martin**, **Kosice**, **Oiticica**, **Carvão**, **Weissmann**, **Pape**, **Uecker**, **Mack**, **Clark**, **Piene**, **Soto**, **Morellet**, Moholy-Nagy. Some have defined their aims in opposition to **Bill**. Most work takes geometric form.

BRAZIL

Neoconcrete artist **Carvão** makes *Color Cube* (p. 84), cement infused with pigment so that "form, volume, material, surface and texture were all transformed into mere support or pretext for color... as if color itself were an object." ◆ Ferreira Gullar publishes influential essay "Diálogo sobre o não-objeto" in Rio's *Jornal do Brasil*. Using

Clark's *Cocoons* (p. 84) as reference, he discusses neoconcrete work that is neither painting nor sculpture, invents term "non-object." ◆ **Clark** exhibits *Animals* (p. 58), hinged aluminum plates to be manipulated by spectator. ◆ **Oiticica** makes his first *Penetrable*; a work based on makeshift slum dwellings, which can be entered by the spectator.

US

Tinguely's kinetic sculpture *Homage to New York* intentionally self-destructs in 30 minutes in sculpture garden at MoMA. ◆ **Reinhardt** begins black canvases measuring 5 x 5 feet to make "paintings which cannot be misunderstood" (continues until his death in 1967). ◆ **Irwin** breaks with figuration and begins experiments with light (first bars and lines on canvas, then dot paintings on convex surfaces, then large three-dimensional painted discs illuminated to enhance shadow and depth). ◆ **Gego** moves to New York, meets gallerist Betty Parsons, Naum Gabo, and **Josef** and Anni **Albers**. **Gego**'s work acquired by MoMA and NY Public Library; returns to Venezuela and teaching. ◆ **Stella** has first solo exhibit at Leo Castelli Gallery, NYC. Incorporates notched edges into stretcher, which corresponds to striped patterns on canvas. (Works later take on sculptural qualities despite his insistence that he is a painter. Shows with Castelli for three decades.)

1961

ENGLAND

Bridget Riley begins painting "optical" works, using black and white to create sharp contrast. (Has first solo show at Gallery One, London, following year. Will introduce color into her paintings after 1965.)

WEST GERMANY

Udo Kultermann shows **Reinhardt** and **Lo Savio** together at Städtisches Museum, Leverkusen.

FRANCE

Stella has first solo show in Europe at Galerie Lawrence, Paris (run by NYC dealer Lawrence Rubin)

ITALY

Lo Savio begins his "metals" series, sheets of opaque black metal bent in different ways to modulate light. Although sculptural, they hang on the wall.

YUGOSLAVIA

First exhibition in a series under New Tendency name takes place in Zagreb. *Nove Tendencije* includes members of Gruppos T and N, GRAV, Nul, Zero, and others with common interest in spectator participation.

BRAZIL

3rd Exposicão de Arte Neoconcreta at MAM–SP. Final show for group. ◆ 6th Bienal do São Paulo; Mario Pedrosa is general director. USSR participates for first time. Brazil represented by **Carvão**, **Nogueira Lima**, **Serpa**, Mavignier, **Clark**. **Clark** awarded sculpture prize for *Animals* (p. 58).

VENEZUELA

Museo de Bellas Artes, Caracas, exhibits **Soto**'s kinetic works, **Gego**'s drawings and sculptures.

US

Three paintings by **Fangor** in *15 Polish Painters* at MoMA. Unlike most more expressionistic paintings in show, his are single geometric shapes with blurred edges. ◆ **Fontana** has first solo show in US, *Ten Paintings of Venice* at Martha Jackson Gallery, NYC. ◆ **Breer**'s documentary *Homage to Tinguely* screens at MoMA. ◆ **Flavin** begins to work with fluorescent tubes of light as primary medium. Has first solo exhibition at Judson Gallery, NYC. ◆ **Serra** studies painting at Yale, works with **Albers** on *The Interaction of Color*, in contact with **Reinhardt**, **Stella**, others. ◆ **Robert Morris** begins making "slab" sculptures.

1962

ITALY

Umberto Eco coins term *arte programmata* in essay for exhibition of same name held at Olivetti Showroom, Milan; includes works by **Munari** (coorganizer), Enzo Mari, GRAV, Gruppos T and N. Eco's term links art, technology, mass production. Show travels to London, Washington DC, NY University, Düsseldorf.

THE NETHERLANDS

Stedelijk Museum, Amsterdam, hosts *Nul* exhibition. Includes works by Germans **Mack**, **Piene**, **Uecker**, **Hans Haacke**; Italians **Dadamaino**, **Lo Savio**, Gruppo T, Gruppo N; and **Kusama**, Klein, and **Soto**. Marks end of Nul group.

FRANCE

Knifer has first significant show outside Zagreb in *Art Abstrait Constructif International* at Galerie Denise René, Paris. ◆ Yves Klein dies of a heart attack at age 34.

ARGENTINA

David Lamelas, age 18, begins showing his drawings at Galleria Estimulo, Buenos Aires.

US

A Concert of Dance #1 by Judson Dance Theatre at Judson Church begins collaborations by loose collective of choreographers, dancers, visual artists, poets, musicians, filmmakers, including **Morris**, Yvonne Rainer,

de Maria, La Monte Young, and others. • Geometric Abstraction in America opens at Whitney Museum; looking at three decades, it includes Albers, Benjamin, Diller, Kelly, Martin, McLaughlin, Reinhardt, D. Smith, Stella. • Kawara spends eight months in New York. • Bell has first solo exhibition, Ferus Gallery, L.A. • Artforum magazine publishes first issue in San Francisco as challenge to East Coast establishment. (Moves to Los Angeles in 1964, upstairs from Ferus Gallery; Ed Ruscha is magazine designer; moves to New York in 1967. Many artists and critics will publish influential material here, including Michael Fried's "Art and Objecthood," Morris's "Notes on Sculpture," LeWitt's "Paragraphs on Conceptual Art.") • Fangor resigns from Warsaw Academy; visits US for first time at invitation of Institute of Contemporary Arts, Washington DC. (In following year he moves to Paris; in 1965 to England; in 1966 to US, teaches painting.) • Judd adds sand to oil paint for texture and cuts into canvases, inserting found objects. (In following year he shows fully three-dimensional cadmium red light wooden objects at Green Gallery, NYC.)

1963
Kawara travels extensively throughout Europe.
ITALY
Manzoni dies at age 30.
WEST GERMANY
Bechers have first gallery exhibit, at Galerie Ruth Nohl, Düsseldorf. • Mack travels to Northern Africa, experiments with light and wind.
FRANCE
Lo Savio, 28, trained as an urban planner, commits suicide at Le Corbusier's Unite d'habitation, prototype for urban mass dwelling. • After experimentation with optical and kinetic devices, GRAV presents Labyrinth, a one-day event at 3rd Paris Biennale, adopting slogan, "It is forbidden not to touch." • Camargo produces monochromatic reliefs. British artist David Medalla sees them on trip to Paris. Through subsequent friendship with Camargo, Medalla and British curators Guy Brett and Paul Keeler become aware of Clark, Oiticica, and Mira Schendel.
BRAZIL
Pape moves away from plastic arts after dissolution of neoconcretists and begins working as a graphic designer. • 7th Bienal do São Paulo. Pedrosa curates a solo show of 30 works by Clark. • Oiticica begins making Bólides (p. 22), containers that hold raw

pigment and other materials, an attempt to further deconstruct painting and (like Carvão) give color a body.
US
MoMA's International Council organizes Josef Albers: Homage to the Square, shown throughout US and South America including Caracas, Buenos Aires, São Paulo. • Morris has first solo exhibit in New York at Green Gallery. • Group show Black, White and Grey at Wadsworth Atheneum, Hartford, with Flavin, Kelly, Martin, Morris, Newman, Reinhardt, T. Smith, Stella. • Clark has first solo show in US at Alexander Gallery, NYC. • After visiting England, Germany, and Switzerland, Gego returns to printmaking in US at Pratt Institute and Tamarind Lithography Workshop, L.A. • Stella has first solo show on West Coast at Ferus Gallery, L.A. • Curator Walter Hopps organizes at Pasadena Art Museum first and only American retrospective of Marcel Duchamp during his life; landmark show has great impact on younger L.A. artists.

1964
Serra travels to Europe and Northern Africa on Yale Traveling Fellowship and Fulbright grant.
ENGLAND
Signals, Centre for Advanced Creative Study, founded in London by Paul Keeler. Critics Guy Brett and Frank Popper, artist David Medalla also involved. Sponsors exhibitions, events; Signals news bulletin focuses on technology and science in arts. Several issues on South American artists Camargo, Clark, Cruz-Diez, Soto, Otero, also included in festival of South American kinetic art. • Keeler organizes first show of kinetic and optical art in Britain, Structures Vivante: Mobiles/Images at Redfern Gallery.
FRANCE
Nouvelle Tendence at Palais du Louvre, Paris, brings artists together again. • Clark travels through Europe; has solo show at Studium Generale Technische Hochschule, Stuttgart; spends time in Paris with Soto and Camargo. • Le Mouvement 2 opens at Galerie Denise René, 10th anniversary of pioneering show; artists now include Albers, Camargo, Clark, Cruz-Diez, Le Parc, Lohse, Mack, Morellet, Soto, Tinguely, Uecker, Vasarely.
ITALY
US pop art introduced at Venice Biennale. Rauschenberg is first US artist to win grand prize. Varisco shows with Italians; Zero creates optical-kinetic room titled "Hommage à Fontana"; kinetic artists

Bury, Le Parc, Soto also included. Soto wins a painting prize.
WEST GERMANY
German-born Hesse returns and immerses herself in Düsseldorf art scene. Artists there include Josef Beuys, the Bechers, Gerhard Richter, Palermo, Zero, Franz Erhard Walther, Hanne Darboven, Haacke. Rainer and Morris mount dance performance during Hesse's stay. She visits Documenta 3 in Kassel and Tinguely in Basel. • Documenta 3 includes Bill, Bury, Kelly, Klein, Le Parc, Mack, Mavignier, Morellet, Piene, Pollock, D. Smith, Soto, Tinguely, Uecker, Vasarely. GRAV and Zero artists show as groups. Entire section dedicated to light and movement.
BRAZIL
Oiticica moves to Rio slum, becoming a passista (lead samba dancer). Produces Parangolés (p. 196), colorful capes that are worn, thrown, waved by dancers. • After 20 years of constitutional government, military seizes power (retains it until 1985); long periods of exile for many artists and intellectuals including Oiticica, Clark, Meireles, Antonio Dias. Their absence affects younger generation of artists.
US
Mel Bochner moves to New York, works as guard at Jewish Museum during its brief but important secular period; is impressed by work of Rauschenberg, Johns, Stella. • Bruce Nauman, in graduate program at UC Davis, abandons painting to work with sculpture, performance, and film. • Judd composes essay (published in 1970) about Newman's work: "It's important that Newman's paintings are large, but it's even more important that they are large scaled . . . This scale is one of the most important developments in the twentieth century art."

1965
FRANCE
Dias wins the painting prize at the Paris Biennale, which includes scholarship from the French government, enabling him to move to Paris from Rio.
POLAND
Roman Opalka begins lifelong series OPALKA 1965/I–∞ consisting of three parts: canvases painted with sequential numbers, photographic self-portraits taken every day he paints, and audio recording of artist counting numbers.

WEST GERMANY
Hesse has solo show at Kunsthalle Düsseldorf; returns to New York.

BRAZIL

8th Bienal do São Paulo. Pedrosa curates solo show of works by **Weissmann**. Also from Brazil: **Nogueira Lima**, **Serpa**, **Schendel**, **Oiticica** (*5 Bolides*). **Camargo** is awarded prize. France sends **Vasarely** exhibition (he wins grand prize); Italy includes **Castellani**; Switzerland sends **Lohse** (26 paintings) and four works by **Tinguely**. Walter Hopps organizes US exhibit, includes six works each by **Judd**, **Newman**, **Irwin**, **Bell**, **Stella**.

US

Judd publishes "Specific Objects" in *Arts Yearbook 8*, announcing new type of three-dimensional work superseding painting and sculpture. ✦ **Riley** has solo exhibitions at Richard Feigen Gallery, NYC, and Feigen-Palmer Gallery, L.A. ✦ **D. Smith** dies in auto accident, age 59. ✦ Curator William Seitz opens controversial exhibit *The Responsive Eye* at MoMA announcing op art and naming **Albers** as father of movement. Rejected by critics, the style influences commercial art and fashion design. More than 15 countries represented by **Albers**, **Bell**, **Benjamin**, **Bill**, **Castellani**, **Cruz-Diez**, **Fangor**, **Gego**, GRAV, **Irwin**, **Kelly**, **Martin**, Mavignier, **McLaughlin**, **Reinhardt**, **Riley**, **Stella**, **Vasarely**, Zero. Travels to St. Louis, Seattle, Pasadena, and Baltimore. During exhibition GRAV sponsors *A Day in the Street*, presenting kinetic and optical art, inviting viewer participation; little interest from NY art world. ✦ **LeWitt** has first solo show, at Daniels Gallery, NYC. ✦ **Reinhardt** mounts three solo exhibits in New York at once: *Paintings, Red, 1950–53* at Graham Gallery; *Paintings, Blue, 1950–53* at Stable Gallery; and *Paintings, Black, 1953–1965* at Betty Parsons Gallery. ✦ **Smithson** begins publishing writings on art. ✦ Gemini GEL print workshop opens in L.A. Open to experimental techniques, it is frequented by international artists. ✦ New Los Angeles County Museum of Art (LACMA) opens.

1966

ITALY

33rd Venice Biennale includes major works by Otero, **Fontana**, **Kelly**, **Castellani**, **Kusama**. **Fontana** wins grand prize for his Cut paintings. **Soto** presents his *Vibrating Panoramic Wall*. **Le Parc** also awarded grand prize for installation *Subdivided Circles*. (This leads to amicable dissolution of GRAV two years later, underscores marketplace preference for individuals over groups.) ✦ Gruppo T disbands.

ENGLAND

In Motion: An Arts Council Exhibition of Kinetic Art organized by Guy Brett in Oxford includes **Bury**, **Clark**, **Colombo**, **Soto**, **Tinguely**. Brett defines kinetic art broadly; the artists who interest him are concerned with redefining concepts of space.

WEST GERMANY

Palermo uses colored fabrics to create paintinglike objects; has first solo show at Galerie Friedrich & Dahlem, Munich.

FRANCE

Buren has first exhibition, at the Galerie Fournier, Paris. Shows only striped paintings, with aim to subvert allusions to content.

BRAZIL

Raymundo Colares moves to Rio from Minas Gerais, enters the Escola de Bellas Artes. (Attends **Serpa**'s classes at MAM–R| the following year; exhibits in group shows.)

ARGENTINA

Lamelas enrolls at the Academia Nacional de Bellas Artes, Buenos Aires.

US

Morris's "Notes on Sculpture" appears in *Artforum*. Influenced by psychology and phenomenology, he establishes criteria for evaluating recent sculpture, rejects "the sensuous object." ✦ Something Else Press Gallery, NYC, founded by **Emmett Williams** and Dick Higgins, hosts first exhibition of concrete poetry in the US. ✦ Bauhaus-trained Marcel Breuer's building for the Whitney Museum of American Art opens, underscoring prominent place for Americans in art world previously dominated by Europe. ✦ *Ad Reinhardt: Paintings* opens at |ewish Museum, his first museum retrospective. ✦ **Castellani** has solo show at Betty Parsons Gallery, NYC. ✦ **Joseph Kosuth** begins conceptual series *Art as Idea as Idea*, consisting of dictionary definitions of words presented as photostatic enlargements. ✦ **Serra** returns from Europe, settles in New York; friends include **Andre**, **de Maria**, **Hesse**, **LeWitt**, and **Smithson**. ✦ Kynaston McShine brings together young US and British artists working mostly in sculpture for *Primary Structures* at |ewish Museum, NYC; includes **Andre**, **Bell**, **de Maria**, **Flavin**, **Douglas Huebler**, **Judd**, **Kelly**, **LeWitt**, **John McCracken**, **Morris**, **Smithson**. Disparaged by older generation, favorably reviewed by **Bochner** in *Arts Magazine*, considered first museum exhibition to highlight minimalism. ✦ **Flavin** has first solo exhibition on West Coast, at Nicholas Wilder Gallery, L.A. ✦ Former Ulm School faculty member **Maldonado** spends year as fellow of Council of Humanities at

Princeton University. ✦ **Bochner** teaches art history at School of Visual Arts, NYC; meets other young artists, including **LeWitt**, **Hesse**, **Smithson**, and **Dan Graham**. He mounts a proto-conceptual exhibition at the school, *Working Drawings and Other Visible Things on Paper Not Necessarily Meant to Be Viewed as Art*, notebooks filled with Xeroxes of artists' drawings and other ephemera (photocopiers became widely available in early 1960s). ✦ **Bell** purchases vacuum-coating machine, allowing him to produce transparent cubes, which he then places on clear Plexiglas bases, creating illusion of weightlessness. ✦ **Douglas Wheeler** wins LACMA New Talent Purchase Award, which provides a solo exhibition and enough money to rent a studio in Venice Beach for a year. He doesn't exhibit his installation because LACMA will not pay for white carpeting he feels is essential. ✦ **Nauman** has first solo exhibit, at Nicholas Wilder Gallery, L.A. His first group show, *Eccentric Abstraction* at the Fischbach Gallery, NYC, also includes **Hesse**, **Sonnier**, and others. Curated by Lucy Lippard, it highlights a trend later called "process art." ✦ Exploring concepts of time and space **Kawara** begins Today series (p. 100): he paints the date in block letters and numbers on monochrome canvases during his travels, sometimes includes a local newspaper. ✦ *10*, an exhibition of New York minimalism at Dwan Gallery, places **Reinhardt** and **Martin** with younger artists, including **Andre**, **Jo Baer**, **Flavin**, **Judd**, **LeWitt**, **Morris**, **Smithson**, and Michael Steiner. ✦ **Gego** returns to L.A.'s Tamarind Lithography workshop on fellowship.

1967

FRANCE

Soto creates first *Penetrable*, to coincide with his exhibition at the Galerie Denise René; they are environments of translucent nylon tubes suspended from ceiling grid, forming a forest through which spectators walk. (Later he adds color and sound; has said he was unaware of **Oiticica**'s earlier works by same name.)

ITALY

Colombo creates *Elastic Space* environment, a gallery housing a three-dimensional grid of elastic cords on pulleys, constantly moving. Spectators move through the space.

WEST GERMANY

Konrad Fischer Gallery established in Düsseldorf, becomes important venue for US and German artists. (Will show **Andre**, **Sandback**, **Nauman**, and **Darboven**.)

THE NETHERLANDS

On return from St. Martin's School of Art, London, **Jan Dibbets** stops painting and turns to photography, pursuing his interest in perspective and geometric forms.

BRAZIL

9th Bienal do São Paulo includes: US: **Ruscha**; Argentina: **Le Parc**, **Lamelas** (prizewinner, age 23); The Netherlands: **Dekkers**, **Schoonhoven** (prizewinner); Venezuela: **Cruz-Diez** (prizewinner); Italy: **Colombo**. ◆ **Oiticica** exhibits *Tropicália* at *Nova Objetividade Brasileira*, Rio, juxtaposing shanty-like structures with emblems of modernity. (Writes essay "Tropicália" the following year, defining an ideal for a distinctly Brazilian vanguard art.)

ARGENTINA

LeWitt travels to Buenos Aires to install work at Instituto Di Tela, Museo de Artes Visuales.

US

Smithson begins to create large works made in and of landscape. ◆ **Walther** moves to New York, associating with conceptual artists such as **Weiner** and **Kosuth**. ◆ **Morris** begins as assistant professor of art at Hunter College, NYC. ◆ **LeWitt** publishes "Paragraphs on Conceptual Art" in *Artforum*, coining the term: "In conceptual art the idea or concept is the most important aspect of the work . . . When an artist uses a conceptual form of art, it means that all of the planning and decisions are made beforehand and the execution is a perfunctory affair . . . Conceptual art is only good when the idea is good." ◆ **Haacke** moves to New York for teaching job at Cooper Union (awarded a full professorship in 1979). ◆ **Reinhardt** dies at age 54.

1968

Morris shows in Europe for first time at Galerie Ileana Sonnabend, Paris, and in solo show at Stedelijk Van Abbemuseum, Eindhoven.

WEST GERMANY

In climate of widespread antiwar protests, Ulm School closes when students and faculty cannot agree on curriculum.

ITALY

34th Venice Biennale opens despite student protests. Many artists withdraw their works in solidarity with protesters. Exhibition includes **Judd**, **Lo Savio**, **Riley**. **Colombo** is awarded first prize; **Riley** wins International Prize for Painting. ◆ **Fontana** dies of heart attack, age 69.

FRANCE

Buren begins subversive project of covering Parisian advertising billboards with striped paper; hires men to wear striped sandwich boards (p. 188).

THE NETHERLANDS

Minimal Art opens at the Gemeentemuseum, The Hague; travels to Düsseldorf and Berlin; includes works by **Andre**, **Flavin**, **Judd**, **LeWitt**, **Morris**, **T. Smith**, **Smithson**.

WEST GERMANY

Documenta 4 disrupted by protests. Included are **Albers**, **Andre**, **Baer**, **Bell**, **Bury**, **Camargo**, **Castellani**, **Diller**, **Flavin**, **Fontana**, **Judd**, **Kelly**, Klein, **LeWitt**, Lohse, **Lo Savio**, **Manzoni**, **Morris**, **Nauman**, **Newman**, **Reinhardt**, George Rickey, **Riley**, **Schoonhoven**, **D. Smith**, **T. Smith**, **Stella**, **Tinguely**, **Uecker**. ◆ **Smithson** visits West Germany in fall; **Bechers** give him tour of steel production sites in the Ruhr Valley. ◆ Heiner Friedrich (future cofounder of Dia) begins to show young US artists in Munich gallery (**Ryman**, **Heizer**, **Bochner**, others).

CZECHOSLOVAKIA

Brief period of liberalization introduced by Alexander Dubcek, then head of Czech Communist Party, becomes known as Prague Spring. Soviets invade in August and reverse reforms. It is increasingly difficult for artists to share information and show work in Western Europe.

BRAZIL

Pape produces *Divider*, huge cloth with holes through which performers put their heads, uniting invisible mass of bodies (p. 120). ◆ **Colares** develops *Gibis* (Brazilian/Portuguese slang for "comic books"), books made of cut colored paper. When spectators turns a page, the composition alters (p. 210). ◆ **Meireles** enrolls at Escola Nacional de Belas Artes, Rio. At 20, has already shown in Brasília and Bahia.

US

Many artists active in antiwar movement; **LeWitt** presents first wall drawing at *Benefit for the Student Mobilization Committee to End the War in Vietnam*, Paula Cooper Gallery, NYC. ◆ **Piene** begins teaching at the Center for Advanced Visual Studies, MIT. (He stays for 20 years, becoming director in 1973; continues to be concerned with interdependency of art, nature, science.) ◆ **Dennis Oppenheim** has first solo show in New York at John Gibson Gallery. Teaches graduate seminars in sculpture at Yale. ◆ **Eleanor Antin** leaves NYC for California (begins teaching at UC San Diego in 1975).

◆ **Kusama** takes to streets of NYC with "happenings." Events develop into carefully staged (and publicized) pieces featuring nude men and women on whom she paints dots. ◆ **Nauman**, in NYC makes videotapes, has first show, at Leo Castelli Gallery. ◆ After studying film and sculpture at UCLA, **Maria Nordman** makes *Eat* installation documenting two people sharing a meal (p. 79). The work is made with two cameras in a constructed room and shown with two projectors in same space the film was shot. (Eventually Nordman eliminates film from her work, focusing on play of light in spaces of her own design.) ◆ *John Baldessari: Pure Beauty*, at Molly Barnes Gallery, L.A., includes word paintings. ◆ **Peter Alexander**'s resin works attract interest of art press. He and other Southern California artists (**Bell**, **Irwin**) are compared with East Coast minimalists **Andre**, **Judd**, **LeWitt**, and **Serra**. ◆ Curator, writer, editor John Coplans organizes exhibition series at Pasadena Art Museum, initiating what would become known as Light and Space movement. Artists such as **Irwin**, **Bell**, **Wheeler**, James Turrell would at times be associated with this rubric.

1969

SWITZERLAND

Live in Your Head: When Attitudes Become Form. Works—Concepts—Processes—Situations—Information opens at Kunsthalle, Berne, travels to Krefeld and London. One of the earliest museum exhibitions to highlight process art, including conceptualism and earthworks, it includes **Andre**, **Robert Barry**, **Bochner**, **Darboven**, **Dibbets**, **Haacke**, **Michael Heizer**, **Hesse**, **Huebler**, Klein, **Kosuth**, **LeWitt**, **de Maria**, **Morris**, **Nauman**, **Oppenheim**, **Ryman**, **Sandback**, **Serra**, **Smithson**, **Sonnier**, **Walther**, **Lawrence Weiner**. **Buren** crashes the scene, papering advertising kiosks with stripes (p. 188) during the night, with **Weiner**'s assistance. **Buren** is arrested for vandalism and ejected from the city.

ENGLAND

Oiticica has solo exhibition at Whitechapel Gallery, London, his first exposure in Europe; is artist in residence at Sussex University through 1970.

ITALY

Smithson completes *Asphalt Rundown*, Rome, first project in Italy.

THE NETHERLANDS

Stedelijk Museum, Amsterdam, opens *Soto* and *Robert Irwin—Doug Wheeler, 1969*.

ENGLAND

Lamelas enrolls at St. Martin's School of Art, London.

BRAZIL

Boycott of 10th Bienal do São Paulo by artists and intellectuals opposing military regime. **Clark**, **Oiticica**, **Camargo**, and **Dias** withdraw works. International artists who support the ban are **Haacke**, **Morellet**, **Buren**, **Bury**, and **Le Parc**. Critic Mario Pedrosa defends the artists and is forced into exile in Chile (later moves to Paris).

US

NYC dealer Seth Siegelaub organizes two shows devoted to conceptual art: *January 1–31: 0 Objects, 0 Painters, 0 Sculptors* includes works by **Kosuth**, **Barry**, **Huebler**, and **Weiner**; followed by *One Month*, which exists only in catalogue form, consisting of a form letter sent to 31 artists with a record of their replies, if any. • **Serra** makes first "prop" pieces, large slabs of steel balanced against each other without welding, emphasizing weight and gravity. • **Dibbets** makes two trips to North America. Works are included in group shows organized by Seth Siegelaub, Paula Cooper Gallery, and Dwan Gallery. • **Sandback** has first solo show in US at Dwan Gallery, NYC; later exhibits at Ace Gallery, L.A. Completes MFA at Yale, where he makes first string sculpture. • With gallerist Virginia Dwan's support, **Heizer** begins *Double Negative* earthwork in Nevada desert, a hole in the landscape.

1970

ITALY

Germano Celant curates *Conceptual Art, Arte Povera, Land Art* at Galeria Civica de Arte Moderna, Turin, comparing three simultaneous movements. Included are **Andre**, **Baldessari**, **Barry**, **Bochner**, **Darboven**, **de Maria**, **Dibbets**, **Flavin**, **Haacke**, **Heizer**, **Huebler**, **Kawara**, Klein, **Kosuth**, **LeWitt**, **Manzoni**, **Morris**, **Nauman**, **Oppenheim**, Giulio **Paolini**, **Ryman**, **Sandback**, **Serra**, **Smithson**, **Sonnier**, **Weiner**.

BRAZIL

Antonio Manuel submits *O Corpo É a Obra* (The Body Is a Work)—his own naked body—for entry into Salão Nacional de Arte Modern at MAM–RJ. Jury censors it. Nonetheless, **Manuel** arrives at opening naked. • **Colares** awarded travel prize at same exhibition. Spends six months in New York and 18 months in Italy.

US

Palermo and friend Gerhard Richter travel to New York. • **Hesse** dies from brain tumor, age 34. • **Newman** dies of heart attack, age 65. • *Information*, organized by Kynaston McShine at MoMA, is first major museum show to focus exclusively on conceptual art, and a scene altered by communication systems and increased mobility. Included are **Andre**, **Baldessari**, **Barry**, **the Bechers**, Beuys, **Bochner**, **Buren**, **Darboven**, **de Maria**, **Dibbets**, **Graham**, **Haacke**, **Heizer**, **Heubler**, **Kawara**, **Kosuth**, **LeWitt**, **Meireles**, **Morris**, **Nauman**, **Oiticica**, **Oppenheim**, **Paolini**, **Ruscha**, **Smithson**, **Sonnier**, **Weiner**. • Having just visited New York to see *Information*, **Oiticica** moves there on Guggenheim grant in November. Works on multimedia projects— texts, performances, films, environmental events. (In exile due to military regime, he will not return to Brazil until 1978.) • **Smithson** completes *Spiral Jetty* in Great Salt Lake, Utah: 6,650 tons of earth, rock, and salt crystals in shape of giant coil 1,500 feet long projecting into lake. Work is documented with film and photos, making it accessible to a larger audience (p. 182). • **Buren** papers L.A. bus benches with his stripes.

1971

US

Guggenheim International includes **Dias**, **Buren**, **Darboven**, **Kawara**, **Dibbets**, **Andre**, **de Maria**, **Flavin**, **Heizer**, **Judd**, **Kosuth**, **LeWitt**, **Morris**, **Nauman**, **Ryman**, **Serra**, **Weiner**. **Buren** hangs immense striped canvas in rotunda from ceiling to floor. Placement is heavily debated by other artists; work is dismantled just prior to opening, without **Buren**'s knowledge. **Andre** withdraws in support of **Buren**. • LACMA curator Maurice Tuchman presents *Art and Technology*, showing results of collaboration between 76 artists and scientists, mathematicians, technicians, and engineers from major corporations. Influential show includes **Baldessari**, **Bell**, **Bill**, **Flavin**, **Haacke**, **Irwin**, **Judd**, **Kelly**, **McCracken**, **Morris**, **Nauman**, **Piene**, T. **Smith**, **Smithson**, **Vasarely**, **de Maria**. • **Newman** retrospective at MoMA. • The Metropolitan Museum of Art hosts a major retrospective of **Albers**'s work. • **Meireles** moves to New York (lives and works there until 1973). • **Haacke**'s solo show at Guggenheim is canceled six weeks before opening due to controversial work, *Shapolski et al. Manhattan Real Estate Holdings, a*

Real-Time System, as of May 1, 1971. Documentation from public records includes photographs of apartment buildings, maps of slum areas with properties marked, and charts outlining business relations within real estate group, providing a survey of one family's holdings. Curator is fired, protests organized by art community. • Responding to pressure from artists and particularly Art Workers' Coalition (who stage protests at museums to force them to respond to the needs of artists), Kynaston McShine initiates Projects series at MoMA, commissioning and showing work by emerging artists. First is **Sonnier**. • **Antin** begins *100 Boots* project, mails 51 picture postcards at intervals to hundreds in US, Europe, and Japan showing 100 boots in various staged situations from Pacific Ocean to NYC, culminating in a Projects exhibition at MoMA. • The Kitchen opens in New York, one of first alternative spaces to show video and performance art. • In collaboration with Miriam Shapiro, Judy Chicago moves the Feminist Art Program from Fresno State College to Cal Arts. (The following year Chicago, Shapiro, and 21 students create Womanhouse, a collaborative installation work converting abandoned Hollywood house into rooms addressing domesticity, sexuality, identity, and class.)

1972

WEST GERMANY

Documenta 5, Kassel, includes **Ad Dekkers**, **Graeser**, Klein, **Loewensberg**, **LeWitt**, **Martin**, **Morellet**, **Ruscha**, **Sandback**, **Schoonhoven**, **Soto**, **Stella**, **Uecker**, **Vasarely**, and many others. **Buren** places vertical stripes on wall behind Jasper Johns's iconic 1958 *Flag*, with Johns's approval. • *USA West Coast* opens at Hamburg Kunstverein. Included are works by **Alexander**, **Bell**, **Irwin**, **McCracken**, **Nauman**, **Ruscha**, and others.

US

Brazilian **Dias** awarded Guggenheim Fellowship; leaves Paris and spends year in New York. (Moves to Milan afterward. Returns to Brazil part-time in 1978.) • *Robert Ryman: Exhibition of Works* opens at Guggenheim, his first solo museum show. • *Bruce Nauman: Work from 1965 to 1972*, his first solo museum exhibition, organized jointly by LACMA and Whitney Museum; travels throughout US and Europe. • Artists Space opens in New York, one of earliest alternative spaces to support contemporary art installation, video, and performance.

1973

BRAZIL

Serpa dies from stroke, age 50. ◆ 12th Bienal do São Paulo includes **Knifer**, **Darboven**, **Paolini**. *Arte Construida*, a special show dedicated to **Serpa**, includes works by **Carvão**, **Clark**, **Nogueira Lima**, and others.

VENEZUELA

The Museo de Arte Contemporaneo in Caracas and the Museo de Arte Moderno **Jesús Soto** in Ciudad Bolivar are founded.

US

Smithson, age 35, dies in plane crash in Texas while exploring site for next project, *Amarillo Ramp*. ◆ **Judd** buys a city block of buildings in Marfa, Texas, where he had lived off and on for two years. ◆ **Kelly** has first retrospective at MoMA. Show travels to Pasadena Art Museum, Walker Art Center, Minneapolis, and Detroit Institute of Arts. ◆ **Palermo** moves to New York. (Lives there until death in 1977.) ◆ Following national trend, alternative spaces open in L.A. Woman's Building, founded by artist Judy Chicago, graphic designer Sheila Levrant de Bretteville, and art historian Arlene Raven, houses Feminist Studio Workshop, first independent school for women artists. Los Angeles Institute of Contemporary Art (LAICA) exhibition space and journal established. (Los Angeles Contemporary Exhibitions opens in 1978.) ◆ Lucy R. Lippard publishes *Six Years: The Dematerialization of the Art Object from 1966 to 1972*, an informal documentary chronology of the art of the period.

1974

THE NETHERLANDS

Dekkers commits suicide, age 35.

ENGLAND

Institute of Contemporary Arts in London organizes exhibition dedicated to the **Bechers**; tours United Kingdom.

BRAZIL

Camargo returns to Brazil permanently after 13 years in Europe.

US

Dia Center for the Arts conceived by German gallerist Heiner Friedrich and wife Philippa de Menil. In addition to permanent collection, they finance several earthworks, some of the largest-scale art made in modern times (such as **de Maria**'s *Lightning Field*, p. 181. This 1977 work, situated in remote area of New Mexican high desert, comprises 400 polished stainless-steel poles installed in a grid measuring one mile by one kilometer.) ◆ **Opalka** has first New York solo exhibition at John Weber Gallery. ◆ Trustees of bankrupt Pasadena Art Museum turn institution over to collector Norton Simon, who has little interest in contemporary art, ending two decades of critically acclaimed exhibitions.

1975

BRAZIL

Clark returns to Brazil after seven years in France, where she taught at Sorbonne. (Growing interest in therapeutic possibilities of art leads to practice of psychoanalysis in 1978.)

US

Le Mouvement 1955: Anniversary Exhibition at Galerie Denise René, NYC. This 20th-anniversary update of landmark show includes original roster of artists: Agam, **Bury**, Calder, Duchamp, Jacobsen, **Soto**, **Tinguely**, **Vasarely**. ◆ **Bill** retrospective tours US, organized by Albright Knox Art Gallery, Buffalo, LACMA, and San Francisco Museum of Art.

1976

US

Albers dies in Connecticut, age 88. ◆ Franklin Furnace (Archive, Inc.) opens in New York, dedicated to supporting artists' books, periodicals, installation art, and performance art. ◆ Printed Matter founded by artists including **Andre**, **LeWitt**, and Lucy Lippard. Mission is to publish and distribute inexpensive artworks, primarily artist's books produced in editions of at least 100 copies. ◆ In response to changing needs of artists, P.S. 1 opens as experimental work center in Queens, NY, with inexpensive studios, performance and exhibition spaces. Inaugural show, *Rooms (P.S. 1)*, invites artists to select a space and create a site-specific work. Included are **Weiner**, **Ryman**, **de Maria**, **Sandback**, **Oppenheim**, **Kosuth**, **Baldessari**, **Wheeler**, **Buren**, **Andre**, **Serra**, **Nauman**, and many others.

1977

WEST GERMANY

Documenta 6, Kassel, includes the **Bechers**, **Flavin**, **Graeser**, **Heizer**, **de Maria**, **Morris**, **Nordman**, **Opalka**, **Palermo**, **Serra**, **Joel Shapiro**, **Stella**, **Walther**; has artists' book section curated by Peter Frank.

FRANCE

Opalka leaves Poland, settles permanently in France. ◆ Le Centre national d'art et de culture, designed by Renzo Piano and Richard Rodgers, opens to public. This brainchild of President Georges Pompidou, with a focus on modern and contemporary art, dance, theatre, music, cinema, and books, becomes one of Paris's most visited attractions.

POLAND

25 years after *Noigandres* review is started in Brazil, concrete poet **Stanislaw Dróżdż** creates *Między (Between*, p. 6) installation; floor, ceiling, and walls painted with letters of this word, concrete poetry as environmental art.

US

Palermo exhibits series of paintings *To the People of New York City* at Heiner Friedrich Gallery, NYC. He dies in Maldives, age 34. ◆ **De Maria** creates *New York Earth Room*, white gallery space (formerly Friederich's gallery in Soho) filled with 280,000 pounds of dark soil, spread 22 inches deep across 3,600 square feet. Room must be regularly hosed, raked, and cleared of mushrooms. (The first version was made at Munich gallery in 1968.)

1978

BRAZIL

Oiticica returns to Rio after eight-year absence. ◆ Fire destroys 80% of MAM—RJ collection.

1979

Dia Art Foundation purchases 340-acre deserted army base in Marfa, TX, as permanent site for **Judd**'s large-scale sculptural installations; also includes works by other artists such as **Flavin**, Chamberlain. (In 1986 a portion is transferred to newly formed Chinati Foundation, of which **Judd** is president.)

acknowledgments

As important as they are to the advancement of knowledge, intellectually ambitious international loan exhibitions lacking blockbuster names are an endangered species in the current socioeconomic climate. Nevertheless Andrea Rich, LACMA's President and Wallis Annenberg Director, never wavered in her support of *Beyond Geometry*, so my first thanks must go to her.

I also want to express my gratitude to the artists whose work appears in the exhibition and this catalogue. Their intelligence, perseverance, and extraordinary creativity made it all possible.

Numerous people in many countries gave invaluable help in the realization of *Beyond Geometry*. This includes the consultants to the show and writers for the catalogue: Ana Regina Machado Carneiro, Sande Cohen, Peter Frank, Paulo Herkenhoff, Valerie Hillings, Inés Katzenstein, Peter Kirby, Brandon Labelle, Miklós Peternák, and Branca Stipančić. I am also grateful for the collaboration of colleagues at Los Angeles institutions: Chrystine Lawson and Clyde Howell, California Institute of the Arts' School of Dance, recreated Lygia Pape's *Divider*; and Fred Dewey, Beyond Baroque Literary Arts Center, organized with Peter Frank a weekend of readings and performances related to the show. It has been a pleasure working with Ann Goldstein, senior curator, Museum of Contemporary Art, Los Angeles, whose *A Minimal Future* shares key concerns with *Beyond Geometry*. Karen Hanus and Julia Langlotz, MOCA's associate registrar and curatorial associate, helped with loans. Andrew Perchuk and Glenn R. Phillips, contemporary programming, Getty Research Institute, organized an important two-part conference in conjunction with the two exhibitions. Ted Walbye, Getty Research Institute Library, helped with photographing loans. Russell Ferguson, UCLA's Armand Hammer Museum of Art, has been extremely understanding and has my sincere appreciation.

Others in the United States who gave crucial advice are: Hugh Davies and Toby Kamps, San Diego Museum of Contemporary Art; Jay Levenson and his staff, International Program, Museum of Modern Art; Gabriel Pérez-Barreiro, Jack S. Blanton Museum of Art, Austin; Peter Ballantine, Donald Judd Foundation;

Rosanna Albertini; Jaroslav Andel; Amy Baker Sandback; Éva Forgács; Jon Hendricks; Judy Hoffberg; Ewa Kirsch; Ruth Sackner; Rachel Adler, Rachel Adler Fine Arts; Angela Choon, David Zwirner Gallery; Paula Cooper, Paula Cooper Gallery; Ivy Crewdson, Barbara Gladstone Gallery; Rosamund Felsen, Rosamund Felsen Gallery; Filippo Fossati, Esso Gallery; Marian Goodman and Jeannie Freilich, Marian Goodman Gallery; Lawrence Markey, Lawrence Markey Gallery; Anna and Mark Quint, Quint Gallery; Marc Selwyn, Marc Selwyn Fine Art.

In Argentina: I am grateful to Augustín Arteaga, formerly of the Museo de Arte Latinoamericano de Buenos Aires; Marcelo Pacheco, Maria Constantini de Silva, and Maraní González del Solar, MALBA; Laura Bucellato and Clelia Taricco, Museo de Arte Moderno; Mario Gradowicz; and Marian Helft.

In Brazil: I would like to thank Ricardo Resende, Museu de Arte Moderna de São Paulo; Ivo Mezquita; Luiz Camillo Osório; Paula Pape; Marc Pottier, former French cultural attaché to Brazil; Paula Terranova; Raquel Arnaud, Gabinete de Arte; and Luisa Strina, Galeria Luisa Strina.

In Venezuela: I received crucial assistance from Tahía Rivero, Banco Mercantil; Ernesto J. Guevara, Galeria Arte Nacional (GAN); Mr. and Mrs. Gustavo Cisneros, Rafael Romero, Luis Enrique Oramas, Ariel Jimenez, and Ingrid Melizan, the Cisneros Foundation; Josefina Manrique, Fundación Gego; Miguel and Lourdes Arroyo; and the Villanueva family.

In France: at the Musée national d'art moderne, Centre Georges Pompidou, important advice came from Jean-Paul Ameline, Brigitte Leal, and Didier Schulman; at the Musée d'art moderne de la Ville de Paris Suzanne Pagé and Beatrice Parent were very helpful; I am grateful as well to Alexia Fabre and Isabelle Limosin, Musée d'art contemporain, Val-de-Marne, Vitry; Denise René, Galerie Denise René; Anne Lahumière, Galerie Lahumière; and Frank Elbaz, Galerie Frank.

In Italy: assistance came from Germano Celant and Astrid Welter, Fondazione Prada; Michela Scotti; Tomasso Trini; Getulio Alviani; Alberto Biasi; Stefano

Buccelatto; Enzo Mari; Giancarlo Politi and Helena Kontova; Nini Ardemagni Laurini and Valeria Ernesti, Fondazione Lucio Fontana; Giangaleazzo Visconti di Madrone, Studio Casoli; Claudio Guinzani, Studio Guinzani; and Alessia Armeni, Galeria Christian Stein.

In Poland: I am grateful to Wieslaw Borowski, Galeria Foksal, and Joanna Mytkowska, Andrzej Przywara, and Adam Szymczyk, Foundation Gallery Foksal; Maria Morsuch, Muzeum Sztuki, Łódź; and Milada Slizinska, Center for Contemporary Art, Ujazdowski Castle.

I would also like to thank Antoinette de Stiger, Art Affairs, Amsterdam; Guy Brett; Victoria Miro and Glenn Scott Wright, Victoria Miro Gallery, London; Vicente Todolí, director, Tate Modern; Margit Weinberg Staber and Elisabeth Grossmann, Haus Konstructiv, Zurich; Rolf Lauter and Irene Gludowicz, Germany; Olivier Debroise, Mexico; Katalin Néray, director, Ludwig Museum of Contemporary Art, Budapest; Julia Klaniczay, Artpool Art Research Center, Budapest; Vit Havránek, Karel Srp, and Tomas Pospiszyl, Prague; and Zelimir Koscevic and Nada Beros, Museum of Contemporary Art, Zagreb.

Toby Tannenbaum, LACMA's assistant chief, museum education, oversaw our educational programs admirably. The design team of Louise Sandhaus, Tim Durfee, and Joel Fox created an enriching and exciting Web program; Paul Zelevansky provided invaluable advice as consultant for educational technology, and Elise Caitlin, LACMA's internet developer, approached the project with good cheer. Thomas Frick edited this publication with erudition and care, and Katherine Go produced beautiful designs for the book and exhibition. Peter Brenner handled all photographic needs, and Giselle Arteaga-Johnson dealt ably with frequently frustrating rights and reproductions issues.

Robert Stone, Robert Stone Design, created spaces that intelligently reflected the show's content and meaning. Art Owens and Bill Stahl worked tirelessly to realize the design within stringent budget constraints, and Jeff Haskin and his team installed a complex and demanding exhibition with consummate professionalism. The exhibitions department, Irene Martin, Beveley Sabo, Christine Lazzaretto, and later Kristin Fredricks, capably oversaw the exhibition's logistics with associate registrar Portland McCormick. LACMA conservators Victoria Blythe Hill, Joe Fronek, Jini Rasmussen, Elma O'Donoghue, Soko Furuhata, Chail Norton, Catharine McLean, John Hirx, and Elizabeth Schlegel, and conservation scientist Marco Leone consulted on and conserved works in the US and abroad in anticipation of the exhibition. As always, I am grateful to Erroll Southers, assistant vice president of protective services, for his understanding and help.

With no special support, LACMA colleagues Dorrance Stalvey and Ian Birnie created wonderful music and film programs to complement *Beyond Geometry*. Bo Smith organized exhibition-related press activity. Anne Dietrich and LACMA's library staff provided research support, and Jacqueline Cone and Edith Wachtel, Museum Service Council, translated key texts for the project.

Michele Urton, Cristin McKnight, and Emily Meixner, curatorial administrators, department of Modern and Contemporary Art, were deeply involved in *Beyond Geometry* at different times. Annalee Andres, Elena Shtromberg, and Kristin Walker provided essential research. Intern Margot Chandler gave needed support over one summer, and long-time departmental research assistant, Roz Leader, put her prodigious organizational skills to work on several aspects of the exhibition.

No one has given more to *Beyond Geometry* than Aleca Le Blanc, LACMA's immensely capable curatorial research assistant. For over four years she has shared all of the pleasures and tribulations of the exhibition. It could not have happened without her, and I am extremely grateful.

Finally, I would like to thank those on whom I have depended for advice and commiseration: my curatorial colleagues Stephanie Barron, Carol Eliel, Howard Fox, and Ilona Katzew; friends and colleagues Laura Hoptman and James Meyer; and my family Paul, Claudia, and Nora Zelevansky.

Lynn Zelevansky

Lenders to the exhibition

A arte Studio Invernizzi, Milan
Ace Gallery, Los Angeles
Adler & Conkright Fine Art,
New York
Anthony Grant Inc.
Archivio Opera Piero Manzoni,
Milan
Barbara Gladstone Gallery,
New York
Camille Graeser-Stiftung, Zurich
Coleçao Gilberto Chateaubriand
MAM, Rio de Janiero
Colección Banco Mercantil,
Caracas
Collection of the Judd Foundation
Collezione Prada, Milan
Dia Art Foundation, New York
Foksal Gallery Foundation, Warsaw
Fundación Museo de Arte
Moderno Jesús Soto, Ciudad
Bolívar
Galerie Denise René, Paris
Galerie Renée Ziegler, Zurich
Galerie von Bartha, Basel
The Getty Research Institute,
Los Angeles
João Sattamini Collection,
Rio de Janiero
Los Angeles County Museum
of Art
Ludwig Museum, Budapest
Marion Goodman Gallery,
New York
Marlborough Gallery, New York
[Mathias Goeritz]
Michael Rosenfeld Gallery,
New York
Musée d'art contemporain du
Val-de-Marne/Vitry-sur-Seine
Musée national d'art moderne,
Centre Georges Pompidou, Paris
Museo de Arte Latinoamericano
de Buenos Aires
Museu de Arte Contemporânea
da Universidade São Paulo
Museum für Moderne Kunst,
Frankfurt am Main
The Museum of Contemporary
Art, Los Angeles
Museum of Contemporary Art,
San Diego
The Museum of Modern Art,
New York
Norton Simon Museum, Pasadena
The Panza Collection, Milan
Paula Cooper Gallery, New York
Projeto Hélio Oiticica,
Rio de Janiero
Richard Paul Lohse Foundation
Solomon R. Guggenheim

Museum, New York
Stedelijk Museum, Amsterdam
Studio Casoli
Van Abbemuseum, Eindhoven,
The Netherlands

Peter Alexander
Chantal and Jakob Bill
Robert Breer
The Eli and Edythe L. Broad
Collection, Los Angeles
Daniel Buren
Colección Cisneros, Caracas
Estate of Lygia Clark
Carlos Cruz-Diez
Antonio Dias
Jan Dibbets
Stanisław Dróżdż
Virginia Dwan
Tony and Gail Ganz
Dan Graham
The Grinstein Family
Milan Grygar
Collection Herbert, Ghent
On and Hiroko Kawahara
Ellsworth Kelly
Nicole Klagsbrun
Julije Knifer
David Lamelas
Col. Adolpho Leirner, São Paulo
Henriette Coray Loewensberg
Heinz Mack
Cildo Meireles
Tracy and Gary Mezzatesta
François Morellet
Robert Morris
Maria Nordman
Antonio Manuel da Silva Oliveira
Roman Opalka
Bohdan W. Oppenheim
Dennis Oppenheim
Giulio Paolini
Lygia Pape
Andréa and Jose Olympio Pereira
Collection, São Paulo
Otto Piene
Robert Ryman
Estate of Mira Schendel
Joel Shapiro
Gilbert and Lila Silverman
Collection, Detroit
The Estate of David Smith
Stuart and Judy Spence
Christian Stein
Francisco Terranova
Goran Trbuljak
Grazia Varisco
Franz Erhard Walther

(Photo credits continued)

60 top, 143, 185 top: © 2004 Artists Rights Society (ARS), New York/ SIAE, Rome; **60 top:** Photo by Marco Carloni, Milano; **61:** Photo by Brian Forrest; **67:** Photo © Jacques Faujour; **76:** © 2004 Estate of Dan Flavin/Artists Rights Society (ARS), New York; **77:** © 2004 Frank Stella/ Artists Rights Society (ARS), New York; **78, 179 bottom left:** © 2004 Bruce Nauman/Artists Rights Society (ARS), New York; **78:** Photo courtesy Sperone Westwater, New York; **81 top left, 136:** © The Estate of Eva Hesse, Hauser & Wirth Zurich London; **81 top right, 147:** © Cildo Meireles; **81 top right:** Photo by Wilton Montenegro; **82:** Photo © Roberto Marossi, Milano, courtesy Fondazione Prada; **84 top, middle, 118, 179 bottom right, 185 bottom, 210:** Photos © Vicente de Mello; **84 bottom, 138:** Photos by Jens Rathmann; **85 top left, 145:** Photos courtesy A arte Studio Invernizzi, Milan, photos by Paolo Vandrasch; **85 bottom left:** © 2004 Estate of Tony Smith/Artists Rights Society (ARS), New York, photo courtesy Matthew Marks Gallery, New York; **86:** © 2004 Richard Serra/Artists Rights Society (ARS), New York; **87:** © 2004 Joel Shapiro/Artists Rights Society (ARS), New York, photo by Wojtek Naczas, Princeton; **90:** © Lawrence Weiner, photo by Kristien Daem; **91, 163 bottom, 198–99, 208, 212:** Photos © The Solomon R. Guggenheim Foundation, New York; **95:** © 2004 The Josef and Anni Albers Foundation/ Artists Rights Society (ARS), New York; **97:** Photo by Otto Piene; **98:** © Fondazione Lucio Fontana, Milan; **104:** © Bridget Riley; **107, 163 top right:** © 2004 Joseph Kosuth/Artists Rights Society (ARS), New York; **109:** Photo by Fredrik Nilsen; **113:** © 2004 Keith Sonnier/Artists Rights Society (ARS), New York; **115:** © Estate of George Rickey/Licensed by VAGA, New York, NY; **117:** Photo by Robert Breer; **118:** © Estate of Sérgio Camargo; **122 top:** Photos by Štěpán Grygar; **123:** © 2004 Robert Irwin/Artists Rights Society (ARS), New York; **123, 142:** Photos © Douglas M. Parker Studio; **124, 146 top, 150, 151:** Photo © Stedelijk Museum, Amsterdam; **128:** Photo courtesy Canal St. Communications; **135, 139 right, 146 bottom, 169, 206, 207, 209:** © 2004 Artists Rights Society (ARS), New York/VG Bild-Kunst, Bonn; **135, 139 right, 146 bottom, 207, 209:** Photos by Axel Schneider; **136:** Photo by Ian Reeves; **143:** Photo by Peter Schälchli, Zürich; **148–49:** © 2004 Jan Dibbetts/Artists Rights Society (ARS), New York, photo by Tom Haartsen; **152:** Photo courtesy Ronald Feldman Fine Arts, New York; **153:** Photo courtesy Galeria André Millan, Rômulo Fialdini; **160:** © Edward Ruscha; **168:** © 2004 Artists Rights Society (ARS), New York/HUNGART, Budapest, photo by Katalin Nádor; **169:** Photo by Robert H. Hensleigh; **170:** © Walter de Maria, photo © 1968 Walter de Maria; **171:** Photo courtesy Paula Cooper Gallery, New York, photo by Gian Franco Gorgoni; **176:** © 1966–68 John Baldessari; **177:** Photo © Sarah Wells, New York; **178:** © 2004 Estate of Douglas Huebler/Artists Rights Society (ARS), New York; **180:** Photo © Hein Engelskirchen GDL; **181:** © 1977 Dia Art Foundation, photo by John Cliett; **182 top, 198–99, 201:** © Estate of Robert Smithson/Licensed by VAGA, New York, NY; **182 top:** Photo courtesy James Cohan Gallery, photo by Gianfranco Gorgoni; **184 bottom:** Drawing by Lawrence Kenny; **185 top:** Photo by Orazio Bacci, Milan; **201:** Photo courtesy James Cohan Gallery, New York; **205:** Photo © CNAC/MNAM/Dist. Réunion des Musées Nationaux/Art Resource, NY, photo by Philippe Migeat; **206 top, bottom right:** Photos by Robert Häusser, Mannheim; **206 bottom left:** Photo courtesy Nicole Klagsbrun, New York; **208:** © 2004 Robert Mangold/Artists Rights Society (ARS), New York, photo by David Heald; **211:** Photo courtesy Paula Cooper Gallery, New York, photo by Tom Powel; **213:** Photos courtesy Galleria Christian Stein; **214:** © Robert Ryman, photo courtesy of the artist and Pace Wildenstein, New York

index